THE GOLDEN AGE OF
PERSIAN ART

1501–1722

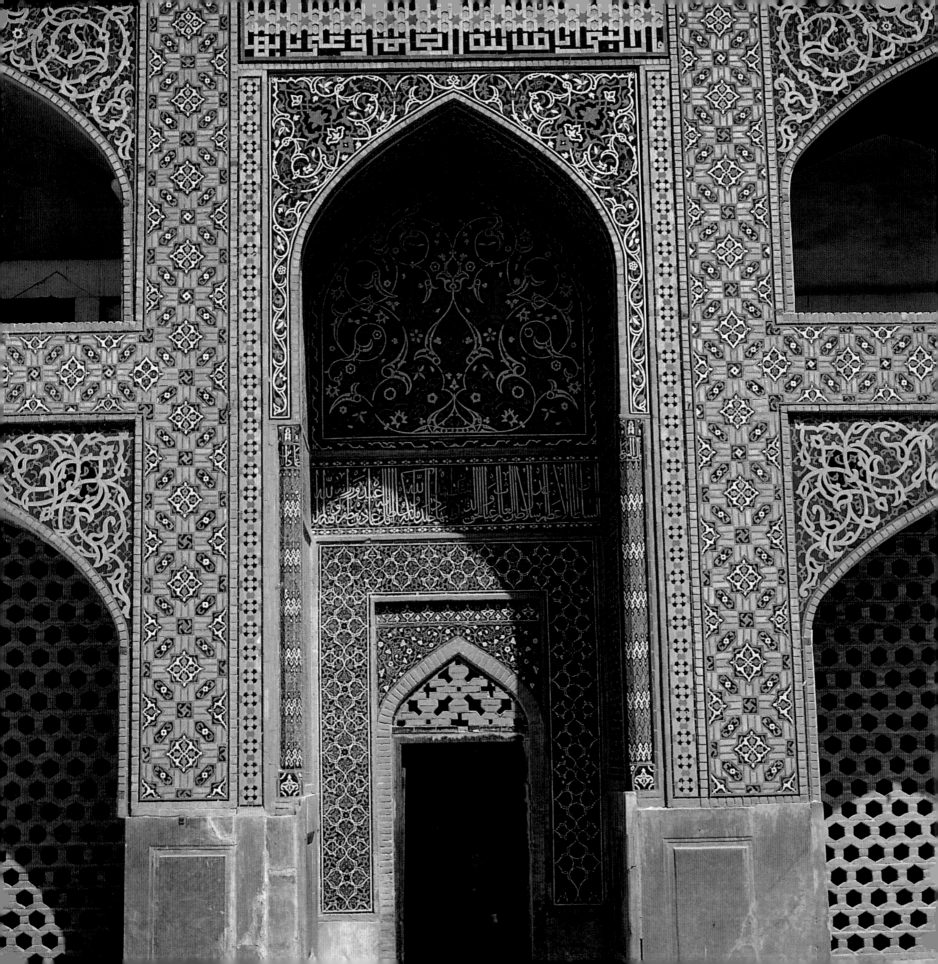

THE GOLDEN AGE OF
PERSIAN ART

1501–1722

Sheila R. Canby

HARRY N. ABRAMS, INC., PUBLISHERS

Frontispiece: Tilework on the Masjid-i Imam, Isfahan, 1612–30
Contents page: Details from fig. 124

Libraryof Congress Catalog Card Number: 99–76377
ISBN 0–8109–4144–9

First published in Great Britain in 1999
by British Museum Press, London

Published in 2000 by Harry N. Abrams, Incorporated, New York

Printed and bound in Italy

Harry N. Abrams, Inc.
100 Fifth Avenue
New York, N.Y. 10011
www.abramsbooks.com

Contents

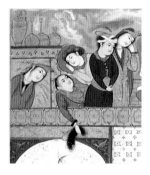

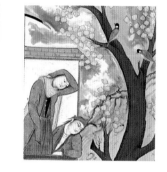

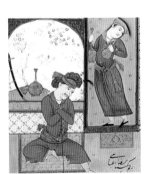

Preface

I exaggerate in calling the Savafid period (1501–1722) *the* golden age of Persian art. It was one of several golden ages with which the history of Iran has been blessed. The Achaemenids, the Sasanians, the Seljuks, the Timurids and even the Qajars could lay claim to the same epithet. Yet the monuments, manuscripts, carpets, textiles, ceramics and metal objects that remain from the Safavid period bear witness to slightly more than two centuries of vibrant culture which developed at first from a fusion of distinct late fifteenth-century idioms and later incorporated an array of foreign influences to end up at a very different place from which it had begun. The purity and opulence of sixteenth-century Safavid art is matched by the internationalism and grandeur of its seventeenth- and eighteenth-century expression. Although the political vicissitudes of the Safavid period must have been vexing for officials, the arts appear never to have been as disrupted as they had been after the Mongol invasions of the thirteenth century or after the fall of the Safavids in the eighteenth century. Thus the period provides an opportunity to study the continual process of artistic evolution over two centuries of Iranian history. Of course, this ambitious idea is tempered by the usual limitations – time, space and money. A book such as this can only touch the high points, as happily much too much Safavid art and architecture survives to make an exhaustive compendium feasible at this time and in this format.

In March 1998 the British Museum held an international symposium on Safavid Art and Architecture. Because the papers from the symposium are being edited now, I have tried to avoid using the ideas expressed by the many superlative scholars who spoke there. While this may impoverish this book, readers will soon be able to follow up some topics discussed here in greater depth in the publication of *Papers on Safavid Art and Architecture*. Otherwise, I marvel at the work of so many scholars on whose published books and articles on the Safavids I have relied. Most of them are included in the Bibliography, but without listing all their names, I would like to express my humble thanks for their erudition.

Specific thanks go to those involved in the production of this book:

photographers John Williams and Kevin Lovelock, editors Teresa Francis and Kim Richardson, designer Andrew Shoolbred, and picture researchers Jemima Scott-Holland and Sophie Tesson. As always, my colleagues Rachel Ward, Venetia Porter, Vesta Curtis, Jessica Harrison-Hall and Robert Knox, Keeper of Oriental Antiquities, have been generous with their time and knowledge. I am indebted to Edmund de Unger and Farhad Hakimzadeh for allowing us to photograph works in their collections and to A.S. Melikian-Chirvani and Susan Stronge for their help in securing metalwork photographs. I would also like to thank Filiz Cagman, Director of the Topkapi Saray Museum, Nurhan Atasoy, Maria Ribeiro of the Fundação Calouste Gulbenkian, Kjeld von Folsach of the David Collection, the University of Uppsala Library, the Textile Museum, the Metropolitan Museum of Art, the Textile Gallery, and the Oriental Institute of the Russian Academy of Sciences, St Petersburg for permission to reproduce works from their collections. Toby Voss and Christina Kwong helped with the index and Annie Searight drew the map. Alexander Morton clarified some confusing historical points, and Adel Adamova and Stuart Cary Welch kindly shared their superior understanding of Safavid art history. Without the support, enthusiasm and intelligent criticism of two Johns and a Jon – Voss, Eskenazi and Thompson – and my dear friend Mark Zebrowski, to whose memory I dedicate this book, I could never have progressed with this project, much less have kept alive the desire to delve into the many mysteries of the Safavids that remain to be solved.

The transliteration system follows in a simplified form that of the *International Journal of Middle Eastern Studies*, with the exception of certain words such as 'madrasa' that have accepted spellings in English. Diacriticals have been omitted because it is assumed that the majority of readers will be non-specialists. Hijra dates of the Muslim calendar precede those of the Christian calendar.

With the exception of that on p. 8, which shows the obverse of a coin of Isma'il I, the coins illustrated on the opening pages of each chapter bear the title of the shah discussed in that chapter.

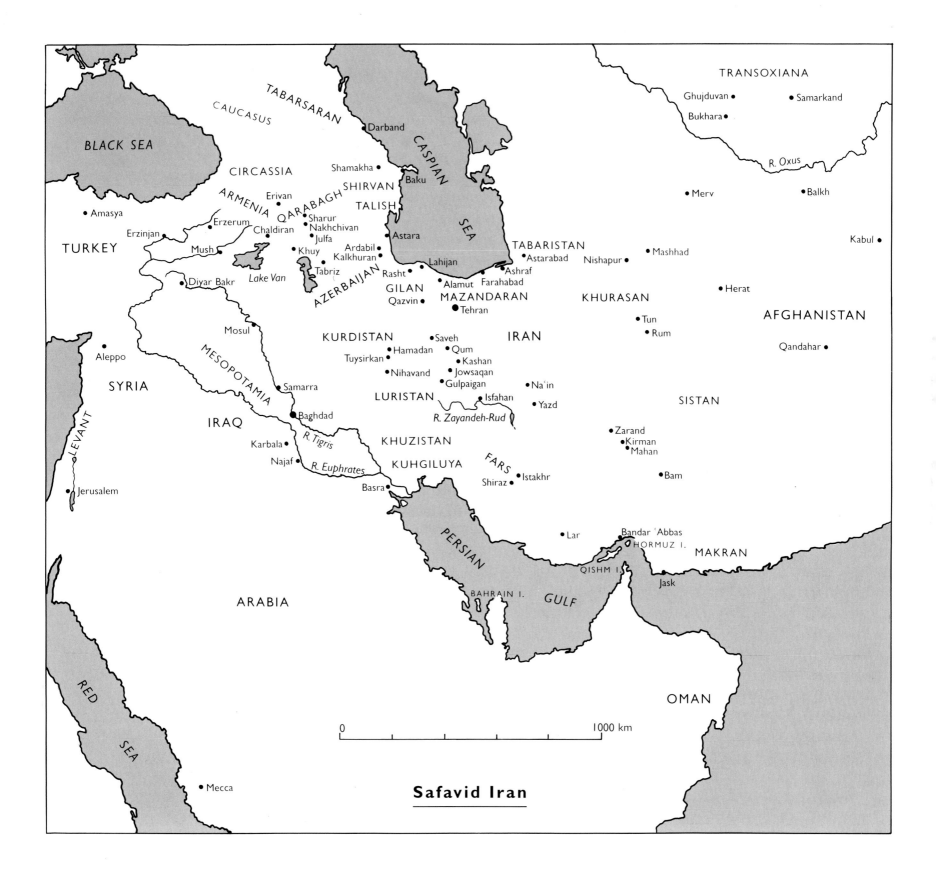

Safavid Iran

Map 7

1

Prelude to the Conquest

Secheaidare [Shaykh Haydar] was a Saint or Master or Prophet, as we should call him, who, by preaching a new Dogma in the Mahometan creed, that Ali was superior to Omar, obtained many disciples and people who favoured his doctrine. So great was his success, that at this time he was considered by all a Saint, and a man almost divine.[1]

Iran in 842/1487, the year in which the first Safavid shah was born, was a land divided. Over the course of the fifteenth century Timurid domination of Iran had diminished until only Khurasan remained in the hands of Sultan Husayn Bayqara, the last ruler of Tamerlane's dynasty. Western Iran and the area around Diyar Bakr and Mosul in northern Mesopotamia were the domain of the Aqqoyunlu (White Sheep) Turkmans, whose leader, Uzun Hasan, made his capital at Tabriz. While the Turkmans and Timurids coexisted peacefully after 875/1470, other dynasties to the east and west of Iran were consolidating their power in the last quarter of the fifteenth century. In Transoxiana the Uzbeks rallied under Muhammad Shaybani and in the 1490s battled with the Timurid prince Babur, the eventual founder of the Mughal dynasty in India, for control of Samarkand. This was achieved in 906/1501, and it was only a matter of time before the Uzbeks extended their hold into Khurasan, seizing Herat in 912/1507, the year after Sultan Bayqara's death. Meanwhile, in the west a far greater power, the Ottomans, sought new regions to subdue after putting an end to the Byzantine empire with the conquest of Constantinople. Although the Mamluks of Egypt and Syria did not fall to the Ottomans until 922/1516, the Ottomans had by then proved their superiority in battle against the Aqqoyunlu Turkmans in 878/1473 and the Safavids in 920/1514. With their enormous armies, extensive use of firearms and solid organization, the Ottoman war machine remained a serious threat to Iran and western Europe into the seventeenth century.

While the Turkmans, Timurids, Ottomans and Mamluks were the great established powers of the late fifteenth century east of the Bosphorus and west of the Pamirs, smaller kingdoms such as Armenia and Georgia and ostensibly non-political religious movements run by shaykhs such as the Safavids at Ardabil exerted a strong influence on events in this period. The name Safavid derives from that of Shaykh Safi, who founded and presided over a dervish order in the late thirteenth–early fourteenth century at Ardabil to the west of the Caspian Sea. Over the course of the fourteenth and fifteenth centuries, the influence and wealth of the Safavid order grew, as did the shrine complex at Ardabil. In the second half of the fifteenth century the shaykhs of Ardabil extended their mission to

1 Detail of fig. 9.

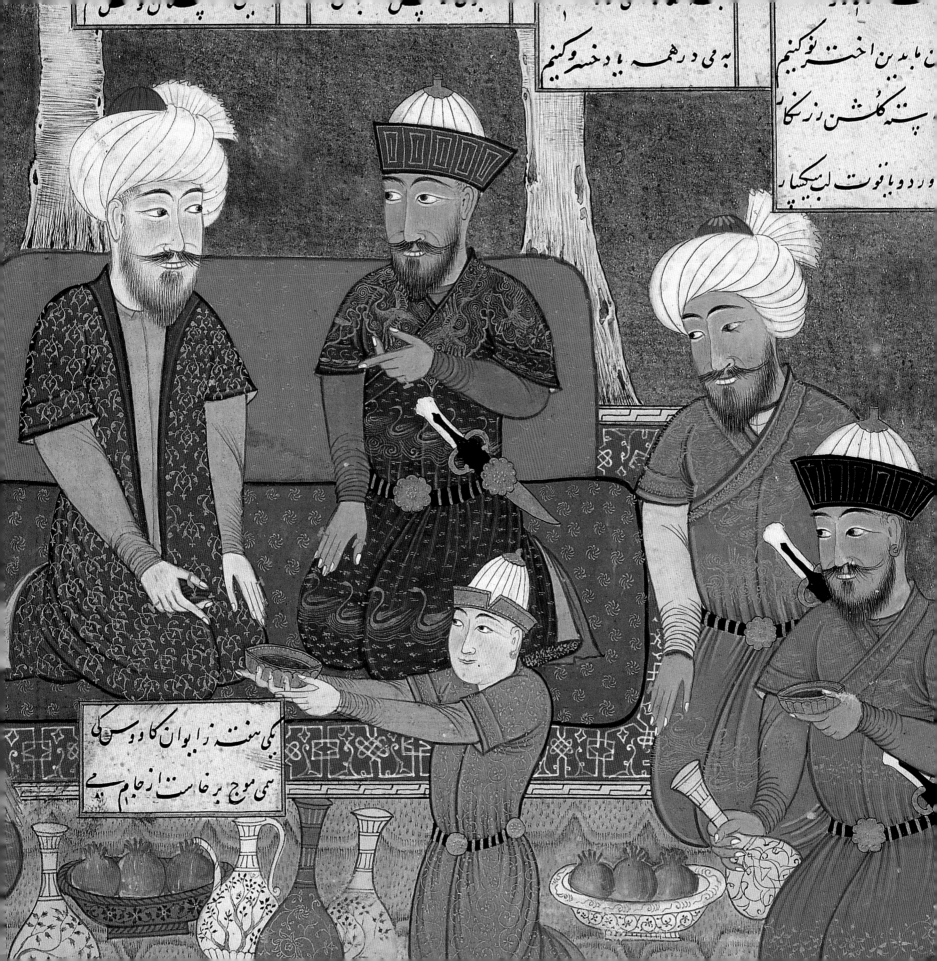

include *jihad*, holy war against the infidel. While the Safavid notion of *jihad* may have sprung from the desire to proselytize, the political reality of assembling an army of zealously committed holy warriors presented a threat to the dominant powers in Shirvan, Azerbaijan and eastern Anatolia, namely the Shirvanshahs, the Aqqoyunlu Turkmans and the Ottomans respectively. Thus the successive deaths of the Safavid shaykhs Junayd, Haydar and ʿAli in the second half of the fifteenth century at the hands of the Shirvanshahs and Aqqoyunlu Turkmans politicized the order and fuelled a desire for revenge.

Born at Ardabil on 25 Rajab 892/17 July 1487, Ismaʿil Safavi entered a world of growing tension between his paternal line, the shaykhs of Ardabil, and his maternal side, the Aqqoyunlu Turkman sultans. The powerful Aqqoyunlu ruler Uzun Hasan had sanctioned the marriage of his daughter Halima Beg, known as ʿAlam Shah Begum, to Haydar, leader of the Safavids. However, the death of Uzun Hasan in 882/1478 and the accession of his sons Khalil and then Yaʿqub Beg led to a change of climate in relations between the two houses. Yaʿqub did not trust Haydar, whose charisma had attracted a large following of Turkmans from eastern Anatolia and Azerbaijan. These men adopted a specific form of headdress which Haydar claimed had been described to him in a dream by ʿAli, Muhammad's son-in-law and successor.[2] Called a *taj-i Haydari*, this consisted of a red felt cap with a tall baton around which the turban was wound with twelve folds, one for each of the twelve Shiite imams. Because of the red colour of the *taj*, the Turkman followers of Haydar were called Qizilbash, or 'red heads'. Whether or not the dream of ʿAli and wearing the *taj-i Haydari* indicate that Haydar himself was Shiite, the choice of a specific headdress differentiated the Qizilbash from other Turkmans and expressed their allegiance to the Ardabil order rather than to Yaʿqub Beg. This loyalty was manifested not only through a turban type and spiritual fealty but also through arms. The Qizilbash formed the basis of an army Haydar raised to fight the Christians of Georgia, as his father Junayd had done before him. However, just as Junayd had succumbed to the Shirvanshahs in 864/1460 as he tried to cross their territory to Georgia, Haydar was killed by Yaʿqub Beg who had become uneasy about his strong following.

In an attempt to limit the influence of Haydar's family, Yaʿqub Beg had his three sons, ʿAli, Ibrahim and Ismaʿil, arrested and taken to Istakhr near Shiraz, where they were imprisoned.[3] Thus, in Rabiʿ II 894/March 1489 at the age of twenty-one months Ismaʿil was relocated to a site over 1,500 km from his place of birth. During the four and a half years that the boys spent in prison, Yaʿqub Beg died and rivalries between the Aqqoyunlu princes flared into civil war. This situation worked in favour of the Safavid prisoners who were freed in 898/1493. However, having drawn the Safavids and their army of supporters into his power struggle, the Turkman prince Rustam then turned on Ismaʿil's older brother, ʿAli, and had him executed. Despite his tender age, all of seven years, Ismaʿil was chosen to succeed ʿAli as the spiritual leader of the order of Ardabil.

Having lost three successive shaykhs to the Aqqoyunlu sultans and Shirvanshahs, the Turkman followers of the order were determined to protect Ismaʿil at almost any cost. Although in 899/1494 the Aqqoyunlu Turkmans plundered Ardabil in search of Ismaʿil, his supporters hid him, first in the house of a *qadi* (judge), then with a sequence of women. Eventually he was taken to join his supporters who were sheltering in the mountains near Ardabil, but the continuing search conducted by the Turkmans required him to move on to Rasht, at times eluding his captors by hiding in the vaults of mosques. Finally Mirza ʿAli Karkiya, governor of Lahijan on the Caspian Sea and a Shiite devotee of the shaykhs of Ardabil, offered to protect Ismaʿil and his Sufi followers.[4]

If his imprisonment and flight from the Aqqoyunlu assassins impressed upon Ismaʿil the seriousness of the threats to himself and the Ardabil order, his five-year stay in Lahijan in 899–905/1494–9 provided the environment in which he could receive a well-rounded education. Mirza ʿAli appointed Maulana Shams al-Din Lahiji to teach him how to read and recite the Qurʾan. Ismaʿil apparently excelled in and mastered Persian and Arabic. In addition, he spoke and wrote Azari Turkish, as his poetry under the pen-name Khataʾi attests. While some of Ismaʿil's time was taken up with meeting his followers from Anatolia and Azerbaijan, he also took pleasure in hunting and fishing in the hills and streams of Gilan. This idyll would have been impossible without the vigilance and guile of Mirza ʿAli, who repeatedly had to deny to the Aqqoyunlu that he was harbouring Ismaʿil. At one point Mirza ʿAli

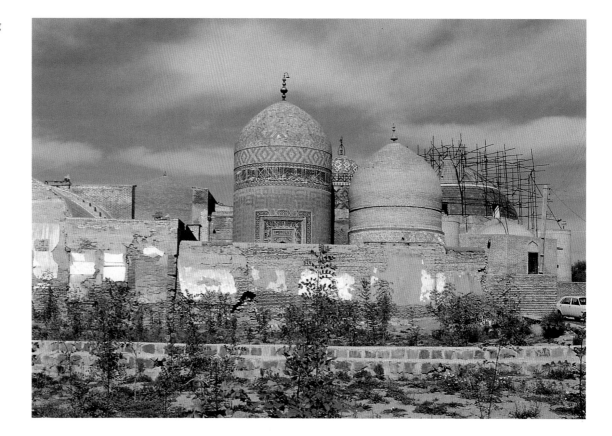

2 Ardabil shrine, view from the south-east showing from left to right the tombs of Shaykh Safi al-Din and Shah Isma'il I, the Haram-khaneh (tomb of Khwajeh Muhiyy al-Din) and the Chini-khaneh (with scaffolding).

reportedly dreamed that 'Ali had instructed him to place Isma'il in a basket and lift it up so that he could swear that Isma'il was not *in* the land of Gilan.[5] Either the gullibility of the Turkmans or, more likely, their increasing political disarray kept them from finding the young shaykh.

By 905/1499 Isma'il, now aged twelve, was ready to emerge from Gilan. Travelling by way of Ardabil, he wintered in Talish, staying in the villages around Astara on the Caspian. Meanwhile, word was spreading among the Sufis of the main Turkman tribes of Anatolia, Azerbaijan and Syria that their *murshid-i kamil* and *padishah* (spiritual and temporal leader) would be ready to meet them in Erzinjan. There in late summer 906/1500 Isma'il and 7,000 supporters congregated and the transformation of the Safavids from religious order to political entity took shape as plans to avenge the deaths of Junayd, Haydar and 'Ali were formulated. First, Isma'il and his army marched on the Shirvanshah city of Shamakha and killed Farrukhyasar, the prince who had defeated and murdered Junayd. Next the Safavids took Baku. At this point they might have

chosen to proceed to Georgia, reviving the holy war begun by Junayd and continued by Haydar. Instead they turned toward Tabriz, capital of the Aqqoyunlus, in the knowledge that the Aqqoyunlu army was advancing north. When the Aqqoyunlus and the Safavids met at Sharur north of Tabriz in late summer 907/1501, the Safavids triumphed and killed the Aqqoyunlu sultan, Alvand. Now in control of Azerbaijan, Isma'il was crowned at Tabriz, coins were issued in his name and the *khutba*, the declaration of the reigning monarch's name at Friday prayers, was read in the name of the twelve imams. The Safavid conquest of Iran and the imposition of Shiism as the state religion had commenced.

The account of Shah Isma'il's childhood and emergence as spiritual and temporal leader of the Safavids incorporates certain key events for the early history of the Safavid state. Equally, one may look to these years for clues to the formation of Isma'il's taste and thus the early stages of Safavid art and architecture. Whether imprisoned by or in flight from the Aqqoyunlu Turkmans, Isma'il would have travelled more than most princes of his day. The

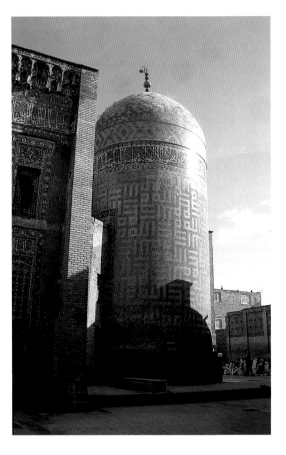

3 Tomb of Shaykh Safi al-Din, Ardabil shrine, completed c. 745/1344, view from the north-west. The word 'Allah' is repeated in glazed turquoise bricks on the sides of the tower. The exterior of the Dar al-Huffaz is partially visible to the left of the tomb tower.

Ardabil shrine [fig. 2], centre of the Safavid order and burial place of his ancestors, would have held profound significance for him. Moreover, while hiding from the Turkmans in one of the mausolea at the shrine, he may have had time to contemplate the building as well as his escape. The range of houses he visited may not have varied much architecturally one from another, but his quarters opposite the *madrasa* of Kai Afridun and presumably close to or within the palace precinct in Lahijan would have afforded him a measure of protection and continuity. Finally, the monuments of Tabriz, especially the Blue Mosque built by the Qaraqoyunlu Jahan Shah or his daughter in 870/1465 and the early fourteenth-century Masjid-i Jami' of 'Ali Shah must have impressed Isma'il with their size and the beauty of their tile ornament.

Much of the scholarly speculation about the Safavids has concentrated on the introduction of Shiism and to which shaykh it should be attributed. Did Haydar's dream of 'Ali and the *taj-i Haydari*, if it occurred at all, indicate that Haydar had formally embraced Shiism? While many specialists believe that aspects of Shiism were acceptable to the shaykhs of Ardabil without their renouncing Sunnism, Isma'il's fervent acceptance of the Shiite way cannot be denied. Possibly his five-year stay at the court of 'Ali Mirza Karkiya, a Shiite himself, was the deciding factor in Isma'il's system of beliefs. Certainly his formal education at the Gilan court by Shams al-Din Lahiji could have provided an intellectual framework within which to embrace Shiism. Furthermore, the extreme Sufi following who rallied to Isma'il's cause when he emerged from Gilan would have incorporated a number of Shiite beliefs in their religion, which was more folk than orthodox Islam. While the impact of Shiism on early Safavid art cannot be pinpointed, objects begin to bear the names of the Shiite imams and some of the intensity found in the religious poetry of Shah Isma'il is reflected in the paintings of the Tabriz master Sultan Muhammad. Thus the connection between the early Safavid system of beliefs and the art of the period is more a matter of mood than of literal illustration of Shiite hagiography.

Like the monuments, domestic buildings and tents that Isma'il could have observed before his accession, so the manuscripts he studied at 'Ali Mirza Karkiya's court and those he may have read for enjoyment would have furnished a standard against which others could be compared. In addition, utilitarian objects from bowls to ewers, clothes to carpets, and bowcases to spears all would have comprised Isma'il's visual environment. While not all such objects can be assigned to a precise date and place so that we can be certain of his familiarity with them, some standing monuments, illustrated manuscripts and dated objects of the late fifteenth century help to define the types of manmade edifices and objects to which Isma'il might have been exposed.

Although at least ten structures are extant today at the Ardabil shrine and many more would have stood in its heyday in the sixteenth and seventeenth centuries, only a handful of significant buildings and numerous graves were clustered at the site in the late fifteenth century.[6] Soon after the death of Shaykh Safi, founder of the Ardabil order, in 734/1334, a room in his *khangah* (dervish lodge), where his followers met, was designated as the place in which he should be buried. By 745/1344 a domed tomb tower [fig. 3] had been constructed over the body of Shaykh Safi by his son,

Shaykh Sadr al-Din Musa. Although it has undergone refurbishment, the present building with its glazed brick decoration is substantially original. To the east was the Gunbad-i Haram (Haram-khaneh), where Shaykh Safi's wife, who was the daughter of his spiritual master, and other women were buried. This had originally been erected between 724/1324 and 735/1334 during Shaykh Safi's lifetime as a tomb for his eldest son, who predeceased him, and is most likely the earliest extant building at the shrine. The hall that leads up to Shaykh Safi's tomb was constructed on the site of a *zaviyeh* (meeting room for the faithful), which was demolished after the shaykh's death. Called the Dar al-Huffaz, the hall functioned as a room for continuous recitation of the Qur'an. Like Shaykh Safi's tomb, this building was constructed by his son, Shaykh Sadr al-Din Musa, during his time as shaykh of the Safavid order at Ardabil (735/1334–794 or 795/1391 or 1392). While the building has undergone interior and external alterations and renovations, its basic shape and relationship to Shaykh Safi's tomb, as they exist today, would have been close to those of the late fifteenth century when Isma'il sheltered in the shrine. However, only the tilework in the entrance portal can be attributed to the fourteenth century (restored in the twentieth century), while the interior decoration stems from the period of Shah 'Abbas I (995/1587–1039/1629).

Another building revamped by Shah 'Abbas, the Chini-khaneh, also originated in the fourteenth century; it has been identified as the 'Dome of the Princes' by Morton.[7] Later altered to accommodate Shah 'Abbas' collection of Chinese porcelain, the chamber, its dome and perhaps its crypt would have been familiar sights to Isma'il. In addition to the standing buildings erected by Shaykh Sadr al-Din Musa in the fourteenth century, a large domed Chilleh Khaneh with glazed brick decoration once stood to the west of Shaykh Safi's tomb, but has been in ruins for at least a century. Golombek and Wilbur have suggested that it functioned as a gathering place for dervish ceremonies.[8] In the fifteenth century Isma'il's grandfather, Shaykh Junayd, added a large rectangular courtyard, and possibly the suite of rooms surrounding it, leading up to the Chilleh Khaneh from the north-west.

The Ardabil shrine is highly distinctive. Not only did it include the domed tomb towers of Shaykh Safi, his son and other family members, but also buildings such as the Dar al-Huffaz and the Chilleh Khaneh which would have accommodated the followers of the Safavid order. The large courtyard to the west of the complex would have been useful when the numbers of people at the shrine exceeded the space available inside the shrine buildings. The decoration, consisting of glazed brick *hazar baf* inscriptions and geometric ornament, and epigraphic and arabesque panels in mosaic faience in portals and around windows, relates to monuments of the mid- and late fourteenth century in Kirman and Samarkand, but the tall, narrow proportions of the entrance to the Dar al-Huffaz recall the Muzaffarid architecture of Yazd of the 1340s.[9]

Although the fortress architecture of Istakhr may have made an impression on Isma'il from his four-year incarceration there, he may not have been inclined to recreate in Azerbaijan the types of buildings to which he was exposed in Fars. One can only speculate on the domestic and public architecture that would have stood in Lahijan at the time of Isma'il. Traditionally, because of the extensive forests of Gilan, houses were built of wood with verandas. However, the palace of Sultan 'Ali Mirza would probably have been constructed of stone or brick as it would have served a defensive purpose as well as housing the local potentate and his staff. Assuming the Lahijan governor's palace was basically similar to that of the Shirvanshahs in Baku, to the north, it would have included a multi-room building of two storeys in which the governor and his family resided; a building devoted to administration, possibly with a jail; a mosque and mausoleum and perhaps a *madrasa*; and a *hammam* (bath), all surrounded by walls.[10] The so-called 'Ross Anonymous' states that Mirza 'Ali set apart a dwelling opposite the College of Kai Afridun for Isma'il,[11] but it is not certain whether this was inside or outside the palace precinct. However, it would seem likely that both the college (*madrasa*) and Isma'il's quarters were well within the palace walls and safe from the Turkman authorities.

In such a palace Isma'il could have become familiar with the warren of rooms in the private, residential part of the complex as well as the *madrasa*, where he may have received his lessons from Shams al-Din Lahiji, and the mosque where he would have worshipped. Just as at Baku, towering *ivan*s (niches) with tiled and stone-carved spandrels and *muqarnas* pendentives would have

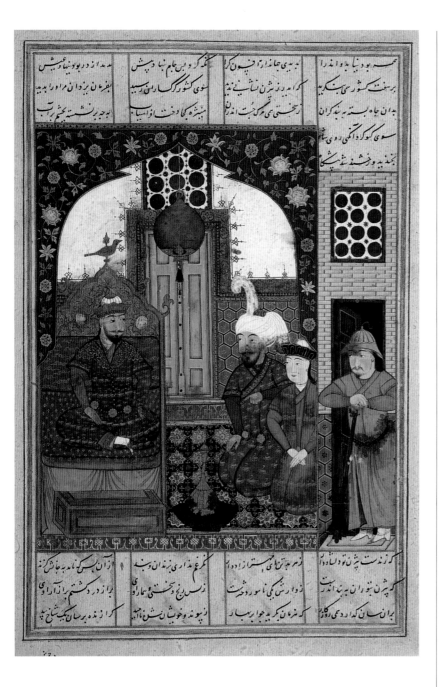


منظر بود دنیا بدو اندر بیش / بداز درد بو نیای خویش / و مردم بیش / و بن حالم کلو بن حالم کلو / سوی کشور گرگ رانم بیش / فنان یزدان مرا ورا بدید / مسبة ترنت بختی از آستان / و جه بر نشته حشم رات

4 'Giv Brings Gurgin before Kay Khusrau', from the 'Big Head' *Shahnameh*, Gilan, Iran, 899/1493–4, opaque watercolour and ink on paper, text and illustration 23 × 14.9 cm, Arthur M. Sackler Gallery, Smithsonian Institution, Washington, DC, S1986.160. The figures are seated in an *ivan*, or arched niche, with a glazed blue and gold tiled dado, painted plaster upper wall and a window with round panes, once silver, now tarnished black.

marked the entrances to different buildings and the sides of the courtyard of the *madrasa*. Otherwise, the decoration of surfaces may have been simpler than those at the Ardabil shrine.

Examination of interior scenes from a *Shahnameh* (Book of Kings) manuscript produced for Sultan 'Ali Mirza in 1493–4 and known as the 'Big-Head' *Shahnameh*, may shed some light on the actual appearance of his palace interiors. Many decorative features are evident in the painting of 'Giv brings Gurgin before Kay Khusrau' [fig. 4] which may have been found in the palace in Lahijan. The main event takes place within an *ivan*, designated by a spandrel covered with an animated floral arabesque on a rich blue ground. Unlike the tiled dado at the back of the chamber or the brick and tiled entrance, there are no lines to indicate that the spandrel is made up of tiles. While such a spandrel could have been painted and gessoed, it is also possible that the artist omitted the lines that denote tiles to avoid detracting from the design. Behind Kay Khusrau's gilded throne with its bird finial, the dado walls of the niche consist of cobalt blue hexagonal tiles with ornamental gold dots, bordered by narrow strips of green and gold and a wider band of gold. These gold sections may have been gessoed and gilded, as one finds in some early Timurid buildings.[12] The upper section of the wall consists of plain white plaster with a row of painted blue knots around the edges. Behind the throne and to the right is a prominently displayed door, most likely of wood painted pink. Above this door and the door at the right are two rectangular windows, the round glass panes of which have tarnished to black. Likewise, the large orb suspended in the centre of the room must have originally shimmered as one would expect of a silver or glass lamp. A sumptuous carpet with a pattern of repeating stars and crosses and a red border with a pseudo-Kufic inscription completely covers the floor of the interior. The exterior walls of the palace are revetted with turquoise-glazed bricks and a dado of cobalt blue and black hexagonal tiles.

Upon his entry into Tabriz in 907/1501, Isma'il could not have failed to be impressed by the Blue Mosque (Masjid-i Muzaffariyah), built in 870/1465, and the monumental early fourteenth-century Masjid-i Jami' of 'Ali Shah. Although today only the *qibla* wall and parts of the two flanking walls that would have formed the sides of a vaulted *ivan* remain, in the fourteenth century the Masjid-i Jami

had a *madrasa* and a *zaviyeh*. The vault itself apparently partly collapsed not long after its construction. Before the vault was a large courtyard with marble paving, watercourses, fruit trees and flowers, tiled arcades and walls, and a central pool with a fountain. This consisted of a square platform with four lions spouting water into the pool; in the centre at a higher level rose an octagonal fountain with two jets.[15] Although historical descriptions of the decoration of the mosque are not overly precise, they appear to indicate that the building was revetted in part with lustreware tiles and with glazed tiles on the exterior façades. Wilber has suggested that 'the interior wall surfaces were coated with white plaster but [it is] more probable that they were hung with woven materials'.[14] Even if the tile decoration was intact in 907/1501, it seems unlikely that textile hangings still covered the interior walls, if they ever had.

The sheer size of the Masjid-i Jami' is exceptional, but the opulent decoration of the Blue Mosque may have had a greater influence on Isma'il's taste and thus on early Safavid architecture than the earlier building. Moreover, although the organization and function of rooms in the palace at Lahijan would have differed greatly from those of the Blue Mosque, the decorative vocabulary of the two complexes may have been similar, with artisans at the provincial palace borrowing ideas from the Turkman capital.

Although much ravaged by earthquakes, the Blue Mosque still boasts glorious tile and brickwork decoration [fig. 5]. The visitor in 1500 would have first been struck by the towering portal with its *muqarnas* semi-dome completely covered in mosaic faience. Floral and arabesque ornament in turquoise, yellow and white provide a rhythmic counterpoint for the slightly raised inscription that forms a frame for the opening of the portal. Traces of tile and unglazed baked brick decoration on the exterior suggest that the whole building was originally covered with decoration. Possibly Isma'il would have noted the unusual plan of the building, with a large central domed chamber and a smaller domed sanctuary on the same axis as the entrance. Certainly the hexagonal dark blue tiles of the central dome chamber are found in manuscript illustrations of the late fifteenth century [see fig. 4]. Moreover, in the smaller dome chamber the purplish blue tiles have gold decoration applied just as in the paintings. The smaller chamber, thought to be a mausoleum for Jahan Shah, has greenish marble slabs resembling

5 Niche on left flanking wall of entrance portal, Blue Mosque (Masjid-i Muzzafariyah), Tabriz, 870/1465. The rich and varied decoration of this Qaraqoyunlu Turkman monument includes intricate tile mosaic with monumental inscriptions in squared Kufic and cursive *thuluth* scripts.

alabaster with a continuous Qur'anic inscription running around its periphery at dado level and in the *mihrab*, an expensive alternative to tiling. Perhaps more influential than the range of decorative techniques was the precision and finesse of the epigraphic, geometric and vegetal patterns which adorn the building. The marriage of ebullience and refinement found at the Blue Mosque was never again replicated. Yet its spirit informed early sixteenth-century royal Safavid architectural decoration as well as the arts of the book.

Other spectacular buildings in Tabriz to which Isma'il became heir, such as Uzun Hasan's Hasht Bihisht garden palace, have

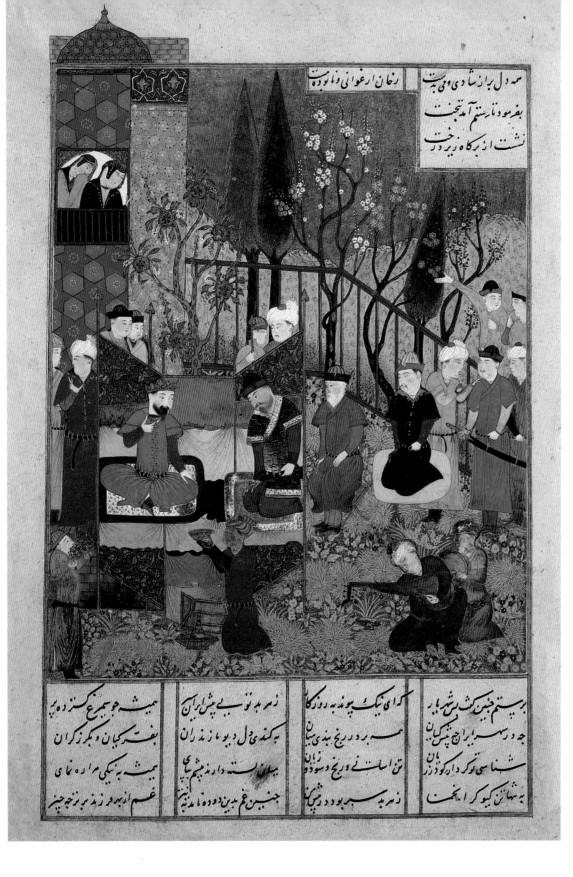

6 'Rustam before Kay Khusrau under the Jewelled Tree', from the 'Big Head' *Shahnameh*, Gilan, Iran, 899/1493–4, opaque watercolour and ink on paper, text and illustration 23 × 15.4 cm, Arthur M. Sackler Gallery, Smithsonian Institution, Washington, DC, S1986.159. When Kay Khusrau met with Rustam to discuss the rescue of Bizhan, he was enthroned under a tree with a silver trunk, golden leaves, flowers of jewels and real fruit.

disappeared. Yet some of the types of portable objects that he would have used before becoming shah can be deduced from a handful of dated or datable pieces of metalwork and ceramics and illustrations of objects in manuscripts.

Two illustrated manuscripts stand out as highly significant documents for the study of the type of books to which Isma'il might have been exposed before his accession. The *Shahnameh* dedicated to Sultan 'Ali Mirza Karkiya in 899/1493–4, the year that Isma'il arrived at Lahijan, includes over 300 illustrations in a range of Turkman painting styles from the folksy 'Big Head' genre to the more restrained Turkman Court Style.[15] It is possible that as many as four artists joined the scribe, Salik ibn Sa'id, in producing this manuscript. Unlike the late Timurid workshop at Herat, where artists strove for stylistic uniformity, the illustrations to the Lahijan *Shahnameh* fall into distinct stylistic groups. At one extreme are the paintings of figures with disproportionately large heads and teeth that poke out between closed lips. At the other are paintings that reveal a greater debt to Timurid painting as filtered by the Turkman Commercial Style of Shiraz. The figures in these works are numerous and small in scale [fig. 6]. The level of complexity of ornament and composition is far greater than in the Big Head group. Also, here one finds the typical Turkman treatment of vegetation, with lush clumps of grass and low-growing plants rendered with yellowish green leaves. The illustrations forming an intermediate group in which the figures are neither exceptionally large nor small may be the work of another individual or of two artists working together. Although Isma'il may have found the toothy big-headed figures amusing, the sophistication, precision and intense colour of the smaller-scale illustrations are the stylistic traits that survived in Safavid painting from the time of his reign.

Like the Blue Mosque and the Masjid-i Jami' of 'Ali-Shah, the contents of the royal library of the Turkmans became Isma'il's when he took Tabriz in 907/1501. We will never know the extent of the library holdings, as Ottoman invasions, royal gift giving, the shift of the Safavid capital to Qazvin and natural disasters have all but erased the historical record. However, some of the finest Turkman manuscripts and albums are kept intact in Istanbul and shed light on the leading artists of the late fifteenth century at Tabriz and their productions. Of these, the *Khamseh* (Five Tales) of

Nizami bears a colophon dated 886/1481, but was begun for the mid-fifteenth-century Timurid prince Babur b. Baysunghur (d. 861/1457) and continued at the behest of the Aqqoyunlu Turkman Khalil Sultan for his father, Uzun Hasan. When he died in 883/1478, his brother Ya'qub Beg, who is mentioned in the colophon, had illustrations added by the two leading court painters, Shaykhi and Darvish Muhammad. Yet more paintings were added when the manuscript came into the hands of Shah Isma'il.[16] The result is that eleven illustrations were completed before 1501 and eleven more were added about 1505.

The artists of the first group of illustrations have combined a plethora of detail drawn on a minute scale with almost dreamlike sequences of colour to create compositions in which architecture and landscape are organically interconnected. People and animals populate but do not dominate the compositions. In these works, far more than in most of the Big Head *Shahnameh* pages, the viewer is aware of the natural setting. Likewise, because of the precision of drawing, we can discover much about the types of material objects employed in Tabriz in the last quarter of the fifteenth century. While the artists responsible for these illustrations were in every way the match of the painters working in Herat at the Timurid court of Sultan Husayn Bayqara in the same period, the mood of the two courts could not be more distant. Where Herat painters present a rational, almost geometric, and somewhat cool world view, the Turkman artists mitigate geometry with motion, the cool with the hot, and incorporate different climates and even times of day in the same composition. Certainly these paintings would have been to the Turkman royal taste, but did they express a different approach to the world from that of the Timurids? While the Timurids were threatened on the east by the Uzbeks and hemmed in on the west by the Turkmans, at the end of the fifteenth century Sultan Husayn Bayqara presided over a brilliant court where poetry and art flourished. By contrast, until the death of Ya'qub Beg the Turkmans were interested in expanding their territory and control in Anatolia and Iran. The unity of this vision did not extend to the arts; rather, in painting different styles coexisted even in the same manuscript. In the decorative arts, artisans borrowed from the dominant workshops of the day to produce metal and ceramic objects that are subtly distinct from those of other domains.

Recent studies of the archaeological remains and petrography of fifteenth-century ceramics have begun to isolate workshops in different parts of Iran.[17] According to Golombek, Mason and Bailey, the important pottery-making centres of Nishapur and Mashhad were joined in the late fifteenth century by Tabriz, probably as a result of potters emigrating from Khurasan.[18] The blue and white wares made at Tabriz derive from Chinese blue and white porcelains [fig. 7], but blue and white wares produced at Nishapur may have been the immediate inspiration for their designs rather than the Chinese wares themselves. Given the great wealth of the Turkman rulers, actual Chinese porcelains and vessels of precious and base metals would have been preferred over Persian stonepaste wares at court. Yet a market for Persian blue and white wares would have existed at other levels of society, as the range in quality from fine to crude wares attributed to Tabriz attests.

The differential between the taste and buying power of the Turkman court at Tabriz, on the one hand, and of satellite courts such as that at Lahijan, on the other, is suggested by comparing the vessels depicted in the Turkman *Khamseh* of Nizami and the 'Big Head' *Shahnameh*. In 'Bahram Gur and the Moorish Princess in the Yellow Pavilion' in the *Khamseh* of Nizami [fig. 8], Bahram Gur reclines in a pavilion with two bulbous golden bottles at his side, one of which sits on a golden platter. Decorated, respectively, with lobes and facets, these bottles would have most likely been gold, as brass was not suitable for vessels containing wine or drinking water unless it was tinned. Nearby a girl waters a flower with a golden ewer and in the foreground another girl kneels beside a stream with a small hemispherical gold cup in her hand. Except for the tiles in the niche, nowhere is a ceramic object to be seen. By contrast, the painting of 'Kay Khusrau and Kay Kaus' from the 'Big Head' *Shahnameh* [fig. 9] features an array of ceramic

bottles, dishes and a ewer and three small golden wine bowls held by a servant boy and two attendants. It is possible that both Persian and Chinese ceramics are depicted here. The cobalt blue and lustre pieces would definitely be Persian and the pale blue ones with dark blue decoration are probably Persian imitations of Chinese wares, but the blue and white pieces could well be Chinese porcelains as their shapes and decoration relate fairly closely to Chinese prototypes, albeit of about 1435.

From the accounts of travellers who visited the court of Uzun Hasan one can deduce that both metal and porcelain vessels were used for serving food, or for containing other items such as jewels, and were considered appropriate as ambassadorial gifts. Josafa Barbaro, who visited Tabriz in 1474, described the presentation of gifts from an Indian ambassador to Uzun Hasan: 'every one of them w[i]th a little dishe of sylver full of such pretiouse stones as I shall declare unto yow hereafter. After them came certein w[i]th vessells and disshes of PORCELLANA.'[19] Ambrogio Contarini, recounting banquets with the king in the same year, noted that four hundred people regularly sat at the king's entertainments. 'The food is brought to them in vessels of copper, and consists sometimes of rice; sometimes of corn, with a little meat ...'[20]

Whereas the blue and white ceramics which now can be attributed to Tabriz reveal the strong influence of China by way of Khurasan, very little metalwork can safely be assigned to Turkman Tabriz. On the basis of an inlaid brass candlestand inscribed with the name of Uzun Hasan, Allan has identified a group of metal objects of various shapes that appear to have been made within the Turkman cultural orbit.[21] In addition, it is possible that the so-called 'Veneto-Saracenic' group of metalwork was produced in Azerbaijan or the Diyar Bakr–Kurdistan region, but it may have been primarily for export to Europe. What is evident in both

7 (opposite) Blue and white rimless stonepaste bowl, north-western Iran, early 16th century, diam. 34 cm, British Museum, OA 1999.7-1.1. This bowl with its lotus decoration enclosed in an ogive derives its rimless shape from a type of Chinese blue and white bowl produced around 1500. The chrysanthemums and vine scrolls in the cavetto are typically found on bowls from north-western Iran.

8 (right) 'Bahram Gur and the Moorish Princess in the Yellow Pavilion', from the royal Turkman *Khamseh* of Nizami, Tabriz, Muharram 886/March 1481, painted by Shaykhi, opaque watercolour, gold and ink on paper, 28.3 × 17.2 cm, Topkapi Saray Library, Istanbul, H.762, fol. 177b. This is one of the illustrations that has earned this manuscript its place as the greatest of all Turkman illustrated books.

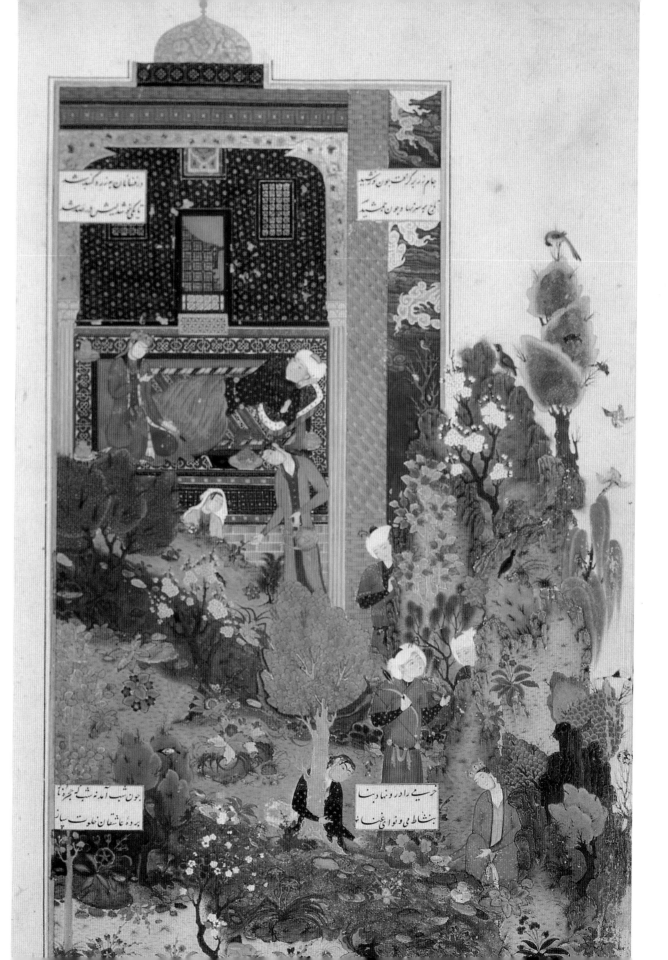

9 'Kay Khusrau and Kay Kaus', from the 'Big Head' *Shahnameh* of Firdausi, Gilan, Iran, 899/1493–4, opaque watercolour and ink on paper, text and illustration 25.9 × 19.6 cm, Arthur M. Sackler Gallery, Smithsonian Institution, Washington, DC, S1986.172. The future shah Kay Khusrau kneels on the right telling his grandfather, Kay Kaus, and assembled courtiers about his adventures, while a young boy serves them wine.

groups of metal wares is the awareness of eastern Iranian metalwork from Herat as well as Mamluk and Ottoman styles and techniques of metalwork. While the intricate arabesque that fills the spaces between geometric, epigraphic and other larger design elements on the 'Veneto-Saracenic' wares [fig. 10] recalls the small-scale, complex ornament of metal objects made in late fifteenth-century Herat, the incorporation of generously executed lotus flowers and bold *thuluth* script on a tinned copper plate of 902/1496–7 relates to the decoration of some Mamluk metal wares of the fourteenth century. Although the lack of metal objects with historical inscriptions impedes the identification of a school of Turkman metalwork in the late fifteenth century, the few pieces that can be assigned to Turkman patronage point to a group of objects related to both Herati and Mamluk metal wares but subtly distinct from both major schools. In some cases design elements recall those of thirteenth-century inlaid metal works of Mosul, now under Turkman control, which might lead one to wonder if some families of metalworkers had either remained in Mosul or returned there at some point in the fifteenth century.

Modern knowledge of other Turkman portable objects, such as textiles and carpets, relies almost entirely on manuscript illustrations. The figures in the royal Turkman *Khamseh* wear either plain coloured long robes and coats or garments made of cloth with repeating gold patterns. Sometimes special decoration on the shoulders or a band of ornament at the waist or knee is evident. Some coats, such as that of the princess, are lined with fur. In the 'Big-Head' *Shahnameh* some servants wear garments of plain cloth while the robes of nobles and kings and even pageboys have repeating gold decoration in bands or all-over designs as well as cloud collars, which had been in vogue throughout the fifteenth century. Although there is no reason to doubt that the textiles depicted in paintings reflect the actual textiles of the period, very few fragments are extant which can be attributed to late fifteenth-century Iran with confidence. Furthermore, since some pieces thought to be fifteenth-century have come out of Tibet, they have been attributed to Transoxiana rather than Azerbaijan or even Khurasan. Even if the fifteenth-century textiles known today were woven in eastern Iran or beyond, it is possible that the raw silk came from the Caspian region, a major silk production area.

Woods has pointed out that the Turkman ruler Ya'qub Beg was determined to maintain the economic health of his realm which depended in large part on the Caspian–Mediterranean silk trade. Gilan, controlled by the Karkiya dynasty, paid the Aqqoyunlu ruler 7,200 kg of silk annually, 'worth more than 1.2 million *akçe*s on the Bursa silk market in addition to nearly 300,000 *akçe*s in transit dues paid at Erzincan'.[22] The fact that the Aqqoyunlu often had difficulty collecting this tribute is probably more a result of resentment and desire to keep their own profits on the part of the silk producers than of an inability to produce the required quantities of silk. Moreover, even if silk from Gilan was sold raw, it must be assumed that the knowledge and appreciation of high-quality silk would have been extensive in Gilan and that its wealthier inhabitants would have possessed silken goods that were as luxurious as those available in Tabriz.

The reference to Bursa, until 857/1453 capital of Ottoman Turkey, is of interest not only because of the fine velvets and other textiles produced there but because the carpets that appear in the 'Big Head' *Shahnameh* appear to be of Turkish rather than Persian manufacture. Josafa Barbaro had noted the carpets from Bursa at the court of Uzun Hasan.[25] With their repeating star and cross patterns in the field and borders of pseudo-Kufic, the carpets in the painting 'Giv Brings Gurgin before Kay Khusrau' [see fig. 4] resemble in a general way the 'Holbein type I' carpets represented in Italian paintings of the 1490s and in some extant examples.[24] In the late fifteenth century, as in the Safavid period, trade was maintained with the Ottomans even in times of political strife. Moreover, Ya'qub Beg was determined to remain neutral in his relations with the Ottomans on the one hand and the Mamluks on the other, presumably as much for economic as for political reasons. Even in the 1490s, during the civil disturbances between rival Aqqoyunlu princes, trade with Bursa most likely continued relatively undisturbed; thus local potentates such as Sultan 'Ali Mirza of Lahijan could buy fine carpets from Turkey as easily as his merchants could sell silk to the Turks.

Although it is impossible to reconstruct the rooms in which Shah Isma'il was reared and those that he entered upon taking Tabriz, the remains of buildings, paintings, ceramics, metal wares and textiles all contribute to a partial knowledge of his environment. As shah he united Iran, but even before his accession artistic ideas travelled to Tabriz, Ardabil and Lahijan from the Timurid east, the Ottoman west and the Mamluk south, not to mention regions such as Fars province that were controlled by the Turkmans. As one would expect, the visual sources of the magnificent manuscripts, textiles, carpets and other products of the early Safavids must be sought in Turkman Iran and its neighbouring states. The miracle of Safavid art lies in the transformation of these latent ideas into new and stunning forms.

10 'Veneto-Saracenic' jug, north-western Iran, late 15th–early 16th century, brass with silver inlay, h. 18.5 cm, diam. of rim 9 cm, British Museum, OA 78.12-30.729, Henderson Bequest. Although the group of metal wares from which this comes may have been made primarily for export to Venice, the intricate interlaced decoration and medallions are typical Islamic motifs.

2
Like a Burning Sun

Shah Isma'il I

1501–1524

For the die of Heaven's choice has been cast in your name, and before long you will come out of Gilan
like a burning sun, and with your sword sweep unbelief from the face of the earth. [1]

The political reconfiguration of Iran that occurred as a result of Shah Isma'il's military successes up to 920/1514 dominates the pages of historical texts and foreigners' accounts, leaving less space for descriptions of his taste and way of life than one finds for either his Turkman predecessors or his Safavid successors. None the less, even reports of his battles sometimes shed light on booty taken and gifts bestowed. Textual accounts of buildings constructed or improved by Shah Isma'il are also terse, although foundation and renovation inscriptions on the buildings themselves augment the written evidence. A handful of portable objects and, of course, coins are inscribed with Shah Isma'il's name and a respectable number of manuscripts are dated within the years of his reign, 907–30/1501–24. Buildings, manuscripts and objects commissioned by high-ranking Safavid officials reflect the taste of the times even if they do not bear the direct imprimatur of the shah. Although Isma'il did not forcibly resettle artisans to the capital at Tabriz from the regions that he conquered, the combination of regional artistic styles that began during his reign and continued under Shah Tahmasp stems from the movement of people and ideas made possible by a new political order.

Isma'il's conquests entailed more than appropriating territory

and winning the fealty, willing or unwilling, of populations. Each major battle won and city taken added armaments, horses and the furniture of war (tents, saddles, cooking equipment, etc.) as well as fortresses, palaces, jewels, money, silver and gold vessels, precious silks, whole libraries and whatever other items of value the provincial princes of the day possessed. Even before Isma'il's victory at the Battle of Sharur in 1501, he had taken Shirvan and 'all of the treasure of the Širvānšāh fell into his hands'. [2] While the cultural inheritance of Shirvan would have resembled that of Gilan and Azerbaijan, there are few clues to what novelties the Shirvanshah treasury would have contained [3] and whether they might have caught Isma'il's fancy or inspired his artisans.

By comparison to his foray in Shirvan, Isma'il's triumph at Tabriz in the summer of 907/1501 after defeating the Aqqoyunlu leader, Alvand, bore the trappings of a self-conscious change of regime, if not yet empire. The beginning of the Safavid state and

11 'Five Youths in a Landscape', from a *Divan* (Collected Poems) of Khata'i, Tabriz, c. 1515–20, opaque watercolour, gold and ink on paper, 15.2 × 12.1 cm, Arthur M. Sackler Gallery, Smithsonian Institution, Washington, DC, S1986.60, fol. 2.

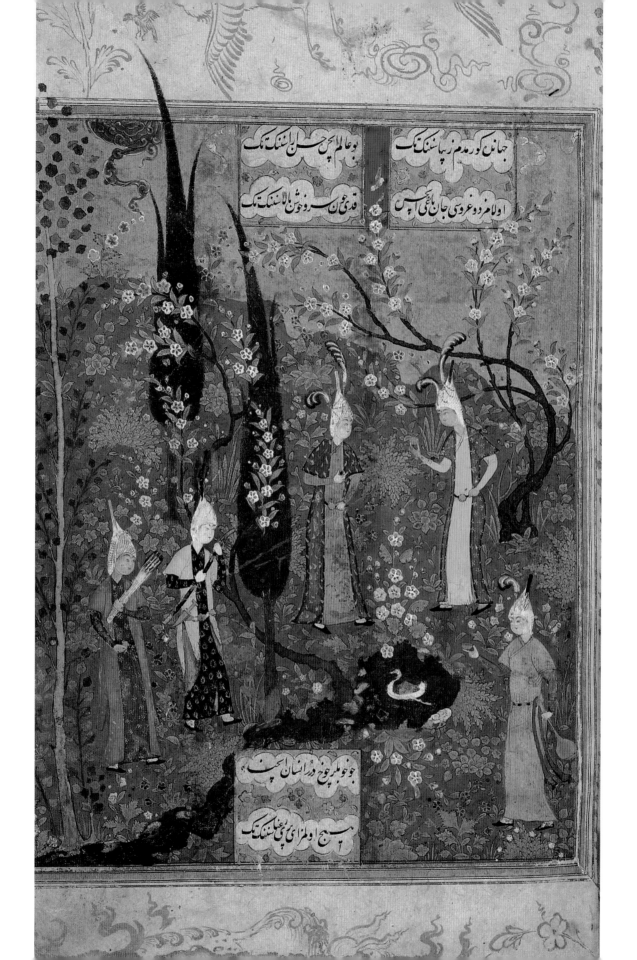

the imposition of Shiism were marked by Isma'il's triumphal entry into Tabriz and ascent of the royal throne; the twelve Shiite imams and Isma'il were mentioned in sermons in the mosques of the city.[4] In addition, new Safavid *dinar*s were stamped with the inscription, 'There is no God but God; Muhammad is the Prophet of God, and 'Ali is the favourite friend of God', and the full name of the new shah, Abu'l Muzaffar Shah Isma'il Bahadur Khan. To his followers, Isma'il was not only *murshid-i kamil* and *padishah*, spiritual leader and king in one, but also combined Turkman and Iranian heritage by virtue of his Iranian father and Turkman mother. Thus both the Turkmans who deserted the Aqqoyunlu house in favour of the Safavids, and the Persian-speaking Iranian aristocracy who traditionally consitituted the administration of the governments imposed on them, could consider Isma'il one of their own. While the Safavids and their Shiite creed met with some resistance in eastern Iran, the personal charisma of Isma'il, described as fair, handsome and of regal bearing, helped immeasurably to bend Iran to his will.

With Alvand out of action, Shah Isma'il turned his attention to another son of Sultan Ya'qub, Sultan Murad, ruler of Fars, Persian Iraq, Kirman and Khuzistan. In response to Sultan Murad's bid for independence, Shah Isma'il engaged his forces in battle near Hamadan in Dhu'l Hijja 908/June 1503; by winning he gained 'untold booty … swift Arabian horses, and other goods and commodities from far and wide, in limitless profusion'.[5] As word of Isma'il's victory spread, envoys from neighbouring regions began to arrive bearing gifts, a scene repeated by the local gentry when he pressed on to Shiraz. Hardly a year passed from 907/1501 to 920/1514 without a serious military engagement. Yet Isma'il maintained a transhumant pattern of summering in one region such as Hamadan and wintering in another such as Khuy. He is reported to have returned to Tabriz in 913/1507–8 after a three-day battle against 'Ala al-Daula Dhu'l Qadar in Diyar Bakr before riding on to a 'beautiful palace he had built at Coi [Khuy]',[6] but numerous other references to Isma'il's love of hunting suggest that in this period of his life Isma'il spent more time in encampments than within the built environment.

Until 915/1509–10 Isma'il focused his activities in the western and southern areas of Iran and Anatolia that had formerly been controlled by the Aqqoyunlu Turkmans. However, the death of the Timurid ruler Sultan Husayn Bayqara in 912/1506 and the subsequent invasion of Khurasan by the Uzbek Muhammad Shaybani Khan in 913/1507 had resulted in the Uzbeks gaining control of all of eastern Iran. In 915/1509–10 Shaybani Khan dispatched his army across the desert and seized Kirman. Diplomatic efforts having failed, Isma'il's only option was to plan to march on Khurasan. From his summer quarters in Gurgan, he set out with his army in 916/1510. Passing through Mashhad, he visited the shrine of the eighth imam, 'Ali al-Riza, and bestowed largesse on the shrine as he had done at Najaf, Karbala and Samarra after taking Baghdad in 914/1508. Meanwhile the Uzbek governors of Khurasan had fled to Herat and Shaybani Khan had decamped for Merv, where he holed up in the citadel while the Safavids besieged it. After some days Isma'il decided to feign a retreat, a ruse which succeeded in drawing out Shaybani Khan and resulted in a pitched battle twelve miles to the west. The Uzbeks were routed and Shaybani Khan killed. His treatment in death reflects either the intensity of Isma'il's hatred for him or the shah's capacity for barbarity: his limbs were severed and each sent to a different province of Iran; the flayed skin of his face was stuffed with straw and dispatched to the Ottoman sultan Bayazid; and his skull was 'encased in gold and fashioned into a chalice that was circulated as a wine cup at banquets and festive occasions'.[7]

At the request of Babur, the eventual founder of the Mughal dynasty of India, Shah Isma'il committed troops to help capture Samarkand in 917/1511. Not only was Babur unable to hold Samarkand, but also the Safavids lost a major battle to the Uzbeks at Ghujduvan in Ramadan 918/November 1512 which led to the Uzbeks overrunning much of Khurasan in the winter of 918/1512–13. Isma'il therefore resolved to lead a second expedition to Khurasan in the spring of 919/1513, but the Uzbeks withdrew across the Oxus without a fight. Meanwhile, in the west the Ottoman sultan Bayazid abdicated in favour of his son Selim II in Safar 918/April 1512. Shah Isma'il failed to recognize Selim's legitimacy and instead supported the legal heir, Ahmad b. Bayazid. In addition to his anger at Isma'il's misplaced allegiance, Selim understood the threat to his empire posed by the restive population of Qizilbash sympathizers in eastern Anatolia. Dire economic conditions and the irresistible attraction of Shah Isma'il – holy warrior,

spritual leader and king – motivated a steady stream of Turkmans to leave Ottoman territory and join the Safavid ranks in the first decade of the sixteenth century. The open rebellion of Qizilbash in Rum and the incursion on Ottoman territory by Isma'il's governor of Erzinjan in order to go to the aid of the rebels precipitated Selim II's plans to march against Iran. On 22 Muharram 920/20 March 1514 Selim II commenced his campaign against Iran with an army of 100,000 men.

By 920/1514 Isma'il had been fighting and winning battles almost annually for fourteen years, since he was twelve years old. His Qizilbash soldiers believed in his invincibility to the extent that they were said to enter the fray without armour, so certain were they of victory. To his men Isma'il was god-like, if not God Himself incarnate, a blasphemous idea that survived as long as he remained victorious. Possibly Isma'il had begun to believe in his own invulnerability. Otherwise, what could explain his decision to meet the Ottomans on the plain of Chaldiran, instead of in mountainous terrain, with 40,000 men, less than half the Ottoman force, having waited until a day after the Ottoman army had arrived and arranged itself for battle? The bad advice of Durmish Khan, the vastly superior numbers of Ottoman soldiers and the Ottoman use of both cannon and muskets in contrast to the Safavid lack of firearms were the underlying causes of the bloodbath that resulted: the Safavid military leadership suffered grievous losses and there were high numbers of casualties of foot soldiers and cavalry on both sides. Isma'il managed to escape with a few supporters, and Selim marched to Tabriz; his army, however, refused to winter there, so he left after eight days. The Ottomans did not depart empty-handed; they are reported to have returned to Istanbul with five hundred loads of treasure and a thousand artisans from Khurasan and other Iranian provinces as well as the Timurid prince Badi' al-Zaman.[8] Moreover, the Ottomans took control of Diyar Bakr, which had the effect of tipping the Safavid centre of gravity to the east, away from Asia Minor and towards the central Iranian plateau.

More than the actual loss of territory to the Ottomans, the Battle of Chaldiran had a calamitous effect on Shah Isma'il. The Turkman tribesmen who had affiliated themselves with the Safavid cause and had fought for their semi-divine spiritual and temporal leader could no longer believe that he was unbeatable. Both his religious and political authority was shaken. Not only did the latent friction between Turkmans and Persians in his government increase, but also Isma'il could no longer command the loyalty of the Qizilbash amirs. Isma'il himself 'went into mourning … He wore black clothes and a black turban, and ordered all *sayyids* to do the same. The military standards were dyed black, and on them was written in white the word *al-qisās* ("retribution").[9] Although Iran lost Hormuz to the Portuguese in 921/1515, Balkh and Qandahar to Babur in 923/1517–18 and 928/1522 respectively, and Herat was twice besieged by the Uzbeks (927/1520 and 930/1523), Isma'il himself never again led his army into battle. Instead he idled away the last decade of his life hunting in Azerbaijan and Armenia, drinking and listening to music accompanied by young men. He also fathered four sons and a number of daughters; the oldest boy, Tahmasp, was born in 920/1514 and by the age of two had been sent to Herat as nominal governor of Khurasan under the tutelage of Amir Khan Mausillu.

Isma'il conquered Iran without destroying its cities and adopted the Turkman capital Tabriz as his own centre of government rather

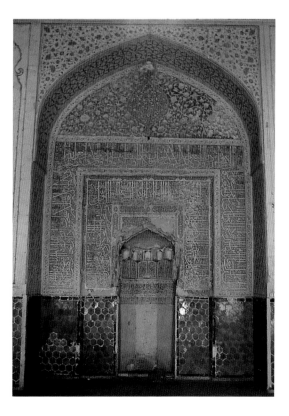

12 Mihrab, Masjid-i Jami, Saveh, restored 927/1520. While the use of stucco in this mihrab has been viewed as an anachronistic reversion to a 14th-century technique, the arabesque in the tympanum and spandrels is closely related to that on illuminations and carpets of the 16th century.

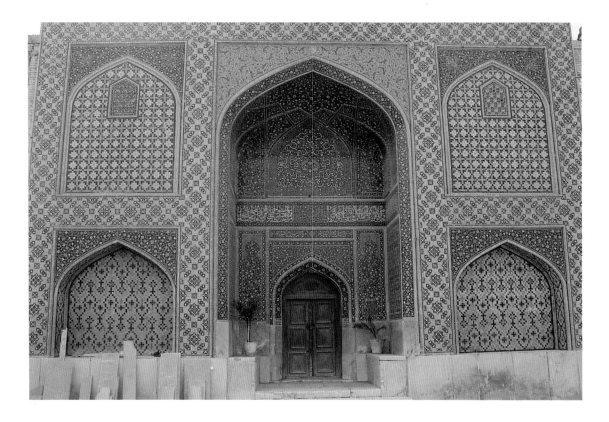

13 Façade, tomb of Harun-i Vilayat, Isfahan, Rabi' I 918/May–June 1512. The variety of techniques of tilework, the interplay of colour and design of the tiled surfaces, and the juxtaposition of flat walls and niches provide this small building with a fine balance between rhythm and solid horizontality.

than building a new complex elsewhere. For these reasons and a presumed lack of interest in commissioning new monuments, his reputation as a patron of architecture rests on a handful of standing buildings, most of which he ordered to be extended or renovated, not built from scratch. Other monuments such as the palace he built in Khuy are no longer extant and thus cannot be judged against their predecessors and successors. As a result of the paucity of notable monuments from the first quarter of the sixteenth century, scholars have considered the architecture of Isma'il's reign to be a continuation of the Timurid and Turkman traditions. However, his renovation of religious buildings fits a general pattern based on the need to establish Shiism as the state religion of Iran. To this end, Isma'il provided the wherewithal to refurbish the shrines of the imams at Najaf, Karbala and Samarra in 914/1508 and Mashhad in 916/1510.[10] Moreover, he promoted the Ardabil shrine both as the dynastic centre of the Safavid family and as a pilgrimage site for the Qizilbash faithful. Probably as a means of coping with the increased number of people coming to the shrine, he constructed the Dar al-Hadith, a functional pendant to the Dar

al-Huffaz, placed at the south-west end of the yard at the shrine. Additionally, Isma'il had the remains of his father, Haydar, brought from Tabarsaran near Darband in 915/1509 and interred at the Ardabil shrine; he may also have planned his own tomb there before his death.[11] For the father of the founder of the Safavid order, Shaykh Jibra'il, the shah erected a mausoleum at Kalkhuran near Ardabil. The building consists of a high dome which meets the flat roof of the square building without transition. Deep axial arched portals provide access to the interior. According to Hillenbrand, 'Such mausolea replaced the tomb tower, offering a far more spacious layout which encouraged large-scale pilgrimages.'[12]

While the constraints of adding on to existing buildings limited the scope for structural innovation, the decoration of the Safavid parts of such buildings as the Masjid-i Jami' at Saveh [fig. 12], restored in 927/1520, does indicate a refinement of arabesque that is paralleled in manuscript illumination and in the ornament on vessels of the early sixteenth century. Despite the archaizing use of moulded stucco in the *mihrab*, the lively light-coloured floral arabesque on a dark ground in the tympanum contrasts artfully

with the dark arabesque on a light ground in the spandrels of the arch. Much of the decoration of the exterior has disappeared, but the dome and the two main *ivans*, south-east and north-west, exhibit masterly – even grand – proportions.

The outstanding surviving building from the period of Shah Isma'il was not a royal commission; it is the tomb of Harun-i Vilayat in Isfahan, built by Durmish Khan Shamlu in Rabi' al-avval 918/May–June 1512. Durmish Khan, Isma'il's brother-in-law, had been appointed governor of Isfahan in 909/1503, but he chose to remain at court in Tabriz and to send a deputy in his place. His surrogate was Mirza Shah Husayn Isfahani, an architect who became *vakil* (head) of government bureaucracy after the Battle of Chaldiran in 920/1514 and an extremely powerful figure at the court of Shah Isma'il. Although the inscription on the tomb of Harun-i Vilayat states that it was 'built by the work of the poor mason, Husayn', he may well have been Mirza Shah Husayn, who is referred to in historical sources by the more elevated title *mi'mar* (architect).[15]

Neither the plan nor the elements of the building – its dome on a high drum resting on an octagon which in turn rests on a square – are particularly novel. Yet the treatment of the façade [fig. 13] provides the interest that is somewhat lacking in the interior. The arched portal is echoed in the blind arches of the upper storey and recessed arches below them. Within each of the arches at the sides of the portal glazed and unglazed bricks are combined in geometric patterns. The spandrels above the side arches consist of profuse arabesques in gold on a cobalt blue ground in mosaic faience. Strips of glazed mosaic tiles and unglazed brick frame the portal and side arches and give the façade compositional unity. The portal itself contains its most surprising features. A lilting spiral arabesque in black on a turquoise ground covers the outer spandrel with the exception of a square containing the names of Allah, Muhammad and 'Ali placed above the point of the arch. Inside the arch, the door itself is flanked by two panels containing tile mosaic vases out of which flowering arabesques grow. A poetic inscription in *nasta'liq* (hanging script) appears above the spandrel of the door and above it a band of *thuluth* runs around the three sides of the interior of the portal. Here, in gold directly above the door, the name of Shah Isma'il is written with titles befitting a holy warrior and descendant of the imams. Although the name of Harun is mentioned in a *hadith* in the inscription, his identity is unknown. The tympanum above the inscription band contains a pair of confronted peacocks surrounded by white Chinese cloud scrolls on a cobalt blue ground. The lively cloud scrolls provide a rhythmic counterpoint to the static birds, with their paradisiac associations.

While the decorative techniques employed on the façade of the

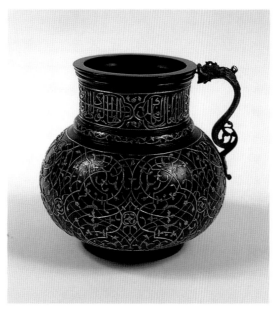 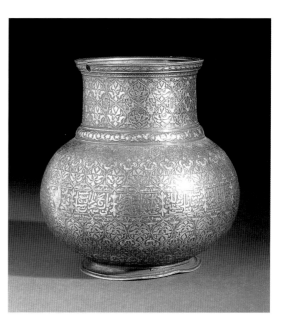

14 (right) Jade jug, Iran, first quarter of the 16th century, inscribed with the name of Shah Isma'il (r. 1501–24), nephrite, inlaid with gold, h. 14 cm, Topkapi Saray Museum, Istanbul, no. 1844.

15 (far right) Brass jug, inlaid with gold and silver, Herat, dated 916/1511, h. 6.37 cm, British Museum, OA 1878.12-30.732, Henderson Bequest. Jugs of this shape were produced in large numbers in Herat in the late 15th century and continued to be made after the fall of the Timurids and the Safavid conquest of Herat from the Uzbeks. The decoration, however, became looser and less intricate in the later examples such as this one, with its repeating floral patterns in lobed medallions.

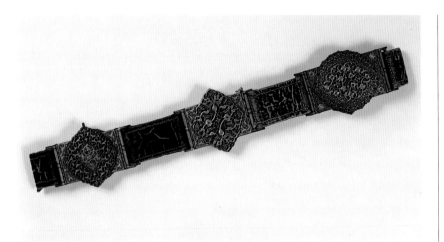

16 Pierced iron belt section, Tabriz?, dated 913/1507–8, inscribed with the name of Shah Ismaʿil, inlaid with gold, h. 5.8 cm, Topkapi Saray Museum, Istanbul, no. 1842. This belt has lobed lozenge-shaped medallions containing arabesques, and a lobed circular medallion containing a falconer on horseback and a groom or runner.

tomb of Harun-i Vilayat conform to those used on Timurid buildings in Transoxiana and Khurasan and to a lesser extent the Blue Mosque at Tabriz, the ornament itself has close parallels to that found on objects of the period of Shah Ismaʿil. For example, the spiral arabesque with spiky split palmette leaves in cobalt or black on a turquoise ground closely resembles the incised arabesque on a jade jug inscribed with the name of Ismaʿil [fig. 14]. Although the arabesque on the jug is combined with overlapping lobed cartouches, it is the dominant design element of the jug's bulbous body, and in the spandrels of the tomb of Harun-i Vilayat it is the only design element. This represents a change in emphasis from fifteenth-century spiral arabesques which are usually subordinate to the inscriptions or ornamental motifs that are laid on top of them.

The shape of the jug with its cylindrical neck and bulbous body and the silver-gilt and enamel dragon-shaped handle is the same as that of a number of inlaid brass jugs produced at Herat in the late fifteenth century. For this reason it has been suggested that the jade jug and its handle are Timurid and the decoration is Safavid. Also, the jug is assumed to have entered the Ottoman imperial treasury as part of the booty after the Battle of Chaldiran,[14] which would imply that its decoration was added between 1501 and 1514. A

brass jug of this shape dated 916/1511 [fig. 15], one year after Shah Ismaʿil took Khurasan, indicates that production of these vessels continued in Herat by the same artisans despite the Safavid conquest.[15] Although the popularity of this shape waned in Iran in the second decade of the sixteenth century, the Ottomans adopted the shape for both metal and ceramic objects, as well as the spiral arabesque which adorns the so-called 'Golden Horn' style of Iznik wares from the early sixteenth century.

Among the other items thought to have been taken from the Safavid treasury after the Battle of Chaldiran, two objects – a belt and a zinc flask – stand out. The belt of crimson velvet has six steel plaques overlaid with filigree gold plaques in different designs [fig. 16]. One of these is inscribed with the name of Shah Ismaʿil and the date 913/1507–8. The inscription reads: 'The just, the consummate Sultan, the guide, the special friend (al-wālī) Abu'l Muzaffar [I]smaʿil Shahzad al-Safavi, may God give him eternal life and exalt his realm and his reign and fill the world with his piety and his beneficence.'[16] While princely figures and soldiers in manuscript illustrations are often depicted wearing this type of belt, early sixteenth-century belts themselves are extremely rare. The exquisite filigree resembles that found on the doublures of bookbindings, which suggests that, as at the Timurid courts at Samarkand and Herat, artisans working for the shah had a common store of designs available through a courtly workshop system, or *kitabkhaneh*. Furthermore, the choice of ornament for the plaques – a *waqwaq*, or animal-headed scroll, and a hunting scene – recalls that of bookbinding.

Although the long-necked zinc flask with gold tracery and openwork gold armatures encrusted with precious stones and pearls does not bear the name of Shah Ismaʿil, it is assumed to be of Iranian workmanship from the early sixteenth century [fig. 17].[17] It is one of a unique group of zinc vessels in the Topkapi Saray Treasury documented from the reign of Sultan Bayazid II (886–918/1481–1512) and may have formed part of a diplomatic gift from Ismaʿil to the Ottoman sultan. The verses in cartouches above the plaques refer to the vessel and the wine-pourer, much as the *ghazals* written by Shah Ismaʿil do. Also, the flask with its elegant long neck and ovoid body is analogous to one depicted in an illustration in a collection of Shah Ismaʿil's poetry, compiled during his reign.

The goldwork and jewels on the Topkapi flask give some idea of the opulence at both the Persian and the Turkish courts, and of why the artistic ideas of one centre were so eagerly adopted elsewhere.

The history of Safavid book illustration before the Battle of Chaldiran is almost as sparse as that of the architecture and decorative arts. However, certain manuscripts such as the *Khamseh* of Nizami with illustrations by the two leading Turkman painters of the court of Sultan Ya'qub, Shaykhi and Darvish Muhammad, were continued after Shah Isma'il's accession. The style of painting changed little, if at all, but the ten illustrations painted after 907/1501 include the tall red Safavid *taj*, with or without a white turban wrapped around it [fig. 18]. For the first fifty years of the sixteenth century this form of headdress remained in vogue and its occurrence in paintings, carpets and some figural textiles is usually a sure indication of an early Safavid date.

Another notable illustrated manuscript associated with Shah Isma'il in the first decade of his reign is stylistically related both to provincial Turkman painting and to the painting of the Tabriz court. The colophon of the *Story of Jamal and Jalal* of Muhammad Asafi states that the manuscript was completed by the scribe Sultan 'Ali in 908/1502–3 at Herat, which was still the capital of the Timurid sultan Husayn Bayqara at that time. S.C. Welch has identified the scribe as Sultan 'Ali Qayini, who taught the children of Sultan Husayn Bayqara, rather than the more famous Sultan 'Ali Mashhadi.[18] Its first illustration contains figures who wear the standard Timurid turban with its low felt cap under the cloth turban, whereas in the rest of the thirty-four illustrations a very wide form of the Safavid *taj* appears.

Since Khurasan did not come under Safavid control until 916/1510, the manuscript must have travelled west before the Safavid paintings were added. Welch's explanation of this is that it was brought to Iran by one of Sultan Husayn Bayqara's rebellious sons, Muhammad Husayn, who had joined Isma'il on campaign in Mazandaran in Dhu'l Qa'da 909/May 1504. The manuscript contains two dated illustrations, one (fol. 35b) from the year 909 and the other (fol. 57b) from 910 [fig. 19]. Since Muhammad Husayn met Shah Isma'il in the last month of the year 909, he would have either already commissioned an artist to begin filling in

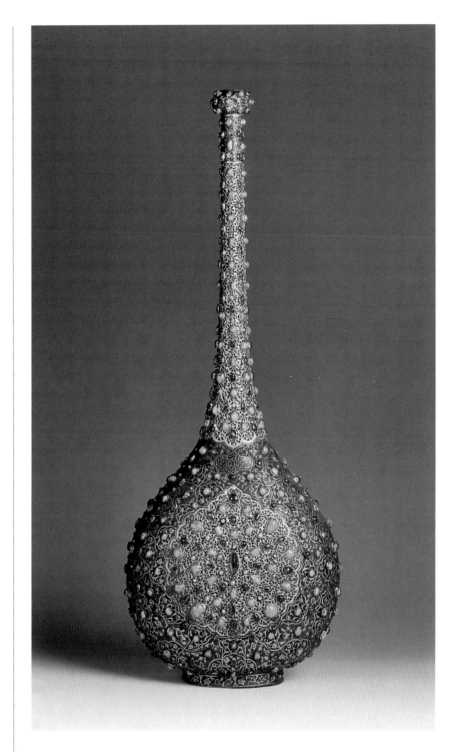

17 Long-necked flask, early 16th century, zinc, partially gilded, with applied gold medallions and encrusted stones, h. 52 cm, Topkapi Saray Museum, Istanbul, no. 2877.

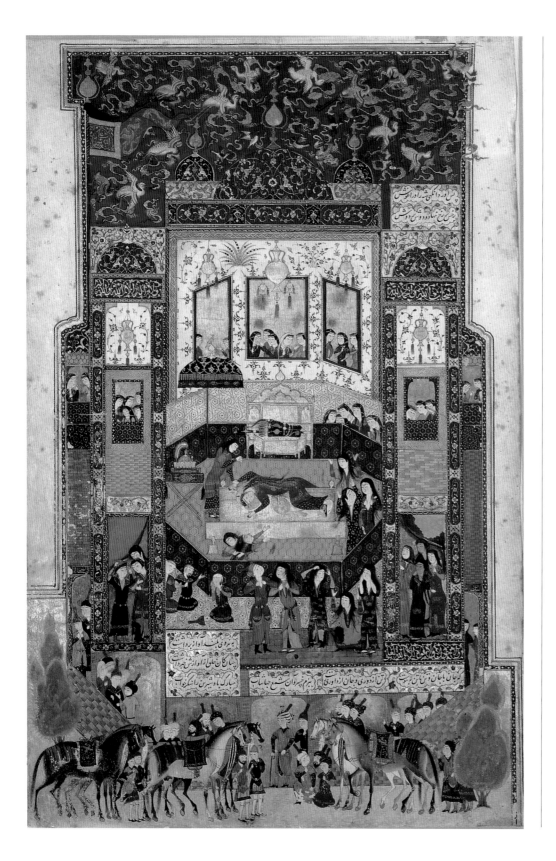

18 'The Suicide of Shirin', from the royal Turkman *Khamseh* of Nizami, Tabriz, c. 1505, opaque watercolour, gold and ink on paper, 29.5 × 19 cm, Keir Collection. The inclusion of men dressed in the Safavid *taj*, or turban cap with a high baton, indicates that this is one of the ten illustrations added to this manuscript after the accession of Shah Isma'il in 1501. Despite the tragic nature of this scene, the gold cloud scrolls and dipping and rolling storks in the sky lighten and enliven the picture.

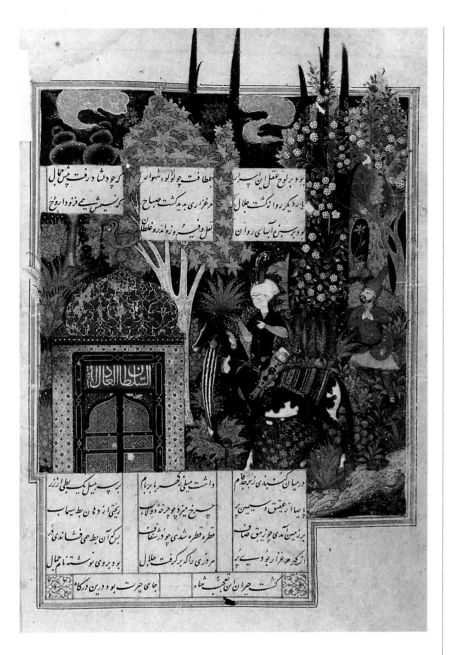

The painting contains Persian verse panels:

چو دست در رفت بر جمال | بطافت چو لؤلؤه شهوار | بود بر لوح عقل این بسار

کرو دیگر روا ز کشت جلال | بارد گر روا ز کشت جلال | مرغزاری بدیکشت صلاح

بر سبزی آبیای روان | خم نبی فه روزه بادره وعطان

بر پمیل کی بطی از رار | داشت میلی اثر با برام | در میان کنید بندی زنو فام

ریختی از دمان بط سیماب | سرخ میز و چو چرخه ولاب | پایا از عیق و سیمین بر

سکی آن بط می فشاندی ار | قطره شدی چو خوسعان | بر زمین می آمد زمین ضان

بو در وی نوشته نام جمال | بو در وی راک بر کرفت جلال | ازک هر مغزار بود دسیر بر

جای حیران بو و درین کرکا | کشت حیران ن تعجب شاه | جای حیران بو و درین کرکا

19 'Jalal before the Turquoise Dome', from a *Jamal and Jalal* of Asafi, Tabriz, dated 910/1504–5, opaque watercolour, gold and ink on paper, page 30.5 × 19.5 cm, Uppsala University Library, MS O Nova 2, fol. 57b. This painting illustrates Jalal before a dome surmounted by a bird which dripped quicksilver from its beak. The drips turned to pearls with Jamal's name inscribed on them.

the pages left blank or Isma'il or a member of his court gave the manuscript almost immediately to an artist who then completed the illustrations. Although the figures in the Turkman *Khamseh* of 886–910/1481–1505 [see figs 8 and 18] are more gracefully drawn than those in the *Jamal and Jalal*, the vibrant treatment of vegetation and the massing and overlapping of patterns in many of the *Jamal and Jalal* illustrations suggests that its artists – for there seem to have been more than one – were familiar with, if not working at, the Tabriz royal studio.

By about 921/1515 the idiom of man and animal inhabiting a natural world of roaring winds, lush and frenzied vegetation and rocks resembling grotesque faces was being honed by the director of Shah Isma'il's artists' workshop, Sultan Muhammad. A native of Tabriz, Sultan Muhammad may have contributed to the *Jamal and Jalal* manuscript[19] and is generally thought to be the artist of 'Rustam Sleeping' from an unfinished *Shahnameh* [fig. 20]. Three other paintings of the same size and style are extant, which suggests that for some reason Isma'il's artists stopped work on the manuscript only to begin again on a new, very ambitious *Shahnameh* about 928/1522. Welch has proposed that the abandonment of the earlier manuscript and commencement of a new one were connected with the return of Prince Tahmasp, the crown prince, from Herat to Tabriz in 928/1522 at the age of eight. Having studied at Herat with the legendary Timurid painter Bihzad, young Tahmasp had developed a taste for the more sedate and subtle late Timurid mode, and so Sultan Muhammad and his atelier adapted their style to suit him. The synthesis that occurred, one of the highest achievements of all Safavid art, is more fittingly discussed as a product of the reign of Shah Tahmasp than of Shah Isma'il, despite the probability that Isma'il commissioned the great royal *Shahnameh*.

Just as the different artists who contributed to the *Shahnameh* of Sultan 'Ali Mirza Karkiya of Gilan did not suppress their stylistic differences to achieve visual unity within the manuscript, so the artists who worked for Shah Isma'il did not conform to a single court style. A *Divan* (Collected Poems) of Khata'i, Isma'il's pen-name, contains three illustrations in a style that differs markedly from that of the previously discussed Tabriz court manuscripts. Here the figures are extremely tall and slender with naive, hairless

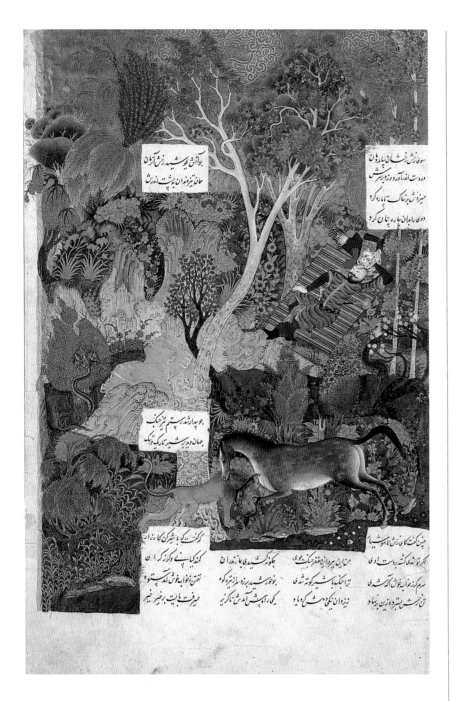

20 'Rustam Sleeping while Rakhsh Fights a Lion', from an unfinished, dispersed *Shahnameh* of Firdausi, attributed to Sultan Muhammad, Tabriz, c. 1515, opaque watercolour and ink on paper, 31.6 × 20.8 cm, British Museum OA 1948.12-11.023.

faces. The vegetation in works such as 'Five Youths in a Landscape' [fig. 11] follows the Turkman/early Safavid norm of clumps of light green flowering plants on a darker green ground, flowering trees entwining tall, dark cypresses, and Chinese-style clouds like kites with tails depicted against a gold sky. Yet the scene is markedly calmer than either the illustrations of *Jamal and Jalal* or 'Rustam Sleeping'. This may be attributable to the subject matter, more a visual analogue than an actual illustration of Khata'i/Shah Isma'il's verses:

> I have never seen anyone on earth so beautiful as you,
> never in this world anyone so gorgeous as you.
> Truly, within the garden of the soul, there can be no
> stature so elegant as your tall, slender cypress.
> Although there are many beauties among humanity, there
> is none so radiant as you.
> In the garden of beauties there is no one with rose red
> cheeks like yours.
> Never have I seen among the poets of the age, Khata'i,
> such a distracted nightingale as you.[20]

Thackston has demonstrated convincingly how of the two princely figures with two feathers each in their turbans, the man at the left next to the cypress is the love object and the figure at the right who offers him a fruit is the lover, inclining slightly towards his beloved like the flowering branch that bends toward the cypress. At the lower right an attendant, the *saqi*, holds a gold wine cup and a long-necked *surahi* (wine bottle) comparable to the jewel-studded one from the Ottoman treasury [see fig. 17]. This, too, is a metaphor for the beloved: 'Your eyes are intoxicated, your stature is a *surahi*, your words are sweet tidbits, and your lips are our goblet.'[21]

Because the inscription on a frieze depicted in another illustration from this manuscript contains the titles of Shah Isma'il, Thackston has proposed that the manuscript was produced during Isma'il's lifetime and probably was a royal commission. On the basis of style the manuscript has been dated to c. 1520. One might expect a more polished, less archaizing style of painting by this date, for the exaggeratedly tall figures and the compositions of two of the three illustrations recall in a general way the illustrations to the Jalayirid manuscript of *Three Poems* of Khwaju Kirmani,

painted at Baghdad in 798/1396.[22] Also, in a *Gulistan* of 919/1513–14 from Shiraz the same very high turban feathers as those in the *Divan* are found [fig. 21], whereas in Shiraz manuscripts of 927/1520 the feathers are smaller. On the other hand, the distinctive treatment of the turbans, which extend down the necks of their wearers, is found in some illustrations to a *Shahnameh* of Firdausi, dated at Tabriz Muharram 931/November 1524, several months after the death of Shah Isma'il.[23] This suggests that an artist or artists worked in this 'elongated' style for the last five or ten years of Isma'il's reign even as the influence of the painters from the newly appropriated Timurid court atelier at Herat was beginning to be felt at Tabriz.

During the winter of 916/1510–11 Shah Isma'il made his headquarters at Herat before campaigning in Transoxiana in the following spring. During this interlude he not only received local lords but also journeyed into the wilderness near Herat in order to meet Hatifi, who was the nephew of the poet Jami and, like his uncle, had been one of the poets in the court circle of Sultan Husayn Bayqara. Hatifi was a Shiite who had written an historical epic, the *Timurnameh*, celebrating the life and exploits of Timur. Either to honour Isma'il or because he was commissioned to do so, Hatifi embarked on a long poem about the shah, the *Isma'il-nameh*, but it remained unfinished at the time of his death in 927/1520. Possibly to commemorate Hatifi's meeting with Isma'il, another luminary of the court of Sultan Husayn Bayqara, the artist Bihzad, painted a small portrait of the poet wearing the Safavid *taj* [fig. 22]. The composition of the picture could not be more simple; against a bright blue ground Hatifi kneels in three-quarter profile, gesturing with his right hand while resting his left hand on his knee. His robe is plain, gathered at the waist by a red and white cloth sash over which a short sash is draped. Unlike Bihzad's paintings of the 1480s and 1490s, the brushwork is relatively painterly or even rough, perhaps akin to the *main tremblant* one finds in the work of European painters in old age. Another sign of the artist's advanced

21 'Game being Cooked for Anushirvan on the Occasion when there was no Salt', from a *Gulistan* of Sa'di, Shiraz, dated 919/1513–14, opaque watercolour, gold and ink on paper, 9.5 × 7.2 cm, British Library, Or. 11847, fol. 19b.

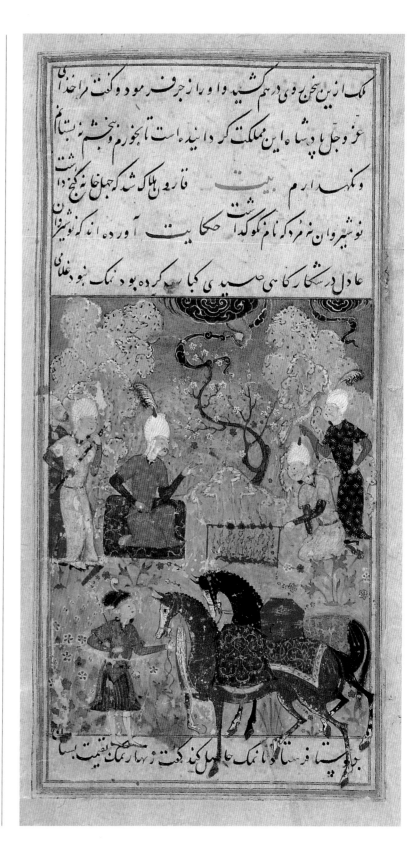

maturity is the intensity of Hatifi's gaze, as if Bihzad had discarded all superfluous details to home in on the essence of the poet. Whether the painting was produced in 916/1511 or later, it is a testament to Bihzad's continuing mastery in the second decade of the sixteenth century.

Because of the ongoing threat of an Uzbek invasion in Khurasan, Shah Isma'il needed as strong a Safavid presence in the province as possible. Thus, in 921/1516 his first-born son, Tahmasp, was sent at the age of two to be nominal governor of Herat under the guardianship of Amir Khan Mausillu. As the heir apparent, Tahmasp received the traditional education of a prince, that is, reading the Qur'an and other religious texts as well as Persian literature, philosophy and history, writing in the seven classical Arabic scripts as well as *nasta'liq*, learning marksmanship and horsemanship, for war and hunting, and whatever lessons of statecraft his guardian deemed necessary. Unlike his father who had received his schooling at a provincial court, Tahmasp had the pick of the scholars, artists and other luminaries who had stayed in Herat after its fall to the Uzbeks in 913/1507. The self-conscious refinement and intellectual ambience of the late Timurid court at Herat contrasted markedly with the politically preoccupied late Turkman court at Tabriz. This difference is reflected in the cool and rational compositions of Bihzad versus the ecstatic intensity of the Turkman *Khamseh* of 886–910/1481–1505. From his environment alone, therefore, Tahmasp could be expected to have developed a world view that diverged from that of his father. By nature, too, Tahmasp differed from his father. As a child he showed an aptitude for painting, and so Isma'il arranged for him to be taught by Bihzad and later Sultan Muhammad. Whereas Isma'il loved the chase, Tahmasp's preferred form of hunting was going fishing. These two pursuits, fishing and painting, reflect his more sedentary

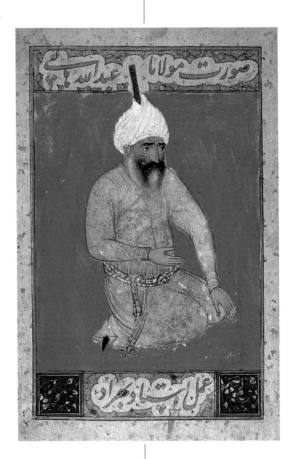

nature, which became more pronounced in maturity. During his childhood he had few reported eccentricities, but as he aged he developed many peculiarities which ultimately had an impact on all aspects of Safavid life, including the arts.

For the history of painting and perhaps the other arts, Tahmasp's stay in Herat was pivotal. When Amir Khan Mausillu was recalled to Tabriz in 928/1522 for insubordination, Tahmasp returned as well. Although there is some question concerning the date, Bihzad was appointed nominal head of the royal artists' atelier and most likely came to Tabriz in Tahmasp's train. It is also likely that Shah Isma'il newly commissioned a royal *Shahnameh* for Tahmasp. The result was the major monument of Safavid painting, the *Shahnameh* of Shah Tahmasp, a manuscript of 380 folios and 258 illustrations. Dickson and Welch have estimated that the book took from 928/1522 to 941/1535 to complete and even then two miniatures were added in the 1540s.[24] The project employed all the leading artists of the day who were in Safavid territory. Some had joined the service of the Uzbeks and worked at Bukhara. Sultan Muhammad was appointed the first director of the project and his superb contributions to the manuscript demonstrate how he adapted his own style, based in the Turkman court idiom, to the style practised at Herat by Bihzad and his followers both at Herat and Tabriz.[25]

While dramatic developments were occurring in the artists' atelier at Tabriz around 928/1522, manuscript production had continued unabated in the provincial centre of Shiraz. In the fifteenth century Shiraz was the primary source of illustrated manuscripts produced commercially, not necessarily for specific patrons. The artists of Shiraz at this time had worked in a simplified style that borrowed elements from Herat and Turkman painting. Although the materials and skills of Shiraz artists were rarely

a match for the Safavid court masters, changes of fashion in dress were registered very quickly there. Thus by Sha'ban 909/January 1504 the shape of the *taj* in Shiraz painting had become narrower and taller than those in paintings from the late fifteenth century.[26] Despite incorporating the Safavid *taj* in their paintings, Shiraz artists were still adhering to compositional tenets established in the fifteenth century. High rounded horizons, ball-like clouds with wispy tails, and figures arranged in rows across the picture characterize the illustrations to a *Gulistan* of 919/1514 [see fig. 21], although interior scenes from this manuscript exhibit the variety of pattern that characterizes Shiraz painting of most of the sixteenth century.

A *Yusuf and Zulaykha* manuscript of 924/1518 demonstrates the development of Safavid painting at Shiraz that paralleled the school of Tabriz. According to the colophon the manuscript was made at the holy tomb or foundation of Hazrat Maulana Husam al-Din Ibrahim at Shiraz. Neither the artist nor the scribe is named. Robinson has noted five other manuscripts which were produced at this foundation, suggesting that this type of establishment operated as an atelier for manuscript production.[27] Although the inclusion of a number of figures and the extension of architecture into the border had occurred in the 919/1513–14 *Gulistan*, the profusion of small-scale patterns on the walls, in the carpet and on the figures' dresses in 'Yusuf Entering Zulaykha's Apartment' [fig. 23] is a harbinger of one of the salient features of sixteenth-century Shiraz painting.

At the court level one must assume that Chinese ceramics continued to be preferred to local products. However, the production of Persian stonepaste imitations of Chinese blue and white porcelains persisted during Shah Isma'il's reign; two bear dates from the 1520s. One, a dish dated 929/1522–3 [fig. 24], depicts two birds perched on the branches of a rose bush. The composition derives from early Ming porcelains with pairs of birds on the single branch of a fruit tree.[28] The inscription includes a poem and the statement that the dish was made at Nishapur. The other is a wine flask with a bird perched in a flowering peony. The bird has turned its head so that its neck and beak point upward. Around the border that joins the two sides of the flask runs an inscription with date and a sort of drinker's plea:

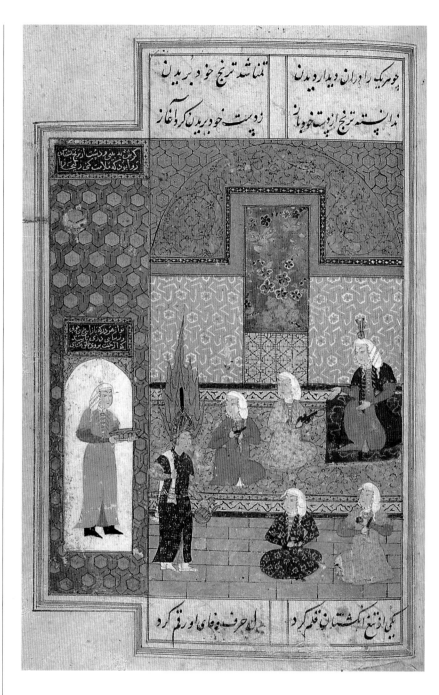

22 (opposite) Portrait of Hatifi, ascribed to Bihzad, Herat, c. 1511, opaque watercolour and gold on paper, image 9.4 × 6 cm, Collection of Prince and Princess Sadruddin Aga Khan.

23 (above) 'Yusuf Entering Zulaykha's Apartment', from a *Yusuf and Zulaykha* of Jami, Shiraz, dated 924/1518, opaque watercolour, gold and ink on paper, 10.4 × 3.2 cm, John Rylands Library, Manchester, Ryl Pers 20, fol. 118a.

Oh, my Lord, may my soul not reach a union with you, and may no word nor sign of my existence come to you, at the end of the time may I not for a moment be with you, in short, may the world not be with you! In this old tavern a drunkard said: may the end of all drunkards be auspicious![29]

The affinity between the two pieces is clear, the artist of the flask having deleted the upper bird from the composition. In addition, the crosshatching and wave and rock motif on the rim of the dish relate it to a group of early sixteenth-century blue and white ceramics with the Nishapur petrofabric. Golombek and Mason have proposed that Nishapur continued as a centre of ceramic production into the sixteenth century, partly in order to suppy Mashhad, home of the major Shiite shrine of Imam Riza, with souvenirs for pilgrims.[30] Since ceramics with similar motifs were also produced at Tabriz, it is possible that the same type of clientele which bought the illustrated manuscripts of Shiraz acquired Persian blue and white vessels such as these. They were not of royal quality, but often they were attractive and looked enough like the pots used at court to be considered fashionable.

As mentioned above, the strong tradition of metal casting continued in Khurasan after the Safavids took the province from the Uzbeks in 916/1510. The decoration on the Safavid bulbous-bodied brass jugs resembled that of the Timurid period in the use of small, tight arabesques and interlocking lobed cartouches with or without inscriptions. Whereas the inscriptions on Timurid vessels of this type were poetical and often from the oeuvre of poets active at Herat in the late fifteenth century, inscribed invocations to 'Ali appear only after 916/1510.[31] The inscriptions on very fine metal wares were supplied by scribes better known for copying manuscripts,[32] and the combination of geometric framing devices, inscriptions and vegetal, floral and cloud motifs all relates to manu-

script illumination. Bronze and brass objects attributed to western Iran after 916/1510, whether completely covered with decoration or with bands and cartouches of ornament and inscriptions alternating with undecorated areas, recall in some respects the façade of the tomb of Harun-i Vilayat. Silver inlay cloud scrolls in cartouches enliven the domed lids and sides of two inkwells [fig. 25][33] attributed to the second decade of the sixteenth century in much the same way as those on the tympanum of the tomb. Likewise the lobed medallion on the side of a western Iranian box loosely resembles the glazed eight-pointed stars in the framing panels of the tomb's portal. Although some types of early Safavid metal wares from western Iran imitate eastern Iranian shapes and others derive their decoration from Herati manuscript illumination, the metalworkers of western Iran initiated the move away from tight, linear all-over ornament towards a taste for balancing areas of decoration with voids. The most successful metal objects from western Iran are therefore visually consistent not only with the other types of portable objects but also with architectural decoration of the second decade of the sixteenth century.

Since the earliest dated Safavid carpets come from the reign of Shah Tahmasp (930–84/1524–76), the assignment of existing uninscribed carpets to the first quarter of the sixteenth century is tenuous at best. From manuscript illustrations of the late fifteenth century [fig. 26] one can deduce that carpets with arabesque designs in the field had been introduced and were used at the same time as those with geometric patterns. On one extant carpet that may have been produced in the early sixteenth century [fig. 27] the field contains spiralling vines that terminate in split palmettes, while the sixteen-pointed star medallion in the centre and four corner pieces are filled with peony and vine motifs. An eight-pointed star enclosing a cross and octagon are the most geometric elements of this carpet. Possibly this type of carpet design originated in Azerbaijan and was stimulated by the

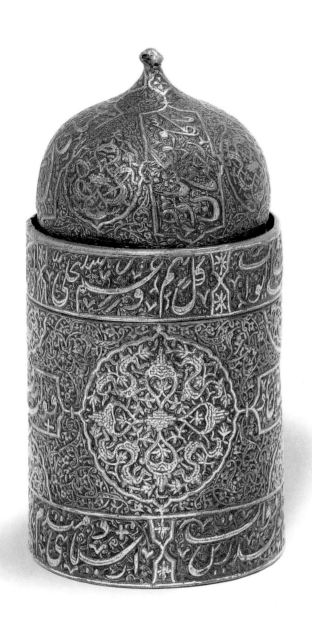

24 (opposite) Blue and white stonepaste bowl, Nishapur, dated 929/1522–3, diam. 33.5 cm, Middle Eastern Culture Centre in Japan, Tokyo, no. 11820-75. This bowl is of singular importance as the earliest dated Safavid ceramic vessel.

25 (above) Inkwell, signed by Mirak Husayn, c. 1510–20, brass with silver inlay and black composition, h. 8.9 cm, diam. 4.7 cm, Victoria and Albert Museum, 454-1888.

refurbishing zeal of Shah Isma'il, whose renovated mosques and shrines would have required new floor coverings. The carpets represented in Herat court painting of the 1490s contain patterns of interlocking lobed medallions and cartouches analogous to illuminated headings in manuscripts, whereas in the 899/1494 Gilan *Shahnameh* some illustrations contain carpets with repeating geometric patterns and others have carpets with arabesque and spiralling scroll motifs. Likewise, in the 909–10/1504–5 *Jamal and Jalal* the scrolling patttern on the carpet of the first illustration, thought to have been painted in Herat, is contained within a medallion, whereas the split-leaf arabesque forms an all-over pattern on many of the carpets in the Safavid miniatures.

Many types of knotted and flat-woven early Safavid carpets have not survived. The striped mat on which Rustam lies in 'Rustam Sleeping' may have been simply a woven blanket or even dyed rush matting. In the *Jamal and Jalal* illustrations one can observe many striped textiles, from horse blankets to cushion covers to the cloths on which enthroned figures sit. Some of these cloths contain floral or vine scrolls within their stripes. Other carpet-like textiles found in paintings include tent coverings; later extant fragments are made of velvet but more durable materials were probably used for the tent exteriors, and tent wall panels of matting or reed screens are depicted in early sixteenth-century paintings (*Jamal and Jalal*, fol. 35b). Figures in *ivan*s and on thrones are often depicted sitting on flat rectangular cushions covered with fabrics with repeating all-over floral or geometric patterns. Since these patterned textiles closely resemble those used for clothing in early Safavid painting, it is possible that both represent silks of the type produced in Iran under Shah Isma'il. As silk cultivation and weaving for consumption in Iran and abroad were perennial and important sources of income in Gilan, Mazandaran, Azerbaijan and central Iran, it is all the more unfortunate that no textiles can be reliably attributed to the period of Isma'il.

Some industries, such as glassblowing, seem not to have figured at all in early Safavid Iran. Round glass windowpanes and glass bottles appear in paintings, but one must assume that glass was imported from Venice or perhaps Mamluk Syria or Egypt. By contrast, wooden objects and building components such as doors, columns and capitals are depicted in paintings and are to be found

26 (left) 'Fariburz Comes before Kay Khusrau', from the 'Big Head' *Shahnameh* of Firdausi, Gilan, Iran, 899/1493–4, opaque watercolour, gold and ink on paper, 24.4 × 16.2 cm, British Museum, OA 1992.5-7.01. The throne of Kay Khusrau is placed on a white carpet with an overall black arabesque design. The painting depicts the rival for the throne, Fariburz, submitting to Kay Khusrau while prisoners are led before them.

27 (right) Carpet with central medallion, early or mid-16th century, Tabriz?, wool, 5.3 × 2.22 m, Fundação Calouste Gulbenkian, Lisbon, T.97. The field of this carpet, with its central medallion, four corner medallion pieces and spiral arabesques, is related to that of 16th-century bookbindings.

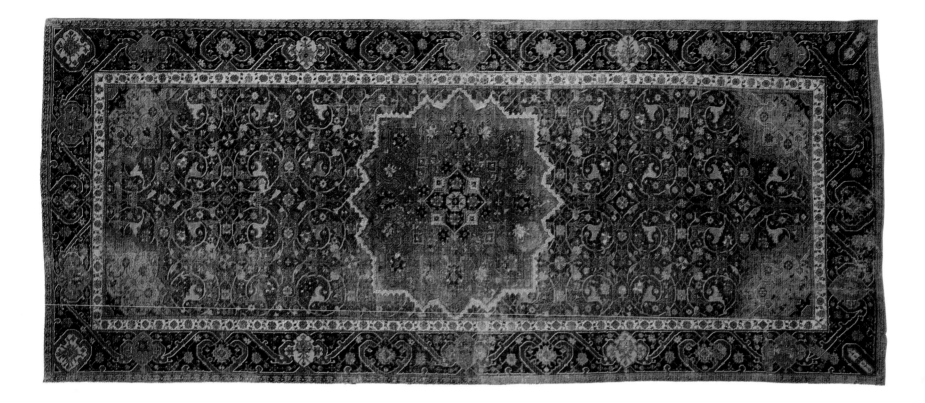

in museum collections in Iran and elsewhere, but are almost entirely unpublished.[34] Since all the areas around the Caspian are heavily wooded by comparison with the rest of Iran, wood was a natural choice for the columns and roofs of porches (*talar*s) on houses and public buildings. Possibly the painting and gessoing of ceilings, found in the seventeenth-century buildings of Isfahan, had already been practised in Gilan, Azerbaijan and Mazandaran in the early sixteenth century. In addition, wood was used for boxes containing multi-volume Qur'ans and large sarcophagi in which smaller stone coffins were placed.

While the main legacy of Shah Isma'il I remains political and religious, both the unification of eastern and western Iran and the imposition of Shiism directly affected the visual arts. The movement of painters from Herat to Tabriz is perhaps the best-documented example of artists emigrating to the new royal atelier, and art historical evidence suggests that potters had already been drawn west at the end of the fifteenth century. The metalworkers of Khurasan continued to produce Timurid-style wares into the second decade of the sixteenth century, but their ideas were adopted and altered by metalworkers in western Iran. The role of certain decorative elements such as the spiral arabesque with split palmettes and Chinese cloud scrolls is more dominant in the decorative arts, illumination and architectural decoration of early sixteenth-century western Iran than in the art of the Timurids or Turkmans. Isma'il's conquest of Iran helped familiarize artisans with new ideas and probably new people. Yet, the true synthesis of the various artistic strains – Timurid, Turkman and regional – occurred in the next generation during the reign of Shah Tahmasp.

3

The Years of War

Shah Tahmasp at Tabriz

1524–1555

I said, 'Who slew all these Ottomans?'
The morning breeze replied, 'It was I.' [1]

When Shah Isma'il dispatched his first-born son, Tahmasp, to Herat in 922/1516 to serve as governor of Khurasan, the boy 'was already showing signs of ability to rule'.[2] He was placed under the guardianship of Amir Khan Mausillu, a Turkman lord. This appointment signalled to Isma'il's Uzbek enemies his resolve to protect his eastern flank and to hold on to the province. For the next five years, before Shah Isma'il recalled him to Tabriz, the prince received his education at Herat, which until 912/1506 had been the last Timurid capital, a centre of high sophistication in letters and the arts. Like Isma'il at Lahijan, it must be assumed that Tahmasp not only received the education expected of a young prince but also that the visual environment, namely the buildings, books and material culture to which he was exposed at Herat, all played a formative role in the development of his taste.

In 928/1522, when Amir Khan Mausillu was dismissed, Tahmasp returned to Tabriz and enjoyed two more years of relative freedom until the death of Shah Isma'il in 930/1524 vaulted him to the Safavid throne. Because of his tender age Tahmasp did not immediately take up the reins of government. Rather, he spent the first decade of his reign, the so-called 'Qizilbash Interregnum', at the mercy of regents from various Qizilbash tribes. The seeds of the troubles that erupted when he came to the throne had been sown in the last decade of Shah Isma'il's rule following the rout of the Safavids at the Battle of Chaldiran when the authority of the shah was so severely shaken. On the one hand, Isma'il tried to contain the fractious Qizilbash by appointing more Persians to high-level government posts but, on the other, his preference for hunting and carousing limited the time and energy that he could devote to controlling the Qizilbash.

With the accession of Shah Tahmasp the Qizilbash amirs who had been granted positions by Shah Isma'il were in the strongest position to exert their authority. Thus Div Sultan Rumlu became the first *vakil*, or vice-regent, under Shah Tahmasp with the agreement of the leaders of the Takkalu and Dhu'l Qadar tribes. Within a year his position was disputed by the head of the Ustajlu tribe. Although battle was averted in the short run, Div Sultan's executions and imprisonment of his enemies ultimately led to showdowns in 932/1526 and 933/1526–7 and the defeat of the Ustajlus. Div Sultan's star did not remain in the ascendancy for long; his rival Chuha Sultan Takkalu convinced Shah Tahmasp

28 Detail of fig. 50.

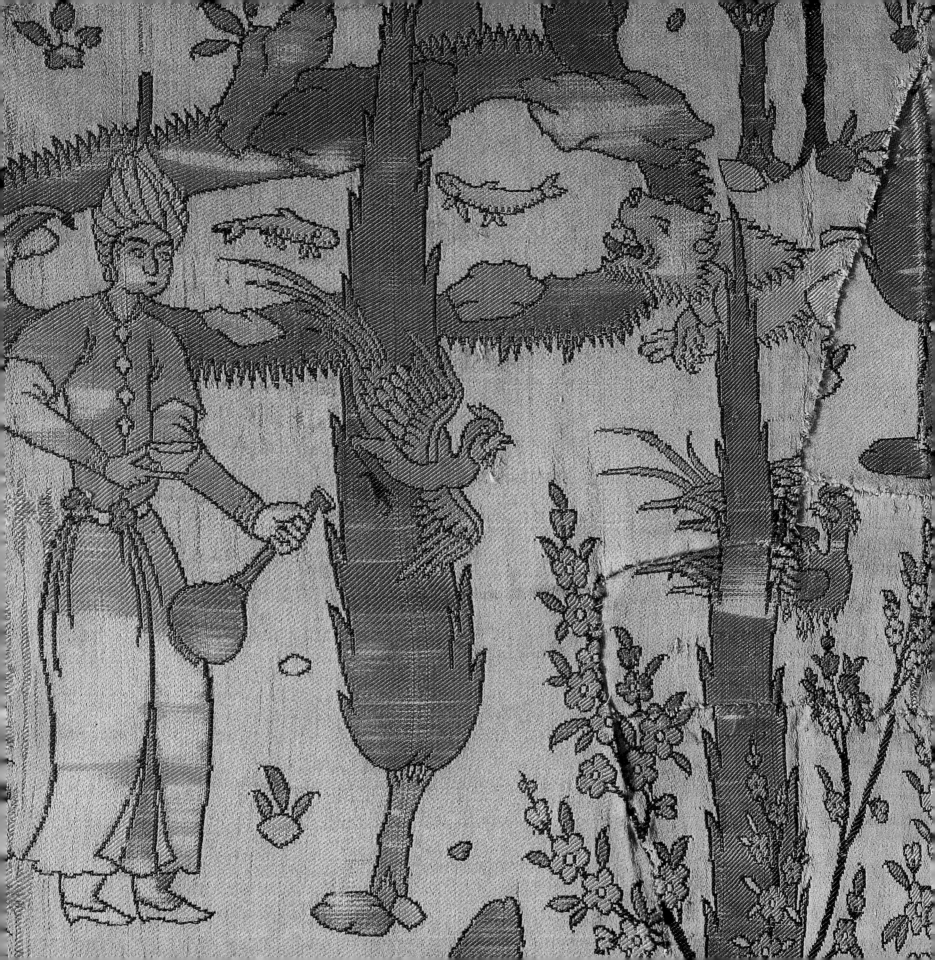

that Div Sultan was to blame for the dissension among the Qizil-bash. As a result in 934/1527–8 the thirteen-year-old shah shot an arrow at Div Sultan as he entered the *divan* (assembly hall), 'which, despite the Shah's lack of strength, struck Div Sultan on the chest. At a signal from Tahmasp Div Sultan was dispatched by the guards.'[3]

Chuha Sultan then took over Div Sultan's post as *vakil*. Yet he, too, followed the pattern of his predecessor by favouring members of his tribe in government and with grants of land. Although Safavid historians mention Shah Tahmasp's growing suspicion of his vice-regent, his perceived cowardice in a battle against the Uzbeks in 935/1528 at which the Shah was not only present but acted valiantly could only have eroded Chuha Sultan's authority at court. In the aftermath of this battle, Shah Tahmasp confirmed Husayn Khan Shamlu, the guardian of his brother Sam Mirza, as governor of Herat, a city that had suffered grievously from months of an Uzbek siege. In an effort to undo Husayn Khan, Chuha Sultan delayed sending aid to Herat for so long that the Uzbeks besieged the city again. Husayn Khan finally was forced to give up and negotiate with the Uzbeks for safe passage out of the city with Sam Mirza, his Qizilbash garrison and some of the Shiite population. Shah Tahmasp and his army, meanwhile, were on campaign in Baghdad and unable to come to Husayn Khan's aid. By early 936/1529–30 the call had gone out for an army to assemble for the reconquest of Khurasan. As Tahmasp and his army of 70,000 men advanced, the Uzbek leader, 'Ubayd Khan, discovered that his amirs would not support him in another battle against the Safavids and he decamped to wait for another opportunity to invade the province.

Meanwhile, Husayn Khan and Sam Mirza were making their way through Sistan to Shiraz. In 937/1530–31 Shah Tahmasp summoned them to meet him in the royal camp near Isfahan. Chuha Sultan saw this as his chance to do away with Husayn Khan, but Husayn Khan foiled his plot by going with a group of supporters to confront him in his tent. Chuha Sultan fled to the *divankhaneh* (assembly hall) where a struggle ensued and two arrows actually struck the royal crown.[4] Although Chuha Sultan was mortally wounded, the Takkalu tribesmen kept his death a secret and prepared for the battle that ensued with the Ustajlus,

Rumlus, Dhu'l Qadars and Afshars. One of the Takkalus 'rushed into the *dawlatkhana* [royal residence] and tried to carry off the Shah to the Takkalu camp. Tahmasp had him put to death, and then gave the order for the execution of that misguided tribe.'[5]

The mantle of power now passed to Husayn Khan Shamlu, who predictably favoured his fellow Shamlus with appointments and land grants. Moreover, he tightly controlled religious and political matters so that the shah had little scope to exercise his power independently. As the shah matured and external threats to Iran continued to require that he raise armies to defend his lands against the Ottomans and the Uzbeks, the Shamlu supremacy became increasingly onerous. Finally, in 940/1533–4 Husayn Khan was suspected of plotting to poison the shah in order to replace him with Sam Mirza, his former princely charge in Herat and the shah's younger half-brother. Husayn Khan was also accused of conspiring with the Ottomans, who invaded Azerbaijan in late autumn 940/1533. Several Qizilbash leaders defected to the Ottoman side at this time, but before Husayn Khan Shamlu could follow suit, Shah Tahmasp had him executed. Instead of awarding another Qizilbash amir with the post of *vakil*, Tahmasp appointed a Persian, Qadi Jahan, and made his brother Bahram Mirza commander of the Shamlu army. These appointments gave as clear a message as possible to the Qizilbash that their interregnum was finished and that Shah Tahmasp, now aged twenty, would henceforth operate as the absolute monarch of Safavid Iran.

By the time that Shah Tahmasp gained full control of his own government, the Uzbeks under 'Ubayd Khan had invaded Khurasan five times (in 920/1514, 932/1525–6, twice in 935/1528 and in 938/1531–2). Because Tahmasp's attentions were focused on putting down an insurrection in Azerbaijan in 938/1531–2, the Uzbeks were able to besiege Herat for a year and a half, during which time the civilian population was preyed upon by their Takkalu defenders, who were themselves reduced to eating cats and dogs. Finally in 940/1533–4 Shah Tahmasp marched on Khurasan. Successful battles, including one in Astarabad where the Safavids surprised the Uzbeks in the bath, intimidated the Uzbeks so that instead of defending Mashhad and Herat, they withdrew across the Oxus. Yet 'Ubayd Khan was only waiting for another opportunity to return to Khurasan. When Sam Mirza and his guardian decided

to attack the Mughals at Qandahar without the permission of Shah Tahmasp, 'Ubayd Khan saw his chance and returned to Khurasan, once again besieging and seizing Herat in 942/1536. As before, Shah Tahmasp returned in the following year and the Uzbeks retreated. Rather than quit the region immediately, the shah campaigned to the south in Sistan and Zamin Davar, where he regained control of Qandahar. He did not return to Tabriz until the autumn of 944/1537. Two years later 'Ubayd Khan died and the Uzbek threat to Khurasan subsided for the rest of Shah Tahmasp's reign.

The nature of the Ottoman menace differed markedly from that of the Uzbeks. Whereas 'Ubayd Khan may have wished to extend his empire to include Khurasan, his Uzbek followers seem to have been more concerned with plundering the province as they were repeatedly unwilling to face Shah Tahmasp and his army in battle. The Ottomans, on the other hand, struck at the administrative heart of the Safavid realm but also threatened some of the most productive regions of the empire, Azerbaijan and Iraq Ajam (western Iran).

Until 939/1533 the Ottoman sultan Suleyman had been so occupied campaigning in eastern Europe that he had not taken advantage of Shah Tahmasp's divided attention between Uzbek invasions in the east and the various Qizilbash rebellions in Azerbaijan. However, when the dissident Qizilbash amir Ulama Sultan Takkalu defected to the Ottoman side, he signalled to Sultan Suleyman the vulnerability of Shah Tahmasp's position in Azerbaijan. By the summer of 941/1534 the Ottomans had besieged Tabriz and in the autumn they began to move on Baghdad. Meanwhile, Shah Tahmasp and his army had traversed Iran from Khurasan by means of forced marches, but the size of the Ottoman army, the exhaustion of the Safavid cavalry and Tahmasp's tenuous grip on the loyalties of his Qizilbash amirs forced him to pause before attacking the Ottoman invaders. The shah's luck held. In early November 1534 near Sultaniyyeh the Ottoman army was caught in a heavy snow storm which resulted in many casualties and forced them to abandon much of their artillery. Although disaffected members of the Takkalu tribe handed over the keys of Baghdad to Sultan Suleyman, the lands around Lake Van and in Azerbaijan that the Ottomans had occupied reverted to Safavid control as soon as the Ottomans departed. None the less, in the spring of 941/1535

Suleyman marched north again in the direction of Tabriz. Harried by small bands of Safavid skirmishers, the Ottomans turned toward Lake Van. While reports of Ottoman losses vary, the result of the Safavid–Ottoman engagements in eastern Anatolia in 942/1535 was that the Ottomans returned to Istanbul in 942/late 1535 without having greatly weakened either the Safavid military or the stability of Shah Tahmasp's government. Tahmasp, accused by historians of passivity and inaction, had clearly observed the tactical advantage of forcing his enemy to commit to a course of action before showing the Safavid hand, and of drawing his enemy further into the difficult terrain of Iran in order to stretch the Ottoman lines of supply to their limits.

When Shah Tahmasp returned to Tabriz in autumn 944/1537, he had been on campaign every year since 938/1531–2. Despite physical bravery in battle, his victories against the Uzbeks and Ottomans derived more from his skill as a tactician and his understanding of the impact that his presence in battle had on his enemies. Unlike his fiery, charismatic father, who could whip up his Qizilbash supporters with emotional politico-religious poetry, Tahmasp kept his own counsel, observed the actions of those around him and received reports of his enemies before acting. Yet, when the time was right, Tahmasp could be swift and decisive. Seditious amirs were executed, rebellious princes incarcerated and invading armies repulsed. It has been argued that Shah Isma'il's loss of the Battle of Chaldiran and the resulting damage to the Safavid house profoundly influenced Tahmasp's methods of fighting his Uzbek and Ottoman foes.[6] However, the prestige of the king on the battlefield still obtained under Tahmasp, as reports state that sightings of the gilded globe atop his personal standard invariably intimidated his enemies and in some cases caused them to flee rather than fight.[7]

While Shah Tahmasp controlled the central Iranian lands by appointing members of his family and high-ranking amirs to provincial governorships, some outlying regions operated more as semi-independent principalities, bound to the Safavids through taxation and treaties. During a time of civil unrest in one of these principalities, Shirvan, the local population invited Shah Tahmasp to help restore order. His response was to send an army in 945/1538–9, led by his brother Alqas Mirza, to subjugate Shirvan.

After several months of battles and sieges, the Shirvanis surrendered, offering to give up the fort of Biqurd to Shah Tahmasp himself. As a reward, Tahmasp appointed Alqas Mirza governor of Shirvan.

In 947/1540–41 Shah Tahmasp launched his first invasion of Georgia. Billed as a holy war, the reasons for this and three subsequent expeditions are somewhat more complicated than a simple desire to convert or punish the infidel. As early as 939/1532–3 Shah Tahmasp had 'repented of all forbidden acts'.[8] In addition to removing from the tax rolls all revenue from taverns, gambling dens and brothels, Tahmasp himself gave up drinking alcohol and using intoxicants such as hashish.[9] Thus a holy war would have been in keeping with Tahmasp's sincere and growing enthusiasm for adhering to the precepts of Islam. For his armies, which by now were battle-hardened from more than a decade of fighting, such an expedition must have appeared an attractive means of increasing their wealth from plunder. Finally, even in his first Georgian expedition Shah Tahmasp may have understood the value of introducing new elements to Safavid society which would be more loyal to him than to the Qizilbash tribes. The immediate pretext for the invasion, however, was the need to subjugate a Georgian ruler who was raiding the territory of his neighbours, Tahmasp's Georgian vassals. In fact Tahmasp failed to capture the rebellious Georgian leader, but his army did slay many Georgian men, took many women and children captive and made off with booty.

In response to a rebellion in Shirvan led by Alqas Mirza, Shah Tahmasp marched north again in 953/1546–7. Since the prince claimed to have seen the error of his ways, the shah changed course and staged another plundering mission in Georgia to coincide with an expedition that Alqas Mirza was leading to Circassia. When the shah learned that his brother had defied him again by striking coins in his own name, Tahmasp sent an army to take control of Shirvan. Alqas Mirza fled after losing two battles to Tahmasp's forces. By 955/1548–9 he was in Istanbul, inciting Sultan Suleyman to invade Iran again.

The Ottoman invasion began in the spring of 955/1548. As before, they took Tabriz briefly, but their stay was cut short by a severe lack of food. Tahmasp had ordered his supporters to lay waste to all the territory between Tabriz and the Ottoman border and to block the underground water channels, the *qanat*s, so that neither man nor beast could survive for long. Avoiding a pitched battle, the Safavids pursued the Ottoman army as it retreated towards Van and Erzerum. Their engagements with the Ottomans in eastern Anatolia met with success, but the war was not over yet. Alqas Mirza had meanwhile seized Hamadan and had taken hostage the wives and children of Bahram Mirza, his younger brother. To avoid a confrontation with the shah's forces, Alqas fled south to Fars province and when city after city closed its gates to him, he proceeded to Baghdad. By 956/1549–50 the Ottomans saw no further use in Alqas Mirza. They sent a force against him and he fled back to Iran. Inevitably, he was taken into custody by the shah's delegates, imprisoned and murdered soon afterward.

For reasons not unlike those for his previous Georgian expeditions, Tahmasp in 958/1551 once again led his army north to the aid of one of his vassals, and again he returned to Iran with 'much wealth, countless prisoners, and flocks of sheep, goats and other animals'.[10] War broke out again with the Ottomans in 961/1553–4 in Armenia, where the Safavids practised the scorched-earth policy as far west as Mush. Then, led by Tahmasp's second son, Isma'il Mirza, the Safavids defeated Iskandar Pasha, an Ottoman amir, and pursued him and his army to the walls of Erzerum. Although Persian sources portray the Ottomans as the invaders, it seems likely that the Safavid forays in Armenia precipitated Sultan Suleyman's retaliation.

In Jumada II 961/May 1554 Sultan Suleyman decamped with a large army from his winter quarters at Aleppo and marched towards Qarabagh in Armenia. In preparation for a confrontation with the Ottomans, Shah Tahmasp had ordered two groups under separate commanders to scorch the lands in the path of the Ottoman army. By the time the Ottomans reached Nakhchivan, they had exhausted their supplies and were forced to move west to Erzerum. Although Shah Tahmasp's large army inflicted some damage on the Ottoman force, the war ended without a major confrontation. The two powers entered into formal peace negotiations and on 8 Rajab 962/29 May 1555 the Treaty of Amasya was ratified; it remained unbroken for the rest of the lives of both Sultan Suleyman and Shah Tahmasp. Despite the loss of Baghdad and Van to the Ottomans, peace on his eastern and western fronts

afforded Shah Tahmasp the crucial opportunity to set his own house in order. Not only did he move the Safavid capital to Qazvin, but he insisted in 963/1555–6 that his household and the great amirs make a public act of repentance to be followed by the population at large. This act has been interpreted as a decisive step in Tahmasp's rejection of the Qizilbash elements of society, but it also marks one of the ways in which the shah tightened his control on the society that he ruled. Tahmasp's increasing puritanism and superstition have been viewed as deleterious to the visual arts in Iran. Although his change in taste did not end all royal commissions, it certainly led to a change of emphasis. The works of art produced for Shah Tahmasp up to 962/1555 contrast markedly with those made – as often for his relations as for himself – after that date.

Until Shah Tahmasp moved the capital to Qazvin, his record of architectural accomplishments in many ways paralleled that of his father. He embellished and renovated the *jami'* (congregational) mosques of Isfahan, Kirman and Shiraz, repaired the Mashhad and Ardabil shrines and many smaller mosques, tombs and shrines throughout Iran, but he undertook no new major construction. Before investigating the works that Tahmasp did commission before 962/1555, it is worthwhile discussing some of the reasons for his minimal impact on Safavid architecture in the first half of the sixteenth century. The city of Herat, where Tahmasp spent his early childhood, had been significantly developed under the Timurid sultan Shah Rukh, who made it his capital, and his wife Gauhar Shad in the first half of the fifteenth century. However, the building and garden complexes constructed outside the city by the last Timurid emperor, Sultan Husayn Bayqara, his most important amir, Mir 'Ali Shir Nava'i, and other nobles would probably have had the greatest influence on Tahmasp. The sultan's palatial assemblage included 'pavilions, government offices, the main residence (a qasr or kušk), a large reservoir bordered by four pavilions, and a meadow'.[11] Associated with the nearby cemetery of Gazur Gah, these complexes were built high above the city of Herat with an eye to creating vistas in the direction of both the city and the domes of the cemetery.

Prince Tahmasp returned to Tabriz in 928/1522. There, as at Herat, the palaces and monuments such as the Blue Mosque erected

29 Southern *ivan*, Masjid-i Jami', Isfahan, 938/1531–2. The complex floral and epigraphic tile decoration is balanced by the stucco *muqarnas* in the arch enclosing squares of Kufic.

by the Qaraqoyunlu and Aqqoyunlu Turkmans in the second half of the fifteenth century were still standing. An Italian merchant who visited Tabriz in 1507 remarked on the 'palaces of former kings [that] are wonderfully decorated within and covered with gold on the outside, and of different colours; and each palace has its own mosque and bath, which are equally overlaid, and worked with minute and beautiful designs'.[12] Although the author did not specify, the decoration he describes must have been predominantly tilework with painted walls above. The 'gold on the outside' would either have been lustreware tiles or paint. Also, as at Herat, palaces were built on the hillsides overlooking the city, with views from windows in a large hall described by the merchant as decorated with marble columns and a blue and gold tiled ceiling. Shah Isma'il preferred to spend his time hunting in the countryside, so the Safavid palatial assemblage of Tabriz had probably changed little, if at all, since the time of the Italian merchant.

Having been reared in cities with large, ornately decorated buildings, the young Prince Tahmasp may not have seen the need to erect new buildings to replace them. Even his record of renova-

tion in the early years of his reign is sparse. However, in 938/1531–2, when he was fighting the Uzbeks and in Azerbaijan, the south *ivan* of the Masjid-i Jami' in Isfahan [fig. 29] was renovated in his name. The *thuluth* inscription band that runs horizontally around the interior of the *ivan* states that Muhammad al-Isfahani repaired and embellished the mosque during the time of Shah Tahmasp and that Kamal al-Din Husain al-Hafiz al-Haravi was the scribe. On the left side of the façade another inscription states that the refurbishment was accomplished thanks to the generosity of Aqa Sultan.[13] The band that runs around the outer edge of the arch contains cartouches with prayers to the twelve imams and Muhammad and Fatima, while the border to the façade was inscribed in 938/1531–2 with the first twenty-one verses of Surat al-Fath from the Qur'an; in 1072/1662 Shah 'Abbas II replaced verses 7 to 16 with his own renovation inscription.

Since Shah Tahmasp did not pay for the renovations of the Jami' Mosque of Isfahan in 938/1531–2, it is unclear to what extent, if any, he was involved in the choice of decoration or inscriptions. As the scribe, Kamal al-Din Husain, was employed by the shah, the selection of Qur'anic verses for the mosque may have been made in Tabriz. Kamal al-Din Husain:

> wrote good *nasta'liq*, combined (*jam'*) the 'six' scripts, and was an expert in diluting lapis lazuli. From Khorasan he came to (Persian) Iraq where he lived for some time in Qum. He was a good reader of the Qor'an. From Qum he went to the royal camp (court) … He was a humble darvish. Shah Tahmasp bestowed upon him a tent, a horse, a camel, harness and equipment, but he did not accept them and was not tempted. He dressed in felt and traveled on foot.[14]

A scribe such as Kamal al-Din could have provided a scale drawing of his inscription, which master tilemakers would then have used as the basis for their mosaic faience. Although any number of wealthy people could have been named Muhammad al-Isfahani, it is more than possible that the patron of the repairs was Amir Mu'izz al-Din Muhammad Isfahani who served as *sadr* from 938/1531–2 to 943/1536–7. Whereas under Shah Isma'il the *sadr* had been responsible for imposing doctrinal unity, the position became less prominent once Shiism was largely accepted in Iran.[15] None the less, the *sadr* was the minister in charge of religious law and certain land grants, so he could have been expected to have the wealth, prestige and piety to pay for the renovations of one of the greatest Iranian mosques in the year that he was appointed to the highest religious post in the land.

Although almost nothing remains today of Shah Tahmasp's palace in Tabriz, a detailed description of it has come down to us from Michele Membré, an Italian who arrived in Tabriz in 946/1539. Many features analogous to those in Membré's account appear in illustrations to manuscripts completed for Shah Tahmasp in precisely the same period. When Membré reached Tabriz, Shah Tahmasp's palace was being rebuilt. It was situated within a garden surrounded by walls of stone and earth with two gates. To the east lay a *maidan* (large plaza) next to which Shah Tahmasp was building a new mosque, and to the north were two other mosques side by side. Within the walls 'the ways are divided off with bars of wood, because it is all gardens'. Near the gate were the Qurchibashi, the head of the royal bodyguard, and the treasury 'where the goldsmiths are'.[16] As one approached the shah's residential quarters, one passed the offices of his brother Bahram Mirza, his *muhrdar* (keeper of the royal seals), Shah Quli Khalifa, and his chief minister, Qadi Jahan. The latter's quarters were built next to the fourteenth-century mosque of 'Ali Shah, now known as the Arg, which in 946/1539 served as an armoury. Also, in what had once been the courtyard of the mosque of 'Ali Shah was a large pool with a rowing boat and pavilion in the centre. Both Shah Isma'il and Shah Tahmasp enjoyed themselves here either being rowed in the boat with friends or, in the case of Tahmasp, a devoted angler, fishing from the pavilion.[17]

The palace itself was reached through a portal lined with niches in which the *qurchi*s (royal bodyguards) sat on the ground with their swords. 'Passing on then,' described Membré,

> to the west, on the left, is the great fair palace, with four chambers, one behind the other, with their carpets and antechambers; and at all the doors stand porters, in accordance with the importance of the doors; for, in the said chambers they are seated all around the walls within, one next to the other; and so the room where the Shah is is very small and beautiful, all worked with azure and

designs of foliage, as are all the chambers, with their vaults, and in the windows certain things which seemed to be panes of glass with figures in them. The second chamber is larger; along it sit his *Sultans* of higher rank; in the third other *Sultans* of lesser rank; in the forth *qurchis* who stand in favour with the King, and are waiting to become *Sultans*.[18]

Nearby was a separate building of four rooms where the shah slept and another which was his bath. Services such as the stables, the kitchen and the armourers were located to the north-east, as was a small mosque.

In the same period that Shah Tahmasp was renovating his palace in Tabriz, he had also undertaken construction of a new building at the Ardabil shrine, the Jannat Sara [fig. 30]. Between 943/1536 and 949/1542–3 the shah had bought houses and enclosures at the north-east end of the shrine. The houses were razed to make way for the large, octagonal Jannat Sara and its dependencies and garden. Morton dates the completion of the building to around

30 Jannat Sara, Ardabil, c. 946–7/1540, with extensive later restoration; partial view of the Dar al-Huffaz at the right. Although the dome of the Jannat Sara has been entirely rebuilt, the exterior form of the façade has apparently remained almost unchanged since the period of Shah Tahmasp.

946–7/1540.[19] Although foreign travellers to Ardabil described the Jannat Sara as a mosque, no Persian sources do so. Called a *maqsura* (enclosure), it may have accommodated an overflow of dervishes at the shrine or served as a space for certain dervish rituals. Alternatively, Shah Tahmasp may have intended it as his own tomb, though ultimately he was buried at Mashhad.[20] By the seventeenth century the building had suffered greatly from water damage, so the dome was repaired and at least partly covered with bricks and mortar and the interior was whitewashed. The dome had collapsed by the mid-nineteenth century and presumably much of the Safavid tilework was gone; what is visible today is mostly restored.

Fortunately the extant pair of carpets dated 946/1539–40 and known as the Ardabil carpets [fig. 31] provide us with some idea of the furnishings that would have been ordered for a new religious building such as the Jannat Sara. Since its acquisition in 1893 the Victoria and Albert Museum's Ardabil carpet has elicited strong public interest and speculation about its original use at the Ardabil shrine. Recent research by King and others[21] has demonstrated that in their original state, the Victoria and Albert Museum Ardabil carpet and its mate in the Los Angeles County Museum of Art could have just fitted into the Jannat Sara if laid side by side. Presumably damaged by the same leaks that led to the seventeenth-century repair of the dome, the carpets were moved to the Dar al-Huffaz and possibly the Chini-khaneh some time before 1843 when two English visitors remarked on a carpet dated 946/1539–40 in the Dar al-Huffaz.[22] Most likely the carpets were sold to pay for repairs to the shrine in about 1884.[23]

With its design of a *shamsa* or sunburst central medallion surrounded by sixteen oval cartouches, two pendant mosque lamps, four corner pieces with sections of the central motif and four oval cartouches, a complex arabesque ground design and a main border design of alternating round and oblong cartouches, the more complete London Ardabil carpet is one of the finest expressions of Safavid religious art. Assuming the carpets were positioned in the centre of the Jannat Sara, their *shamsa* designs would have mirrored the dome above them. The inscription, from an ode by the poet Hafiz, reads: 'I have no refuge in the world other than thy threshold; My head has no resting-place other than this doorway.' In this setting the couplet may allude to the Muslim prayer ritual

in which the worshipper would touch his head to the ground and raise it to look upwards, actions that would have emphasized the visual impact of both dome and carpets.

Although the designs of the two carpets are almost identical and both are knotted in wool on silk warps and wefts, the Los Angeles one has sixty-two knots to the square centimetre whereas the London example has forty-six. This discrepancy may indicate that the carpets were made in two workshops under the same management using the same cartoon. As the earliest examples of dated sixteenth-century knotted carpets and among the very few with a signature, the Ardabil carpets are key documents for the study of the medium. The role of the maker, whose name appears as 'the servant of the court Maqsud of Kashan', was most likely that of designer, but it is not certain whether he oversaw the manufacture of the carpets in Kashan or near the court in Tabriz or in another carpet-making centre such as Yazd. None of these remaining questions detracts, however, from the meditation-inducing beauty of the Ardabil carpets.

Visitors to the court of Shah Tahmasp report the use of sumptuous silk carpets not only inside his palaces but on the ground outside them and in encampments. When Michele Membré first encountered Tahmasp in 946/1539, he came upon the shah in a vast encampment at Marand to the west of Tabriz. In the midst of 5,000 tents, Shah Tahmasp's court consisted of a succession of tented pavilions including an oblong audience hall, chambers for sleeping, a domed tent enclosing the bath and another domed tent 'in which are painters'.[24] Membré's meeting with the shah was held in 'the place of audience, with those beautiful pavilions, all decorated with cut designs of foliage inside and, on the floor, carpets of great price. The King was thus seated upon a *takya-namad*, that is a felt of Khurasan, which was of great price.'[25] In such a setting, where the king and his brothers spent their time fishing and hunting, the designs on their carpets may have been figural rather than floral and vegetal like the Ardabil carpets.

31 Ardabil carpet, north-west Iran, signed 'the work of a servant of the court Maqsud Kashani', dated 946/1539–40, silk and wool, 10.51 × 5.34 m, Victoria and Albert Museum, 272-1893.

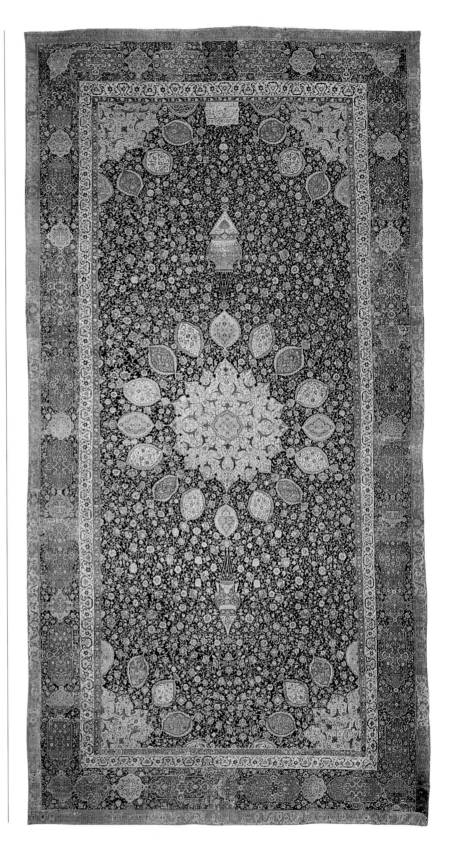

A group of very fine carpets with hunters on horseback and on foot chasing deer and small game and fighting lions can be placed in the second quarter of the sixteenth century on the basis of a signed and dated example in the Poldi Pezzoli Museum in Milan. The carpet with its silk warps, cotton wefts and wool knots bears the name of Ghiyath al-Din Jami and the date 949/1542–3. At forty-one knots per square centimetre it is only slightly less fine than the London Ardabil carpet. Its central lobed medallion and four corner pieces contains a symmetrical arrangement of flying cranes and cloud scrolls. An even more luxurious example of carpet-making in this period is the hunting carpet in the Museum of Fine Arts, Boston, which has silk warps, wefts and knots as well as silver gilt, silver and silk brocade [fig. 32]. In its quadripartite central medallion and its four corner pieces the long tail feathers of the mythical bird, the *simurgh*, echo the contours of the medallion. The hunt takes place on a yellow silk ground punctuated by a spiral arabesque. Yet, unlike the Poldi Pezzoli carpet and other small silk hunting carpets of this period, the main border is inhabited by noblemen being served wine and fruit in a garden setting. While the hunt is one of the oldest artistic and poetic metaphors of Iranian art, the inclusion of Safavid grandees on a picnic in the border localizes such a sumptuous carpet. If it did not actually accompany the shah or a member of his family on encampments, it may have served as a reminder of the glories of the field when the court was in the palaces of Tabriz.

Whereas the extant buildings and restorations that were commissioned either by or in the name of Shah Tahmasp attest to his desire to maintain and glorify the religious edifices of Safavid Iran, his most celebrated contribution to the arts in the first half of his reign was as a patron of deluxe illustrated manuscripts. Even if Tahmasp did not actually study painting with Bihzad in Herat between 922/1516 and 928/1522, his literary education would have

32 Hunting carpet, Tabriz?, c. 1540, silk and metallic threads, 4.8 × 2.55 m, Centennial Fund, Gift of John Goelet and unrestricted textile purchase funds, Courtesy, Museum of Fine Arts, Boston, 66.293. This is one of the finest examples of court-level carpet manufacture in which favourite themes of 16th-century Safavid visual arts – hunting, feasting and imaginary beasts – are combined.

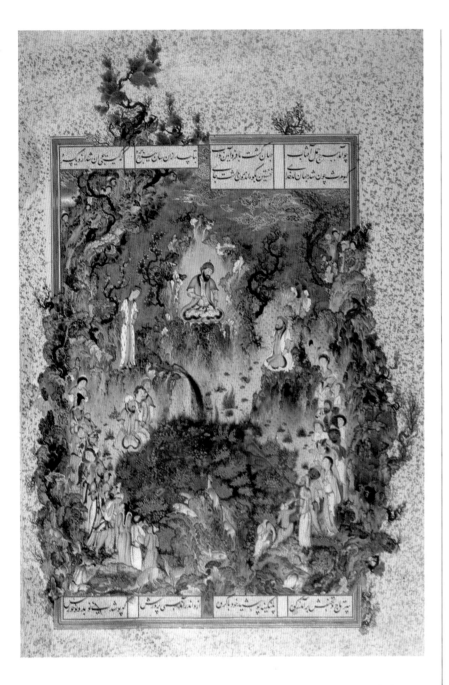

been derived from the books in the Timurid royal library. Certainly illustrated manuscripts of the late fifteenth-century Herat school and perhaps even the *Shahnameh* produced in 833/1429–30 for the bibliophile Timurid prince Baysunghur would have been available to the young Tahmasp. Thus, as Dickson and Welch have maintained, Prince Tahmasp would have returned to Tabriz in 928/1522 familiar with the taste of Timurid Herat.[26] The style of painting as embodied by Bihzad's works is characterized by spatially rational compositions, a lively portrayal of individuals in a range of expressive poses, extremely careful and precise technique and a brilliant palette in which blue, green and gold are used liberally.

Either because of the appointment of Bihzad as head of the royal artists' workshop at Tabriz or to accommodate Tahmasp's preference for the cooler, more orderly painting of Herat, Sultan Muhammad, the director of Shah Tahmasp's *Shahnameh* project, subtly adapted his style during the 1520s. The result was a range of extraordinary illustrations in the Tahmasp *Shahnameh* of which 'The Court of Gayumars', folio 20v, is the crowning achievement [fig. 33]. The painting depicts the first Iranian king, Gayumars, seated in the centre on a rocky throne, telling his son, Siyamak, that he will be killed by the Black Div, the incarnation of evil, and that the only salvation for the world will be Hushang, Siyamak's son, who stands at the left. Until this time, Gayumars and the race of men who dressed in leopard skins had lived in peace with all creatures, a condition demonstrated by the men carrying the deer up the mountain on the right or the crouching man holding a lion cub next to its mother. The oval composition underpins the upward movement of rocks and figures which is counterbalanced by the downward rush of the now tarnished silver waterfall in the centre of the picture and the remarkable melting blues, pinks and lavenders of the rocks. While Sultan Muhammad's attention to composition may have been inspired by contact with Herat school painters or paintings, he preserved to a remarkable degree the myriad Turkman-style hidden grotesque faces of people and animals that populate the rocks and clouds like souls animating the landscape. In contrast to the idealized faces of Gayumars and his race of people, these tiny visages in the rocks are often individualized, raising the question of whether they might be concealed portraits rather than simply monsters of the artist's imagination.

33 'The Court of Gayumars', from the Shah Tahmasp *Shahnameh* of Firdausi, attributable to Sultan Muhammad, Tabriz, c. 1522–5, opaque watercolour, gold and ink on paper, image 34.2 × 23.1 cm, Collection of Prince and Princess Sadruddin Aga Khan. In its minute scale, its remarkable composition, the myriad hidden animal and human faces and the beauty and modulation of its palette, this painting is unsurpassed in Persian painting of any period.

'The Court of Gayumars' confirmed Sultan Muhammad's pre-eminence among Shah Tahmasp's painters. One of the few individual paintings to be mentioned in any sixteenth-century text, the work was described by Dust Muhammad in 951/1544 as 'such that the lion-hearted of the jungle of depiction and the leopards and crocodiles of the workshop of ornamentation quail at the fangs of his pen and bend their necks before the awesomeness of his pictures'.[27] Welch has estimated that Sultan Muhammad worked on 'The Court of Gayumars' for three years,[28] which sets it apart from the other 257 illustrations to Shah Tahmasp's *Shahnameh* and partly explains its wealth of detail and colouristic intensity. For practical and stylistic reasons the majority of the paintings in the *Shahnameh* of Shah Tahmasp are painted on a somewhat larger scale, with fewer figures and less tonal variation than 'The Court of Gayumars'. Many of the illustrations are superb works of art and provide much information about the material culture of the Safavids.

As the collecting of calligraphies and single-page paintings increased in this period, compilers of albums such as Dust Muhammad consciously arranged the works to reflect the chain of artistic development from the fourteenth to the sixteenth century. These visual compendia, as well as Dust Muhammad's 951/1544 Preface to the Bahram Mirza Album, Malik Daylami's 968/1560–61 Preface to the Amir Husayn Beg Album, Mir Sayyid Ahmad's Preface to the Amir Ghayb Beg Album of 972/1564–5, the late sixteenth-century account of Qazi Ahmad and signed or ascribed paintings, provide the basic information about which artists were working for Shah Tahmasp and the nature of their familial or student–teacher relationships.[29] Sultan Muhammad, the doyen of the Tabriz school, was the father of the artist Mirza 'Ali, who also contributed to Shah Tahmasp's *Shahnameh*, and the grandfather of Mir Zayn al-'Abidin, who was a painter and illuminator in the last quarter of the sixteenth century. Whereas artists such as Bihzad and presumably Mir Musavvir moved to Tabriz from Herat and Badakhshan, respectively, their students and pupils were brought up in the court atelier at Tabriz. Some of them, namely Dust-i Divaneh, a pupil of Bihzad, and Mir Sayyid 'Ali and his father, Mir Musavvir, left Iran in the 1540s to join the Mughals in Kabul and then Delhi. Yet other Safavid court artists such as Muzaffar 'Ali, a student and

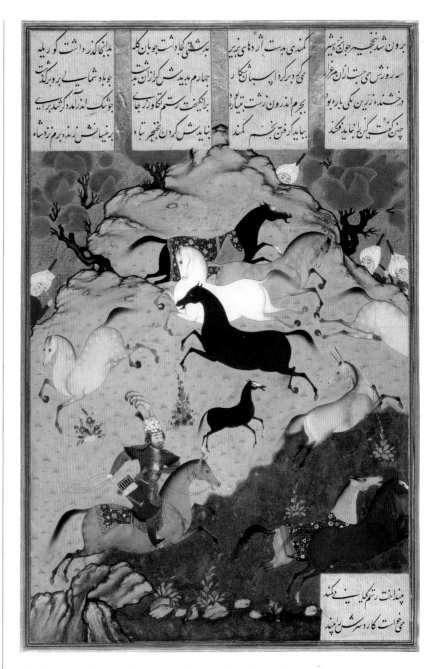

34 'Rustam Pursues Akvan, the Onager-*div*', from Shah Tahmasp's *Shahnameh*, attributable to Muzaffar 'Ali, c. 1530–35, opaque watercolour, gold and ink on paper, image 26.8 × 17.3 cm. Collection of Prince and Princess Sadruddin Aga Khan. The hero Rustam is about to lasso an onager which had been attacking a herdsman's horses and which was believed to be the demon Akvan in disguise.

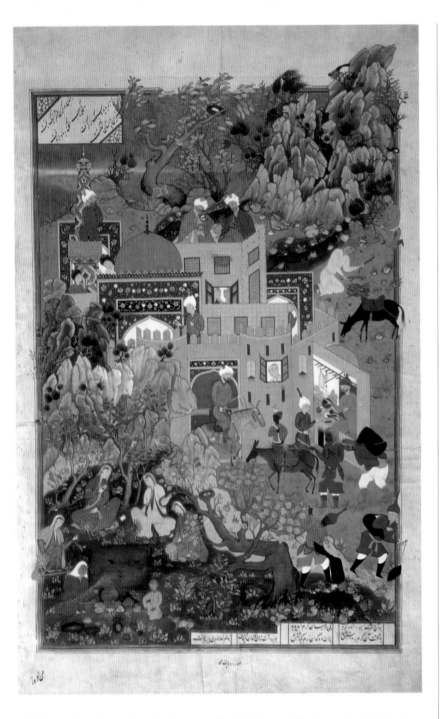

35 'Haftvad and the Worm', from the Shah Tahmasp *Shahnameh* of Firdausi, ascribed to Dust Muhammad, Tabriz, c. 1540, opaque watercolour, gold and ink on paper, image 40.6 × 26.7 cm, Collection of Prince and Princess Sadruddin Aga Khan. Haftvad's daughter spared a worm she found in an apple, and in return it grew enormous and spun great quantities of silk, thereby enriching her family and village.

relative of Bihzad, and Aqa Mirak remained at Tabriz, becoming confidants of the shah.

The regional sources of the styles of Sultan Muhammad and Mir Musavvir, both artists of the older generation, are evident in their earlier *Shahnameh* illustrations. Whereas Sultan Muhammad's early *Shahnameh* paintings exhibit the spatial illogic and natural dynamism of 'Rustam Sleeping' [see fig. 18], Mir Musavvir's illustrations from the 1520s, including the only dated painting in the manuscript, 'Ardashir and the Slave Girl Gulnar' of 934/1527–8,[30] have compositions that are carefully constructed with an emphasis on the geometry of architectural elements and the specific rendering of objects such as lamps, bowls and ewers. By the 1530s the synthesis of the eastern and western Iranian styles of painting was well under way. Sultan Muhammad's compositions had become more architectonic, while those of Mir Musavvir were more broadly conceived and dramatic; both artists ceased to include a plethora of minute details in their illustrations. The younger generation of painters furthered the development of the new style with their contributions to the manuscript. The contributions of Mirza 'Ali and Aqa Mirak reveal a heightened interest in characterization and opulent colour. Muzaffar 'Ali's illustrations combine elegance and exuberance [fig. 34], while Mir Sayyid 'Ali, 'Abd al-Samad and the artist Dust Muhammad, who should be identified with Dust-i Divaneh [see fig. 35], the three artists who with Mir Musavvir joined the Mughal atelier, took great care to depict the stuff of the material world.

Shah Tahmasp's repentance of all forbidden acts in 939/1532–3 did not yet include a strict Muslim prohibition of human imagery, and his support for his artists and calligraphers remained strong through the 1530s. As a result, following the completion of the *Shahnameh* in about 944/1537, the employees of the royal atelier embarked on another lavish commission, an illustrated *Khamseh* of Nizami. Produced between 946/1539 and 949/1543, the manuscript was copied at Tabriz by the scribe Shah Mahmud of Nishapur. Fourteen illustrations from the sixteenth century and three from a seventeenth-century refurbishment remain in the manuscript, while at least four were removed from it and are in museum collections. Instead of a large stable of painters, only a handful of the shah's best artists, namely Sultan Muhammad, Aqa Mirak, Mirza

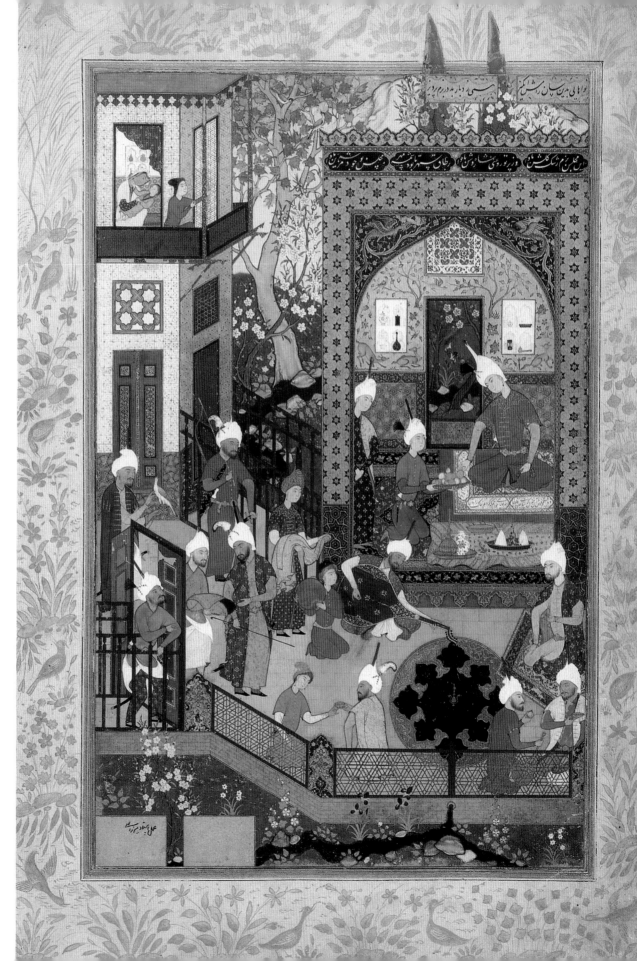

36 'Khusrau Listening to Barbad Playing the Lute', from a *Khamseh* of Nizami, ascribed to Mirza 'Ali, Tabriz, dated 946–9/1539–43, opaque watercolour, gold and ink on paper, page 36.5 × 25.1 cm, British Library, Or. 2265, fol. 77v. The depiction of garden pavilions, such as the one in which Khusrau is seated, and the private quarters at the left reserved for the women and children of the king, closely resembles the written descriptions by European travellers of the Safavid palaces at Tabriz and Qazvin.

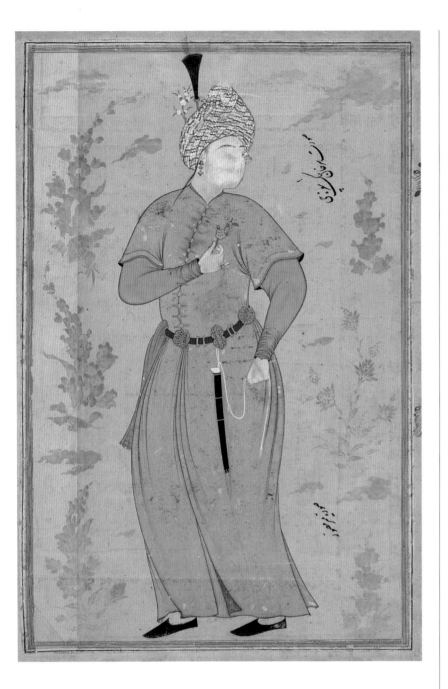

composition is, it incorporates numerous realistic details, such as the niches behind Khusrau which enclose a pencase, an hourglass, bottles and bowls. Mirza 'Ali has adroitly interwoven elements of the narrative with details of Safavid court life that would have given the patron, Shah Tahmasp, pleasure on many levels.

In the 1530s and 1540s the Safavid court artists supplemented their manuscript illustrations with single-page paintings for inclusion in albums, called *muraqqa*'s. Thus in the 1530s Mir Musavvir was engaged in painting portraits such as the one of 'Sarkhan Beg the Table-steward' [fig. 37]. Even if the paint on the figure's face had not been removed, his identification on the basis of the portrait alone, without the inscription, would have been impossible for today's viewers because of the level of idealization in Persian portraiture in this period. Possibly the figure's pose, girth and clothes would have been clues to his identity, but such figures were hardly rare and, like today's fashion models, they conformed to certain stylish norms. Even the sitter's belt with its jewel-studded medallions is of a type that was being made in the second decade of the sixteenth century, as an example taken from the Safavids at Chaldiran attests [see fig. 16]. Those appointed to the position of table-steward (*sufrachi*) were young men, often of noble birth and chosen for their physical beauty. Serving the shah and his brothers as personal attendants, the table-stewards were reportedly present at a musical entertainment given by Bahram Mirza, the shah's brother, in 946–7/1540 where they drank aquavit along with the prince and eventually, 'drunk, [they] stretched out on the carpets on the ground'.[51]

In 951/1544, the same year that Dust Muhammad ibn Sulayman al-Haravi compiled a sumptuous album of paintings and calligraphies for Bahram Mirza, the deposed Mughal emperor, Humayun, took shelter at the Safavid court. In 952/1546 he requested Shah Tahmasp to release Mir Sayyid 'Ali and 'Abd al-Samad to his service. By Shavval 956/November 1549 they, as well as Mir Musavvir and the painter Dust Muhammad, were in the Mughal court at Kabul. While Humayun must have admired the ability of all four of these artists to depict the material world faithfully, Shah Tahmasp would probably not have been inclined to release them if he himself were still actively patronizing them. Certain painters, such as Aqa Mirak, Mirza 'Ali and Muzaffar 'Ali,

'Ali, Mir Sayyid 'Ali and Muzaffar 'Ali, contributed to the manuscript. As a result the illustrations exhibit a greater stylistic uniformity than those of the *Shahnameh*. A painting such as 'Khusrau Listening to Barbad Playing the Lute' [fig. 36], ascribed to Mirza 'Ali, presents the story of an evening's revelry in the sophisticated setting of a Safavid palace garden. As lyrical and complex as the

did remain in favour with the shah. Apparently a specialist in horse paintings, Muzaffar 'Ali continued to produce single-page works for albums, such as the 'Hunter on Horseback' [fig. 38], maintaining the elegant style of his illustrations to the *Shahnameh* and *Khamseh*. Qazi Ahmad noted of Muzaffar 'Ali that 'besides painting, he had a most wonderful hand in calligraphic copying (*muthanna*), wrote nasta'liq well, excelled in gold sprinkling and gilding, and was outstanding in his time in coloring and lacquer work (*raughan-kari*). Few have been so versatile as he.'[32]

Aqa Mirak continued to work at the court where he was appointed *garak-yaraq* for the shah, that is the person in charge of supplies for court offices. However, he and Mir Sayyid 'Ali[33] also were responsible for painting two vaults in the audience hall of Shah Tahmasp in Tabriz. From Dust Muhammad's account, it is difficult to separate the description of the wall painting from that of the other furnishings: 'It is a heaven adorned with stars, a place decorated with the likenesses of people. It is … an Eden resplendent with serving-boys and houris. Its carpets would dazzle the eyes of the great …'[34] This passage does reveal that in 951/1544 Shah Tahmasp had not yet turned entirely away from the visual arts. In fact, Aqa Mirak is thought to have played a leading role in the illustration of a very large Book of Divination (*Falnameh*) which was produced in the 1550s. Although Shah Tahmasp may have chosen to have a manuscript on the subject of divination because of his growing superstitious religiosity, the unusual size may be due to other factors. First, unlike a manuscript which he would have read to himself, the text of this book would have required consultation with others, for which a large format would have been more practical. Furthermore, assuming the manuscript was conceived around 962–3/1555, the shah may have been suffering from the onset of the long-sightedness that many people experience in middle age. Paintings on the scale of those in the *Shahnameh* and *Khamseh* would have been very difficult to see without eyeglasses, whereas the *Falnameh* pages pose no such problem.

Painters were by no means the only members of the royal *kitabkhaneh*. The scribes who copied the texts of the manuscripts

37 (opposite) 'Sarkhan Beg the Table-steward', signed by Mir Musavvir, Tabriz, c. 1530, opaque watercolour, gold and ink on paper, 33 × 22 cm, British Museum, OA 1930.11-12.02. This portrait would have been intended for an album which would have included paintings and calligraphies. The faces and Safavid *taj* on paintings from this album were later erased.

38 (right) 'Hunter on Horseback', attributable to Muzaffar 'Ali, Tabriz, c. 1540, opaque watercolour and gold on paper, 15.5 × 24.2 cm, British Museum, OA 1996.3-26.01, purchased with the help of the National Art Collections Fund. Despite the lack of a written attribution, this painting bears the hallmarks of Muzaffar 'Ali, a first-rate painter of horses.

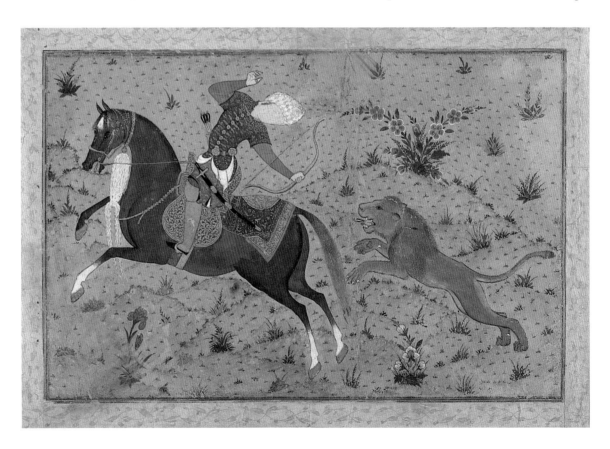

had traditionally been the elite members of the library, a position emphasized in contemporary texts by discussing them as the most recent members of a chain that stretched back all the way to Imam ʿAli. Shah Mahmud Nishapuri, who copied the British Library *Khamseh* of 946–9/1539–43, spent his early career in the service of Shah Tahmasp, having come to Tabriz from Nishapur. When the shah tired of calligraphy and painting, Shah Mahmud moved to Mashhad, where he lived in a *madrasa* at the shrine of Imam Riza for twenty years until his death in 972/1564–5. After he left the court, where he had copied manuscripts and produced calligraphic samples 'both in a large and a small hand', he continued as an independent scribe, writing specimens of calligraphy for inclusion in albums as well as teaching and composing poetry.[35] Although calligraphers were respected for their ability to write in various styles, the most prevalent script in the sixteenth century was *nastaʿliq*. The elegant, elongated letters of this hand were equally well suited to writing on the horizontal, as in manuscripts, and on the diagonal, as in single-page *qitʿa*, or calligraphy specimens [fig. 39]. The *nastaʿliq* script was devised by Mir ʿAli Haravi, a fifteenth-century calligrapher at the Timurid court, and as a result Herat was the source and

home of many of the pre-eminent scribes of the period of Shah Tahmasp. Although the scribes were employed by the shah, many of them remained in Herat and presumably sent their work to Tabriz. Of those who served at the court in Tabriz, some, such as Mir Sayyid Ahmad Mashhadi, worked as clerical scribes, writing letters to the Ottoman sultan and other official documents as well as calligraphic samples [fig. 40].[36] Others were called upon to provide inscriptions for buildings (see p. 46 above) or had specialities such as writing epitaphs on tombstones. The versatility of the master scribes served them well because, when Shah Tahmasp released them from royal service, significant numbers of them emigrated to India where they were welcomed at the Mughal and Deccani courts.

The art of illumination in the Safavid period represents a step in a long chain of developments stretching back ultimately to the earliest eighth- and ninth-century Qur'ans. By the sixteenth century the conventions regarding which pages or sections of books were appropriate for illuminating had been long established. Thus a luxury manuscript may have a *shamseh*, or sunburst design, containing the name of the patron or other information, on the

39 (left) Four lines of poetry in *nastaʿliq* script, signed by Muhammad Qasim ibn Shadishah, Tabriz, first half of the 16th century, ink, gold and opaque watercolour on paper, 19.8 × 11.7 cm, British Museum, OA 1994.5-19.02. Muhammad Qasim taught several leading scribes of the later 16th century.

40 (above) Four sections of a *ziyaratnameh* (letter of recommendation) from the shrine of Imam Riza written in *taʿliq* script, Mashhad, dated 14 Dhu'l-Hijja 939/5 July 1533, ink on paper, right to left (a) 21.4 × 17.7 cm, (b) 22.7 × 17.5 cm, (c) 22.8 × 22.7 cm, (d) 24.6 × 18.5 cm, British Museum, OA 1996.5-21.01(a–d).

41 Double-page illuminated frontispiece, from a *Khamseh* of Amir Khusrau Dihlavi, made for Abu'l Fath Bahram Mirza, Tabriz, c. 1530–40, opaque watercolour, gold and ink on paper, 30.2 × 18.3 cm, Arthur M. Sackler Gallery, Smithsonian Institution, Washington, DC, S86.0067-68. The gold cartouches above and below the text include the title and author's name and the mention of the library of Bahram Mirza, the brother of Shah Tahmasp.

recto of the first page, followed by an illuminated double-page frontispiece or *sarvlah*. Through the body of a manuscript chapter headings (*unvan*s) would be highlighted by illuminated bands and text pages could contain illuminated cornerpieces. Finally, double-page illuminated finispieces can be found in some manuscripts.

The style of illumination during the period of Shah Tahmasp owes much to Timurid antecedents from Herat. Illuminated headings from late fifteenth-century Herat manuscripts feature rectangles with a blue ground covered with an arabesque of thin gold tendrils joining red, pink and white flowers, all bordered by a predominantly gold band of interlace. Chapter headings appear in a central cartouche that overlaps irregular lobed quatrefoils. The comparison with Safavid royal illumination points up many similarities and a few differences [fig. 41]. First, the cartouches in the heading panels do not always overlap but connect by their inter-

laced outlines to lobed triangles. While the components of Safavid illumination do not differ greatly from those of the Herat school, subtle changes in the palette and in a preference for certain motifs can be noted. Thus in a frontispiece to Bahram Mirza's *Khamseh* bright red flowers and compartments signal a shift away from the cooler palette of Herat. In addition, the ubiquitous split-palmette here forms a lively scroll on the black ground of the band surrounding the text and headings. At Tabriz illuminators favoured squared edges and straight lines around their illuminations, while at sixteenth-century Shiraz illuminators preferred illuminations that extended into the margins in a series of gold and blue-lobed triangular projections.

In addition to the various forms of illumination that set off headings and text passages, the borders of many fine Safavid manuscripts were decorated with gold sprinkling, floral or geometric

42 (left) Page from the *Gulistan* of Sa'di with decorative border attributable to Sultan Muhammad, Tabriz, 1525–30, gold and ink on paper, 29 × 19 cm, Keir Collection. The borders to this dispersed manuscript consist of coloured paper with animals of the types mentioned by Sadiqi Beg which are highly animated and expressive.

43 (right) Front cover of a *Divan* of Mir 'Ali Shir Nava'i, signed by Mir Sayyid 'Ali, Tabriz, 1535–40, lacquer on pasteboard, 24.1 × 15.2 cm, British Library, Or. 1374. By outlining the trees, birds and clouds in gold against a black sky, Mir Sayyid 'Ali has produced a glittering effect in a composition that otherwise follows the canons of manuscript illustration.

patterns, or scenes of fantastic and wild animals in landscape [fig. 42]. These real and imaginary animals belonged to an accepted repertoire which the late sixteenth-century artist Sadiqi Beg described in his *Canons of Painting*. He differentiated between 'decoral art' (*naqqashi*), figural painting (*suratgari*) and animal design (*janvar-sazi*). Decoral art consisted of seven basic patterns: *islimi* (ivy and spiral pattern), *khata'i* (Chinese floral pattern), *abr* (cloud-like foliage), *vaq* (human-headed scroll), *nilufar* (lotus), *farangi* (Frankish pattern) and *band-i rumi* (Anatolian knot pattern). While cautioning artists to avoid parodying the works of past masters when portraying humans and animals, Sadiqi Beg noted that the aim of animal design was 'artful imitation'. He defined the types of forms in this genre as follows: 'the *simurgh*-bird, the *azhdar*-dragon, the *hizabr*-lion, and the *gav-i ganj* or "guardian bovine"'. He then described 'the motif called *girift-o gir*, which is to say, the "give and take" of animals locked in battle'. He advised the artists to avoid slackness in drawing the animals, to show them entirely engaged in combat with one another, and not to repeat identical patterns in order to avoid monotony.[37] The use of these animal forms in manuscripts was an important innovation in the early Safavid period and may have led to the incorporation of these motifs in other media. In some instances artists relied on stencils to reproduce the border designs from one page to another. However, even repeating floral borders were more often painted freehand. The most spectacular examples were the work of the leading court painters such as Sultan Muhammad, whose combating animals are as full of life as any in his manuscript illustrations.

The first half of the sixteenth century was a time of innovation in another art of the book, that of bookbinding. By the end of the fifteenth century book covers fell into several categories: leather covers with stamped and tooled decoration on the exterior but no added colour; stamped and tooled leather covers with gilding; and

44 Pair of book covers and flap, Shiraz?, c. 1505–10, tooled, stamped, gilded and painted leather, each cover 24.3 × 13.8 cm, Keir Collection. The front cover consists of an enthroned prince with servants, a musician, and angels above; animals in landscape are found on the back cover and flap.

the rare lacquered example, painted in polychrome on leather and covered with a transparent shellac (*raugan*). The inside surfaces of the covers often have filigreed areas under which coloured paper has been laid. These techniques were continued into the Safavid period, but lacquer covers became increasingly popular. Not only was Muzaffar 'Ali mentioned as an excellent lacquer-worker, but also Mir Sayyid 'Ali tried his hand at painting lacquer book covers [fig. 43], treating the book cover as if it were a manuscript illustration of a courtly picnic. Tooled and stamped leather bindings with gilding were also produced with figures and animals in landscapes as if they were the frontispieces of illustrated manuscripts [fig. 44].

The more typical composition of early Safavid book covers consisted of a tooled and stamped central medallion, usually ogival but sometimes round, on a plain ground with tooled and stamped corner pieces. Even when the ground was also decorated, the medallion and corner pieces were usually retained as a design element. The decorative vocabulary of this type of bookbinding ranges from cloud scrolls and split-palmette leaf arabesques to mythical beasts and actual wild animals and birds and angels. Non-figurative motifs were favoured for religious books such as the Qur'an. In the use of the central medallion and corner pieces as well as the choice of decorative elements, this group of bookbindings relates closely to Safavid carpet design and suggests that members of the ateliers that produced books may have provided designs for the carpet makers.

Although the illustrated manuscripts and albums commissioned by Shah Tahmasp and his brothers were essentially private works that would not have been viewed outside court circles, some compositions were copied or traced and adaptations of them have come down to us. The original paintings provide a more or less accurate record of the style of buildings, objects and fashions that was prevalent in Tahmasp's reign. Paintings such as 'Khusrau Listening to Barbad Playing the Lute' [see fig. 36] or 'Sarkhan Beg the Table-steward' [see fig. 37] provide information about metalwork, ceramics, textiles and carpets that is not readily available through extant objects. Thus the gold dishes and wine cups in figure 36 are mentioned in texts but have not survived, whereas partial and complete pencases and inkwells are known from this period or

45 (left) Bowl, dated Rajab 945/Nov.–Dec. 1538, cast and turned brass, engraved decoration, h. 14.5 cm, diam. 38.5 cm, Victoria and Albert Museum.

46 (opposite, top left) Blue and white stonepaste bowl, north-west Iran, first half of the 16th century, diam. 35.4 cm, British Museum, OA 1964.10-13.1. Although the vine scroll in the cavetto and centre is derived from Chinese blue and white, the painterly treatment of the flying duck is typical of Persian 16th-century blue and white wares.

47 (opposite, top right) Polychrome stonepaste bowl, north-west Iran, mid-16th century, blue, turquoise, purple and ochre under a transparent colourless glaze, diam. 31.7 cm, Victoria and Albert Museum.

slightly earlier [see fig. 25]. The type of metal bowls that remain from this period are made of cast brass and have either slightly bulbous or straight sides and a narrow everted rim [fig. 45]. Scenes from the 946–9/1539–43 *Khamseh* that portray tradesmen and other non-royal figures include bowls of this type and suggest, not surprisingly, that the hierarchy of metals from base to precious was paralleled by their use by the different levels of Safavid society. The decoration of this group of brass bowls consists of inscription bands on the exterior beneath the rim and above bands or pendants of arabesque ornament. In some cases the name of the owner is incorporated in the inscription and often verses of poetry will refer to the use of the bowl, for example, 'May every fruit that is sweet in heaven's orchard/Be the fruits in thy bowl at thy gathering.'[38]

Dated candlesticks are almost entirely absent from the corpus of metalwork of the first half of the sixteenth century. In the illustrations of Shah Tahmasp's *Shahnameh* and *Khamseh* the standard type of candlestick, called a *sham'dan*, has a wide truncated conical base and cylindrical shaft, either plain or punctuated by knobs and a cylindrical socket to hold the candle. With stylistic variations this shape of candlestick had been used in Iran and the Arab world at least since the thirteenth century. Why no examples can be assigned to the first half of the sixteenth century is unclear unless

scholars have dated candlesticks to the fifteenth century that belong in the sixteenth century. Their ubiquity both in court paintings of Tabriz and in commercial illustrations from Shiraz has been ascribed to artistic anachronism, or may suggest long-term usage of traditional candlesticks; this is an area ripe for further research. By 946/1539 a new type of pillar candlestick, the *mash'al*, had begun to be produced. A very tall example in the Astan-e Quds Museum in Mashhad bears the date 1 Jumada II 946/14 October 1539 and signature of 'Master Da'ud, the founder. Made in Lahore' as well as that of the designer Iskandar ibn Shukrullah.[39] Despite its Indian provenance the decoration of lobed ovals containing arabesques and horizontal bands of arabesque is purely Persian, and it must have been made expressly to be donated to the shrine of Imam Riza at Mashhad.[40] In the second half of the sixteenth century this type of candlestick superseded the *sham'dan*.

Chinese blue and white porcelains were used at the Safavid court, just as they were under Shah Isma'il, while Persian stonepaste and earthenware ceramics were produced for more general use. Until more petrographic studies are completed, the only way to establish a ceramic chronology from the mid-1520s to the mid-1550s is to chart the stylistic development of the numerous blue and white wares and less common black and green wares, black and

turquoise wares and polychrome wares.

Although ceramic production continued at Nishapur in the second quarter of the sixteenth century, it also prospered at Tabriz, where it is assumed the so-called Kubachi wares were made. Dishes decorated in underglaze blue and black include those that combine geometric and vegetal designs. Bands of hexagons enclosing one or more dots remained popular, as did the stylized wave and crest motif on the border [fig. 48]. Some dishes feature central motifs, such as the duck and vine scroll with blossoms, which rely more closely on Chinese prototypes, but the rim design connects them to other wares from sixteenth-century Tabriz [fig. 46]. Few sixteenth-century pots with human or animal decoration derive from the vocabulary of Safavid art. However, one mid-sixteenth-century polychrome bowl contains a figure of a kneeling man with a Safavid turban playing a rubab while a woman dances and plays her castanets [fig. 47]. The use of blue, turquoise, purple and ochre underglaze anticipates the far more numerous polychrome vessels and tiles of the Kubachi type from the seventeenth century, but the band of hexagons in the cavetto relates to the blue and white bowl also made in Tabriz [see fig. 48]. While such a piece is clearly influenced by miniature painting, the actual drawing must have been the work of the potter. Unlike Turkish ceramics of the same period, Persian wares rarely give the impression of slow and careful painting. Rather, the pigments appear to have been quickly applied, as if the potters were either concerned only with approximating certain designs or in a hurry to mass-produce their wares.

As with certain groups of metalwork, the existing evidence for early Safavid textiles does not match those depicted in manuscript illustrations and single-page paintings. 'Sarkhan Beg the Table-steward' [see fig. 37] wears a long blue short-sleeved robe over a long-sleeved green shirt. The robe has a repeating pattern of gold roundels which one might assume are a brocaded pattern on a silk ground. Such textiles, as well as those with all-over arabesque designs on a black ground, plain cloth with gold cloud collars and less frequent decoration of birds or animals in gold on a plain

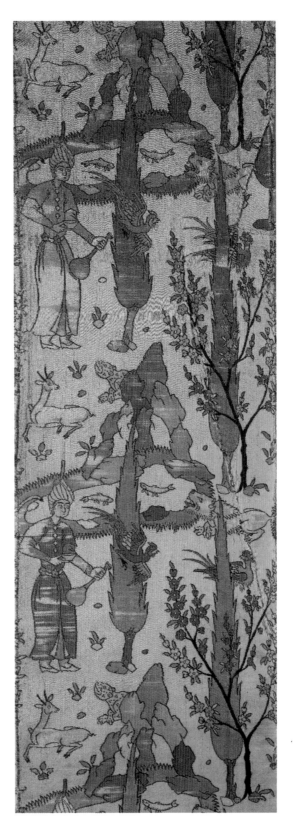

49 (above) Textile fragment with animal combats, early 16th century, silk lampas, 73.6 × 48.1 cm, Textile Museum, Washington, DC, 3.184, acquired by George Hewitt Myers in 1952. The remarkable sophistication of this and many Safavid textiles is evident in the details of colour variation such as the pink bellies of the wild asses and in the use of a range of repeating motifs.

50 (right) Cupbearer in landscape, 16th century, silk lampas textile fragment, 117.4 × 34 cm, Textile Museum, Washington, DC, 3.306, acquired by George Hewitt Myers in 1931. The elegant cupbearer and tall cypresses coupled with flowering trees suggest the romantic themes found in Persian love poetry.

51 (above) Velvet fragment with scene of dragon-slayer, 16th century, silk, cut, voided velvet with metal threads, 74 × 54 cm, Keir Collection. This and other lobed ogival fragments of this textile are said to have come from a Turkish tent once in the possession of the Sanguszko family of Poland, acquired in 1683 after the Ottoman siege of Vienna.

52 (right) Velvet with metal threads, 16th century, 241 × 205 cm, Keir Collection. Angels, pheasants and cloud scrolls are ubiquitous on luxury carpets and textiles of the 16th century.

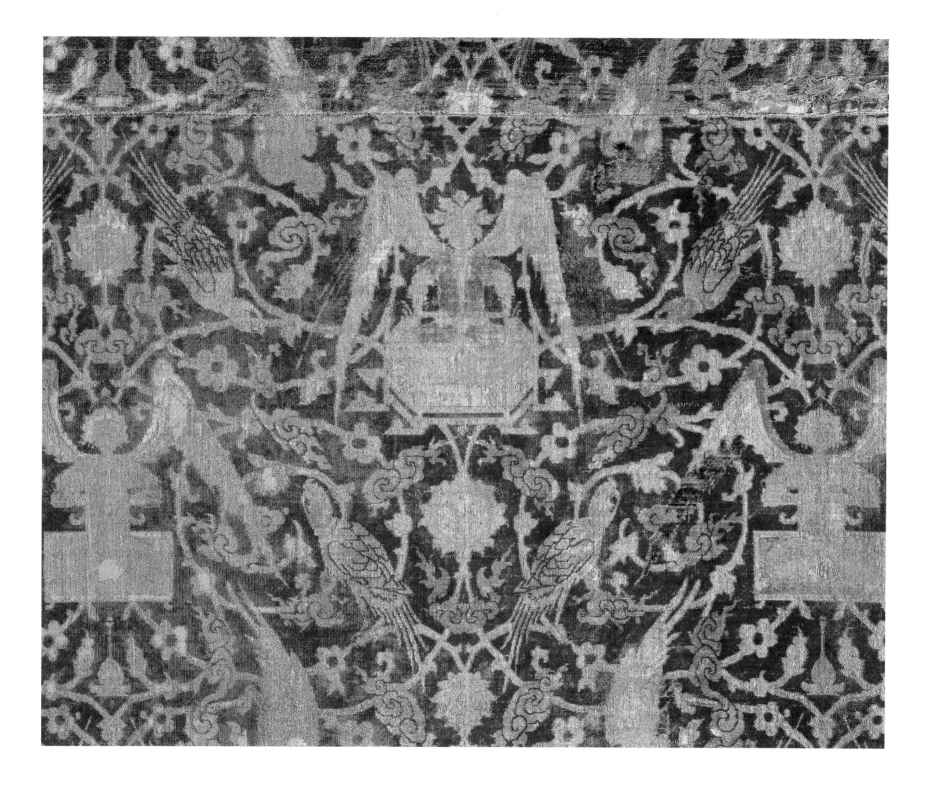

53 (left) Qur'an
stand, dated
95[..]/1543–52,
carved walnut,
h. 64 cm, w. 21.5 cm,
David Collection,
Copenhagen, 34/1976.
Despite the rarity of
published wooden
objects of the Safavid
period, certain
traditional items such
as bookstands were
produced for private
and institutional use.

ground, are those that appear in manuscript illustrations of the 1530s. However, the textile fragments themselves that are extant from the sixteenth century are almost exclusively decorated with human and animal figures. Possibly this accident of survival is the result of the fragility of fabrics used for clothing as compared to those used for furnishings. In some instances the decorative motifs, such as animal combats [fig. 49], are the same as those found on carpets, bookbindings and manuscript borders, which may suggest that they were produced for domestic use, not for apparel. Other silk textiles more closely resemble the paintings themselves than the textiles in the paintings. Painters supplied the designs for the lampas-weave silks of a cupbearer in landscape and a soldier leading a prisoner, and in one painting of c. 947/1540 a figure is depicted wearing a coat made of this type of figured fabric [fig. 50].

From paintings and extant examples we can deduce that velvet textiles were used extensively in tents, for cushion covers and for clothing. Ogival, lobed fragments with patterns of dragon-slayers in landscape [fig. 51], hunting scenes or Khusrau spying Shirin bathing have been cut down from lengths of velvet containing complex repeating scenes. Ogival sections appear on tent panels in paintings and the extant examples may have originally been intended for the walls of tents, although the painted versions usually are non-figurative. Like the lampas weaves, Safavid velvets are structurally highly complex [fig. 52], which shows that their production 'was extremely labor-intensive and required great skill. This is best demonstrated in the quality of color, the high number of colors incorporated in one shed of the supplementary weave of a lampas, the substitution of pile warps in velvet, and the length of some of the repeats.'[41] The degree of specialization required for these textiles resulted in unabashedly luxurious fabrics. They were not only used at court and by those who could afford them, but also may have been the textiles given as robes of honour by the shah to loyal servants of the crown.

As in the period of Shah Isma'il, works in certain media such as wood are rare and underpublished. 'Khusrau Listening to Barbad Playing the Lute' and other paintings of musicians depict beautifully inlaid wooden instruments, but the instruments themselves have not survived. Fortunately, the sumptuous inlaid cenotaph of Shah Isma'il I is extant at the Ardabil shrine and testifies to the

continuing expertise of craftsmen in northern Iran during the reign of Shah Tahmasp.[42] Simpler wooden objects such as the inscribed Qur'an stand of 95[..]/1543–52 [fig. 53] not only demonstrate the continuing use of a traditional form associated with the holy book but also show that *thuluth* script was deemed fitting for such an item, rather than *nasta'liq*.

Despite the political turbulence of his years ruling from Tabriz, Shah Tahmasp was a committed and enlightened patron of the arts. As a near prisoner of his Qizilbash guardians in the first decade of his reign, he must have found refuge in his artists' workshop. At least two of his court artists, Aqa Mirak and Muzaffar 'Ali, were his close companions, and Sultan Muhammad had been his teacher. Furthermore, his artists travelled with him on encampments and, one imagines, some military campaigns, a factor that must have contributed both to his commissioning of exceptional illustrated and illuminated manuscripts and to the diffusion of artistic ideas to artisans of other media.[43] Thus strong correspondences exist between the formats of bookbindings and those of carpets. Likewise, the animal combats, dragons, *simurgh*s and *chi'lin*s of decorative borders in manuscripts reappear in the elegant silk hunting carpets of this period. Stylish young men in Safavid turbans serving wine from long-necked bottles appear in both paintings and silk textiles, while the same taste for spiky split-leaf arabesque found on buildings informs the metalwork of the period. The same scribes who copied manuscripts for Shah Tahmasp are known to have provided inscriptions for buildings, and most likely illuminators at the royal atelier produced designs for both tile makers and metalworkers.

Although the evidence is circumstantial, it points to the *kitabkhaneh* of Shah Tahmasp in the first thirty years of his reign as the source of decorative ideas for carpets, textiles, architectural ornament, metalwork and probably inlaid woodwork made for the shah and his family. Only blue and white ceramics owe little to this artistic vocabulary, either because they were not made for the court or because Chinese blue and white porcelains, their source of inspiration, were deemed superior in design to native Persian wares. Rather than decry the paucity of monuments commissioned by Tahmasp, we should perhaps marvel at his ability, while fighting wars and insurrections, to patronize the artists in his retinue so intelligently that they not only produced illustrated manuscripts of surpassing beauty but also disseminated their ideas to artists in other media. That these ideas were then adopted by artisans who made carpets, textiles, manuscripts and metalwork for non-royal patrons or commercial purposes is not surprising. Unlike luxury manuscripts, carpets and textiles would not have been made within the court where those working on non-royal products could not see them. Similarly, the compositions of famous artists were copied and made available to the artists of Shiraz and other centres. Thus the dominant artistic style formulated in Shah Tahmasp's *kitabkhaneh* spread not only to artisans servicing the court but also to provincial centres where craftsmen worked commercially and for non-royal clients. However, without Tahmasp's superb taste and vision of how things should look, his artists would never have achieved what is now viewed as one of the defining moments in the history of Persian art.

4

A New Capital and New Patrons

Shah Tahmasp at Qazvin

1555–1576

... he is more of a melancholy disposition than anything else, which is known by many signs, but principally by his not having come out of his palace for the space of eleven years, nor having gone once to the chase nor any other kind of amusement ...' [1]

In 962–3/1555 three significant events occurred which had a direct impact on life at every level in Safavid Iran. First, the Safavids and the Ottomans signed the Treaty of Amasya, ending forty years of hostilities and alleviating the threat to Iran's western border. Second, the great amirs and court attendants publicly forswore acts forbidden in Islam in a Decree of Sincere Repentance.[2] Third, Shah Tahmasp moved the capital from Tabriz to Qazvin, which was well east of the Safavid–Ottoman border and thus safer from foreign occupation. Although the timing of the move might seem odd in light of the Treaty of Amasya, Tahmasp had set the plan in motion as early as 951/1544–5 between two wars with the Ottomans, when he bought the land on which his palace and the government buildings would be built. In different ways these events set the tone for most of the remaining years of Shah Tahmasp's reign.

With the move to Qazvin the tempo of Shah Tahmasp's life slowed perceptibly. When a Turkman chief rebelled in Astarabad in 962/1554–5 and 965/1557–8, the shah dispatched armies to deal with the problem but did not lead them himself. Likewise, in response to fighting between the amirs of eastern and western Gilan and the assassination of the shah's emissary, Tahmasp sent a military force to Gilan in 975/1567–8. Although the Safavids were successful in the short run, the shah was once again compelled to order a company of *qurchi*s, the royal bodyguard, to put down a rebellion in Gilan in 979/1571–2. Despite being vastly outnumbered, the *qurchi*s routed the Gilani army and shot and killed their leader, thus restoring order to the province. Similarly, in 967/1559–60 the Uzbeks raided the region of Jam on the eastern fringes of Safavid Iran, but as so often in the past they were more interested in booty than occupying territory. At Qandahar Shah Tahmasp's army had more success; they besieged the city in 965/1557–8 and after six months won it back from the Mughals. Shah Tahmasp may have lost his taste for battle, but he also could differentiate between

54 Detail of fig. 62.

rebellions and raids, on the one hand, and serious threats to the territorial integrity of his empire on the other. Even when his armies were not successful, Tahmasp's patience usually paid off and he regained control of the areas in question.

Of greater consequence for the Safavids than these military skirmishes were Shah Tahmasp's relationships with his brothers and children. By the time the Safavid capital moved to Qazvin, his half-brother Alqas Mirza had rebelled, been imprisoned and died. His other half-brother, Sam Mirza, had been forgiven once for insubordination and spent the 1540s and 1550s compiling a literary history, the *Tuhfa-yi Sami*. In 969/1561–2, however, Sam Mirza was again suspected of political intrigues, and this time Shah Tahmasp sent him to Qahqaha prison in Qarabagh, where he remained until his death in 974/1566–7. Only Tahmasp's full brother, Bahram Mirza, enjoyed his constant trust and affection. An inspired patron of calligraphy, painting, literature and music, Bahram Mirza indulged excessively in alcohol and opium and died of fever in 956/1549 at the age of thirty-two.[3] Not only had Shah Tahmasp appointed him to the governorships of Khurasan, Lahijan and Hamadan, and to significant military commands, but the two brothers also employed some of the same artists and calligraphers and clearly shared similar passions for the arts. One can only speculate on the impact that Bahram Mirza's death had on Tahmasp, but the shah did favour this brother's sons with governorships and gave one of his own daughters in marriage to the middle son, Ibrahim Mirza.

As for Shah Tahmasp's own sons, Muhammad Khudabandeh, the eldest, born in 938/1531–2, served as governor of Khurasan for most of the years between 943/1536–7 and 974/1566. When his eyesight deteriorated to near-blindness, he was transferred to the governorship of Shiraz. Although Shah Tahmasp kept one of Muhammad's sons at Qazvin as a hostage, Muhammad Khudabandeh avoided provoking his father's wrath and thus stayed out of prison. His brother Isma'il was not so fortunate. Born in 940/1533–4, Isma'il succeeded his uncle Alqas as governor of Shirvan in 954/1547–8. Despite leading the Safavid army to several important victories, Isma'il displeased Shah Tahmasp, who sent him to Herat to be governor of Khurasan. He served only six months in this post before being removed to Qahqaha prison. This

incarceration, which lasted for nearly twenty years, was apparently caused by Tahmasp's suspicion that his son wished to overthrow him, 'a fear which was assiduously played upon by the powerful *wakil* Ma'sum Beg Safawi'.[4] Even before his imprisonment Isma'il had exhibited an impetuousness both in battle and at play which contrasted markedly with his father's more phlegmatic character. Although his imprisonment did Isma'il no good at all, the fact that Tahmasp did not have him killed preserved the possibility of his accession to the throne, a concept not lost on his Qizilbash supporters at the time of Tahmasp's death.

From 962/1554–5 until 971/1563–4 Shah Tahmasp fathered seven sons by six different women, and possibly also some daughters whose dates of birth are not known. It would seem that the shah's more sedentary existence at Qazvin was conducive to family life, though several of these younger sons were sent away at a young age as governors to the provinces. Vincentio D'Alessandri, writing in 1575, noted a younger son 'of five years, who is with his father, as at that age he is very cheerful and pleasing'.[5] In any event, none of these sons fell foul of his father, and the daughters either married cousins or other grandees or, in the case of Pari Khan Khanum, remained single and in attendance on the shah.

Although some significant tombs were constructed between 962/1555 and 984/1576, the major architectural achievement of this period must have been Shah Tahmasp's buildings at the new capital, Qazvin, many of which have not survived the earthquakes of the past four and a half centuries. While Tahmasp's decision to move the capital to Qazvin is usually attributed to his desire to house the government and court in a safe location further from the Ottoman border than Tabriz, he may have tired of living in an inherited palace and wished to construct a complex of buildings entirely to his own taste. In addition to the palace buildings he commissioned 'the whole complex known as the Sa'adatabad Garden, comprising numerous bathhouses, four markets, and the Eram Gardens'.[6] Tahmasp's three palaces – the Chihil Sutun, the Gunbad-i Munabbat-kari and the Ivan-i Bagh – and their gardens were commemorated in a collection of five poems composed at Tahmasp's request by 'Abdi Beg-i Shirazi and entitled *Jannat al-'Adan*. Although most of Tahmasp's construction is no longer extant, 'Abdi Beg-i Shirazi provides a vivid description of the complex.

The work began with the mapping out of a vast park, called Sa'adatabad, at one end of which was constructed the Daulat-khaneh or Government Palace. From 951/1544–5 to 963/1556 Shah Tahmasp stayed in this building when he was in Qazvin. Meanwhile the park was divided by two avenues, one running north–south, the other east–west, and both bordered by water channels and gardens. The Royal Ivan or Chihil Sutun was placed at the intersection of the two roads; before it stood a pool with a pavilion on columns, much like that at Tabriz. Also as at Tabriz, princes, grandees and courtesans built their dwellings and gardens in the vicinity of the Chihil Sutun. Although it is much restored and additions have been made to it, the Chihil Sutun is still standing today [fig. 55]. It consists of two storeys, the lower built of stone to dado level and the rest of brick. The blind arches were originally decorated with tiles. Inside the building the ground floor consists of a large central chamber with smaller rooms on its periphery, while the upper storey comprises a large room with a wide arched window in the centre of each wall and blind niches painted with various scenes to either side. Seventeenth-century European travellers to Qazvin described this palace as small and imagined that it served only as a place for conversation. The organization of the rooms and the choice of subjects for the wall paintings suggest that it incorporated both private and public spaces used for entertainment. Whereas the wall paintings of the Chihil Sutun derive from literature and the courtly repertoire of hunts and picnics, the Palace of Government, according to 'Abdi Beg-i Shirazi, had doors and walls decorated with the vocabulary of illuminated borders of manuscripts – foliage, flowers, birds, magical beasts and humans in non-narrative settings.[7]

The subjects of the seven wall paintings, as outlined by 'Abdi Beg-i Shirazi, include Shirin and Farhad at Mount Bisutun; Khusrau spying Shirin bathing; the Egyptian women cutting their fingers at the sight of Yusuf; a feast; a hunt; a game of polo; and a young woman promenading with friends in a garden.[8] Although the painted niches are bordered by a band containing a floral scroll, it is possible that the walls were also adorned with inscriptions which referred to the paintings and gave the feast, the hunt, the game of polo and the garden scene a literary context. One would expect Shah Tahmasp to have commissioned his court artists to

55 Chihil Sutun, Qazvin, c. 963/1556. This royal pavilion formed part of Shah Tahmasp's palace complex, which was mostly constructed over the period when he moved the Safavid capital from Tabriz to Qazvin.

plan and execute these wall paintings, but remarkably at least one, if not two, of the scenes were designed by Tahmasp himself. In particular, the composition of Yusuf and the Egyptian ladies is mentioned by Qazi Ahmad as having been 'pasted on the lower part of the western pavilion with an appropriate verse'.[9] In addition, Muzaffar 'Ali, a contributor to Shah Tahmasp's *Shahnameh* and *Khamseh* and a companion of the shah, was responsible for the 'paintings of the royal palace, and of a royal assembly in the Cehel Sotun hall'.[10] Muzaffar 'Ali not only drew the compositions, but 'most of the painting was also his work'.[11] Aqa Mirak, also a close friend of Tahmasp, is not mentioned as having worked on the Qazvin palaces, perhaps because he was occupied with the *Falnameh* illustrations in this period.

Either the poem of 'Abdi Beg-i Shirazi, completed in 967/1560, or the Chihil Sutun paintings themselves must have exerted a strong influence on domestic architecture in Iran in the third quarter of the sixteenth century, as the decorated walls of a palace in Na'in demonstrate [fig. 56]. Although the date and original owner

56 View of *ivan*, palace, Naʿin, 972–83/1565–75. The painted rooms of this palace occur on one long side of a sunken courtyard. The rooms opposite them have been turned into a museum and it is not certain whether they, too, were originally decorated.

of the house are not known, the style of the wall decoration points to 972–83/1565–75 as the most likely period of decoration and perhaps construction. The reception area of the house centres on a sunken, rectangular courtyard surrounded by rooms on two levels. While the upper rooms on one side of the courtyard have been made into a museum, the two rooms opposite them consist of an open *ivan* and a room of the same shape next to it with a wall pierced by three doors on the courtyard side. Above the doors are three windows with pointed arches. The two outer windows are filled with lattice work and the centre one is a blind arch. The walls are whitewashed from the floor to a height of approximately 2.7 metres and have square recessed panels in which objects can be placed.[12]

The noteworthy feature of this palace is the decoration of the upper walls and vaults of the *ivan* and the neighbouring room. Above a band of poetry containing verses by Hafiz in cartouches, each side of the *ivan* contains three or four large niches with pointed arches of which the centre one is a window. These alternate with narrow niches; between both types of niches painted ribs rise to form the ribs of the net vault. The niches and vault are covered with decoration which appears to be painted in white on beige ground but is in fact the result of carving away from a white stucco surface to leave the design elements in white and the background in unpainted plaster.[13] On some of the large compositions details have been painted in green or red, which gives a similar effect to certain textiles produced in the second half of the sixteenth century.[14]

While the small niches are all adorned with a bear throwing a boulder down at other animals [fig. 57], each of the large wall niches in the open *ivan* contains scenes that either illustrate a narrative or derive from the decorative repertoire of manuscript borders and bookbindings. From right to left the eight scenes are: (1) a large tree with bears, monkey and birds in it, and lions in combat and at play on the ground below; (2) a very damaged picture of a prince enthroned in a garden with his ladies entertaining him; (3) angels in a tree; (4) Farhad and Shirin at Mount Bisutun; (5) a hunt, perhaps depicting Khusrau and Shirin [fig. 58]; (6) Yusuf appearing before Zulaykha and the Egyptian women; (7)

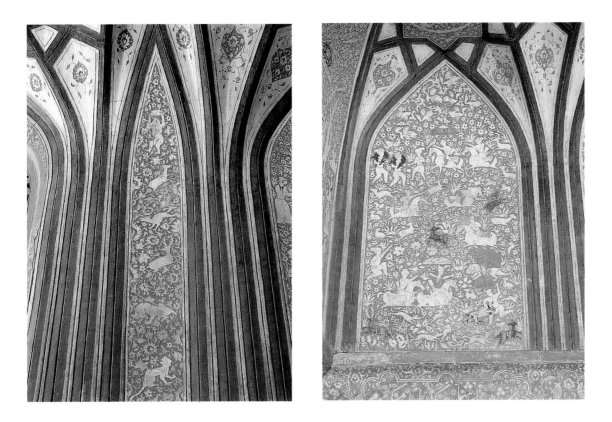

Khusrau and Shirin or another royal couple enthroned and being entertained, perhaps at their wedding feast; and (8) a polo match and lovers in a garden. That six of the eight subjects (numbers 2, 4, 5, 6, 7 and 8) are the same as those chosen for Shah Tahmasp's Chihil Sutun palace in Qazvin strongly suggests that the provincial grandee who commissioned this decorative scheme sought self-aggrandizement by emulating the royal palace.

In the enclosed vaulted room the niches with figural scenes are more formalistically composed. Each consists of a pair of drinkers, angels or lovers placed between the trunks of two entwined trees at the lower left and right. Between them a vase with bulbous shoulders rests on a stylized two-headed dragon platter. Out of the vase spring two branches in the shape of an ogive which enclose scenes of Layla and the dying Majnun, angels and a young man drinking, and a large eagle. Other niches are filled with floral ornament. Stylistically, the paintings in the Na'in palace conform to those assigned to Qazvin in the third quarter of the sixteenth century. The silhouette of the figures has become more elongated than those of the 1540s. The figures' necks are long and graceful and their

heads are smaller in proportion to their bodies. The ladies' headdresses now consist of a kerchief that comes to a point at the back of the head. More significantly, the men's turbans have ceased to be wrapped around the Safavid *taj*. Presumably this reflects a change in fashion as well as a political shift forced by Shah Tahmasp away from Qizilbash domination and thus a rejection of Qizilbash symbols.

Unlike the choice of subjects at the Na'in palace, which could have been made on the basis of familiarity with Shah Tahmasp's Chihil Sutun or 'Abdi Beg-i Shirazi's poem, the style and composition of the wall decoration would most likely have derived from book illustrations and illumination or drawings based on such sources. Before 962/1555 the ultimate source of the designs could have been the royal *kitabkhaneh*, but later the chain of influence cannot be traced directly back to the shah's artists, since he disbanded their atelier at that time or shortly afterwards. As discussed, several of the most promising young artists at the court – Mir Sayyid 'Ali, 'Abd al-Samad and Dust Muhammad – and at least one older painter – Mir Musavvir – had left Iran for India before the capital moved to Qazvin. Others, such as Bihzad and

Sultan Muhammad, had died before 962/1555. Muzaffar 'Ali, Aqa Mirak, Qadimi and possibly Mir Zayn al'Abidin all remained at court, but other court artists such as Mirza 'Ali, 'Ali Asghar and Shaykh Muhammad left the service of Shah Tahmasp to work for his nephew, Sultan Ibrahim Mirza, the son of Bahram Mirza. Calligraphers did likewise or moved to the shrine cities of Mashhad and Qum, where they supplied inscriptions for religious buildings or worked for Sultan Ibrahim Mirza.

Poets fared no better at Shah Tahmasp's Qazvin court. As Iskandar Beg Munshi explained:

The number of poets who flourished at that time, either at court or in the provinces, was legion. Early in his reign, Shah Tahmasp gave special consideration to the class of poets ... During the latter part of his life, however, when the Shah took more seriously the Koranic prescription to 'do what is right and eschew evil,' he no longer counted poets pious and upright men because of the known addiction of many of them to the bottle. He ceased to regard them with favor, and refused to allow them to present him with occasional pieces and eulogistic odes.[15]

Instead, when the shah rejected panegyrics in praise of himself, he suggested that poets should write 'eulogies of 'Ali and the other infallible imams ... At once all the poets at court set to work madly writing *haft-bands*; fifty or sixty such poems rained down on the Shah, and their authors were all rewarded.'[16] Like the artists, only a few musicians were retained, and eventually all but the military band were disallowed at court.

The diaspora of so many artists, calligraphers, poets and musicians may have benefited provincial centres, such as Gilan, Shiraz, Mashhad and Qum, but ultimately it weakened the system that had unified the arts between 930/1524 and 963/1555. Fortunately, during the decade after the move to Qazvin, Shah Tahmasp's nephew, Sultan Ibrahim Mirza, adopted the mantle of the royal patron and commissioned an exceptional illustrated copy of the *Haft Aurang* (Seven Thrones) of Jami. Having been appointed governor of Mashhad in 962/1554–5 at the age of sixteen, Sultan Ibrahim arrived in the city the following year when it seems work on the manuscript began. Simpson's admirable newly published study of the *Haft Aurang* charts the production of the manuscript

and reveals many points of practice that may have been at variance with those of the manuscripts made for Shah Tahmasp.[17] First, under the directorship of the calligrapher, Muhibb 'Ali, head of Sultan Ibrahim's *kitabkhaneh*, five leading Safavid scribes copied the seven *masnavi* poems of the manuscript. Working in three different cities — Mashhad, Qazvin and Herat — the scribes were supplied with individual text sheets on which they could write at their own pace. When a scribe completed transcribing one of the *masnavis*, he passed it on to the member of the library 'team' who placed the sheet in its borders. At this point the illuminators would decorate the text pages. Simpson believes that the painters would have received their folio-sized pages after the completion of the illumination. The pages were placed in order and sewn into quires once all the work was completed.[18]

Because of this system it was possible, when the final compilation of the book took place, for the *masnavis* to be bound in an order that did not reflect the chronology of the work on the manuscript. In other words, the three *daftars* or sections of the 'Chain of Gold', dated 963/1556, 964/1557 and 966/1559, precede 'Yusuf and Zulaykha', dated 964/1557. Possibly because the scribes were busy with other work in this period, the book took nine years to complete. In addition to the calligraphers — Shah Mahmud al-Nishapuri, Rustam 'Ali, Muhibb 'Ali, Malik al-Daylami, 'Ayshi ibn Ishrati and Sultan Muhammad Khandan — the illuminator 'Abdullah al-Shirazi signed one illuminated title page and the painter Shaykh Muhammad signed one painting. Stylistic evidence of 'Ali Asghar can be found in some illustrations from the manuscript which would corroborate his mention by Iskandar Beg Munshi as having worked in the prince's atelier.[19] S.C. Welch has attributed other paintings in the manuscript to Muzaffar 'Ali, Aqa Mirak, 'Abd al-Aziz, Qadimi and Mirza 'Ali.[20] If these artists contributed paintings to the manuscript, they may have followed the pattern of the calligraphers, working from Qazvin rather than relocating to Mashhad. The result is an opulent manuscript with paintings that range in style from the classical mode of the 946–9/1539–43 *Khamseh* of Nizami to a more mannered idiom in which pictorial and narrative ambiguity abound. Such paintings are full of jarring juxtapositions of pattern and colour, carpets with figural designs that appear as alive as the human and animal figures in the scene,

59 'The Discovery of a Dying Man', from a *Matlaʿ al-Anvar* of Amir Khusrau Dihlavi, Qazvin, c. 1560–70, opaque watercolour, gold and ink on paper, 22.6 × 16.1 cm, British Museum, OA 1937.7-10.0325, Gift of Charles Shannon, RA, from the Ricketts and Shannon Collection. The *Matlaʿ al-Anvar* of Amir Khusrau was written as part of his *Khamseh* at the turn of the 14th century and modelled on the *Makhzan al-Asrar*, or 'Treasury of Mysteries', the first book of Nizami's *Khamseh*.

and vertiginous compositions. While the style and decorative programme of the manuscript would have been tailored to Sultan Ibrahim Mirza's personal taste, they do not herald a shift in the vocabulary of ornament in other media, as Shah Tahmasp's manuscripts had done. Rather, the *Haft Aurang* established the younger artists who participated in the project, such as Shaykh Muhammad and 'Ali Asghar, and influenced others who were active in Qazvin, Shiraz and Khurasan.

One of the results of Shah Tahmasp's disbanding of his artists' atelier was the need for court artists to find alternative sources of employment. Thanks to Sultan Ibrahim Mirza and certain regional patrons, the court artists continued to be employed and commercially produced illustrated manuscripts still found a market. Book illustrations attributed to commercial artists working in Qazvin, such as 'The Discovery of a Dying Man' from a *Matla' al-Anvar* of Amir Khusrau Dihlavi [fig. 59], rely on pictorial devices found in

60 (far left) 'Picnic in the Mountains', school of Muhammadi, Khurasan, 1560s, opaque watercolour and ink on paper, 22.3 × 14.4 cm, British Museum, OA 1920.9-17.0302. As a notable with a moustache receives a cup of wine from a smiling boy, other youths play music, serve fruit, read poetry or catch the fruits that their friend in the palm tree has tossed in their direction.

61 (left) Double cloth, 16th century, silk, 30.5 × 15.6 cm, Textile Museum, Washington, DC, 3.280, acquired by George Hewitt Myers in 1947. The poetic verses placed in vertical and horizontal cartouches praise the beauty of the cloth and compare it to Shirin, the Armenian princess in Nizami's story of *Khusrau and Shirin.*

62 (right) Silk carpet, Kashan?, second half of the 16th century, 2.30 × 1.80 m, Fundação Calouste Gulbenkian, Lisbon, T. 100. The relatively small size of the silk carpets thought to have been made in Kashan in the 16th century suggests that they were laid on top of other larger carpets and used for sitting.

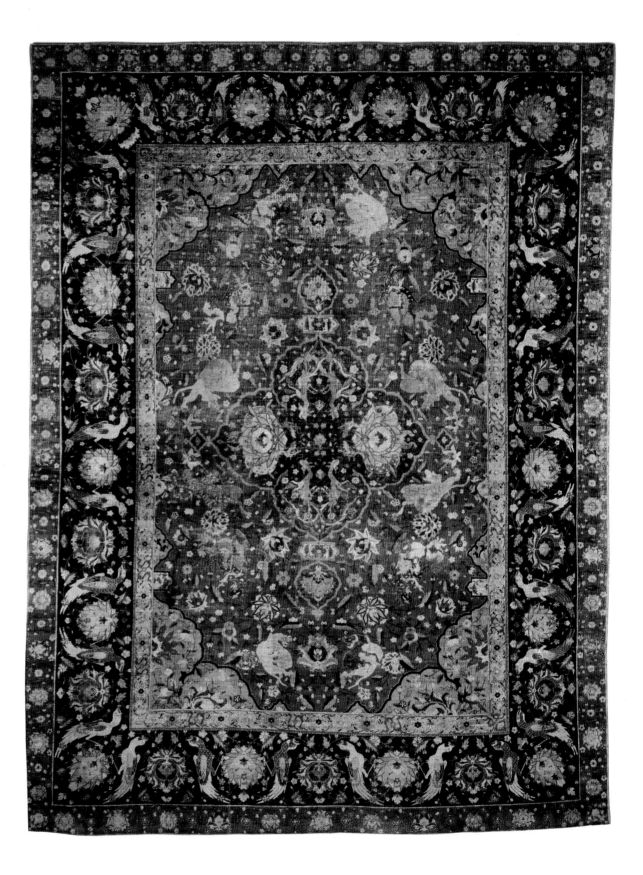

63 Inside upper cover, lacquer bookbinding, 16th century, lacquer on paper pasteboard, 30.4 × 18.5 cm, Victoria and Albert Museum, 353-1885. Lacquer bookbindings originated at Timurid Herat in the late 15th century and grew in popularity in the 16th and 17th centuries.

the work of the *Haft Aurang* artists, such as the flattened profile of the figure in a striped shirt, borrowed from 'Ali Asghar, the long necks and pouchy cheeks of the youths, and the almond-shaped eyes with corneas formed by a vertical line, similar to those of some figures by Shaykh Muhammad. Yet the sketchy treatment of rocks, trees and clouds, the smaller size of the book, and the thinness of paint indicate that the manuscript containing this illustration did not meet the standards of the royal atelier, even though its artist relied on royal prototypes.

While Qazvin and Shiraz artists continued to produce illustrated manuscripts until the end of Shah Tahmasp's reign, a new type of single-page work was gaining currency in Khurasan. The leading exemplar of this form of painting was Muhammadi of Herat. By about 967/1560 he was producing very fine drawings of princely subjects, such as hunts and picnics, genre scenes including encampments and Sufis dancing, and portraits of youths, dervishes and girls. His drawings, executed in pen and ink on plain paper, often include details in polychrome. This technique was adopted by his followers working in the late sixteenth and early seventeenth century [fig. 60]. Equally influential were Muhammadi's portraits, both for their characteristic swaying pose, tipped-up feet and round smiling faces and for the simplicity of their setting.[21] Whereas Qazvin manuscript illustrations are characterized by large numbers of figures and a quantity of ornamental detail, the illustrated manuscripts produced in Khurasan during the last third of the sixteenth century contain few figures and blocks of contrasting colour arranged in almost abstract patterns. While the schools of Qazvin and Khurasan painting are related to one another, their differences are more a question of degree and emphasis than of ideology.

As in paintings of the first half of the century, the textiles found in works datable to 962–84/1555–76 are at variance with actual pieces thought to be of this period. In paintings of this period most robes either have repeating floral patterns in gold or are of solid-coloured cloth. Among the few textiles assigned to this period, a red and white silk double cloth derives its imagery from manuscript illustration [fig. 61]. Divided into a series of rectangles, the textile contains a vertical row of vignettes showing Shirin on her horse, a line of poetry, Farhad at Mount Bisutun, another line of poetry.[22] This row is divided from the next by a narrower band in which

64 Bowl, mid-16th century, cast and turned brass, tinned, with engraved decoration and black composition, h. 17.8 cm, diam. of body 32.6 cm, Victoria and Albert Museum, 535-1876. The inscriptions on this piece describe it as a food bowl; the cartouche that would have been inscribed with the owner's name has been left blank.

lobed cartouches containing a hemistich of poetry alternate with cartouches containing a spotted deer, both at right angles to wider bands. The other wide band contains a vignette of two young men flanking a cypress tree, a cartouche containing a pair of ducks, and a domed pavilion. Such pieces are sturdy and lightweight, more suitable for garments than furnishings. Yet their absence from manuscript illustrations and portraits emphasizes the uncertainty about their use. The technique and colour scheme, however, must have met with favour because they continued to be employed well into the seventeenth century, as later examples attest. Presumably this type of fabric was produced in one workshop which adhered to the weaving and compositional formula established in the third quarter of the sixteenth century while adapting the imagery to the style of the day.

Although the decorative arts lacked a central, guiding force in the period 962–84/1555–76, the strength of the system established in the first half of the century sustained a high level of quality in carpet and textile production. Carpets continued to be a staple of royal gift-giving. In 961/1552–3 Sultan Bayazid, the rebellious son of the Ottoman sultan Suleyman, came to the Safavid court and was given 'carpets from Kerman and Jowšaqan woven with gold thread, pieces of felt in various colours, precious stuffs from many regions'.[23] While connecting written reports with existing carpets is difficult, one can note the correlation between some carpet designs and bookbindings and manuscript illuminations. A silk carpet in Lisbon, one of a group thought to have been made in Kashan, consists of pairs of fabulous animals in combat on a red ground, a quatrefoil central medallion containing two pairs of *simurgh*s and two pairs of dragons, corner pieces with flowers and birds and a main border of S-shaped pheasants alternating with lotuses [fig. 62]. The pheasants and flowers also appear on the inside of a lacquer bookbinding in the field surrounding a central medallion with Majnun and the animals in the wilderness painted in gold on a black ground [fig. 63].[24] The combination of the pheasants, found on the Lisbon carpet, and Majnun in the wilderness, found in manuscripts and textiles, suggests that the arts of the book continued to be the source of decorative motifs for carpet and textile makers in the third quarter of the sixteenth century. Royal commissions of carpets would have continued for gifts both to individuals and to institutions, and to replace worn ones. In fact:

> it was the Shah's custom to present every royal baby with
> a carpet and all the trappings of a cradle. Shah Tahmasp
> sent for the infant 'Abbas [the future shah, born in
> 978/1571] the carpet which was spread beneath his own
> royal throne in the Chehel Sutun hall of the palace at
> Qazvin, together with all the necessary appurtenances for
> his cradle.[25]

Given the shah's reputation for miserliness in later life, this gift would have been an economical way to honour the newborn prince while allowing the shah to benefit from a new carpet.

The study of metalwork from the last two decades of Shah Tahmasp's reign is hampered by a dearth of dated pieces. Melikian-Chirvani has signalled a brass bowl with rounded sides, a low straight neck and slanting ring foot as a probable product of the mid-sixteenth century [fig. 64]. He cites this piece as the first appearance of overlapping compositions of large and small lobed ogives which become standard in Safavid metalwork. He also notes

65 Detail, 'Yusuf before Zulaykha and her Maidens', from a *Yusuf and Zulaykha* of Jami, third quarter of the 16th century, opaque watercolour, gold and ink on paper, 12 × 6.7 cm, British Museum, OA 1914.4-7.07. Ewers and basins of the type held by Yusuf were used for washing hands and perhaps fruit, not for drinking and eating.

ample in the Victoria and Albert Museum[28] is decorated with bands of interlaced vines alternating with undecorated ribs on its top and neck, and engraved roundels, cartouches and arches filled with flowers and vines adjacent to plain metal areas on its belly. Not only the shape but also the alternation of plain and decorated areas remained fashionable into the seventeenth century.

As with metalwork, the study of Persian ceramics from the third quarter of the sixteenth century must rely on a single dated piece, a fragmentary blue and white plate with the twelve signs of the zodiac in the cavetto, and in the centre of the base the signature of 'Abd al-Vahid in 971/1563–4, surrounded by an interlocking vine scroll [fig. 66]. Although the cloud scrolls found so often in early Safavid tiles, carpets and illuminations are still present here in some of the zodiacal roundels, the scales between the roundels may indicate an awareness of Iznik pottery of c. 957/1550 in which scales had begun to appear.[29] The strong central arabesque motif and its use in a roundel in the base of a plate is more closely connected to designs on metal objects[30] of the second half of the sixteenth century and perhaps by extension to illuminated *shamsa*s or sunburst decoration in manuscripts than to decoration on other ceramic objects. Also its stylistic distance from Chinese prototypes relates it to the figural group of so-called 'Kubachi' wares that are assumed to have been produced in Tabriz or another north-west Iranian centre. Even a group of blue and white bulbous jars ornamented with large flower blossoms, serrated leaves and broken stems which Arthur Lane dated to the third quarter of the sixteenth century owe more to the Safavid decorative vocabulary than to Chinese models.[31]

One group of ceramic tiles bears mention, namely a set of hexagonal tiles said to have come from the Safavid palace in Qazvin [fig. 67]. While their runny glazes and craquelure might suggest that they were not made for the royal establishment, the choice of angels, birds, animals and flowers as the individual motifs on each tile connect them with the types of 'filler' decoration found on carpets and even the wall paintings of Na'in. Moreover, the borders of each tile consist of scrolls incised through the glaze, in precisely the same technique as the black and turquoise North Persian wares of the late fifteenth century.[32] Like the roundels of the zodiac plate, each tile contains only one motif and a minimum

the close connection between the decoration of this bowl and manuscript illumination of the type found in illuminated books of the Tabriz school, where the influence of Herat was fully synthesized by the mid-sixteenth century.[26] New shapes of metal objects evolved in this period, in particular the *mash'al* or pillar candlestick. By 969/1561–2, the date of a pillar candlestick in the Iraq Museum, Baghdad, the form had developed from a very tall, tapering cylinder to a somewhat shorter, faceted cylinder made by a western Iranian metalworker.[27] Elegant ewers with long necks and curving spouts and handles are attested and appear regularly in paintings from the third quarter of the century [fig. 65]. An ex-

of vegetal ornament. Although Chinese wares would have continued to be used and copied in this period, the zodiac plate and Qazvin tiles bear witness to a parallel strain of ceramic production in Iran that was related to the other Persian decorative arts.

Probably because of the strength of the atelier system in the first half of the sixteenth century and the torrent of new ideas that it engendered, artists and artisans who could bear the new puritanism after 957/1550 managed to survive. For painters, illuminators, scribes and other artists of the book Sultan Ibrahim Mirza proved to be a generous and much loved patron. Thanks to him the atelier system remained alive, and as before older artists taught younger ones, often their own children or cousins. The makers of textiles, carpets, metalwork and some ceramics continued to derive their motifs and decorative ideas from bookbinders, illuminators and painters after 957/1550, but it must be assumed that the outlets for their products included the domestic, non-royal market as well as Mughal India, Ottoman Turkey and the Levant. From the mid-sixteenth century on, considerable numbers of talented Persians

67 Group of tiles, Qazvin, c. 1555–65, stonepaste with polychrome glazes, Victoria and Albert Museum. These tiles are said to have come from Shah Tahmasp's palace complex at Qazvin, though their runny glazes suggest that they decorated a 'back of house' area, not the rooms of the king or his family.

66 Fragmentary dish with signs of the zodiac, north-west Iran, dated 971/1563–4, signed by ʿAbd al-Vahid, stonepaste ware with underglaze blue decoration, diam. 41 cm, Staatliche Museen zu Berlin, Islamisches Museum, I.1292. In Safavid and earlier times belief in astrology was not viewed as incompatible with Islam.

from all walks of life emigrated to India, stimulating the eastward trade of Persian goods. Fortunately, Shah Tahmasp did not systematically renounce the material world when he released his artists and musicians. He still acquired 'Boscasinian cloth' from the east, 'close velvets and other silken fabrics' from Khurasan, woollen cloths from Aleppo[33] to give in payment to soldiers, and jewels and silks for his harem. While the reasons for closing the royal *kitabkhaneh* are rooted in his increasingly strict religiosity, it is none the less odd that he did not imagine that his actions might have a negative effect on the production of other luxury items. Presumably the benefits of peace and the ability of artisans to find markets for their wares counteracted the dampening effect of the shah's actions and contributed to the survival and development of the 'Qazvin style' in painting and its analogues in other media.

5

The Lowest Ebb

Shahs Isma' il II and Muhammad Khudabandeh

1576–1587

The city is full of sorrow and woe; O where is our king? [1]

In Rabi' II–Jumada I/October 1575 Shah Tahmasp, aged sixty-one, fell seriously ill. During the two months of his affliction the rivalries between different Qizilbash tribes that had laid dormant for over forty years resurfaced as amirs from different factions attempted to influence the choice of Tahmasp's successor. Although he had been imprisoned for eighteen years, Tahmasp's second son, Isma'il, was strongly supported by amirs of the Rumlu, Afshar and Turkman tribes as well as by his sister Pari Khan Khanum. Muhammad Khudabandeh, Isma'il's elder brother, was universally discounted as a potential heir to the throne because of his near-blindness. Isma'il's main rival was his younger half-brother, Haydar, whom Shah Tahmasp had kept at court and involved in running the affairs of state. The Ustajlu amirs and cousins of his Georgian mother, who herself was a rival of Pari Khan Khanum, formed the pro-Haydar faction. While the two factions did not come to blows during the period of Tahmasp's illness, they waged a mighty war of words, slandering whichever prince their enemies supported and trying to convince the shah of the treachery of one and the loyalty of the other. The shah reacted by sending some Ustajlu amirs to distant posts and by hiring a bodyguard for Isma'il, but neither son's situation changed nor was either of them know-

ingly designated heir to the throne. In the end, when Shah Tahmasp died on 14 Safar 984/14 May 1576, he still had not made his preference known. After a lifetime of deliberation before he acted, the shah failed to time his final decision right, or perhaps after one of the longest reigns in Iranian history he chose to leave his succession in the hands of fate. While the pro-Haydar faction announced that their candidate was named heir-apparent in Shah Tahmasp's will, their enemies claimed the document was a forgery. Although the people of Iran may have been ready for a change, they certainly could not have asked for a worse decade than the one that followed the death of Shah Tahmasp.

Writing of the Safavid court in 1575, the Italian Vincentio D'Alessandri had made remarks about the two princes that in retrospect seem remarkably prescient. Of Isma'il he noted that he:

is particularly beloved by his father, but his fear of him is great, seeing how ardently he is desired as ruler by all the

68 'Picnic Party with Youths Wading in a Stream', from a *Khamseh* of Nizami with a *Khamseh* of Amir Khusrau in the margins, Mashhad, dated Dhu'l qa'da 984/February 1577 and Rabi' I 985/July 1577, opaque watercolour, gold and ink on paper, each folio 28.3 × 17.5 cm, Keir Collection.

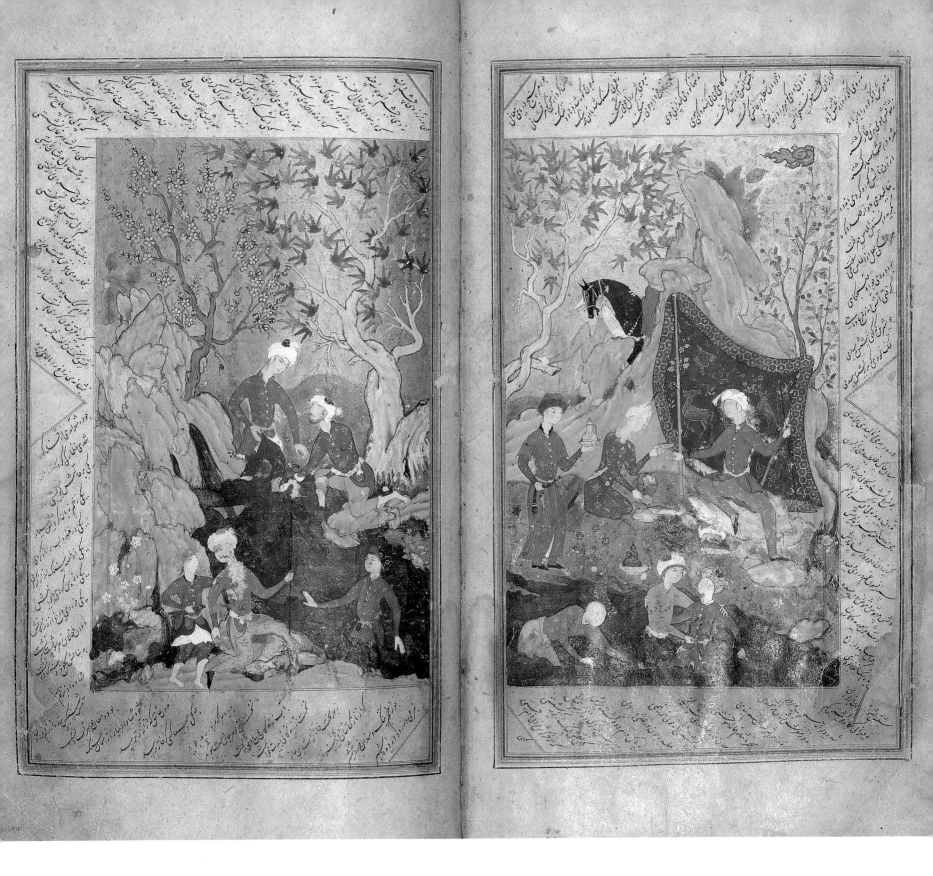

people; and the Sultans are especially afraid of him from his too proud disposition; so that if he ever comes to succeed to the throne he may have to replace a great number of the chiefs of the soldiery, and to oppose all his brothers, who have taken possession of many portions of the kingdom.[2]

Sultan Haydar was described as:

> small in stature, most fascinating and handsome in appearance, and excelling in oratory, elegance and horsemanship, and most beloved by his father; he is very fond of hearing people discourse about war, although he does not show himself much fitted for that exercise, from his too delicate and almost feminine nature.[3]

Given the bellicose nature of the resurgent Qizilbash tribes in this period, it is not surprising that they should have preferred Isma'il who had defeated the Ottomans in battle at an early age.

Shah Tahmasp was buried within the Qazvin palace precinct at Yurt Shirvani 'between the harem garden and the palace'.[4] This either indicates that his grave was covered by a yurt, a round domed tent, or by a brick or stone tomb tower in the shape of a yurt, or simply in a building named 'yurt' which was actually 'the gabled building in the palace'. Here Shah Tahmasp's coffin was placed until Shah Isma'il decided where it should go.[5] In any event, his body was moved within a few months to the grounds of the shrine of the Imam Riza at Mashhad. Before Tahmasp's initial burial could be achieved, Prince Haydar had crowned himself shah and then had realized that his enemies had locked him in the palace. When his supporters stormed the palace to free him, the pro-Isma'il camp entered as well and proceeded to the harem where Haydar was hiding. As he tried to escape in women's clothing, they spotted him and slew him. His supporters, including his brother Mustafa, dispersed as some of the supporters of Isma'il occupied the palace and others rode to Qahqaha to pledge their fealty to the prince. While Isma'il's supporters waited for him to arrive in Qazvin, his sister Pari Khan Khanum attempted to govern, but during the ten days between the death of Shah Tahmasp and the arrival of Isma'il Qazvin slid into chaos with rioting, looting and violence fomented by the Isma'il faction against the supporters of Haydar.

By the time Sultan Ibrahim Mirza, who had originally sided with Haydar, and the keeper of the royal regalia, Mirza Salman, rode to meet Isma'il on the plain of Zanjan, his name had been read in the *khutba* in the Friday mosque of Qazvin and he was shah *de facto* if not yet *de jure*. By mid-Rabi' I 984/mid-June 1576 Shah Isma'il had reached Qazvin. 'He did not enter the city at once, but camped on the northern side of it, since he was awaiting a propitious hour for his entry.'[6] Eventually the shah entered the royal palace, but before his official coronation he ordered changes to be made in the buildings of the palace complex and some new buildings to be constructed. All the while Qizilbash tribes were converging on Qazvin in anticipation of Isma'il's coronation, and the shah's allies were busy assassinating anyone whom they thought had been in the pro-Haydar faction. Finally, on 27 Jumada I 984/22 August 1576 all the grandees of Iran – princes, amirs and government ministers – gathered in the Chihil Sutun hall. Then Shah Isma'il II entered and took his place on Shah Tahmasp's throne where the assembled dignitaries each kissed his feet.

From May until August Shah Isma'il had not attended to any of the normal business of government. He vested in his cousin Sultan Ibrahim Mirza and several high government officials the power to deliver certain judgements in court, but all major decisions were held in abeyance. After a few months during which the shah had failed to make the necessary government appointments and had complained about the people he had installed, he openly turned against Sultan Ibrahim Mirza. Apparently Isma'il had feared that unless he treated Ibrahim Mirza with respect, the prince would convince his brother, who was governor of Qandahar, to start a rebellion in Khurasan. When that prince died of natural causes, Isma'il had no further reason to show favour to Sultan Ibrahim.

The fate of Sultan Ibrahim Mirza's brother was the exception to the rule during the reign of Shah Isma'il II. Upon the shah's orders six Safavid princes were murdered in one day. These included Sultan Ibrahim Mirza himself, universally recognized as a highly cultivated man whose influence on Shah Isma'il II's artistic patronage will be assessed below, Shah Isma'il's brothers Sultan Mahmud Mirza, Imamquli Mirza and Sultan Ahmad Mirza, the infant son of Sultan Mahmud Mirza and one of the sons of Shah Tahmasp's deceased brother Bahram Mirza. The shah also ordered the killing

of another son of Bahram Mirza and his infant son. Although the shah's mother prevailed upon Isma'il not to assassinate his blind brother Muhammad Khudabandeh, he did order the murder of his brother's eldest son, Hasan. Muhammad Khudabandeh and three of his sons were placed under house arrest in Shiraz and the order went out for his other son, 'Abbas Mirza, who was in Herat, to be executed. Before this order could be carried out, Shah Isma'il II died of a combination of poison and opium on 13 Ramazan 985/24 November 1577.

Although a slave girl had given birth to a son by Isma'il during his reign, only the guardian of the baby seriously considered him a claimant to the throne. Despite Muhammad Khudabandeh's visual impairment, the amirs recognized the importance of his having sons who could succeed him and they believed that while he would be shah in name, the real power would be vested in his sister, Pari Khan Khanum. Even during her short interregnum, Pari Khan Khanum tried to undo some of her brother's wrongs. She freed all the nobles and amirs that Isma'il had imprisoned and permitted those who asked to go to Shiraz to present themselves to the new shah. Fortunately, the leaders of the various Qizilbash tribes made their peace with one another, though this proved to be short-lived. From a political and social point of view the best thing that can be said about the reign of Shah Isma'il II is that it lasted only eighteen months. His murder of almost his whole family set a terrible precedent for future Safavid kings, while his inattention to matters of state and his violent and erratic personality provided a shaky foundation for his hopelessly inadequate heir, Muhammad Khudabandeh.

One of the few unregrettable aspects of Isma'il II's reign is his revival of the artists' atelier and the patronage of poets and musicians at the Safavid court. Although Shah Tahmasp had reappointed a librarian at the very end of his life, only one illustrated manuscript, the *Garshaspnameh* (Story of Garhasp) of Asadi dated 981/1573, can be safely attributed to the artists of his workshop [fig. 69]. Muzaffar 'Ali, who had served Tahmasp for his whole career, painted the first of the eight paintings in the manuscript, and two younger artists, Sadiqi Beg and Zayn al-'Abidin, contributed at least two of the other illustrations. Some figures in the paintings recall the lithe, long-necked youths found in Qazvin-

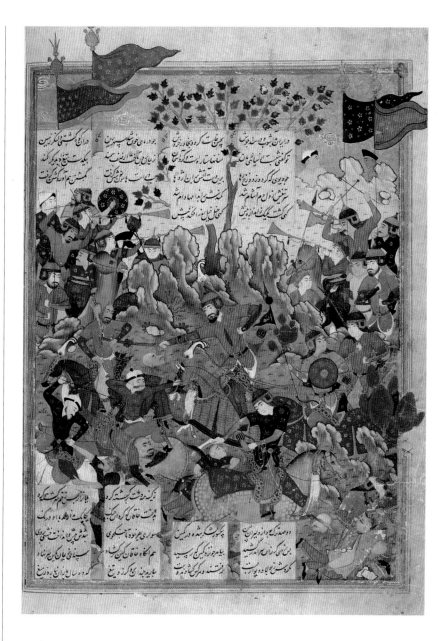

69 'Nariman Killing the Khaqan of Chin in Battle' from a *Garshaspnameh* of Asadi, by Zayn al-'Abidin, Qazvin, dated 981/1573, opaque watercolour, gold and ink on paper, page 25 × 21.5 cm, British Library, Or. 12985, fol. 90b. The text of this manuscript was copied by Mir 'Imad, an important calligrapher at the court of Shah 'Abbas. Garshasp was one of the shahs chronicled in the *Shahnameh*.

style portraits of the 1560s. However, other details such as the treatment of rocks and a greater preference for orange, mauve and light blue anticipate the one major manuscript thought to have been produced for Shah Isma'il II, a dispersed *Shahnameh*. The *Garshaspnameh* paintings exhibit a high level of action, but little tension. The myriad implied levels of meaning that characterize many of the illustrations to Sultan Ibrahim Mirza's *Haft Aurang* have been replaced in the *Garshaspnameh* by paintings that present the narrative straightforwardly and without innuendo, as if the manuscript were to be read by a child, not a sophisticated adult.

In ordering the execution of Sultan Ibrahim Mirza, Shah Isma'il II's political aim may have been to minimize the chances of rebellion or diminution of his power, but he may have also wished to fulfil a cultural ambition. When he arrived in Qazvin as shah, Isma'il II may not have attended to the business of government, but he did immediately order the palace to be refurbished and new buildings to be constructed. Furthermore, Sultan Ibrahim Mirza formed a close relationship with the shah and may have been influential in his decision to restore the patronage of poets, musicians and artists at his court. Sultan Ibrahim Mirza himself was a skilled poet, woodworker, calligrapher, painter and musician, and he was at the centre of a circle of poets, scribes, artists and musicians. He also collected calligraphy, painting and porcelain. If Shah Isma'il II had schemed to expropriate his cousin's collection and library, his hopes were dashed. Gauhar Sultan Begum, the wife of Sultan Ibrahim and sister of the shah, 'destroyed most of the contents of his [Sultan Ibrahim's] library by throwing the manuscripts into the water, so that they should not fall into the hands of the Shah; the china she smashed, and his other belongings she destroyed by fire'.[7]

Sultan Ibrahim Mirza's artists, however, did enter the royal atelier of the shah. Zayn al-'Abidin, Sadiqi Beg, 'Ali Asghar, Siyavush and other artists who may have been new to court service were commissioned, probably upon Isma'il II's accession, to prepare an illustrated *Shahnameh*. Robinson has proposed that the manuscript was never completed because of the shah's premature death,[8] a point supported by the fact that the forty-nine paintings that survive do not include any illustrations of later parts of the epic. Although some illustrations by artists of the older generation show a certain compositional debt to the *Shahnameh* of Shah Tahmasp,

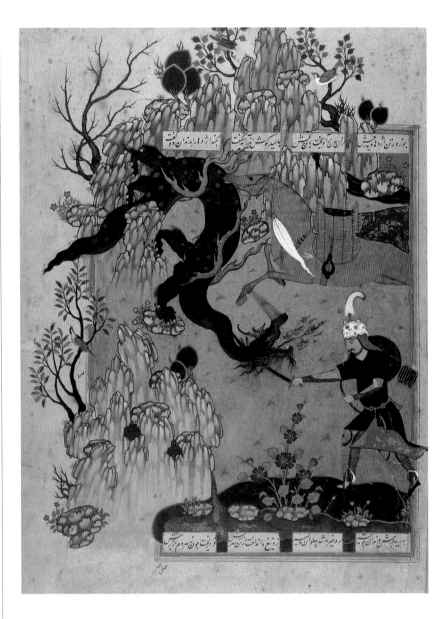

70 (above) 'Rustam Kills the Dragon', from a *Shahnameh*, Qazvin, c. 984–5/1576–7, ascribed to Sadiqi Beg, opaque watercolour, gold and ink on paper, page 42.9 × 30.6 cm, Collection of Prince and Princess Sadruddin Aga Khan.

71 (opposite, above) Torch stand, dated 985/1577–8 or 989/1581–2, cast brass, engraved, with black composition, h. 29.5 cm, diam. of base 15.9 cm, Victoria and Albert Museum, 411 K-1880.

72 (opposite, below) Pillar candlestick, dated 986/1578–9, cast brass, engraved, h. 32.5 cm, Metropolitan Museum of Art, New York, 29.5.3. The plain zigzag bands that separate inscribed from decorated areas provide a forceful structure for the elegant engraved script and arabesque decoration.

the figural types, palette and treatment of foliage are consistent with the Qazvin style of the third quarter of the sixteenth century. Possibly because of the unadorned borders that would have been sprinkled with gold, but also because of the reduced density of detail, the Shah Isma'il II *Shahnameh* illustrations appear somewhat flat, as if the patron was unable to inspire his artists.

Compared to similar works from the period of Shah Tahmasp, in Sadiqi Beg's 'Rustam Kills the Dragon' [fig. 70], a powerful scene in which Rustam cleaves the dragon's throat while his horse, Rakhsh, crunches its spine with his teeth, all extraneous figures have been removed, the foliage of trees is sparse while the size of individual flowering plants has increased, and the rocks jut upwards rather than in a variety of directions. The figures are placed closer to the picture plane than previously, and Sadiqi Beg has not hesitated to portray Rakhsh as an enormous mass of horseflesh, broader of beam than the dragon, hurtling across the page. This bit of artistic licence serves a dramatic purpose but deviates from the unwritten rules of proportion that governed court paintings of the Shah Tahmasp period. The technical quality of Sadiqi Beg's illustrations in this manuscript is as high as that of all but the most exceptional court paintings of the sixteenth century, but for overall conception the most compelling of the artist's works would not appear until the 1590s.

In the same period that Shah Isma'il II's *Shahnameh* was being produced, some artists continued to work in a style closely related to that of Sultan Ibrahim Mirza's *Haft Aurang*. Although a manuscript combining the *Khamseh*s of Nizami and Amir Khusrau with two colophons from Dhu'l Qa'da 984/January–February 1577 and Rabi' I 985/May–June 1577 has been assigned to Mashhad,[9] some artists, such as Shaykh Muhammad, who worked in this style returned to Qazvin with Sultan Ibrahim Mirza in 983/late 1574. Thus a parallel mode of painting was practised in the mid-1570s which reflects the taste of Sultan Ibrahim Mirza, even if he was not the actual patron of the manuscripts in which these paintings appear. A double-page composition of youths wading in a stream from the 984–5/1577

manuscript [fig. 68] depicts a princely figure seated before a canopy being served wine while small groups of young men frolic in and near a stream. The long, thin necks, wavy collars, pointed chins, puffy cheeks and wiry bodies of the young men all recall the works of Shaykh Muhammad rather than the stiffer figures of Sadiqi Beg in this period. As will be discussed, artists, perhaps in the circle of Shaykh Muhammad, who returned to Khurasan at some point after Shah Isma'il II's death, continued to employ the sinuous line and versions of this figural type in manuscript illustrations and single-page works through the period of Shah Muhammad Khudabandeh, while others perpetuated the more stolid Qazvin style of the *Garshaspnameh* and Isma'il II's *Shahnameh*.

Given the brevity of Shah Isma'il's reign, dated objects and textiles from this period are exceedingly rare. One torch stand bears a date that can either be read as 985/March 1577–March 1578 or 989/February 1581–January 1582 [fig. 71]. With its alternating bands of horizontal fluting and inscriptions of distichs from the *Bustan* of Sa'di and a *ghazal* of Katibi Turshizi, the candlestick is very similar in shape and decoration to at least one other extant example. It demonstrates the development of such torch stands after their introduction with the tall pillar candlestick of 946/1539 and the example from 969/1561–2, and points to the appeal in the 1570s and 1580s of alternating areas of fluting and engraved epigraphic and floral or foliate decoration. Ceramics, textiles and carpets that might have been made in the reign of Shah Isma'il II but are undated will be discussed with objects from the reign of Muhammad Khudabandeh.

In the three months between the death of Shah Isma'il II and the coronation of Shah Muhammad Khudabandeh at Shiraz, Pari Khan Khanum had attempted to run the government. However, the shrewd grand vizier, Mirza Salman, who had slipped out of Qazvin to join the shah in Shiraz, realized that Muhammad Khudabandeh took no decisions himself and that his wife, Mahd-i Ulya Khayr al-Nisa Begum, wielded all the power with little or no reference to her husband. In the tradition

established by Shah Isma'il II, Mahd-i Ulya wasted no time having her rival dispatched, and so on the day of the shah's coronation, Pari Khan Khanum was strangled. Unlike under Muhammad Khudabandeh's predecessor, however, appointments were duly made, dividing up the provincial governorships between the different Qizilbash amirs. The shah then proceeded to make lavish payouts of robes of honour and coins from the treasury to all manner of government officials and the royal bodyguard so that soon corruption was rife and the treasury was bankrupt.

Because of the shah's weakness, the Qizilbash tribes renewed their internecine struggle almost as soon as his reign began. Although the governor of Mashhad, Murtaza Quli Khan, was able to repulse an Uzbek incursion in Khurasan in the spring of 968/1578, the Ottoman invasion in the same year had far more serious repercussions. Taking advantage of uprisings among the Kurds and Georgians, Sultan Murad III (982–1003/1574–95) ordered his vizier, Mustafa Pasha, known as Lala Pasha, to lead an army to Georgia. At first the Ottomans made small gains in Georgia, but in the years that followed the Persians suffered serious losses of territory in Kurdistan and Luristan, and in 993/1585 Tabriz fell to the Ottomans. Even in the face of such dire external threats the Qizilbash tribes continued their struggle against each other, the Shamlus and Ustajlus loosely joined against the Turkmans and Takkalus. By Jumada I 987/July 1579 the Qizilbash amirs had arranged the assassination of Mahd-i Ulya which was followed by the persecution of her supporters from Mazandaran, the province of which she was a princess. Even in the wake of the murder of the mother of his four sons on whom he depended entirely, the shah did not punish the conspirators, but named his oldest son, Hamza Mirza, crown prince at the age of thirteen.

The shah's second son, 'Abbas Mirza, had been appointed governor of Herat as an infant in 979–80/1572 by Shah Tahmasp with Shahquli Sultan Ustajlu as his guardian. At the time of Isma'il II's accession in 984/1576, the Ustajlus fell out of favour in Qazvin, giving the enemies of Shahquli Sultan an excuse to murder him. After this was accomplished, the five-year-old 'Abbas Mirza was left without a guardian until the shah appointed 'Aliquli Khan Shamlu, grandson of Durmish Khan Shamlu, to be governor of Herat and ordered him to assassinate the prince. This act was forestalled by

the death of Shah Isma'il II, and before 'Aliquli Khan could accede to Mahd-i Ulya's command to return 'Abbas to Qazvin, she had been murdered. Thus, even though the Turkman and Takkalu amirs had gained the ascendancy at court in Qazvin, 'Aliquli Khan Shamlu retained his governorship of Herat and guardianship of 'Abbas. Meanwhile, a power struggle between Murtaza Quli Khan Turkman, governor of Mashhad, and 'Aliquli Khan led to open conflict. Despite being defeated in battle by Murtaza Quli Khan, 'Aliquli Khan and his allies decided to proclaim 'Abbas shah in Rabi' I 989/April 1581. This was too much for Shah Muhammad Khudabandeh and his all-powerful vizier, Mirza Salman, to countenance. The shah dispatched a large army to Khurasan which quashed 'Aliquli Khan's rebellion but allowed him to remain as governor of Herat.

In the aftermath of Mirza Salman's successful campaign against 'Aliquli Khan, the Turkman amirs increasingly distrusted the vizier. They resented his incursion, as an Iranian government official, into military matters which they considered to be the sole province of the Qizilbash. His military successes only aggravated their resentment. In 991/1583 the amirs prevailed over the shah and assassinated Mirza Salman. The obvious dissension in Iran was a clear signal to the Ottomans, who once again invaded north-west Persia in 992/1584. Although Prince Hamza led the Persian army against the invaders, he was hampered by disagreements among the Qizilbash, who failed to present a united force against the Ottomans. Finally, in Dhu'l Hijja 994/December 1586 Hamza Mirza was murdered in his camp in Azerbaijan by his barber.

Even though by the time Hamza Mirza was murdered 'Abbas Mirza had been carried off to Mashhad by its Ustajlu governor, the Shamlu and Ustajlu amirs at court threw their support behind his younger brother, Abu Talib Mirza, who was designated crown prince. Upon this news 'Abbas garnered the support of Turkman leaders, first in Khurasan and then in other parts of the country. With a small group of supporters 'Abbas and Murshid Quli Khan, governor of Mashhad, set out for Qazvin. Meanwhile Shah Muhammad Khudabandeh, Abu Talib Mirza and their bodyguard had left the capital, so 'Abbas entered the city unchallenged. On 14 Dhu'l Qa'da 995/16 October 1587 the shah re-entered Qazvin and handed his crown to his oldest surviving son, 'Abbas Mirza.

Unlike his uncle and his mother, 'Abbas did not seek immediately to execute his brothers and father; rather, he imprisoned them at Alamut and in time his father returned to Qazvin, where he died peacefully in 1003–4/1595–6.[10]

Shah Muhammad Khudabandeh's blindness and weakness essentially disqualified him as a patron of the visual arts. His son Hamza Mirza, who stayed in Qazvin, patronized at least two of Shah Isma'il II's artists, Siyavush and his brother, Farrukh Beg. Yet many of the employees of the royal library sought commissions elsewhere. Some provincial governors, such as Khan Ahmad of Gilan, were able to attract scribes and probably artists who had worked in the royal library in Qazvin.[11] Meanwhile, Sadiqi Beg gave up painting entirely and became a wandering dervish. Eventually he joined the retinue of Amir Khan Mausillu, governor of Hamadan, and later joined his fellow Afshar tribesmen in battle against the Turkmans at Astarabad. With the accession of Shah 'Abbas I he returned to painting.

Certain artists from the atelier of Sultan Ibrahim Mirza appear to have remained devoted to his memory and were retained to illustrate and illuminate two collections (*Divan*s) of his poetry that had been compiled by his daughter Gauhar Shad Begum. One of these, 'Abdullah Shirazi, had worked for twenty years in Sultan Ibrahim Mirza's library and then served Shah Isma'il II. After Sultan Ibrahim Mirza's death he moved to Mashhad to become a carpet spreader in the sanctuary of the shrine and attendant at the grave of Sultan Ibrahim Mirza, but he did not retire from his artistic career. Most likely Gauhar Shad Begum herself commissioned 'Abdullah Shirazi and other artists from her father's circle to work on these manuscripts. The colophon of the earlier *Divan* states that 'it was completed by Abdullah, "the old companion of the deceased prince," in Mashhad in 989/1581–82.'[12] The second volume of the *Divan* contains 'Abdullah Shirazi's signature on the opening double-page illumination and on a rock in one of the illustrations in which the date 990/1582–3 is included. It seems likely that

73 'Ibrahim Mirza's Garden Party', double-page finispiece from a *Divan* of Sultan Ibrahim Mirza, fols 86b–87a, Qazvin, dated 989/1581–2, opaque watercolour and gold on paper, page 23.8 × 16.6 cm, Collection of Prince and Princess Sadruddin Aga Khan. Although the prince in the pavilion is not identified, it should be assumed that he is Sultan Ibrahim Mirza, whose collected poems form the text of this volume.

74 'Lovers in a Pavilion', detached from a *Divan* of Hafiz, attributable to Bihzad Ibrahimi, Tun, dated Ramazan 989–Rabi' I 994/September 1581–February 1586, opaque watercolour and gold on paper, page 31.5 × 20 cm, Keir Collection. Paintings of romantic scenes such as this often evoke the mood of the poetry they accompany rather than illustrating the text.

Shaykh Muhammad, who also returned to Khurasan after the death of Shah Isma'il II, contributed illustrations to the 989/1581–2 manuscript. The double-page finispiece of the *Divan* depicts a prince, perhaps Sultan Ibrahim Mirza himself, in a garden pavilion being served by beautiful youths in the company of men conversing, making music, playing backgammon and shooting birds [fig. 73]. While neither as large nor as complex as the paintings in the prince's *Haft Aurang*, this illustration retains the animated figures and generous inclusion of natural elements found in the earlier manuscript and the *Khamseh* of 984–5/1577.

Even as late as 994/1586 'Abdullah Shirazi and his former colleagues continued to produce illustrated manuscripts in the so-called Mashhad style. A painting of 'Lovers in a Pavilion' [fig. 74] detached from a *Divan* of Hafiz dated Ramazan 989–Rabi' I 994/September 1581–February 1586 has been attributed on the basis of style to Bihzad Ibrahimi who signed two other illustrations from this manuscript.[13] As Çağman and Tanindi have pointed out, although nothing is known from the written sources about this artist, the word 'Ibrahimi' indicates that he had worked in the atelier of Sultan Ibrahim Mirza. The colophon of the manuscript also sheds light on patronage during the reign of Shah Muhammad Khudabandeh. It states that the manuscript was produced in the city of Tun in Khurasan for Sultan Sulayman. This was Sulayman Khalifa Turkman, governor of Tun from 989/1581 to 995/1587, the son of a Qizilbash amir and son-in-law of Murtaza Quli Khan, the powerful governor of Mashhad. Whether 'Abdullah Shirazi, who was the illuminator of this manuscript, and Bihzad Ibrahimi and two other painters actually produced the manuscript in Mashhad, as seems likely, or did the work in Tun, cannot be determined. However, for a manuscript containing eight illustrations to take nearly five years to complete suggests that the artists were not all working in the house of the patron.

In a similar fashion to 'Abdullah Shirazi, 'Ali Asghar seems to have left the capital after the death of Shah Isma'il II and returned to Kashan, of which he was a native. Although the names of specific patrons who might have acquired or commissioned illustrated manuscripts from 'Ali Asghar during the reign of Shah Muhammad Khudabandeh are unknown, a number of works have been attributed to him on the basis of style.[14] With its large number

of small-scale figures 'Iskandar Shooting Duck from a Ship' [fig. 75] is a throwback to the double-page frontispiece of Shah Isma'il II's *Shahnameh*, assigned to 'Ali Asghar. Unlike the work of many artists in that manuscript, 'Ali Asghar's figures are imbued with a certain nervous energy, which is also found in the bearded figure of Iskandar as he leans back to take aim at the birds and in the boatmen steering the smaller craft in the foreground. In this picture, new, full turban types have been incorporated and the Safavid *taj* is entirely absent. 'Ali Asghar's oeuvre is consistently populated by characteristic figures, such as the man with the flattened profile in the boat at the left, or figures whose heads incline at an acute angle, or men with beards that are sometimes a bit mangy, sometimes long and sometimes very dark and thick. These personages survived in his work into the period of Shah 'Abbas I, when they typify the Qazvin style against which younger artists would eventually develop the new Isfahan style of painting.

Although the number of dated illustrated manuscripts from the decade of 984–94/1576–86 proves that a demand continued regardless of the chaotic conditions, the major development of this period was a new emphasis on single-page works, either painted or drawn, for inclusion in albums. A respected practitioner of this type of work, Muhammadi of Herat, mentioned previously, apparently worked for 'Ali Quli Khan Shamlu, the guardian of 'Abbas Mirza in Herat, in the 1570s and 1580s, producing portraits of his patron and others for inclusion in albums. Likewise, many of the former court artists also increased their output of single-page portraits and group scenes. These works were sometimes falsely inscribed with the names of well-known artists, but it is not certain whether this was done to indicate the artistic tradition of the painting or drawing or simply to fool an unsuspecting buyer. Needless to say, such a situation would not have arisen if the artists had been working under the aegis of the court atelier. As the base of buyers of art broadened, so the repertoire of images expanded to include portraits of figures such as falconers, who may have been servants of the court but were not necessarily noblemen [fig. 76]. Portrayed alone, such figures stand on their own merits, not as part of a social pecking order. While the artistic movement towards more portraits and fewer illustrated manuscripts may have been motivated by economic necessity, it provided the groundwork for the major

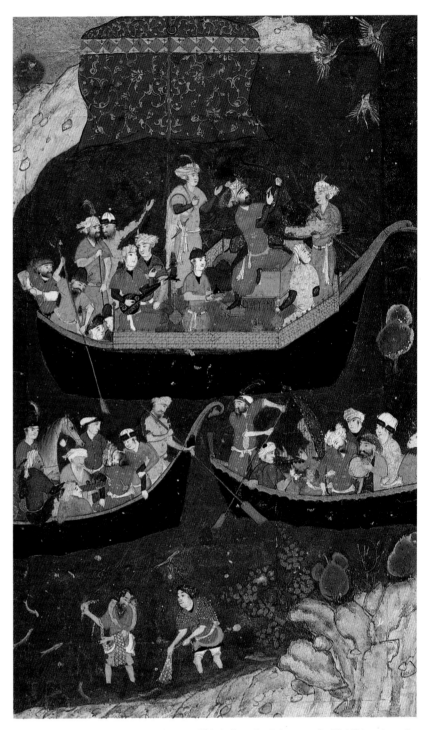

75 'Iskandar Shooting Duck from a Ship', detached from a *Sadd-i Iskandar* of Mir 'Ali Shir Nava'i, attributable to 'Ali Asghar, Kashan?, 1580s, opaque watercolour, gold and ink on paper, 13.5 × 22.4 cm, British Museum, OA 1937.7-10.0323, Gift of Charles Shannon, RA, from the Ricketts and Shannon Collection. Alexander the Great is known in Persian as Iskandar.

seventeenth-century trend of painting works for albums. Moreover, the hardships of the 1570s and 1580s resulted in the continued spread of motifs used in book illumination and binding into decorative arts such as ceramics, metalwork and carpet-making without notable innovations. A number of scribes who had once worked at court moved to the great shrine cities of Mashhad and Qum, where they provided architectural inscriptions and copied Qur'ans and other religious books.

Because of the absence of dated carpets from the period 985–95/1577–87 stylistic comparison with earlier and later examples provides the only clue to what groups were in production. Carpets with hunting scenes and animal combats in the quadripartite field around a central medallion continued to be produced in wool and silk. Some exceptional pieces have no medallion and have bisymmetrical designs derived from book illustration but more closely resembling the wall paintings in Na'in.[15] The general tendency in carpet design over the course of the second half of the sixteenth century is from central medallions outlined in a contrasting colour and set off from the field, to central medallions that are invaded by leaf and vine elements encroaching from the field and producing a broken outline. Likewise, the design of compartments of cartouche, lobed roundel and bell shapes placed separately in horizontal, vertical and diagonal rows in the field evolved into a pattern of overlapping compartments.[16] The use of large palmettes and Chinese cloud scrolls in the so-called Herat carpets relates to similar ornament on ceramics from the last quarter of the sixteenth century, but both carpet makers and potters were probably influenced by similar designs on the borders of manuscript pages and the interiors of bookbindings. Although documentary evidence has allowed a group of small silk tapestry-woven carpets to be assigned to Kashan, the places of manufacture of other sixteenth-century carpets remains conjectural. Presumably the capitals, Tabriz and Qazvin, had luxury carpet makers, but Kashan and Yazd, with their established silk-weaving industries, must have also figured largely.

With textiles, as with carpets, the lack of dated examples and the continued appearance of figural motifs in actual examples but not in garments depicted in manuscript illustrations is puzzling. Furthermore, the Safavid *taj* seemingly continued to appear on figures in textiles when it had become far less common in painting.

76 Falconer, Qazvin style, late 16th century, opaque watercolour and gold on coloured paper, 15 × 8 cm, British Museum, OA 1948.12-11.09, Bequest of Sir Bernard Eckstein, Bt. The bird, apparently a Saker falcon, seems to be focusing on the object held in the falconer's gloved hand, perhaps a tidbit of meat to sustain the bird and reward it for doing its job.

Although the male lover wears the *taj* in 'Lovers in a Pavilion' [see fig. 74], he may be a portrait of the patron, Sulayman Khalifa Turkman of Tun, who could have been expected to wear the head-dress of the Qizilbash. The robes of all the figures in 'Lovers in a Pavilion' are of solid colours with loosely spaced repeating gold patterns of flowers and foliage. Although these elements are not connected by vine tendrils, they resemble the gold flowers and leaves used for the edge of the pavilion roof and for many manuscript borders. Unfortunately, examples of this type of cloth have not survived, or have remained unpublished.

While no major new trends developed in ceramics in this period, blue and white and polychrome wares were produced which not only employed motifs introduced in the 1560s but also, like carpets and textiles, demonstrate an awareness of the decoration of illuminated book borders. The shape of a ewer [fig. 77] that may date from the 1570s is most likely based on a metalwork prototype. The scales that decorate its shoulder, however, relate to those that appear between the roundels in the astrological dish dated 971/1563–4 [see fig. 66]. The large blossoms connected by swooping narrow tendrils on the bulbous body of the ewer are more reminiscent of floral arabesques in illuminated borders of manuscripts than of Chinese blue and white wares, although floral scrolls certainly figure in Chinese ceramics of the first half of the sixteenth century. The tradition of ceramic tombstones also continued in this period. One dated 987/1579 is inscribed with a pious saying and the name of the deceased in black, yellow, white and blue under a transparent glaze.[17]

As for metalwork of the period, one dated pillar candlestick from 986/1578–9 in the Metropolitan Museum of Art [fig. 72][18] demonstrates how, now familiar with the faceted slightly conical form of the object, metalworkers expanded their decorative repertoire. Now *nasta‘liq* inscription bands alternate with bands of arabesque. The fluting of an almost contemporary candlestick of 985/1577–8 is absent from the Metropolitan piece, perhaps indicating that two workshops were producing *mash‘al*s at the same time.[18] Bath pails with or without long spouts and handles, basins with flat rims and bases and no foot and other metal objects with engraved split-palmette arabesque decoration were also produced in this period, although the published examples are not dated.

Politically and economically the reigns of shahs Isma‘il II and Muhammad Khudabandeh nearly brought the Safavid dynasty to a premature end. Architecture, the most expensive of all the arts, suffered the most in this period. Although the palace buildings sponsored by Shah Isma‘il II might have proved interesting or innovative if they had survived, Muhammad Khudabandeh seems not to have made his mark on any city. The painters, calligraphers, illuminators and bookbinders who left royal service in 1577 worked for provincial governors and Safavid princes and princesses, but presumably they did not collect a salary. Thus their skills were available to those who could pay, which probably contributed to the dissemination of artistic ideas hatched in the court ateliers of Qazvin and Mashhad. On the other hand, without strong, sustained patronage the innovations in the arts of the book that were necessary to drive new developments in the ornament of carpets, textiles, metalwork and ceramics were absent, and the visual arts coasted on the strength of past glories until at least 1587.

77 Ewer, north-west Iran, 1570s, stonepaste with underglaze blue decoration, h. 29.5 cm, Keir Collection. Despite its restored spout, the reliance of this piece on metalwork shapes is evident, though the profile is somewhat more squat than that of comparable metal ewers.

6
From Qazvin to Isfahan

The Glorious Reign of Shah 'Abbas I

1587–1629

Abbas, the Persian emperor was of stature low, of a quick aspect, his eyes small and flaming,
without any palpebra or hair over them: he had a low forehead, but a high and hawked nose, sharp chin,
and after the mode of Persia was upon the chin beardless.[1]

The invasion of Khurasan in Muharram 996/December 1587 precipitated the events that led to Murshid Quli Khan Ustajlu's advance across Iran to Qazvin with his ward, 'Abbas Mirza. Fearing that 'Abbas would be abducted from him in battle, Murshid Quli Khan saw his bid to have Shah Muhammad Khudabandeh abdicate in favour of 'Abbas as his best hope of retaining power and containing his rival 'Ali Quli Khan Shamlu, governor of Herat. The selfish motivation of Murshid Quli Khan did lead to the coronation of 'Abbas and his own appointment to the most powerful Persian ministerial post, but it also resulted in the Uzbek capture of Herat in 997/1588–9. Although the loss of territory to the Uzbeks and Ottomans was a grave external threat to Safavid Iran, the most pressing problem from the outset of Shah 'Abbas' reign was the need to find a way to control the feuding Qizilbash amirs. By the time of his accession 'Abbas had suffered the loss of his mother and brother at the hands of the Qizilbash and had been abducted in a Qizilbash struggle. Thus he was under no illusions as to the thirst of the Qizilbash amirs for power at any price. A conspiracy to replace Murshid Quli Khan within a year of 'Abbas' accession confirmed his view of his amirs, and he did not hesitate to quash their rebellion. However, the shah's patience with his overly ambitious guardian was wearing thin and within a year of his accession Murshid Quli Khan had himself been assassinated.

Shah 'Abbas knew that no offensive on his eastern front would be possible without securing the west. The Ottomans had already taken control of parts of Georgia, Azerbaijan, Shirvan and Khuzistan, including the cities of Tabriz, Erivan and Qarabagh, and in 1587 they added Baghdad to their empire. The only way that Shah 'Abbas could stem the Ottoman tide was to make peace, so on 14 Jumada I 998/21 March 1590 the Peace of Istanbul was signed, to the great disadvantage of the Safavids. Not only did they lose substantial territory but also they were forced to send a Safavid prince as hostage to the Ottoman court and to agree to a cessation of the ritual cursing of the Orthodox caliphs, which had been institutionalized in the time of Shah Isma'il I. Shah 'Abbas must have realized that such a peace, in which Tabriz, the first Safavid capital,

78 Pillar candlestick, signed by the servant of the family of Muhammad [ibn] Ahmad, dated 1007/1598–9, beaten, engraved and enamelled copper, h. 21 cm, diam. 13.5 cm, British Museum, OA 90.3-15.5. Although some controversy surrounds the authenticity of enamelled Safavid metalwares, pieces such as this suggest that experimentation in the technique began in the 16th century.

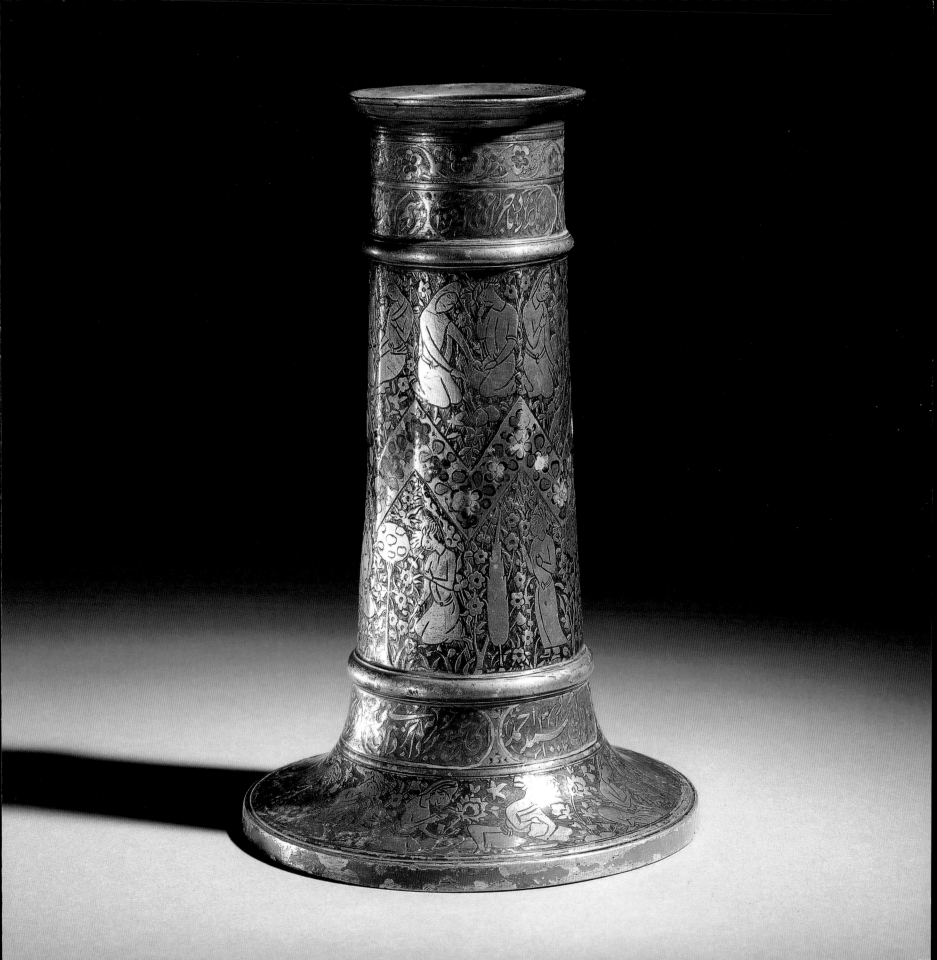

had passed to the Ottomans, would not be sustained over the long term. However, in the short term he achieved his aim of buying the time in which to reform his army and to plan the assault on Khurasan.

A first attempt to engage the Uzbeks in battle in 997/1588–9 had been cut short by the need to return to Qazvin to protect the northern and western borders of Iran against further Ottoman incursions. In the meantime, the Uzbeks took advantage of more Qizilbash in-fighting and seized Mashhad, leaving only Ardabil and Qum as major Shiite shrine cities still in Iranian hands. In addition to the Uzbeks' horrific slaughter of soldiers and many of the clerics connected with the shrine of Imam Riza, they thoroughly looted the shrine. The description of this desecration provides a glimpse of the wealth of such an institution:

> The holy shrine was plundered, and the jeweled
> chandeliers of gold and silver, the candlesticks, the rugs,
> and the china bowls and vessels were carried off. The
> shrine library which housed a collection of books from all
> parts of the Islamic world, including precious copies of the
> Koran in the writing of the immaculate Imams and
> masters of the calligraphic art such as Yaqut Mosta'semi
> and the six masters, and other learned works of priceless
> value, was pillaged; the Uzbegs sold these masterpieces to
> one another like so many potsherds.[2]

Whereas Shah Muhammad Khudabandeh had allowed the Qizilbash amirs to fight incessantly among themselves and jockey for power, Shah 'Abbas spent much of the 1590s executing anyone he suspected of disloyalty to the crown. He did not hesitate to replace governors who ruled their subjects harshly. As a result, provincial governorships changed hands with alacrity, but only in a few cases did the shah award these posts to his young sons in the guardianship of tribal amirs. 'Abbas realized early in his reign that using physical force alone against the Qizilbash amirs was a temporary measure and that something more was needed to change the social balance of the Safavid political and military hierarchy. Otherwise, the rivalry between the Turkmans and Tajiks, as the native Persians were called, would continue to fester and cause instability. Shah 'Abbas' solution was to build up a corps of *ghulams*, that is Georgian, Armenian and Circassian Christians who had been brought to the Safavid court as children, had converted to Islam and who were loyal to the shah, not to a tribe or family. This practice had been initiated by Shah Tahmasp, but as his reign progressed Shah 'Abbas systematically pursued it as a matter of policy. While historians have noted that the erosion of Turkman military and political power led ultimately to a weakening of Safavid military might,[5] it enabled Shah 'Abbas to gain control of Iran and to regain the territory lost by his father.

Until 1004/1595–6 'Abbas focused his attention on the restoration of order and the installation of loyal governors in the provinces of Iran. By the ruthless suppression of rebellious amirs and close monitoring of the effectiveness of the shah's appointees, the process of pacifying such regions as Gilan and Luristan and strengthening the rule of the central Iranian lands was well under way. None the less, the pattern of gains and losses against the Uzbeks continued, with the Uzbeks fleeing before the Safavid army only to return to Khurasan again when the shah had left the area. The centralization process in the political sphere was paralleled by a strengthening of the religious hierarchy within the Twelver Shiite creed and official disdain for the excesses of Sufism. Individual dervishes who gathered large followings and preached heterodox ideas were expelled from the mosques by the clerics and eventually arrested. Many of those accused of being members of the heretical Nuqtavi sect fled to India to avoid persecution in Iran. Developments such as these indicate the degree to which Safavid Shiism had moved away from the ecstatic mysticism of Shah Isma'il I by the time of 'Abbas I, a phenomenon that was linked to the demise of the Qizilbash in Safavid society.

In 1006–7/1598 events in Khurasan finally favoured Shah 'Abbas; both the Uzbek khan 'Abdullah and his son Abd al-Mu'min died, leaving no clear heir to the regions of Transoxiana and Khurasan which they had controlled. Even before the death of 'Abd al-Mu'min, Shah 'Abbas had resolved to muster a vast army for the reconquest of Khurasan and set out in Ramazan 1006/April 1598. Although the Uzbek amirs who had supported either 'Abdullah or 'Abd al-Mu'min laid claim to the governorships of the major cities of Khurasan and Transoxiana, they were soon intimidated by the Safavid armies marching east to reclaim Nishapur, Mashhad and Herat. By Muharram 1007/early August 1598 Shah 'Abbas had

marched peacefully into Nishapur and performed the pilgrimage barefoot and bareheaded to Mashhad from a site several miles outside the city.[4] Only Herat remained in Uzbek hands, and on 6 Muharram 1007/9 August 1598 the Safavids defeated the Uzbeks in battle at Rabat-i Parian near Herat and then took the city.

With Khurasan returned to Safavid hands, Shah 'Abbas could turn his attention to other regions lost to the Ottomans as well as to other matters of importance to him. As early as 999/1590–91 'Abbas had ordered a new royal bazaar, or *qaisariyya*, to be built in Isfahan and a new *maidan* or large open plaza to be cleared at its south-western edge near the existing palace of Naqsh-i Jahan. Although the *maidan* originally served as a polo ground and race-track, by 1595 it was partly or completely surrounded by a wall and was the scene of extravagant royal entertainments. Until 1006/1598 Qazvin remained the Safavid capital and Isfahan was the place to which Shah 'Abbas went 'for recreation, especially hunting'.[5] However, having spent the winter of 1006/1597–8 in Isfahan, hunting and feasting, the shah decided to move the capital to Isfahan; in the spring of 1598 work began in earnest on the buildings, gardens and avenues of a new royal quarter north of the Zayandeh-Rud river and garden suburbs to the south.

Although the Safavids suffered the loss of Balkh in 1011/1602, by the spring of 1011/1603 Shah 'Abbas was prepared to start the reconquest of lands lost to the Ottomans. First, his men seized and razed the fort at Nihavand near Hamadan which the Ottomans had built as a garrison early in his reign. Then, when the Ottoman governor of Tabriz was absent from his city fighting a group of Kurds, 'Abbas led a surprise march on Tabriz and retook the city. This punishing defeat of the Ottomans encouraged 'Abbas to continue his campaign in Azerbaijan. While one of his generals accepted the surrender of Nakhchivan, the shah and his army besieged Erivan. More than six months after it had begun and after spending the winter in trenches, Shah 'Abbas and his men ended the siege of Erivan victoriously in Muharram 1013/June 1604. Over the course of the next eight years the Safavids persistently campaigned in Azerbaijan, Armenia and Shirvan, so that by 1022/1613 the Ottomans and Safavids signed another treaty at Istanbul which restored the Persian–Turkish borders to more or less what they had been at the time of the Treaty of Amasya, with

the exception of the Baghdad region which remained in dispute. Not until 1032/1622–3 did another Safavid campaign restore Baghdad, Karbala, Najaf and the Kurdish territory around Mosul to their empire. Although these lands remained in Safavid hands for the rest of Shah 'Abbas' reign, his successor, Shah Safi, could not hold onto them.

A true lateral thinker, Shah 'Abbas incorporated his master plan for the development of Isfahan into his strategy for building up the *ghulam* regiments and other segments of Safavid society at the expense of the Qizilbash. In the reigns of shahs Isma'il I and Tahmasp the Qizilbash leaders whose troops were called up in time of war had been paid by land grant, not directly from the treasury. Although this kept the royal treasury healthy enough, it awarded too much regional power to the Qizilbash amirs and led to abuses of local populations as well as defiance of the shah. To curb the power of the Qizilbash, Shah 'Abbas greatly increased the ranks of the *ghulam*s who formed a standing army and were loyal to the crown. He also systematically converted tracts of land and even provinces, such as Mazandaran, to crown lands. The income from the crown lands helped to a certain extent to defray the costs of the

79 'Ali Qapu palace, Isfahan, c. 1006–25/1598–1612, east façade. Built on the site of a 15th-century palace, the 'Ali Qapu was used for both administrative purposes and royal entertaining.

army, but other sources of income were sought. The building of the *qaisariyya* bazaar in Isfahan in 1501 may have originally been intended to cater to the court and its retainers when they were visiting Isfahan, but when Isfahan became the capital in 1598, this bazaar became the primary outlet for luxury goods and their production was subsidized by Shah 'Abbas.

Unlike Shah Tahmasp, Shah 'Abbas' welcoming attitude to foreign ambassadors and merchants from Europe and India stimulated trade, especially of silk, to both the east and the west. Whereas Iran had long maintained diplomatic and economic ties with India, the opening up of trade with Europe provided a new set of challenges which the shah solved by turning to one of his important minority populations, the Armenians. In 1013/1604, as part of his campaign to restore lands lost to the Ottomans, Shah 'Abbas pursued a scorched earth policy in the border lands of Armenia, displacing thousands of people, including the whole population of the city of Julfa, a city of wealthy merchants. The Armenian populations were dispersed throughout central Iran, but special attention was given to the Julfans, for whom the shah ordered a new suburb of Isfahan to be constructed in 1014/1605 south of the Zayandeh-Rud river. In this quarter, New Julfa, the Armenians were allowed to worship openly in the churches that they built and were given free citizenship. The Armenians figured not only in Shah 'Abbas' political strategy but also as key players in his plans for trade with Europe. As Christians, polyglots and renowned merchants with pre-existing ties to Europe, they were the ideal group to open trade routes west of the Ottoman empire. Thus Shah 'Abbas decided to provide the Armenians of New Julfa with bales of silk at no initial cost to trade in Europe with the obligation to repay the shah upon their return. Once established, this silk trade brought wealth both to the shah and the Armenians and kept the controlling instincts of the European trading companies in check for at least fifty years.[6] The tariffs paid into the royal coffers helped support the cost of Shah 'Abbas' army which in turn led to the reconfiguration of Safavid society.

Although Shah 'Abbas had added palaces to the royal complex at Qazvin, no trace of them survives and these alone would not have earned him the reputation as the greatest Safavid patron of architecture. Rather, his grand and inspired plan for the development of Isfahan has enchanted visitors to the city for nearly four hundred years. Iskandar Beg Munshi, 'Abbas' biographer, describes the genesis of the shah's design. The shah spent the winter of 1006/1597–8 in Isfahan at the Naqsh-i Jahan palace. This had been built in the fifteenth century and renovated by Shah Isma'il I; it was completely rebuilt by 'Abbas between 1006/1598 and about 1025/1612 and renamed the 'Ali Qapu (Sublime Porte). Iskandar Beg Munshi continues:

> In the spring of 1598, he approved plans for the
> construction of magnificent buildings in the Naqš-e Jahān
> district, and architects and engineers strove to complete
> them. From the Darb-e Dowlat, which is the name for the
> city gate located within the Naqš-e Jahān precincts, he
> constructed an avenue to the Zāyanda-rūd. Four Parks
> [Chahar Bagh] were laid out on each side of the avenue,
> and fine buildings adorned each. The avenue was
> continued across the river as far as the mountains
> bounding Isfahan to the south. The emirs and officers of
> state were charged with the creation of the parks and the
> construction of lodges on a royal scale within the parks,
> each to consist of reception rooms, covered ways, porticos,

80 'Ali Qapu palace, Isfahan, c. 1006–25/1598–1612, wall decoration, ground floor, west-facing wall.

balconies, finely adorned belvederes, and murals in gold and lapis lazuli.

At the southern end of the avenue, there was to be a vast garden, terraced on nine levels, for the pleasure of the king's guests; it was to be known as the 'Abbāsābād garden. The river was to be spanned by a bridge of special design: it was to have forty arches and, when the river was in spate, water would flow through all of them … On each side of the avenue, water flowed through channels, and trees were planted along them – planes, pines, and junipers. A stone conduit was also constructed down the center of the avenue to form another channel for water.[7] The tree-lined avenues of the Chahar Bagh were surrounded by palaces built by Safavid noblemen which were separated from the *maidan* by the royal precinct and palace. Here the 'Ali Qapu combined the functions of palace and government building [fig. 79]. On its north, west and south sides it faced walled, private gardens and buildings of the royal household, whereas its east side gave onto the *maidan*. Here on the roof of the second storey the shah could observe entertainments from a viewing platform or just the swirl of humanity in Isfahan's grand public piazza. Inside the 'Ali Qapu, arrayed over six storeys, were rooms for administrative functions below the second storey, a reception hall with a fountain

81 Eastern side of the *maidan*, Isfahan, early 1590s–1604. Although the *maidan* of Naqsh-i Jahan was laid out in the early 1590s, construction of the buildings and arcade around it did not begin until 1598.

and pool at the platform level and on the top, and a music room with niches of moulded stucco in the shapes of the various porcelain objects which they contained. The walls of the lower rooms of the palace are painted with scenes of birds and animals in landscape and floral and vegetal arabesque decoration in pale colours that recall book illumination and some carpets of the period [fig. 80]. The walls of the rooms around the music room are adorned with pictures of beautiful youths drinking and entertaining one another, also in the style of artists working at the Safavid court.

By 1012–13/1602–4 construction had begun on a second storey of the arcade surrounding the *maidan* [fig. 81]. The order for this building had been issued in the wake of the refusal of the merchants whose establishments were in the vicinity of the Masjid-i Jami' of Isfahan, to the north-east of the Naqsh-i Jahan area, to agree to the rebuilding of the old *maidan* in their neighbourhood. They suspected Shah 'Abbas of trying to seize control of the commercial life of the city. Whereas the *maidan* had previously served as a walled rectangular ground for sports and entertainments, now buildings containing shops were constructed on the

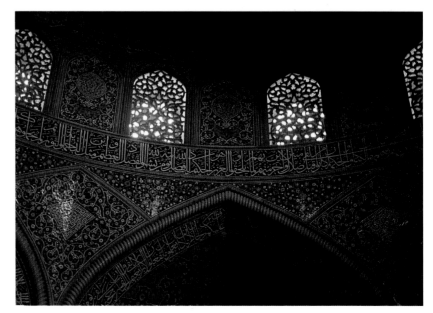

ground floor while the second storey contained storerooms and lodgings.

Directly across the *maidan* from the 'Ali Qapu lies the Masjid-i Shaykh Lutfallah, named for the shaykh who was the imam of the mosque[8] and intended as the shah's private mosque [fig. 82]. Designed by Muhammad Riza b. Husayn and built between 1011/1602–3 and 1028/1618–19, this is one of the gems of Safavid architecture. The mosque's façade and entrance portal faced west, and its dome was placed off-centre to accommodate the entrance hallway leading to a door directly opposite the *mihrab*, which is placed in the south-eastern wall of the dome chamber. Although the single-shell dome appears somewhat squat from the exterior, on the interior it soars above the drum pierced with windows that admit a lovely filtered light [fig. 83]. The exterior of the dome is covered in a combination of unglazed buff-coloured bricks and glazed bricks that form a pattern of superimposed arabesques in turquoise and white rimmed with black. A *thuluth* inscription band encircles the drum below the dome and above Kufic inscription panels that separate the windows with their turquoise glazed exterior grilles. The effect of the dome from the exterior is both stately and luminous. Even so, it does not prepare one for the perfect harmony of the interior. Each of the four walls and four corners consists of a pointed arch bordered by a turquoise glazed cable

82 (above, left) Entrance portal and dome of the mosque of Shaykh Lutfallah, Isfahan, 1011–28/1602–19, designed by Muhammad Riza b. Husayn. This small, elegant mosque, placed directly across from the 'Ali Qapu, was intended for Shah 'Abbas' private worship.

83 (above, right) Pierced windows viewed from the prayer hall of the mosque of Shaykh Lutfallah, Isfahan.

above a dado of arabesque decoration punctuated by lobed ogives. A band of Qur'anic verses in white on cobalt blue ground serves as a border for each arch and runs around the *mihrab*. Likewise, the windows and arched panels of the zone of transition are set between two inscription bands that encircle the dome. The dome itself is decorated with rows of tiled ogives set within unglazed bricks and decreasing in size towards the top, which is decorated with a sunburst design in turquoise on white. The balance and simplicity of the architectural elements in this chamber are the perfect foil for the variety and intricacy of the decoration and the superb inscription bands written by the shah's favourite scribe, 'Ali Riza 'Abbasi.

Whereas in Iranian architecture the single-domed chamber without a courtyard is an unusual plan for a mosque, it is common for mausoleums and shrines. In the Safavid period there may have

been some blurring of these distinctions so that at Ardabil Shah Tahmasp's Jannat Sara, also a large domed chamber, could have served as a prayer hall rather than a mausoleum, and the architect of the mosque of Shaykh Lutfallah may have followed suit. The other major monument facing onto the *maidan* at Isfahan, the Masjid-i Shah,[9] also reveals novel variations on the standard four-*ivan* plan [fig. 84]. Work on this exceptionally large structure began in 1021/1612–13 with the entrance portal which was completed in 1025/1616. Inscriptions state that the construction was directed by Muhibb 'Ali Kika Lala and carried out by Ustad 'Ali Akbar al-Isfahani. Muhibb 'Ali was in charge of the administration of royal palaces in Isfahan and acted as chief engineer on various building projects of Shah 'Abbas. Unlike the *maidan* and *qaisariyya* bazaar, which were conceived as rivals to the existing *maidan* and bazaars to the north-east, the Masjid-i Shah was Shah 'Abbas' answer to 'the temple at Mecca and the mosque at Jerusalem'.[10] The site of the mosque on the south side of the *maidan* was cleared by demolishing a *caravansarai*. Although, as will be discussed, one of the dominant features of the building is the skin of blue tilework, the discovery of a marble quarry near Isfahan at the time the building was begun was viewed as highly providential, as the marble could be used to adorn the mosque.[11]

Unlike most buildings commissioned by Shah 'Abbas, the Masjid-i Shah took over thirty-five years to complete, in large part because of its exceptional size.[12] Like the Shaykh Lutfallah mosque, its orientation is at an angle to that of the *maidan*. Thus one enters through the towering portal flanked by two minarets and turns right at an oblique angle to pass through an *ivan* into the courtyard [fig. 85]. There one encounters another lofty façade with minarets

84 (below) Masjid-i Shah (Masjid-i Imam) viewed from the 'Ali Qapu, begun 1021/1612–13, completed c.1040/1630. This grand congregational mosque, commissioned by Shah 'Abbas, has been called the culmination of Persian architecture.

85 (below, right) Courtyard and northern *ivan*, Masjid-i Shah (Masjid-i Imam). Looking in the direction of the entrance to the mosque from the courtyard, one can observe from the placement of the minarets how the entrance is at an angle to the rest of the building.

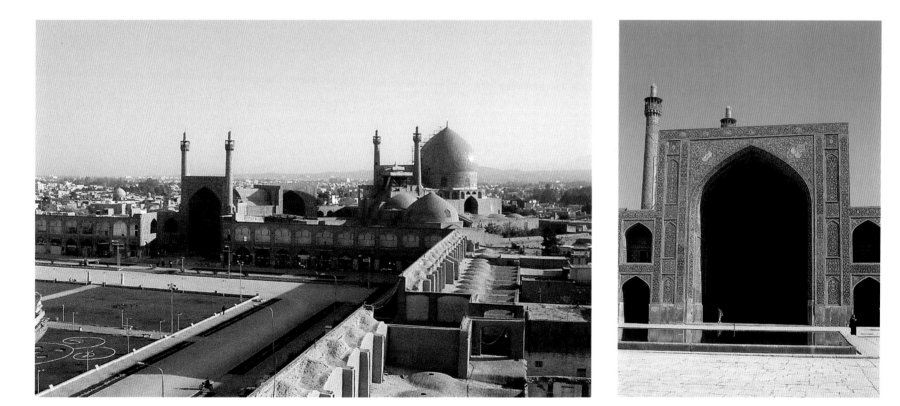

to either side and an *ivan* leading to the prayer hall under a high double-shell dome. As if to echo the *maidan*, a two-storey arcade connects the four *ivan*s. Unlike most four-*ivan* mosques the subsidiary *ivan*s on the east and west precede domed chambers, which in turn open in a south-westerly direction onto two *madrasa*s with courtyards. These are separated from the sanctuary by two winter prayer halls, each covered by eight low domes [fig. 86]. Although the bent entrance to the mosque might appear awkward in plan, it allows people to see both the portal and the prayer hall dome from the *maidan*. Inside the mosque the visitor is enveloped in a haze of blue and yellow *cuerda seca* tiles. Although the quality of the designs of the tile ensembles is somewhat coarse by comparison to those of the Shaykh Lutfallah mosque and of earlier Safavid buildings, the overall effect of the tilework in the Masjid-i Shah is to induce a mood of serenity, which one imagines would have pertained even when the mosque was full of worshippers.

86 (above) Prayer hall dome, Masjid-i Shah (Masjid-i Imam), Isfahan, begun 1021/1612–13, completed c. 1040/1630. Almost every surface of the mosque is covered in *cuerda seca* tiles, which give one an impression of the diffusion of light and, by extension, ephemerality.

87 (below) Thirty-three Arch Bridge, also known as Allahvardi Khan Bridge, Isfahan, c. 1008/1600. This bridge connects the main avenue of Shah 'Abbas' Isfahan, the Chahar Bagh, with his gardens to the south of the river.

The Masjid-i Shah and mosque of Shaikh Lutfallah have rightly been hailed as the pinnacles of Safavid architecture. However, Shah 'Abbas and his most important courtiers excelled as patrons of architecture not only for the beauty and originality of their structures but also for the variety of buildings they commissioned. In Isfahan, as part of Shah 'Abbas' development that ran

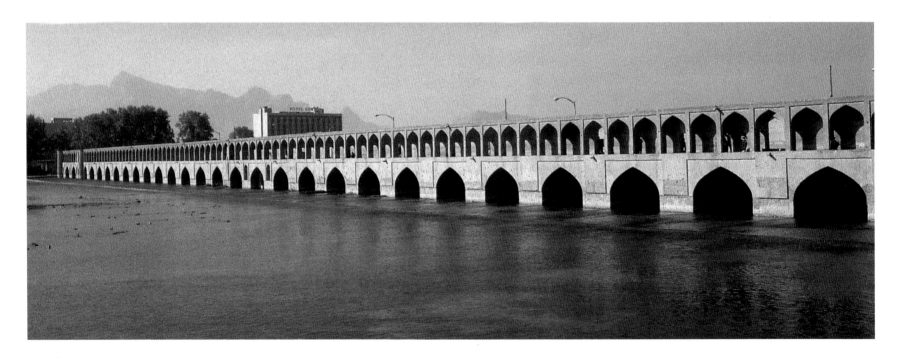

from the Chahar Bagh south to the Hazar Jarib gardens, the shah's leading general, Allahvardi Khan, commissioned a bridge of thirty-three arches to span the Zayandeh-Rud as a continuation of the avenue that intersected the Chahar Bagh [fig. 87]. This elegant bridge, built around 1008/1600, is a multipurpose structure; either side of the road that runs down its middle is lined with arcades containing niches large enough for people to sit or stand inside and observe the river passing below. Thus the notion of pleasant strolling, riding and conversation that were enjoyed in the Chahar Bagh and other gardens of the city was extended to the experience of crossing the river itself.

Shah 'Abbas' building projects touched every region of Iran. As part of his programme to stimulate trade and communications, he sought to make the roads safe and thus built many *caravansarai*s at stages along the main trade routes. These buildings are as markedly devoid of decoration as the royal Safavid mosques and palaces of Isfahan are awash with it. Hillenbrand has supposed the existence of official blueprints issued by the shah's planners, which would account for a high level of uniformity among the *caravansarai*s said to have been built in the early seventeenth century.[13] According to the standard plan, Safavid *caravansarai*s followed the four-*ivan* scheme with a one-storey arcade running between the *ivan*s. Often the four corners have turrets and the sides of the building would have differing numbers of bays. In cities, *caravansarai*s were located adjacent to bazaars and had two or more storeys so that animals could be penned below and travellers could sleep and store their goods above. A requirement of all *caravansarai*s was a water source or reservoir, space for animals and people, and protection from the threat of wild animals and brigands.

Shah 'Abbas expressed his enthusiasm for regions such as Mazandaran by building at least six palaces and hunting lodges near the Caspian Sea. To improve access to the north from Isfahan, he ordered the building of a road, dubbed the 'Stone Causeway', which crossed the marshes of the Caspian littoral. While Shah 'Abbas' fondness for hunting in Mazandaran is often mentioned, he may have had several reasons for choosing this province as the site of a number of new garden and palace complexes of which two, Ashraf and Farahabad, are the most famous. First, he had taken the opportunity of a vacancy in the succession of local amirs in Mazan-

daran to convert the province to crown lands in 1005/1596–7. Certainly his real reasoning behind this was to gain control of the silk production centred there. However, the shah's excuse for appropriating Mazandaran was that it was the hereditary fief of his mother's family and that in the absence of any other rightful male heir, the province was his legitimate inheritance.

A very fertile region with an annual rainfall of 40–60 inches, Mazandaran offered the shah, whose fondness for gardens had already been demonstrated in Isfahan, an excellent setting in which to have his design ideas realized. These included the building of a huge artificial lake at Barfarush complete with man-made islands, bridges and pavilions accessible only by boat. In 1020/1611, at the village of Tahan on the Caspian, Shah 'Abbas ordered a royal palace to be constructed on the banks of the local river. 'Since he was always in a happy mood when he was there, he renamed the place Farahabad (place of joy).'[14] As in Isfahan, the complex consisted of a large arcaded *maidan* with a mosque on the south side and palace buildings on the north. Here buildings for official receptions and administration were separate from the private apartments, which included a palace near the sea called Jahan Numa ('View of the World'). In 1021/1612–13 at Ashraf near Astarabad,

the Shah laid the foundations of another palace, with all necessary ancillary buildings such as bathhouses, workshops, and houses … Ašraf lived up to its name in every respect; the Shah devoted an increasing amount of attention to it, and laid out gardens and parks in which nestled attractive residences, each equipped with a cistern. In the midst of each cistern fountains played, the water for them being brought down from the higher slopes of the mountains. The fountains were fashioned with cunning artistry, some taking the form of flames, others the shape of the cascade which firework makers make from gunpowder.[15]

Known as Bagh-i Shah, Ashraf consisted of eight separate gardens of which six were positioned along the axis leading from the entrance up a series of terraces to a large pool, at the end of which stood a palatial building. Parallel to the central avenue ran water channels, and the gardens to either side were planted with towering cypresses and orchards of fruit trees. In one of these gardens,

88 Bagh-i Fin, Kashan, late 16th century with 19th-century buildings. This tiled watercourse runs directly from the entrance to the walled garden at Fin to the square pool set before the central pavilion.

the Bagh-i Sahib Zaman, stood a two-storey building devoted only to royal functions and 'for storing and displaying royal possessions'.[16] Two contiguous gardens placed at an angle to the main axis contained the private residential quarters of the shah and his harem as well as pools and watercourses. Not only would the watercourses have been lined with onyx or agate but the pavilions were decorated with painted walls and the floors were covered with carpets of silk and gold. While the actual layout of plants and trees is not described, the aim of such gardens was to maximize beautiful views, pleasant breezes, sweet smells from flowers such as roses and flowering trees, and shade from plane trees.

Although the Mazandaran gardens of Shah 'Abbas suffered in the ensuing centuries, one garden in Kashan, the Bagh-i Fin, incorporates many of the features of Safavid gardens built by Shah 'Abbas [fig. 88]. Buildings which he is said to have erected at the site early in his reign were replaced in the nineteenth century, but the overall layout of the garden resembles that of the Mazandaran complexes on a smaller scale. A water channel lined with blue glazed tiles runs on the axis from the entrance to a square pool before a pavilion. The pavilion itself is bisected by water channels and separated from a smaller building by a long, rectangular pool.

The channels that cross the main pavilion run to the edges of the cultivated garden and are the source of its irrigation. It is not difficult to imagine the pleasure of entering this garden from the desert heat outside its walls. Great cypresses and plane trees provide shade and low fountains gurgle, inviting one to stroll or sit quietly conjuring up the banquets and entertainments held in the days of Shah 'Abbas.

As at the Mashhad shrine, Shah 'Abbas commissioned various improvements to the Ardabil shrine. According to Iskandar Beg Munshi, he paid for a gold railing around the shrine of Shaykh Jibra'il, a silver railing 'and other adornments' around the sacred enclosure, the renovation of some tombs and the designing of a garden around one of the tombs.[17] In addition, in 1015–16/1606–8 the shah placed many of his Persian books, his Chinese porcelains, celadon wares, 'wine cups and other Ghurid and Chinese bowls', and various livestock in a *waqf* (religious endowment) for the shrine.[18] In order to accommodate the ceramics and books housed in the shrine, the building called the 'Dome of the Princes' was revamped with rows of niches with openings in the shape of the ceramics that were stored in them. The room was henceforth dubbed the Chini-khaneh, or 'china chamber' [fig. 89].

As is reported by European travellers to the various palaces of Shah 'Abbas and those of his great lords, such as Allahvardi Khan and his son Imamquli Khan, luxurious carpets covered the floors

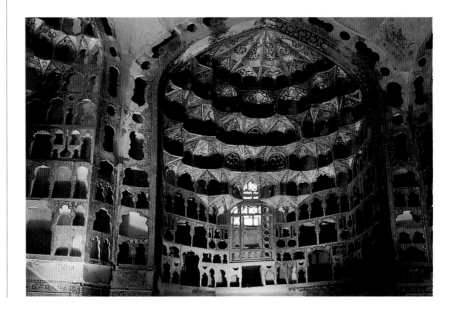

and were laid on the ground. In both the Shaykh Lutfallah mosque and the Masjid-i Shah the floors that are now bare would have been entirely covered with rugs, possibly made in near-identical pairs and designed to complement the tilework on the walls and ceilings. While some centres such as Kashan, Kirman and Herat continued to make carpets with designs similar to those on earlier sixteenth-century examples, the move of the Safavid capital to Isfahan stimulated production of new types of carpets in which silk and gold were used liberally. Workshops were established in Isfahan, and one of these was situated within the palace precinct next to the royal goldsmiths.[19] These so-called 'Polonaise' carpets[20] fall into two main design categories and are otherwise grouped according to technique. While production is thought to have begun in the late sixteenth century in Isfahan, the heyday of this type of rug occurred during the seventeenth century in the reign of Shah ʿAbbas. The finest examples have silk warps and wefts, but the majority use either cotton or silk and cotton. The knots are always silk and far more brocading is found in this type of carpet than in groups of the sixteenth century. Unlike sixteenth-century brocaded carpets, the metal threads of Polonaise carpets are passed over several rather than two warps at once, resulting in a weakening of the structure of the carpet. Because silk is not as absorbent of dye as wool, the palette of these carpets tends to feature pastel shades.

One type of Polonaise carpet has a central medallion and rows containing two alternating design elements [fig. 90]. Thick vines terminating in split palmettes and spiral vines with blossoms are bisymmetrically arranged on the field. In the second group of Polonaise carpets spiral vines and lancet leaves are the dominant design features and central medallions are either entirely absent or metamorphosed into vaguely medallion-shaped units. Unlike all classes of sixteenth-century carpets, the colour of the field of carpets in the Polonaise group is not uniform, but varies in the interstices between design elements. As Erdmann has noted, 'the outcome – and probably the intention – of this innovation is a broader enrichment of the surface picture ... at the expense of structural clarity'.[21] As the number of these carpets in European collections attests, their glittering surface and luxurious texture ensured their esteem as an item of trade and diplomatic exchange. Fortunately, the careful treatment of these carpets by their European owners has ensured

89 (left) Chini-khaneh, Ardabil shrine, refurbished by Shah ʿAbbas 1015–16/1606–8.

90 (above) Polonaise carpet, Isfahan?, early 17th century, silk pile brocaded with gold and silver threads, 2.10 × 1.41 m, Fundação Calouste Gulbenkian, Lisbon, T. 71. The predominantly gold and salmon palette is typical of the so-called Polonaise group, the luxury carpets of the period of Shah ʿAbbas.

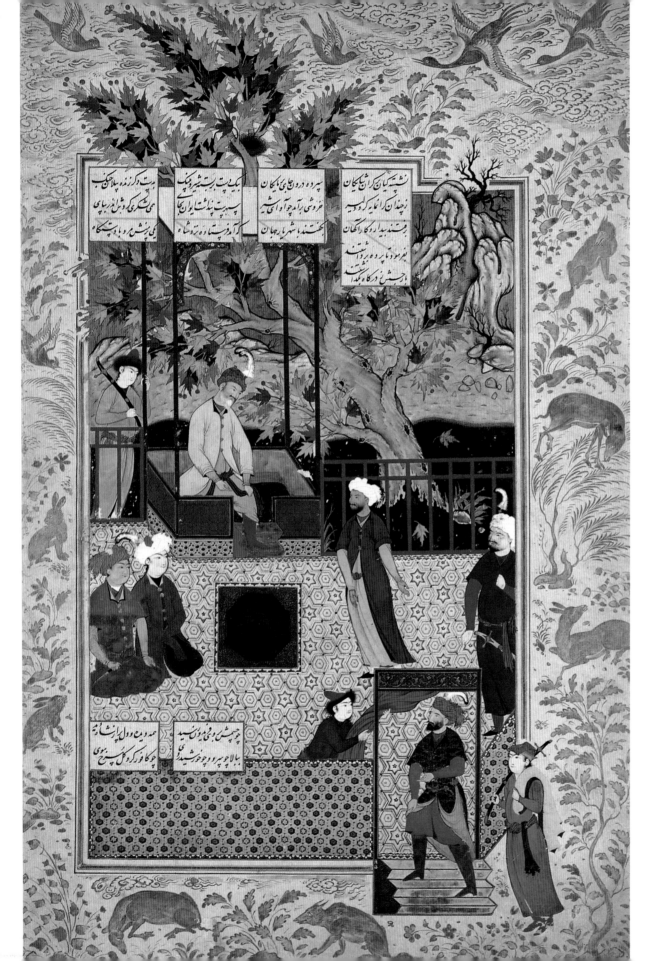

91 (left) 'Faridun Spurns the Ambassador from Salm and Tur', from a fragmentary *Shahnameh* of Firdausi, attributable to Riza, Qazvin, c. 995–1005/1587–97, opaque watercolour, gold and ink on paper, page 40.7 × 26.1 cm, Chester Beatty Library, Dublin, MS 277, fol. 7b. Here Faridun, enthroned in a garden, rejects the peace proposal of his fratricidal sons' envoy.

92 (opposite) 'Man Attacked by a Bear', attributable to Riza, falsely ascribed to Bihzad, Qazvin, c. 1000/1592, ink on paper, 7.7 × 9.3 cm, British Museum, OA 1920.9-17.0254(3). Despite the spontaneity of this drawing, it almost certainly was not drawn from life.

their survival, whereas the only examples now in Iran are those that were acquired in the twentieth century.

Oddly, single-page paintings and manuscript illustrations from the reign of Shah 'Abbas rarely include carpets that are depicted with enough detail to identify them according to type. Despite descriptions of carpets on the floors of reception halls or placed on the ground for sitting, figures in paintings of this period are infrequently portrayed seated on carpets. They either sit directly on the ground or in buildings with solid-coloured textiles covering the floors or on thrones or tabourets. Whether this implies a distancing of imperial carpet makers from artists, that is, a change in the dependence of carpet makers on the *kitabkhaneh* for designs, or simply the development of new artistic styles in which such details as carpet design were unimportant remains unclear. The issue is further confused by the presence in paintings from the early seventeenth century onwards of cushion covers and clothing with figural designs rendered with great care and specificity. Furthermore, the designs of late sixteenth- and early seventeenth-century bookbindings do not parallel those of the Polonaise carpets, but develop more conservatively along the lines of sixteenth-century stamped, tooled and embossed models or are painted and lacquered. Only the pale colours of the carpets are duplicated in some Shah 'Abbas period bindings.

With the accession of Shah 'Abbas the royal artists' studio was quickly reconstituted. Artists such as Sadiqi Beg, Zayn al-'Abidin, 'Ali Asghar and his son Riza, Shaykh Muhammad, Siyavush and Habiballah entered the service of the shah and soon were engaged in the production of an illustrated *Shahnameh*. Although the manuscript was never completed and paintings were added in 1086/1676 by Muhammad Zaman, its sixteenth-century paintings are attributable on the basis of style to Sadiqi Beg, whom Shah 'Abbas appointed director of his artists' workshop, Riza, who worked jointly on some pages with his father, 'Ali Asghar, and a third anonymous artist, possibly 'Ali Asghar working alone. Zayn al-'Abidin was the illuminator.

The illustrations to Shah 'Abbas' *Shahnameh* under Sadiqi Beg's leadership reveal a fondness for certain motifs, such as jutting rock formations, found in his contributions to the 984–5/1576–7 *Shahnameh* of Isma'il II. However, as a group the illustrations to the later manuscript contain a greater degree of detail and a sharpening of expression gained from a reduction of extraneous figures. In 'Faridun Spurns the Ambassador from Salm and Tur' by Riza the figures' gestures and glances carry meaning, while typical Qazvin-style elements such as the go-between's skirt billowing to the right or new touches such as the furled blue curtain drawn hastily from the gate imply movement [fig. 91]. All of these factors plus Riza's remarkably fine brushwork contribute to the dramatic tension of the picture and herald within the traditional medium of the illustrated *Shahnameh* the first stirrings of a new style of painting.

While Sadiqi Beg produced at least one other illustrated manuscript in the period of the *Shahnameh* (c. 995–1003/1587–95),[22] he and Riza are best represented in the 1590s by their single-page drawings and paintings. Riza's earliest dated work from 1000/ 1591–2, a drawing of a seated middle-aged man holding a cup, contains an inscription stating that it is based on a design by Shaykh Muhammad.[23] From a stylistic point of view this is significant because it confirms Shaykh Muhammad as the inspiration not only for the composition of this drawing but also for its calligraphic line of varying thickness. Throughout the 1590s Riza and at times

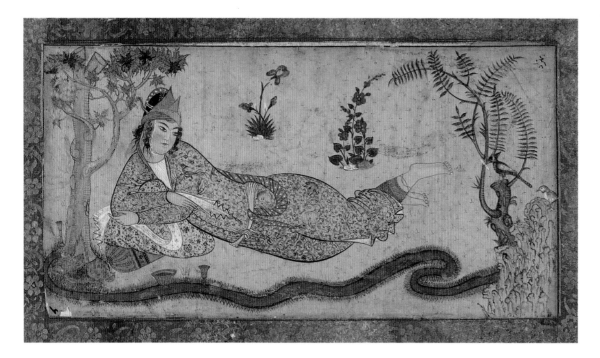

Sadiqi employed this fluid form of draughts-manship to define mass and suggest movement. Unlike earlier sixteenth-century drawings the contours of forms, such as the bear's back in 'Man Attacked by a Bear' [fig. 92], are broken rather than outlined by a single line of uniform thickness.

Another way in which Shaykh Muhammad may have influenced Riza and Sadiqi Beg is by exposing them to European paintings. According to Iskandar Beg Munshi, Shaykh Muhammad 'introduced the European style of painting in Iran and popularised it, and no one equalled him in the delineation of faces and figures'.[24] While greater naturalism is not immediately obvious in the portraits by Riza and Sadiqi Beg, both artists incorporated European figures in their work as early as the 1590s. Sadiqi Beg copied Flemish woodcuts[25] and Riza based a drawing of a nearly nude sleeping woman on an engraving by Marcantonio Raimondi.[26] He then produced a painted version of this figure in which he altered her pose, added a stream and more rocks to the setting, and placed a letter next to her.[27] In the hands of Sadiqi Beg or a close follower this figure was transformed into Balqis, the wife of Solomon, who received love letters from him carried by a hoopoe [fig. 93]. By depicting the figure awake and fully clothed in a robe with a remarkable *waqwaq* design, the artist has metamorphosed a European-inspired composition into a Persian image complete with Persian literary allusions.

The subject matter of Riza's and Sadiqi Beg's single-page works from the 1590s fall into two broad categories: portraits of young courtly figures of either sex and older men who are labourers, dervishes or of indeterminate class. The former type of portrait, whether painted or drawn, enjoyed a vogue through most of the sixteenth century and continued to be in demand in the seventeenth century. Drawings of dervishes and other non-courtly types, however, became extremely popular under the influence of artists such as Riza and Sadiqi as well as Muhammadi and Siyavush [fig. 94]. Despite Shah 'Abbas' suppression of the Sufis in 1002/1593–4,

93 (above) 'Balqis and the Hoopoe', attributable to Sadiqi Beg, Qazvin, 1590s, opaque watercolour and ink on paper, 9.9 × 19.2 cm, British Museum, OA 1948.12-11.08, Bequest of Sir Bernard Eckstein, Bt. Balqis, the Queen of Sheba, reclines beside a rivulet observing the hoopoe perched on a tree stump and holding a rolled *billet doux* from King Solomon in its beak.

94 (right) 'An Old Pilgrim', Isfahan, late 16th–early 17th century, watercolour and ink on paper, 9.7 × 5 cm, British Museum, OA 1920.9-17.0279(2). Drawings of shaykhs, dervishes, working men and the aged were particularly popular from about 1590 to 1610 and were often collected in albums.

writers often called attention to a person's humility by characterizing him as a 'dervish'. Moreover, the dervish's relative freedom from convention appealed to independent souls such as Riza and Sadiqi Beg but also to certain types of patrons who bought their work as well as that of their many emulators.

With the move of the capital to Isfahan, changes occurred in the royal *kitabkhaneh*. Sadiqi Beg ceased to be director, and was replaced by the calligrapher 'Ali Riza 'Abbasi who supplied the inscriptions to the Friday mosque in Qazvin and the two mosques in the *maidan* at Isfahan. From about 1011/1603 to 1019/1610 Riza abandoned his work for the court and a period ensued in which he depicted only dervishes, wrestlers and non-courtly figures. When he returned to the royal atelier, his style changed markedly. In place of the calligraphic speed that had characterized his drawings and the fine brushwork and the exquisite rendering of textures of his paintings, closed contours and thick lines now typified his drawings while his paintings featured a new palette in which purple and yellow ochre predominated. In all his works the silhouette of the figures now tended towards bottom-heaviness, accentuated by the large melon-shaped thighs and narrow shoulders of both men and women. As late as the 1620s Riza still recalled his artistic forerunners, as a portrait based on a work by Muhammadi demonstrates [fig. 95]. Despite the return to the slender, elongated torso of the 1560s and 1570s, Riza has given the figure a seventeenth-century face complete with thick eyebrows which meet, round cheeks and full lips.

Like his and Sadiqi Beg's drawings of the 1590s, Riza's paintings of Isfahani youths from about 1019/1610 until his death in 1044/1635 set the style for a group of artists who were active during the reigns of Shah 'Abbas' successors, shahs Safi and 'Abbas II. At the end of his life Riza portrayed a European, and in a portrait by one of his students Riza is shown painting a man in European dress. This type of work not only reflected the increasing presence of Europeans in Isfahan but also demonstrates Riza's innovative role in Safavid painting throughout his long career. Although European ideas entered Persian painting slowly through the work of Shaykh Muhammad, Riza and Sadiqi Beg, the momentum increased after the death of Shah 'Abbas and ultimately European art exerted as much influence on Persian painting as Chinese art had done in the fourteenth and fifteenth centuries.

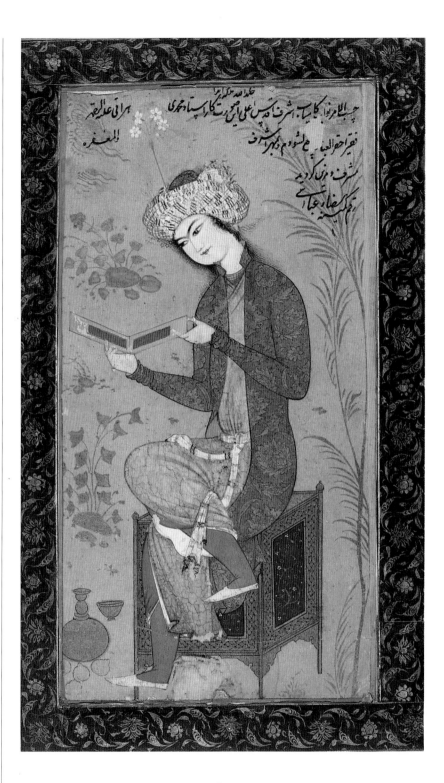

95 'Youth Reading', signed by Riza-yi 'Abbasi, c. 1035/1625–6, opaque watercolour, gold and ink on paper, 14.5 × 8 cm, British Museum, OA 1920.9-17.0298(3). This painting is based on a work by Muhammadi.

Although the paintings of Riza from the late sixteenth and early seventeenth century rarely include figures in garments of anything but plain cloth, his works of the 1620s portray men and women dressed in elegant brocades with large patterns and a great quantity of gold. Fabrics of this type had been in production since at least the beginning of the seventeenth century, since they are listed in European archives as early as 1603.[28] Given the large scale of their patterns, it seems likely that such textiles were intended for use as furnishing fabrics, not for garments, except heavy cloaks. The patterns, weave and weight of textiles used for most clothing until about the 1620s are represented by a group of eight pieces with the signature of Ghiyas, a master textile designer from Yazd who enjoyed favour at the court of Shah 'Abbas.[29] These compound satins consisted of scenes derived from Persian literature, such as

Layla visiting Majnun in the desert, and have a wealth of floral and vegetal detail in the field between the figures and animals. The vocabulary of bookbindings and manuscript borders also occurs in early seventeenth-century figured textiles, as is evident on a hat with animal combats and Chinese style *chi'lins* [fig. 96]. Although the shape of this hat is not found often in Persian painting of the early seventeenth century, its shape and the two slits in its brim are related to those found in a hat on a figure depicted by Riza in 1023/1614.[30] Certainly the robe worn by Balqis in figure 93 would have been made of this type of fabric, even if no textiles with the *waqwaq* design have survived.

Unlike the carpets, which appear little influenced by the *kitabkhaneh*, the designs of the finest figured textiles may have originated in the artists' workshop, after which they were 'translated' by men called *naqshband*, such as Ghiyas, into terms that were understandable to weavers. Qazi Ahmad mentions one Maulana Kepek who 'was good at 'aks, and in mastering that art made [new] discoveries. He created curious images, wonderful designs, rare colorings.'[31] Although Minorsky takes '*aks* to mean the gold painted decoration found in the borders of illuminated manuscripts [see fig. 42], he notes that Bayani says that '*aks* refers to the use of stencils. If so, the standard forms of chinoiserie decoration could have been easily passed among artists working in different media. As some large-scale velvets featured standing figures alone or in pairs, the direct influence of painters working in the royal atelier seems more likely. A famous velvet[32] in which a youth in an extravagant turban inclines his head towards the falcon perched on his hand not only reproduces the silhouette of Riza's Isfahani

96 (left) Hat, early 17th century, silk, compound cloth, h. 19 cm, w. 31 cm, Keir Collection. As the 16th century progressed, men's headdresses branched out from turbans to include a variety of caps, with or without fur lining. Hats with a split brim such as this one appear in the 1576–7 *Shahnameh* of Shah Isma'il II and later.

97 (right) Textile fragment, early 17th century, silk, double cloth, 32.5 × 17.5 cm, British Museum, OA 1985.5-6.1, acquired with funds given by Edmund de Unger, Esq. As the group of related red and off-white silk textiles ranges stylistically from the last quarter of the 16th century to the first quarter of the 17th, it is probable that they were the speciality of one workshop or locality.

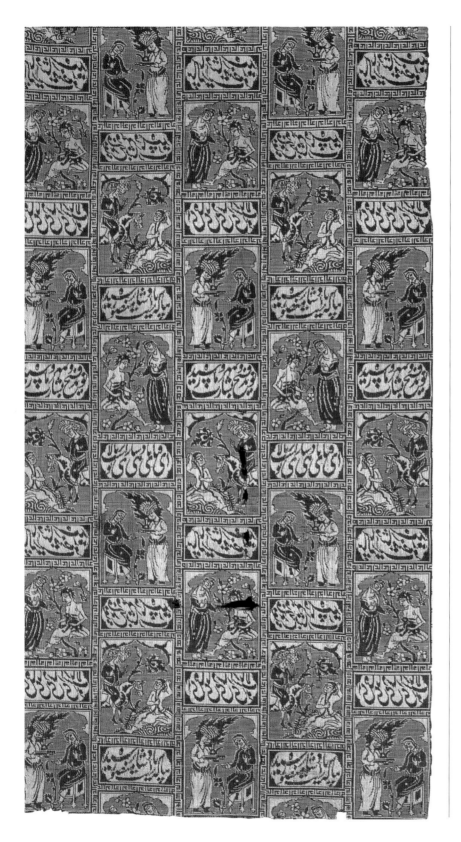

youths but also simulates his staccato treatment of turban and sash fringe with clusters of silver-foil-wrapped loops. These luxury fabrics were used for garments as well as furnishings. The appearance of cushion covers with expressively drawn figures who sometimes gaze at the 'real' sitter in the picture[33] may also indicate close co-operation between weavers and painters, though the latter were certainly exercising artistic licence in these works. Finally, like certain types of carpets, some classes of textiles that had first been produced in the sixteenth century [see fig. 61] continued to be manufactured in the seventeenth [fig. 97]. Although the same format of rectangles containing pictorial vignettes from the story of Layla and Majnun and inscriptions appears in seventeenth-century silk, the figural style has been adapted to that associated with the Isfahan school of painters. Textiles such as this provide a glimpse into the exigencies of the market, namely the need of weavers to amend the patterns of their wares to reflect the fashion of the day.

Although foreign visitors to the court of Shah 'Abbas describe the use of gold vessels at banquets, the great majority of extant metal objects from the late sixteenth and early seventeenth centuries are made of brass or tinned copper. A brass pillar candlestick dated 996/1588–9 demonstrates the continuity of this form at the beginning of the reign of Shah 'Abbas.[34] Its shaft is faceted and decorated all over with a split-leaf palmette and arabesque design. The socket and the transition to the foot each have a central inscription band set between a row of floral scrolling, repeated in simplified form on the sides of the foot. Likewise, a pillar candlestick dated 1007/1598–9 and signed by Muhammad [ibn] Ahmad retains the faceting and inscription bands above and below its shaft [fig. 78]. However, this piece is decorated with sixteen vignettes of youths and girls pouring wine, playing music or lounging on cushions, as well as one image of Layla and Majnun in the wilderness. Moreover, the surface of the zigzag band in the middle of the shaft, the base and the ridges near the socket are all enamelled. This is a very early and rare occurrence of enamelling in Safavid metalwork. Although the workmanship on this piece is somewhat careless, the figured imagery and enamelling suggest that its maker was experimenting with new effects on an established shape of object.

An undated flask in the British Museum [fig. 98] bears very similar decoration on its elegantly rounded body and thus must be

close in date to the 996/1588–9 candlestick and possibly from the same place of manufacture. On the neck, above and below a flattened boss, rise overlapping ogives between pairs of elongated leaves, simplified in the uppermost band. The shoulder contains an inscription in five cartouches that refers to the function of the flask. Although its shape resembles that of the vessels held by young wine-servers in Safavid painting, this flask was most likely used for ablutions in conjuction with a basin from which it has become separated.

An undated brass basin [fig. 99] is decorated with arabesques and split-palmette leaves very much along the same lines as those found on the body of the flask. Its shape with compressed rounded sides, no foot, a slightly everted neck and minimal lip is generally analogous to that of a group of basins published by Melikian-Chirvani of which one is dated 1013/1604–5.[35] The decoration of a tinned

copper bowl [fig. 100] of similar shape, however, relates far more closely to that of the group discussed by Melikian-Chirvani which he assigns to a Khurasan production site and to an undated bowl which he attributes to western Iran.[36] Although its decoration is hardly as sharp as that of the Khurasan group, the organization of motifs on the body of the basin recalls the alternation of ornament and voids that one finds on both the Khurasan and the western Iranian bowls. Around the neck runs an inscription in cartouches separated by undecorated quadrilobes. Suspended at intervals from a narrow band of joined trilobes, half ovals with trefoils join alternately to cartouches with overlapping scrolls and larger quatrefoils enclosing animals in cusped roundels. The blank areas between these design elements contain multipetalled flowers. Although at least two major schools of metalwork must have

98 (above) Flask, c. 998/1590, cast brass, engraved decoration, h. 37.8 cm, British Museum, OA 78.12-30.735, Henderson Bequest. Makers of Safavid base metal objects maintained the elegant forms associated with gold and silver wares.
99 (below) Basin, late 16th–early 17th century, inscribed with later owner's name, Muhammad Hasan al-Husayni, cast brass, engraved decoration, h. 12.1 cm, diam. 28 cm, British Museum, OA 78.12-30.733, Henderson Bequest.

100 (below) Bowl, late 16th–early 17th century, cast copper, originally tinned, engraved decoration, inscribed with owner's name, Rahim, h. 9.5 cm, diam. 24 cm, British Museum, OA 1969.2-12.1, Gift of H.A.N. Medd, Esq. Most likely, bowls of this type were produced with blank cartouches which could be engraved with the owner's name at the time of purchase.

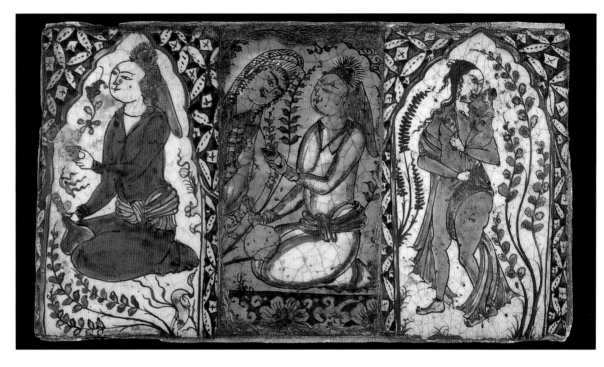

101 Tile panel, north-west Iran, late 16th–early 17th century, stonepaste with polychrome underglaze decoration, 26.5 × 46 cm, British Museum, OA 1895.6-3.1-3. In addition to two vignettes of drinkers, this panel includes on the right a mother and child, probably derived from a European image of Venus and Cupid or Mary and Jesus.

existed in the early seventeenth century, the metalworkers relied on a very similar range of ornament and, like bookbinders, some produced groups of pieces covered in non-figural decoration while others included human and animal figures and left certain areas of their pieces undecorated. Objects were also produced from the beginning of the seventeenth century which combined all-over decoration and human and animal forms, producing a type of ornament that recalls the silks with figures and inscriptions in separate compartments.

From the period of Shah 'Abbas a greater variety of shapes of metal objects is available. Thus bath pails with bulbous shoulders narrowing to a base of approximately half their diameter are found in various collections.[37] The same profile is employed, with the addition of long crescent-shaped spouts, for vessels used for pouring water in the bath,[38] a shape that is sometimes copied in ceramic. Footed tinned copper bowls used for liquids range in shape from examples with low sides and a splayed foot to the type with high walls, an everted rim and a low slightly conical foot.[39] Metal hawking drums are depicted in paintings from the fifteenth century on but only appear as extant objects from the late sixteenth century.[40] Finally, as early as 1011/1602–3 a new shape of ewer was intro-

duced to the corpus of Safavid metalwork.[41] On the basis of a related fifteenth-century Indian example Zebrowski has suggested that the shape entered Iran from India, but sixteenth-century Chinese blue and white ceramic vessels related to this shape are also extant. The unusual form of the ewer and its ceramic counterparts consists of a body in the shape in profile of an inverted spade with a hollow handle in the shape of a rounded arch rising from the shoulders. At the top of this is a casket-shaped device with a hinged lid into which liquid can be poured. A spout attaches to the upper body below the handle and rises up before turning out. The foot is high and slightly everted or terminating in a splayed band. The shape of this ewer diverges sufficiently from that of its long-necked counterparts of the sixteenth century to suggest a taste for the exotic which would not be unexpected in the cosmopolitan city of Isfahan in the early seventeenth century.

Much of the ceramic production during the reign of Shah 'Abbas relies heavily on Chinese and celadon prototypes. Certain styles such as Kubachi wares enjoyed their last hurrah in the first quarter of the seventeenth century, and discrete groups of monochrome wares suggest that some potters were centred in Isfahan. The Kubachi wares that indicate a date in the period of Shah

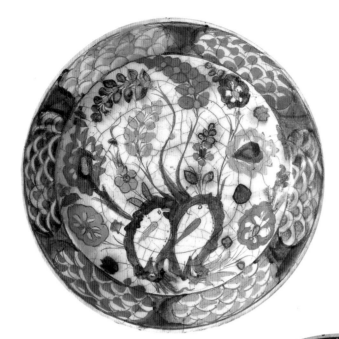

'Abbas are tiles [fig. 101] and flat-rimmed dishes decorated with figures wearing the headgear of c. 1008/1600 in polychrome glazes on a white, turquoise or coral ground. Other dishes of the same shape contain vegetal ornament without figures [fig. 102], while a number of pieces with similar decorative motifs are glazed in blue, black and white alone [fig. 103]. A further group assigned by Lane to north-west Iran around 1008/1600 is the continuation of the north-west Iranian group of wares decorated in black under turquoise or green transparent glazes which had begun in the fifteenth century. By the beginning of the seventeenth century the decoration has lost much of its earlier solidity to flimsy, sketchily drawn forms [fig. 104]. Although textual information is absent, the most likely explanation for the decline of the Kubachi wares is the turmoil that engulfed Azerbaijan in the last quarter of the sixteenth century as the result of Ottoman invasions and occupation. By the time Shah

'Abbas restored Tabriz to the Safavids, its potters, if indeed they were the makers of Kubachi wares, must have moved to Qazvin, Isfahan or elsewhere, but their wares were superseded by those of other centres.

One group of monochrome ceramics exhibits a close relationship to painting of the Isfahan school, which suggests that the moulds for the pictorial motifs on the sides of flasks, small bottles and small hookah bases derived from drawings by painters and illuminators. The images include a man with a lion on a chain,[42] derived from a drawing by Sadiqi Beg,[43] two camels in combat[44] based on a famous and often copied composition by Bihzad, a couple *in flagrante* with a sleeping duenna in attendance, young men in landscape,[45] and a number of variations on floral arabesques within arched panels. Some of the small arch-shaped bottles have two openings, indicating that they are hookah bases. The tube which attached to the mouthpiece would have been fed

102 (opposite, top left) Dish, north-west Iran, late 16th–early 17th century, stonepaste with polychrome underglaze decoration, diam. 26 cm, British Museum, OA 1970.7-16.1. The sketchily drawn decoration in the centre of the dish includes a pair of plump birds in a pool from which wavy-stemmed plants grow.

103 (opposite, top right) Dish, north-west Iran, late 16th–early 17th century, stonepaste with underglaze blue and black decoration, diam. 39.7 cm, British Museum, OA 96.6-26.6, Gift of Sir A.W. Franks. While the panels in the cavetto derive from Chinese prototypes, the turbaned figure in the centre of the dish with his oddly stunted hand is painted in the late Qazvin–early Isfahan style.

104 (opposite, centre) Dish, north-west Iran, c. 1008–9/1600, stonepaste with underglaze black decoration under a transparent turquoise glaze, diam. 34.3 cm, British Museum, OA 1904.6-30.1. Ceramics painted in black under a turquoise glaze first appeared in Iran in the 12th century and continued to be in vogue well into the Safavid period.

105 (right) Ewer, Mashhad?, signed by Mahmud Mi'mar Yazdi and decorated by Zari, dated 1027/1616–17, stonepaste with underglaze blue decoration, 19th-century metal spout, h. 24.8 cm, British Museum, OA 1902.5-21.1. The blue and white decoration is based on Chinese models but the shape of the piece stems from Indian metal ewers.

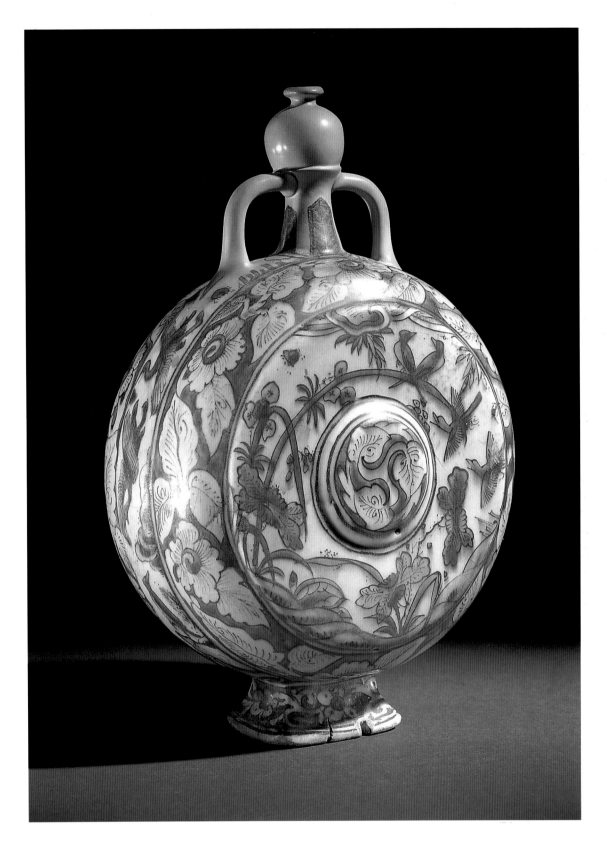

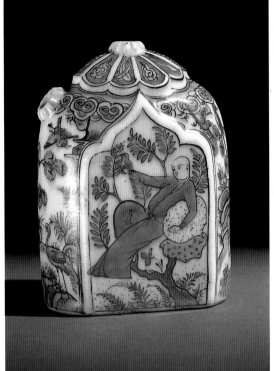

106 (left) Pilgrim flask, Mashhad, dated 1036/1626–7, stonepaste with underglaze blue and black decoration, modern knob and handles, h. 22.4 cm, British Museum, OA 1950.10-19.1. Like many blue and white Safavid ceramics, this piece has three Chinese-style characters on its base.

107 (above) Hookah base, Mashhad, c. 1019–40/1610–30, stonepaste with underglaze blue and black decoration, h. 13.6 cm, British Museum, OA 1910.5-11.2. The reverse side of this piece depicts the youth trying to coax the bird from the tree, whereas here he has succeeded and has it in his grasp.

into the side hole, through the water and out of the top hole to the bowl of tobacco. Tobacco had been introduced to Iran at least as early as 1021/1612[46] and being an addictive substance had caught on immediately. Despite occasional government prohibitions, tobacco-smoking remained popular and generated the production of a range of ceramic water-pipes. A painting by Riza dated 1029/1630[47] depicts an archer smoking a pale green glazed pipe with a face on its side. In shape it is identical to the extant mono-chrome-glazed moulded pipes, indicating their use, if not their manufacture, in Isfahan.

Although European travellers to the court of Shah 'Abbas do not mention specific pottery-making centres, later visitors such as Jean Chardin list Shiraz, Mashhad, Yazd, Kirman and Zarand as the primary sources of Persian ceramics, of which the most beauti-ful, he claims, were made in Shiraz.[48] Of these cities, Kirman is mentioned most often by other Europeans, but even Isfahan is alluded to with respect to its potters. While no pottery from the reign of Shah 'Abbas can be assigned to Shiraz, Yazd and Mashhad present a more promising picture. A ewer decorated in underglaze blue and dated 1027/1616–17 bears two inscriptions, stating 'work of Mahmud Mi'mar [the architect] Yazdi' on the opening of the handle and 'the poor Zari is its decorator 1025' under the foot [fig. 105]. The inscriptions imply that the vessel was 'built' or at least its form was provided by Mahmud, but that Zari painted the decora-tion. Although the *nisba* 'Yazdi' might indicate that the piece was made in Yazd, Lane has suggested that Mahmud Mi'mar Yazdi may be the same as Kamal al-din Mahmud Yazdi who built the golden dome of the Sahn-i Kuhna at the Mashhad shrine in 1015/1606–7. If so, perhaps the vessel was made at the established ceramic centre of Mashhad for the pilgrim market or for donation to the shrine.[49]

As previously mentioned, metal ewers of this shape were produced in Iran as early as 1011/1602–3, but their shape derived from prototypes produced in India from the mid-fifteenth century onwards. Possibly, as with the tall pillar candlestick made in Lahore in 946/1539 and now in the Mashhad shrine, the shape of this ewer was adapted by Iranian metalworkers and then potters from an Indian example presented to the shrine. The decoration of the blue and white vessel consists of panels on the body containing a waterfowl in landscape with a mountain and round blossoms floating in the sky, a deer and a bird before a stylized waterfall, a waterfowl in landscape with palm trees, a waterfowl in landscape with a mountain and floating daisies, and a panel of stylized cloud and other 'illegible' motifs below the spout. The sides of the handle are decorated with birds and flowering branches, and stylized cloud forms appear on the top of the handle, the top of the body and as pendant trefoils in a band on the shoulder of the vessel. The splayed foot has lotus panels below a ridge with cusps around its upper edge.

In 1020/1611 Shah 'Abbas donated 1162 pieces of Chinese porcelain plus half his library and money for renovation of the Dar al-Huffaz, tombs and Chini-khaneh at the Ardabil shrine. Among the blue and white porcelains that he gave are at least five sixteenth-century plates that contain deer in landscape near a waterfall.[50] Such plates were presumably also to be found in other collections and thus available for potters such as Zari to adapt to their needs. Likewise, the Chinese plates that were sources for the birds in landscape were exported,[51] but the Persian potter has simplified the original scene, reducing the number of birds from two to one and misunderstanding the clusters of pine needles so that they are transformed into floating 'daisies'. Although the compositional elements of Mashhad wares have been characterized as having black outlines to keep the blue glaze from running, the lines are absent from this vessel.

Unfortunately the 1027/1616–17 ewer has limited use for assigning other blue and white pieces to the early seventeenth century because of its unusual shape and the absence of black outlines. A pilgrim flask dated 1036/1626–7 below its rectangular foot, however, has more features that can be associated with Mash-had [fig. 106]. Its flat sides consist of a central boss with three leaves in white reserved on a blue ground. Around this is a band with birds perched on a branch above a landscape. The outer band includes leaves and flowers with thinly striated veins on a blue ground. Along the join of the two sides the potter has painted flying ducks and bees. Although many of the design elements are outlined in black, this has not kept the blue glaze from running. The plump flowers with striated veins and the fondness for depicting them in reserve seem to be typical of the Mashhad group. Yet within this

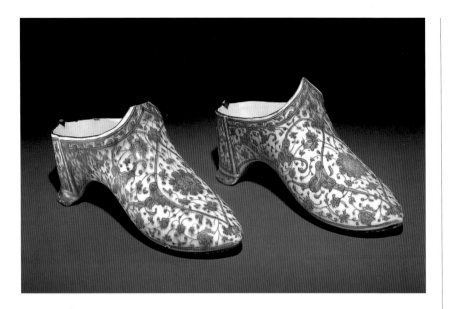

108 Bath rasps in the shape of a pair of shoes, Kirman, early 17th century, stonepaste with underglaze blue decoration, l. 24.4 cm, British Museum, OA 87.6-17.3, Gift of Sir. A.W. Franks. Various uses, including as a pair of vases, have been suggested for these ceramic shoes: it is most unlikely, despite their authentic shape, that they were ever worn.

style the quality of draughtsmanship varies considerably and cannot always be taken as an indication of date. For example, the details of a hookah base decorated with a youth in a tree [fig. 107], a favourite early seventeenth-century theme, have been rendered with great care, but the piece must date to the second or third decade of the century, the same period as the two dated pieces discussed here.

While some distinct groups of ceramics, such as the monochrome glazed moulded wares, may have been produced in Isfahan, and the Mashhad blue and white wares present a fairly uniform picture, the pottery of Kirman was far more plentiful and varied in style. The genesis of Kirman and nearby Zarand as major pottery producing centres is not entirely understood, but certain aspects of this development can be proposed. As early as 1000/1591–2 Ganj 'Ali Khan, one of Shah 'Abbas' retainers when he was a prince at Herat, had been appointed governor of Kirman. By 1007/1598 the building of a large complex including a *caravansarai*, a mosque, two bazaars, a *maidan*, an administration building and a cistern had

been completed at Kirman. This not only included panels with inscriptions by 'Ali Riza 'Abbasi, but also elaborate chinoiserie tile panels. Assuming the tiles were made locally, they would have required a specialized workforce. Possibly a group of potters emigrated to Kirman to work on this project and then established themselves there making a full range of ceramic objects. To speculate on the identity of these potters, one might recall the decline of Kubachi wares at the end of the sixteenth century and suggest that potters of north-west Iran might have emigrated to Kirman. This is not entirely idle speculation for two reasons: Ganj 'Ali Khan himself was a Kurd and presumably maintained strong ties with his

109 Imitation celadon charger, Kirman?, early 17th century, stonepaste with opaque green glaze and fluted cavetto, diam. 42.5 cm, British Museum, OA 1949.4-14.1. The impact of Chinese celadon wares on Persian and other Islamic ceramics was almost as great as that of blue and white porcelains. From the 14th century onwards Persians imitated the shapes and tried to match the colours of the Chinese originals.

Kurdish tribesmen as 'all the Kurdish contingents that had accompanied the Shah on [the] expedition [to Qandahar in 1031/1621–2] were placed under his command'.[52] Thus Kurdish craftsmen from north-west Iran might have considered Kirman a safe or desirable place to which to relocate. Further, on the basis of the stylistic connection between dragon carpets made in the Caucasus in the fifteenth century and mid-sixteenth-century vase carpets, most likely from Kirman, it has been proposed that through nomads or some shift of the producers of dragon carpets the design and technique were brought to Kirman.[53] Although the Caucasus is north of north-western Iran, the movement of people from that region to Kirman represents the same north-west/south-east trend as the proposed relocation of Kubachi potters. The continuation of pottery production at Kirman and Zarand is more easily explained by the proximity of Kirman to the Persian Gulf port of Bandar 'Abbas directly to the south, which was a major entrepôt for trade to India, the Far East and by sea to Europe.

Little external evidence exists to indicate which seventeenth-century ceramics were made in Kirman or Zarand, and dated pieces from the reign of Shah 'Abbas that would help to place groups thought to be from Kirman are lacking. On the basis of pieces dated to the end of the seventeenth century and other fragments that were found near Kirman, certain general stylistic traits can be identified. The very sharp drawing and fondness for spiky leaves found on Kirman polychrome wares that may be from the second half of the century may have antecedents in the carefully painted arabesques on a pair of bath rasps in the shape of shoes thought to have been produced at Kirman [fig. 108]. Although it has been suggested that such novelty pieces were based on Delft examples,[54] it is more likely that they were made for export to Europe, where the Dutch East India Company mixed them with Chinese export wares for sale to clients. A later class of slip-decorated monochrome wares may have antecedents in a group of large green glazed dishes [fig. 109] that copy Chinese celadons, but again no external information gives a preference to their having been made in Kirman.

However, they are characterized by spur marks in the foot which are also found on later Kirman wares.[55] Finally, a group of hexagonal and octagonal dishes has been assigned to Kirman. These have no painting in the cavetto, simple lozenge designs on their rims and decoration that is either of Chinese inspiration or after Persian paintings. The clarity of draughtsmanship is consistent with other early pieces from Kirman and the shapes survive into later periods of Kirman ceramics. Much remains to be learned about the Kirman and Zarand kilns in the first quarter of the seventeenth century, but the period of Shah 'Abbas I was most likely the formative era of Kirman ceramics before the great expansion in production from about 1050/1640 until the end of the century.

So many ceramics, metal objects, carpets, textiles, books and buildings remain from the reign of Shah 'Abbas that one can hardly do them justice, much less discuss other media at any length. The opening up to Europe not only changed the style of Persian art, it enabled the Iranians to import materials such as glass that were not produced locally. From paintings depicting half-empty carafes of red wine, we know that such bottles were in use by the 1620s. Moreover, they must have been a popular item as they appear in portraits of fashionable courtesans. Other items such as gems with the seal of Shah 'Abbas are rare but do exist. At court the beautiful young attendants are described by foreigners as having turbans stuck with large plumes and jewels, so their existence is not surprising. Finally, this was the era in which cut-steel panels in the shape of cartouches were apparently beginning to be fashioned for application to wooden doors. The tradition gained strength over the course of the century, as a later dated example will show (see fig. 146). Although Isfahan was the undisputed heart of Shah 'Abbas' Iran, many other cities such as Shiraz and Kirman blossomed in the first quarter of the seventeenth century thanks to the wealth of their governors or the shah's energetic development schemes. It would have been a remarkable time to see Iran, and we are fortunate nearly four hundred years later that so much of it survives.

7

A Voluptuous Interlude

Shah Safi

1629–1642

. . . Shah Safi, that Persian Ivan-the-Terrible . . . [1]

On 24 Jumada I 1038/19 January 1629 Shah 'Abbas died of fever at Ashraf in Mazandaran. Unlike Shah Tahmasp, he had given his succession some thought and had chosen his grandson, Abu'l-Nasr Sam Mirza, to be the next shah. Within a month of the burial of Shah 'Abbas in Kashan, Sam Mirza, dubbed Shah Safi, had been officially crowned. The magnitude of Shah 'Abbas' influence on all aspects of Persian life had to some extent obscured the negative aspects of his legacy, and only with the accession of the eighteen-year-old Shah Safi did these inherited problems surface.

At the start of his reign in 995/1587 Shah 'Abbas had married two women on the same day: one was his first cousin, the daughter of the fifth son of Shah Tahmasp, and the other was the widow of his older brother, Hamza Mirza. In 999/1590–91 Shah 'Abbas appointed his infant son, Muhammad Baqir Mirza, known as Safi Mirza, governor of Hamadan, with a Qizilbash guardian, thereby following the pattern set by his own parents in sending him to Herat at age two. However, in 1023/1614 rumours of Safi Mirza's plots to overthrow his father reached Shah 'Abbas' ears and in the following year he was murdered by a servant 'as a mark of his fidelity' to the shah.[2] At this point Shah 'Abbas broke with tradition and confined his other sons to the harem, which not only deprived them of any education in statecraft or war, not to mention academic subjects, but also exposed them to levels of intrigue that were far more treacherous than the whisperings of court officials. Inevitably, Shah 'Abbas came to distrust his two surviving sons, Sultan Muhammad Mirza and Imamquli Mirza, and ordered them to be blinded. Like the brothers of Shah 'Abbas, whose eyes were put out in the beginning of his reign, these two sons were considered unfit to rule because of their blindness. The other two sons of Shah 'Abbas predeceased their father, which left him no choice but to name his grandson, the son of Safi Mirza, as his heir.

Not only did the murder of Safi Mirza fill Shah 'Abbas with gloom without alleviating his distrust of his other children, but also it set a terrible precedent for Shah Safi. Within five years of his accession he had ordered the assassination of almost all the Safavid princes, including his uncles who had already been blinded, as well as a number of the leading military and administrative officials who had risen up the ranks under Shah 'Abbas. With the execution of Imamquli Khan, an enormously rich and powerful man who was

110 Detail of fig. 114.

the governor of Fars, Kuhgiluya, Lar, Hormuz, Bahrain, Gulpaigan and Tuysirkan, and most of his sons in 1041/1632, Shah Safi converted all his territories into crown lands. Although such a callous move in one stroke greatly enhanced the central treasury and power of the shah, it was symptomatic of a trend that ultimately weakened the Safavid state. In regions controlled by provincial governors the governors were responsible for maintaining armies at their own expense, which they funded by taxes and other income. When these provinces converted to crown lands, the money for defence came from the royal treasury. Royal appointees collected taxes in their areas, but the system was open to abuse and the local populations were often resentful. Under a strong, judicious king like Shah 'Abbas, excesses were kept in check, but Shah Safi was not equipped to keep the system in balance and his subjects content.

Shah 'Abbas' centralizing tendencies had also changed the nature of artistic patronage. Under his predecessors the royal *kitabkhaneh* had functioned as the source of designs for bookbindings, illuminations, lacquerware, some classes of ceramics, architectural inscriptions and decoration, metalwork and certain types of carpets and textiles. As a result of the disrupted royal patronage under Shah Muhammad Khudabandeh and the dispersal of artists and calligraphers, Shah 'Abbas was compelled to reconstitute the *kitabkhaneh*. However, rather than follow the model of his grandfather, which was based on a Timurid structure, 'Abbas instituted a system of royal workshops for the manufacture of luxury textiles and other commodities which were intended for external trade as well as domestic use. While the *kitabkhaneh* continued to operate as a royal scriptorium with calligraphers, painters, bookbinders, illuminators and related craftsmen, it ceased to be the fount of designs for carpet makers and some textile makers once the capital moved to Isfahan in 1006/1598. Furthermore, the designs of carpets and textiles produced expressly for foreign markets would have had a looser connection with the taste of the monarch than those of the sixteenth century which emanated from the *kitabkhaneh*. Both Persian and foreign observers from the time of Shah 'Abbas have remarked on the simplicity of his clothes and personal adornment, which suggests that rather than being an expression of his personal taste, his support for the royal monopoly

in the trade in silk and carpets was grounded in economic pragmatism.

While Shah Safi maintained the royal workshop system, he abandoned the royal monopoly in the silk trade. Instead of sending royal agents annually throughout Iran to buy up all available silk, he allowed merchants to buy the silk at source. This change occurred because the Armenian merchants of Isfahan 'had consolidated their hold on Persian commerce, mostly over exports and imports of silk and cloth respectively, and had spread their interests into internal trade, too',[3] thus forming a monopoly of their own. Even if the shah did not enjoy the massive profits on the sale of silk of his predecessor, the market expanded during his reign, bringing in more money through duties paid on exports.

Despite Shah Safi's reputation for cruelty, his innate weakness and lack of leadership encouraged the perennial enemies of Iran, the Ottomans and Uzbeks, as well as the Mughals, to seek military advantages during his reign. Within six months of his accession the Ottoman army, led by the grand vizier, had started moving towards Iran, but it was not until the following spring that the Ottomans scored a victory in battle and occupied Hamadan. While the Persians eventually regained control of the city, they suffered repeated Ottoman incursions until 1045/1635 when Erivan was lost and Tabriz was plundered. Even after the Persians regained Erivan in the spring of 1045/1636, the Ottomans would not agree to a peace treaty. Instead, in Sha'ban 1048/December 1638 they invaded Mesopotamia and took Baghdad. The Persians could not have anticipated in the aftermath of this Ottoman conquest that they had lost Mesopotamia forever, but the Treaty of Zuhab, which was signed on 14 Muharram 1049/17 May 1539, marked the permanent end to the Iranian presence in Mesopotamia and to hostilities between the Ottomans and the Safavids.

In the east the Uzbeks, led by the Janid khans of Bukhara and Balkh, staged eleven major raids of Khurasan during the reign of Shah Safi. True to form, these campaigns were plundering exercises but the armies, which numbered in the tens of thousands, might have had a longer lasting impact on Iran if their leaders had so desired. The loss of Qandahar in 1048/1638 stemmed from the disaffection of the local ruler from the Safavid court after the grand vizier, Saru Taqi (as Mirza Muhammad Taqi was called), had with-

drawn certain subsidies. The local ruler simply placed himself and Qandahar under the jurisdiction of Shah Jahan and the city passed into Mughal control.

Despite being outmanoeuvred in Qandahar, Saru Taqi deserves much of the credit for keeping the government and economy of Iran steady and on track during the reign of Shah Safi. Descended from a line of government administrators, Saru Taqi distinguished himself during the reign of Shah 'Abbas by overseeing the raising and widening of the roads and bridges in Mazandaran leading to Farahabad and Ashraf. From 1025/1616–17 until the death of Shah 'Abbas, he held the position of *vazir-i kull* of Tabaristan, comprising Mazandaran and Rustamdar. In 1043/1634 Shah Safi appointed him to the post of grand vizier. Saru Taqi was notably efficient but overly powerful and thus not universally loved. However, he also helped fill the intellectual vacuum that resulted from the shah's inadequacy and decadent way of life. A notable patron of architecture, he supervised the reconstruction of the Shiite shrine at Najaf in 1040/1631 and later, as grand vizier, built palaces and other buildings in Isfahan.[4]

When Shah Safi died in 1051/1642 of the effects of taking alcohol as an antidote for opium, to which he had long been addicted, Iran was at peace and financially sound. The arts had not suffered but neither had any major monuments been constructed, though a few royally commissioned buildings had been erected in Isfahan, Shahristan and Turbat-i Haydariyya, and a few others had been renovated.[5] One monument, the Madrasa Mulla 'Abdullah, was constructed on the north-east corner of the Naqsh-i Jahan *maidan* next to the *qaisariyya* bazaar. It is oriented at an angle to the *maidan* in the same way as the Masjid-i Shah and the mosque of Shaykh Lutfallah, but otherwise its square four-*ivan* plan is not unusual. Its construction may indicate a desire on the part of Shah Safi to continue the work of his grandfather in developing the area around the *maidan*. Of course, the decoration of the Masjid-i Shah

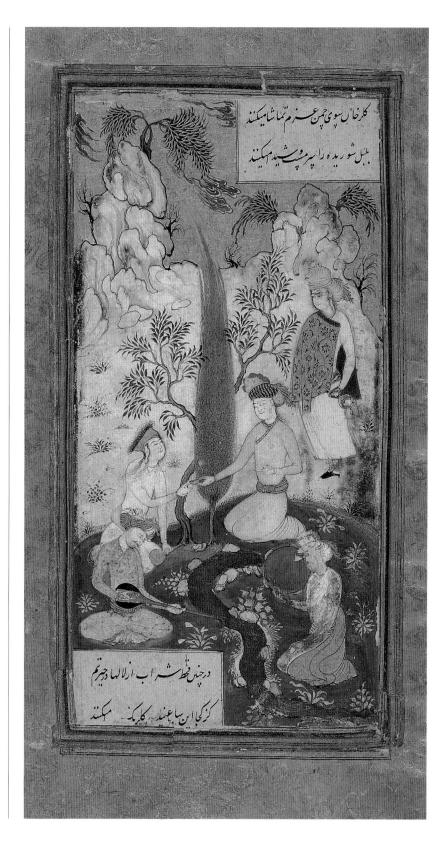

111 'A Young Man Entertained Outdoors', from a *Divan* of Baqi, dated 1046/ 1636, opaque watercolour, gold and ink on paper, page 28.2 × 17 cm, British Library, Add. 7922, fol. 2*r*. The format of this picture with its limited number of figures and pronounced verticality is in accordance with Riza-yi 'Abbasi's latest illustrated manuscript, which may also have been made for Shah Safi.

continued under Shah Safi, when marble slabs were placed on the dadoes of the monument, but these are in keeping with the stated aims of Shah 'Abbas and his architects and do not represent a stylistic departure. Possibly Shah Safi also saw no need for investing large sums of money in architecture when so much of the royal precinct of Isfahan was newly built. In short, there is scant evidence for any more than the faintest interest in architecture on the part of Shah Safi, and innovation was the province of well-placed non-royal patrons such as Saru Taqi, not the king himself.

Painting during the reign of Shah Safi suffered less neglect than architecture. Riza-yi 'Abbasi was still alive and remained active until his death in Shawwal 1044/April–May 1635. In the 1620s he had painted many single-figure portraits but had also produced a group of works based on originals by Bihzad which correspond to the Timurid revival in painting and architecture that occurred in the second and third decades of the seventeenth century. Dotted among the straightforward portraits of young men carrying flasks in this period are more elaborately rendered figures of courtesans which provide a foretaste of the more remarkable of his last paintings. These works, portraying a rather decrepit Qizilbash archer and a European feeding wine to his dog,[6] come close to caricature, in which at his advanced age Riza must have felt he could safely indulge. Although no seals or inscriptions indicate royal patronage, one painting and one illustrated manuscript may have been intended for the new shah. The painting depicts a pair of lovers with the woman seated on the man's lap as he wraps his arms around her with one hand stroking her chin and the other reaching inside her dress to fondle her belly.[7] Her golden wine cup rests on her knee while the half-empty glass wine bottle sits on the ground before her, next to some pears. Without revealing much flesh, Riza has produced an erotically charged double-portrait, one which not only may reflect the voluptuous life of Shah Safi but also presages the more explicit paintings of the 1630s and 1640s.

The illustrated manuscript that may have been intended for the recently enthroned Shah Safi is a *Khusrau and Shirin* of Nizami with nineteen illustrations signed by Riza and a date of 20 Safar 1042/6 September 1632.[8] Although the quality of the paintings is variable and some paintings are most likely the work of assistants, Riza would have overseen the production of the manuscript. With-

out abandoning his figural style, Riza reduced the number of figures in each scene to the bare minimum while enlarging their scale in relation to their setting. The paintings show a marked preference for bright pink, almost fuchsia, coloured grounds which were adopted by Riza's student, Mu'in Musavvir, who was probably one of his assistants on this project. The tall, narrow-page format and preference for fewer large-scale figures can also be found in the eight illustrations to a *Divan* of Baqi, written in Ottoman Turkish [fig. 111]. The colophon includes the date of the manuscript, 1046/1636, and the name of the scribe, Bandeh-yi Shah-i Najaf Afshar ('the servant of the king of Najaf, Afshar'), which is thought to indicate that the manuscript was produced for Shah Safi.[9] However, judging from its language, the specific mention of Najaf and the slightly old-fashioned style of the figures, the manuscript may be the product of a provincial centre such as Najaf rather than Isfahan.[10]

In the reign of Shah Safi a group of artists became active who were strongly influenced by Riza and had most likely studied with him. The names of two of them, Muhammad Yusuf and Muhammad 'Ali, are inscribed on three of the 550 illustrations to a *Divan* of Hafiz, dated 1050/1640–41, in the Topkapi Saray Library. Malik Husayn Isfahani, the father of Muhammad 'Ali, is also known for works dated in the 1640s but was active in the 1630s, in particular as one of the illustrators of a Persian translation of the *Suwar al-kawakib* of al-Sufi, dated between 1040/1630 and 1042/1632 and copied by the scribe Muhammad Baqir al-Hafiz.[11] The patron of the manuscript was probably Abu'l-Fath Manuchihr Khan, the governor of Mashhad from 1034/1624 until his death during the reign of Shah 'Abbas II (1052–77/1642–66), who had commissioned its translation from Arabic into Persian. According to Barbara Schmitz, while Muhammad 'Ali is the artist of most of the illustrations to the New York version of this manuscript, another copy in Cairo dated 1043/1633–4 is likely to contain more paintings by Malik Husayn al-Isfahani.

Mu'in Musavvir, whose prolific career spanned the second two-thirds of the seventeenth century, was proficient enough by the mid-1630s to paint a portrait of his master, Riza, which he completed (or copied) forty years later.[12] Dated works by him from the period of Shah Safi include a 'Portrait of a Youth' from

20 Ramazan 1047/5 February 1638 and 'Lovers' from 11 Muharram 1052/11 April 1642.[15] These works reveal the early use of a fluid line and thin ink which characterizes the drawings of Mu'in Musavvir throughout his career. Portraits such as these appear to be quickly drawn sketches, a view supported by the inscription on the 'Portrait of a Youth' stating that the work was done 'at the house of his dear and venerable friend Shafi''. Since the drawings come from the so-called Sarre album containing works by Riza and his son Shafi' and others that were produced at the house of 'Aqa Mu'ina' (probably Mu'in Musavvir himself), the 'Shafi'' to whom Mu'in refers in his inscription may be the same as Riza's son. Certainly he and Mu'in were the closest followers of Riza. Not only do some of their works adhere to the style of Riza's paintings, but also the

artists completed works left unfinished by Riza. The eleven drawings in the Sarre album dating from 1042/1632 to 1052/1642 provide the best source for comparison and dating of uninscribed drawings to the period of Shah Safi. In addition, they introduce us to the work of both Mu'in Musavvir and Shafi' 'Abbasi.

Muhammad Shafi', called Shafi' 'Abbasi after Shah 'Abbas II, first emerges in his own right as the artist of a group of flower drawings gathered in an album of related works. The inscription on the earliest of Shafi''s signed examples in the album is dated Muharram 1050/April–May 1640 and states that 'Muhammad Shafi' [I]sfahani coloured it in the *madrasa* of Maulana 'Abd Allah' [fig. 112]. This *madrasa*, presumably the same as the *madrasa* of Mulla 'Abd Allah, had been built by Shah Safi adjacent to the

112 (right) Floral spray, signed by Muhammad Shafi' Isfahani (Shafi' 'Abbasi), dated Muharram 1050/April–May 1640, ink on paper, 15.1 × 8.2 cm, British Museum, OA 1988.4-23.034. Despite the later identification in Persian of this plant as a hyacinth, it bears little resemblance to that flower.

113 (far right) Narcissus, signed by Shafi' 'Abbasi, dated 5 Rabi' I 104[2]/10 September 1632, ink on paper, 20.4 × 14.9 cm, British Museum, OA 1988.4-23.011. This fragmentary drawing of a flower identified as a narcissus has been pasted over a page containing an unfinished painting of another flower.

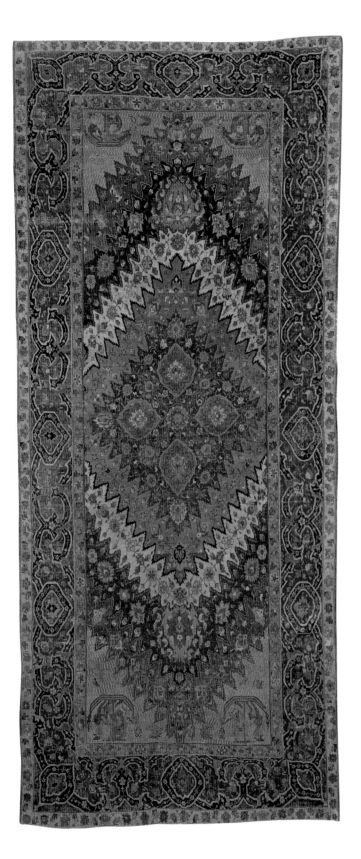

maidan and the *qaisariyya* bazaar. The flower in the drawing, oddly identified in another hand as a hyacinth, is drawn in a lively fashion with the petals of its blossoms twisting in the breeze and surrounded by buzzing bees. The foliage and petals are shaded with hatched lines, a possible clue that the artistic source for this and other flower drawings in the album was a European engraving. A damaged drawing of a lily which can be attributed to Shafi' on the basis of style is inscribed: 'It was on Tuesday the fifth of Rabi' I that the shah left the capital Isfahan for Baghdad in the year 104[2]' [fig. 113]. The date to which this corresponds is Tuesday 10 September 1632, but one wonders if it signifies that the artist was accompanying the royal camp. Despite their simplicity, these drawings indicate Shafi''s willingness to copy European designs, although there is no indication of whether this choice reflected the shah's taste. If such works have a connection with the Safavid court, they are more likely to have been drawings supplied to weavers who transformed them into textile designs.[14]

Without dated examples the stylistic development of carpets in the period of Shah Safi can only be suggested with reference to carpets given to European embassies. The textiles of the 1639 Iranian embassy to Duke Friedrich III of Holstein-Gottorp are now housed in the Rosenborg Castle, Copenhagen. Whereas the large Polonaise carpet used only a few times for Danish coronations was given in 1665 to Queen Sophie Amalie by the Dutch East India Company directors and may date to the second half of the seventeenth century,[15] the numerous velvets with gold and silver thread that lined the walls of the ground-floor tower room at Rosenborg Castle until 1911 most likely were included in the gifts of the Persian ambassador in 1639.[16] Before their transfer from Gottorp Castle in 1817 the textiles, which had probably arrived in Europe rolled in bolts, had been used to cover tables, as wall coverings and as bed hangings in many of the rooms of the castle. Four figural and five floral patterns are represented in them: an inebriated

114 'Portuguese' carpet, southern Iran?, first half of the 17th century, wool, 4.77 × 2 m, Fundação Calouste Gulbenkian, Lisbon, T. 99. Although the markedly contrasting diagonal bands with serrated edges in the field of this type of carpet are novel in Safavid carpets, the narrow format is typical of pieces from southern Iran.

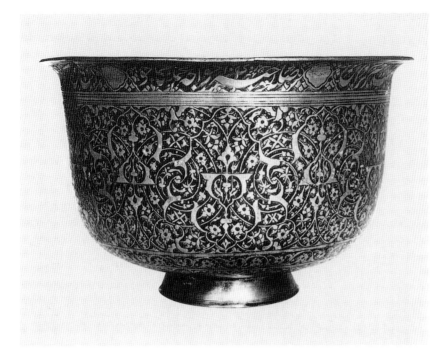

115 Wine bowl, Iran or North India, dated 1040/1630–31, inscribed with owner's name, Khwajeh Muhammad Kaju, tinned copper, engraved decoration, black composition, h. 14.6 cm, diam. 23.75 cm, Victoria and Albert Museum, I.S. 1324-1893. Although this bowl was acquired in India, its decoration is closely related to that of Iranian metalwork from the reign of Shah 'Abbas.

youth, a falconer and attendant, a supplicant, a young woman with a flower; and serrated leaves, birds and flowers, double floral, ogival and rosette scroll. The style of the figures with their heavy faces and wide hips relates closely to the work of artists such as Riza-yi 'Abbasi from the 1620s and 1630s and Mu'in Musavvir and Shafi' 'Abbasi from the 1630s. In 1691 a diplomatic pouch made of the identical Falconer velvet and containing a letter from Shah Sulayman was sent to the Danish king. This raises the question of how long such royal velvets were stored by the Safavid shahs and more specifically whether the Rosenborg Castle velvets were actually produced in the reign of Shah Safi or earlier. If Shah 'Abbas reverted to Shah Tahmasp's practice of storing large numbers of textiles which were presented as honours to his subjects and gifts to foreign ambassadors, Shah Safi could as easily have inherited these velvets as ordered their production. Only their stylistic relation to the paintings of the 1620s and 1630s argues against an earlier date.

The fact that small pieces of the same fabric were still in use in the 1690s suggests that it was still considered prestigious enough to use for diplomatic purposes, unless Shah Sulayman wished to insult the Danish king by sending his letter of protest in an old-fashioned envelope. This seems unlikely, however, since the shah was trying to extract damages from the Danes.[17]

Kirman maintained its position as a carpet centre where the production of 'vase technique' carpets persisted. To the system of three superimposed lattice patterns punctuated by blossoms, floral sprays and sometimes vases, the carpet makers now added serrated,

116 Ewer, first half of the 17th century, stonepaste with moulded and carved decoration and polychrome glazes, 18th–19th-century brass lid, spout and handle, h. 35.5 cm, British Museum, OA 78.12-30.627, Henderson Bequest. The group of ceramics to which this ewer belongs imitates the Chinese Fahua technique but the shape follows Indian metalwork.

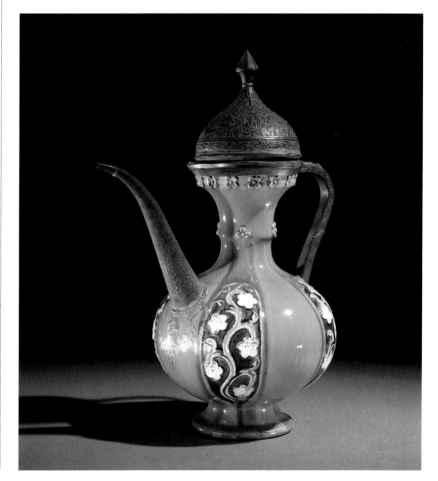

sickle-shaped leaves. While the motif was probably introduced in the period of Shah 'Abbas I, its popularity lasted through the period of Shah Safi and beyond. Another group that may date from this period are the so-called 'Portuguese' carpets [fig. 114]. These are characterized by a serrated lozenge-shaped central medallion containing blossoms, partridges and hoopoes, and corners with ships crewed by men dressed in European clothes. Along with sea monsters and fish, a man who is either swimming or drowning is depicted in the sea. The palmette and arabesque border is of a type found on many seventeenth-century Persian carpets, but the designs of the field are uncommon and have sparked a disagreement over whether these carpets were produced in Iran or in India.[18] Possibly they represent another aspect of the 1630s vogue for depicting Europeans, as both the paintings of Riza and a group of seventeenth-century Persian red and white silks of Europeans in ships suggest.[19]

The study of metalwork of the 1630s is also somewhat clouded by the existence of a considerable number of vessels now attributed to North Hindustan, a designation that includes Kashmir and Lahore. Thus a tinned copper wine bowl, called *badiyeh*, with high vertical sides, an everted rim and a low foot, an owner's inscription and the date 1040/1630–31 and typical Safavid split-palmette arabesque decoration may be of North Hindustani origin by virtue of having been found in India [fig. 115]. The diameter of the foot is smaller than that of a similarly ornamented bowl[20] and closer to that of one bowl dated 1030/1620–21 and another from the second half of the seventeenth century, which may indicate a gradual change in the proportions of such bowls. To an even greater extent than with carpets, metalwork types seem to have remained constant in the period of Shah Safi, and without more dated examples pieces cannot be attributed to the

1630s, as opposed to the previous or following decade, with any confidence. However, the close reliance of North Hindustani metalwork on Safavid prototypes at least demonstrates close interaction between Iran and India, and may point to increased trade between the two regions from the 1630s.

As with the ewer dated 1027/1616–17 [see fig. 105], Persian potters continued to combine Indian-style shapes with Chinese-style decoration to produce unusual classes of ceramics. A ewer with an eighteenth- or nineteenth-century brass lid, spout and handle [fig. 116] belongs to a group of wares based on Chinese ceramics called Fahua wares, produced under the Ming dynasty in the sixteenth or seventeenth century in imitation of cloisonné. The sides of the moulded globular ewer consist of vertical bands glazed turquoise or pale blue separated by panels containing undulating flowering vines carved in relief and glazed yellowish on a manganese ground. Four-petalled florets have been applied to the neck and rim of the ewer in the same fashion as on a bulbous-bodied, straight-spouted ewer with monochrome grey-green glaze in the Victoria and Albert Museum.[21] In shape both the British Museum and the Victoria and Albert ewers are based on Indian models. Even the repaired lid of the British Museum piece is domed like the Indian prototype,[22] but without its bird-shaped finial. Zebrowski has attributed the Indian bronze ewer to North India and the seventeenth century, but it is impossible to pinpoint how the Persian potter would have come to adapt this shape to his ornate ewer. The connection of the monochrome-glazed Victoria and Albert ewer with another type of seventeenth-century North Indian spouted vase[23] leads to the question of whether a particular ceramic workshop was producing this line of wares to suit the taste of an atypical clientele. Indians had long been established as moneylenders in Iran, and perhaps in this period of general prosperity and

internationalism they could afford to commission ceramics that combined traditional Indian shapes and Chinese decoration.

In this period the production of blue and white wares with a stonepaste body continued unabated. A hookah base dated 1051/1641 with a high flaring neck, squat bulbous body and low, cup-shaped spout[24] is one of a large group that derive their shape from the Chinese 'kendi', a type of ewer. Like the 1027/1616–17 ewer [see fig. 105], the sides of this hookah base consist of panels containing landscape scenes. While many such objects are clearly dependent on Chinese motifs for both the decorative bands that separate one formal element from another and the larger decorative passages, others reveal a more original approach. A dish with a floral spray filling most of the interior surface and a border of blossoms in reserve on a blue ground [fig. 117] relates more to earlier so-called Kubachi wares than to Chinese prototypes. While the flowers on thin stalks may bear some relation to the Kirman treatment of vegetation, the flowers in reserve in the border panel recall the many Mashhad wares decorated in reserve. Thus such a piece does not fall automatically into a particular seventeenth-century stylistic grouping and cannot readily be assigned to either Mashhad or Kirman by comparison to other pieces thought to come from one city or the other. The only sure thing about Persian blue and white wares in the 1630s is that production was sustained and still inspired, although not entirely dominated, by Chinese wares.

According to Tavernier, who first travelled in Iran in 1633, glass was made at three or four locations in Shiraz and shipped to centres throughout the country. Presumably this was born of necessity as Shiraz was the place where the best rosewater and wine were produced. The long-necked bottles and globular bottles with short necks of clear glass depicted in paintings holding red wine may have been of local manufacture but it is difficult to date surviving examples with any precision. Moreover, well into the seventeenth century Venetian glass remained a desirable commodity. Even the glass *qalyan*s, or water-pipes, used for smoking tobacco, which were noted by Adam Olearius in 1637 were imported from Venice, along with mirrors and bottles.[25] For fine glass the Persians still relied on Venice and it seems that the same Armenian merchants who took silk to trade in Europe returned to Iran with Venetian glass to sell. Although Chardin claimed that glassmaking had been introduced to Iran in the late sixteenth century by an Italian at Shiraz,[26] this story did not appear in the accounts of Europeans writing in the 1620s or 1630s.

Objects in other media are difficult to assign to the period of Shah Safi. So much of what was made in royal and commercial workshops represented a continuation of the styles established under Shah 'Abbas. Only the work of individual artists who signed and dated their paintings and drawings provides a large enough corpus of material to give some idea of how the arts of the book evolved in the 1630s. In general, European influence is more consistently evident in this period than before, but this coexisted with a strong conservative strain that is manifested in manuscript illustrations resembling those of the first decade of the seventeenth century. The subtle variation of Safavid themes found in North Indian metalwork of the seventeenth century adds to the difficulty of secure attribution but also points up the increasingly close artistic relationship between Iran and India. With ceramics the introduction of Indian metalwork shapes in combination with Chinese-style decoration results in some of the most innovative pieces of the first half of the century. The study of the arts from the period of Shah Safi has been hampered perhaps by the uncharismatic nature of his personality and his rule. However, non-royal patronage thrived in this period, as did commerce, so further scrutiny should reward the researcher with a fuller picture of Persian art in the 1630s.

117 (opposite) Dish, first half of the 17th century, stonepaste with underglaze blue decoration, diam. 37.6 cm, British Museum, OA 1951.7-21.1. The inclusion of a decorative band that runs only part of the way around the rim of the dish is very rare on Safavid blue and white ceramics.

8

A New Focus

Shah 'Abbas II

1642–1666

During a review held in 1660 'Abbas II discovered that the same arms,
horses and men passed before him 10–12 times.[1]

The death of Shah Safi might have precipitated a crisis of succession since his oldest son, Sultan Muhammad Mirza, was only eight and a half years old when he was crowned, taking the name Shah 'Abbas II. However, such was the strength of the alliance between the grand vizier, Mirza Muhammad Saru Taqi, and Shah Safi's mother that the changeover was effected peacefully; Shah 'Abbas II was enthroned on 16 Safar 1052/15 May 1642. The shah's tender age precluded him from all but the ceremonial functions of the ruler at the outset, but by the same token he was freed from the harem early enough in his life to be given a proper education. As a result, he not only excelled at horsemanship and developed a passion for polo but also he acquired an appreciation of literature, especially theological texts. His classical education included instruction in writing and this was augmented by lessons in painting from both Persian and European artists.[2] It seems likely that Saru Taqi imparted his own enthusiasm for architecture to the young prince, who from early in his reign added substantially to the already remarkable Safavid assemblage at Isfahan.

As Shah Safi had sunk deeper into his addictions, Saru Taqi had effectively run the day-to-day business of government. He was efficient and ruthless and had made his fair share of enemies in the process of maintaining his loyalty to the shah. Among these were the English East India Company, which had complained to the shah in 1633, when Saru Taqi was still governor of Mazandaran, about his 'alleged dishonesty in the delivery of silk'.[3] On the other hand, he drove very hard bargains with foreign trading companies in the interest of procuring the best deal for the Iranians. His intransigence with regard to the amounts and prices of silk he expected the Dutch East India Company to buy led in Rabi' I 1055/May 1645 to a brief Dutch blockade of Bandar 'Abbas and a bombardment of the island of Qishm followed by the Dutch boycott of Persian silk until 1062/1652.

To maintain his strong position Saru Taqi engineered the execution in Dhu'l Hijja 1052/March 1643 of an important *ghulam* minister, Rustam Khan, who was in Mashhad in his capacity as field marshal and wished to return to Isfahan after the accession of Shah 'Abbas II. Other important functionaries who were too openly ambitious were dealt with through banishment from Isfahan or the withdrawal of tax concessions. By Sha'ban 1055/October 1645 Saru

118 Detail of fig. 127.

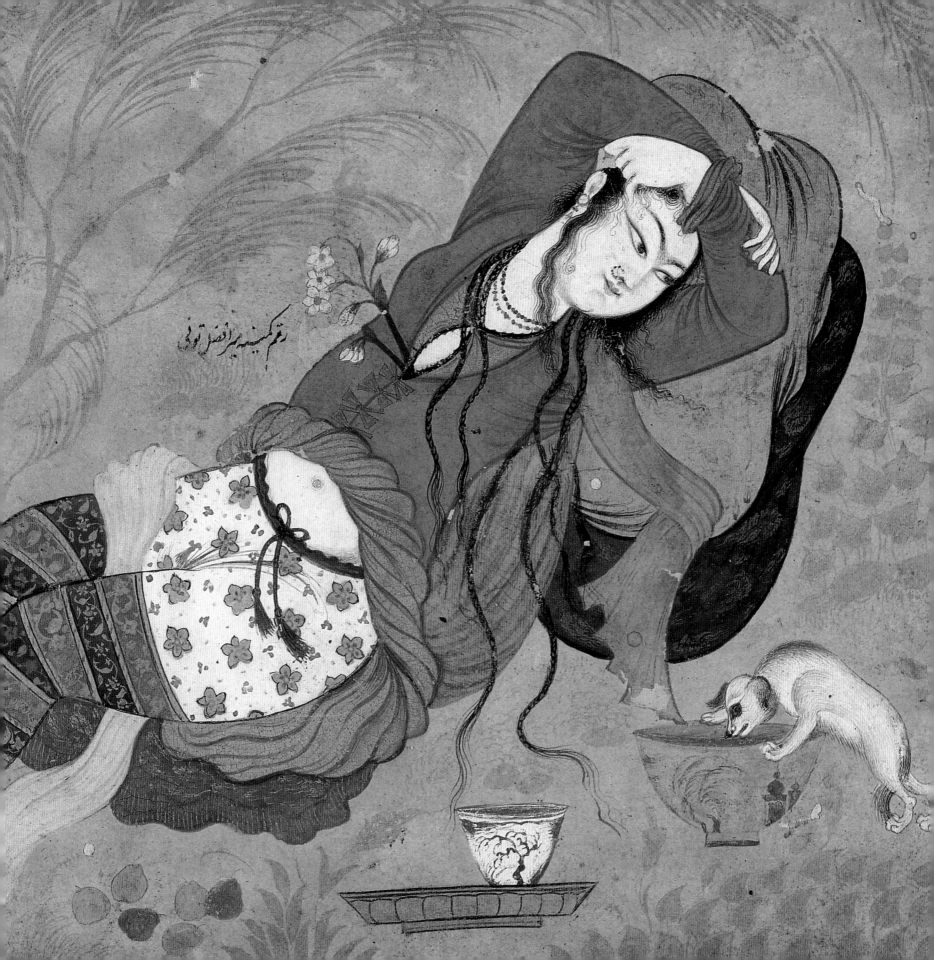

Taqi's high-handed ways had worn thin even with the twelve-year-old 'Abbas II. As had happened so often before in Safavid politics, the shah made his displeasure known, in this case to Jani Khan, one of Saru Taqi's arch-enemies, and the next day this man and a group of Qizilbash of the Shamlu tribe and their friends assassinated Saru Taqi. Jani Khan's ascendancy lasted only four days until he, too, was murdered along with his co-conspirators and various noblemen and their retainers, ostensibly because they were plotting the murder of the shah's grandmother, an ally of Saru Taqi. It is more likely that Shah 'Abbas II wished to take the reins of power into his own hands and took advantage of the assassination of Saru Taqi by eliminating both his murderers and other grandees who may have had nothing to do with the deed. The result was that the shah's new appointees retained a level of respect or fear of the shah that kept them from trying to overthrow him but did nothing to stop their own jockeying for position.

Unlike all his predecessors Shah 'Abbas II did not have to contend with invasions or serious threats of war from the Ottomans. The peace treaty of 1049/1639 held in part because he chose to ignore opportunities to become embroiled in local rebellions against them. Instead the two empires exchanged embassies and maintained peaceful relations. With the Uzbeks inter-family quarrels led to the Persians acting as intermediaries but they avoided armed conflict with their old enemies. Such was not the case with the Mughals, however, whose sultan, Shah Jahan, was planning to invade Transoxiana rather than coming to the aid of the Uzbek khan of Turkestan who had been ousted by his son. In order to counter the Mughal incursion in Transoxiana, the Persians revived a plan, shelved at the time of Shah Safi's death, to retake Qandahar. In the autumn of 1058/1648 Safavid troops stormed the city and took it in early 1649 before Prince Aurangzeb could reach it. His efforts to counter-attack failed, as did those of his father, Shah Jahan, who besieged Qandahar for two and a half months in 1060/1650. A subsequent attempt to take the city was led by Dara Shukuh, the Mughal crown prince, in 1063/1653, but he could not unseat the Persians. Although Aurangzeb overthrew his father in 1068/1658 and executed Dara Shukuh the following year, Shah 'Abbas II recognized his right to the throne and exchanged embassies with the new emperor. However, Aurangzeb maintained his claim to Qandahar, which led to hostility between India and Iran increasing to such a degree that Shah 'Abbas was planning an invasion of India at the time of his death in 1077/1666.

Following the arrival of English traders at Jask in the Persian Gulf in 1616 and their crucial assistance to the Persians in ousting the Portuguese from Hormuz, the English received concessions such as a customs franchise in Bandar 'Abbas, the port developed to replace Hormuz, the right to trade freely throughout Iran and a promise of considerable supplies of silk. By the 1630s the Armenian control of the overland silk trade, the high price and unreliable quality of raw silk, not to mention political upheaval in England, led to a decline in Anglo-Persian trade. However, until the first Anglo-Dutch War in 1652 English shipping between Surat in India and Persia and Basra remained healthy and benefited from the dropping-off in overland trade in the 1640s and 1650s between Iran and India at the time of the Qandahar hostilities. Meanwhile, the Dutch East India Company enjoyed strong support from the Dutch government and actively traded spices, sugar and textiles from Southeast Asia in exchange for silk and other Persian textiles.

While the Dutch were the dominant European sea traders in Iran after 1652, the Armenians and Indians also controlled a segment of this trade. The Armenians wished to extend their monopoly in the silk trade whereas the Indians were simply expanding in an area where they had traded for centuries. Not only were Indian merchants and moneychangers, mostly from Gujarat, established in most of the major Persian cities, but also in the 1630s and 1640s shipments from India increased noticeably. These brought cotton cloth, indigo and trans-shipped goods from the Far East, including Chinese ceramics. In addition to ships that came into the main ports of Bandar 'Abbas and Kung, Indian dhows avoided taxes by putting in to smaller ports. Although the Mughals embargoed Indian ships at Surat during the Qandahar hostilities in 1058/1648–9, the sea trade seems to have benefited as a result of roads blocked intermittently at Qandahar. None the less, Qandahar remained the most important point on the land routes from Khurasan to India, especially the Deccan.

Compared to the reigns of the previous Safavid shahs, Shah 'Abbas II presided over a period of peace and prosperity. He was genuinely interested in the administration of justice and the eradi-

cation of abuses visited upon his subjects by unscrupulous public officials. Although he loved hunting and polo as much as any Safavid shah, he attended to state business regularly every week and paid as much attention to the safety of his subjects as to economic and military questions. Perhaps as a logical development of Shah 'Abbas I's promotion of orthodox Shiites and his own interest in theology, he enjoyed good relations with Shiite clerics, but unlike his great-grandfather he supported dervishes. While he was very tolerant of Christians, and some major Armenian churches were constructed during his reign, his vazir, Muhammad Beg, convinced him to force the Jewish population of the whole country to convert to Islam. Like the blinding of his four brothers and killing of his nephews, this reveals the cruelty that Shah 'Abbas II could display. When he contracted a deadly disease, probably syphilis,[4] about 1073/1662, his behaviour became more erratic and his punishments more severe, but even then his reputation as a just king was not damaged. He died in the autumn of 1077/1666 at the age of thirty-three and was buried in Qum next to his father.

As mentioned above, Shah 'Abbas II's early interest in architecture may have been encouraged by his grand vizier, Saru Taqi. From the time of his appointment by Shah Safi in 1043/1633 until his death in 1055/1645, Saru Taqi completely renovated a palace for himself in Isfahan and built a bazaar, a *caravansarai*, a coffee-house, one or more mosques and several baths.[5] He must also have been instrumental in the alterations to the 'Ali Qapu that provided an expanded reception area through the addition of the *talar*, the open porch with tall wooden columns and a painted ceiling from which the shah and his retinue could view the *maidan*.[6] The increasing formality and attention to hierarchy at court functions[7] must have necessitated additional space to accommodate the serried ranks of dignitaries. The use of wooden columns, perhaps an imported idea from Mazandaran,[8] lends lightness to the structure while providing a roofed space in which large numbers of people could sit or stand.

In one of Shah 'Abbas II's major monuments, the Chihil Sutun palace in Isfahan, the *talar* resting on wooden columns reappears, used to marvellous effect [fig. 119].[9] The palace, to the north-west of the 'Ali Qapu complex, is set before a long rectangular pool in which it is reflected. The centre of the third bay of the *talar*

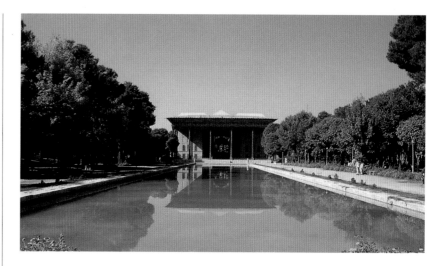

119 Chihil Sutun, Isfahan, completed 1056–7/1647, façade and pool. Like most Safavid palaces, the Chihil Sutun incorporates a pool inside the building and is reflected in the long pool placed in front of the building on an axis with its porch.

contains a pool into which four lion fountains disgorge water from the four corners. This is echoed by a smaller pool on the same axis in the centre of the large three-sided porch that precedes a smaller *ivan*. This, in turn, leads into a large horizontal audience hall. Two long halls flank the three-sided porch and smaller rooms can be found next to the long sides of the audience hall. The equivalent of the interior *ivan* lies on the same axis but opens onto the exterior, as do the verandas at either end of the audience hall. Although the three distinct sections of the building led scholars to believe it had been constructed in three different periods, recent research has demonstrated that the Chihil Sutun dates from 1056–7/1647.[10]

Aside from the unusual plan of the Chihil Sutun and its ingenious transition from open to closed spaces, it is most remarkable for the programme of wall paintings to be found on both the exterior and interior of the building. In addition to six large murals on the upper walls of the audience hall, the dado level of the audience hall, the smaller rooms, the verandas and the back *ivan* all contain small panels of figures feasting and hunting very similar to those found in the upper rooms of the 'Ali Qapu. The niches that form the upper walls of the small rooms flanking the audience hall contain scenes of feasts or literary narratives, recalling in type, but

120 (above) Blind arches painted with figures of Europeans, exterior of Chihil Sutun, Isfahan, completed 1056–7/1647. The extensive decorative programme at the Chihil Sutun includes paintings of Europeans and Persians on the exterior and large-scale murals of the Safavid kings receiving foreign emissaries.

121 (below) Khwaju bridge, Isfahan, 1060/1650. From the time it was built the Khwaju bridge has functioned as more than a route for traffic across the Zayandeh-Rud. Its viewing pavilion was reserved for royalty, but the niches on either side of the central road were accessible to passers-by for meeting friends or simply enjoying the view of the river.

not in style, the paintings from the house in Naʿin. The walls of the verandas are decorated with men and women in European dress [fig. 120]. Whereas the figures in the small interior panels adhere stylistically to the work of the 1630s and 1640s of Riza and his school, the large historical murals and the paintings of Europeans are rendered in a style that borrows ideas of shading, modelling and perspective from European painting. While Persian interest in European painting had manifested itself as early as the late sixteenth century, the Europeanizing fashion was strongly endorsed during the reign of Shah ʿAbbas II and coexisted with more traditional Safavid painting until the end of the century when the traditional style faded away.

Babaie's analysis of the iconography of the wall paintings in the Chihil Sutun reveals the political preoccupations of Shah ʿAbbas II in the first decade of his reign. Excluding two paintings facing one another in the central bay painted in the nineteenth century, the others in the audience hall depict Shah Ismaʿil in battle with the Uzbeks, Shah Tahmasp holding a reception for Humayun, Shah ʿAbbas I and Vali Muhammad Khan, the Uzbek khan of Turkestan, and Shah ʿAbbas II and Nadr Muhammad Khan, the ousted Uzbek khan. With the exception of Shah Ismaʿil victorious over the Uzbeks, the theme of the paintings is the magnanimity of the Safavid shahs towards their counterparts from the east. Against a

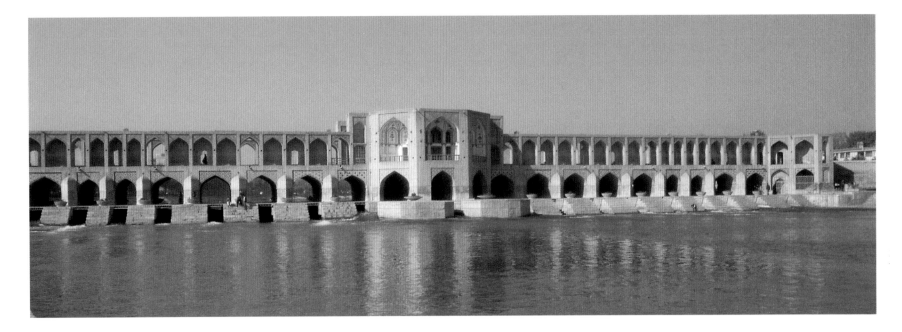

backdrop of growing tensions with the Mughals, these paintings stress the role of the Safavid house as a safe haven for the rulers of neighbouring lands.

In the small rooms on the long sides of the audience hall, the paintings of literary themes follow the established programme of scenes from *Yusuf and Zulaykha* and other perennial favourites, except for one composition depicting the 'Hindu Princess Preparing to Immolate Herself'. While this relates to the early seventeenth-century Mughal poem about suttee, *Suz o Gudaz*, which gained popularity in Iran in the mid-seventeenth century, it also ties in with an event in the 1640s that was considered to be confirmation of the Safavid right to Qandahar. Shortly after the Persian siege of the city, one of the Mughal emperor's officials died and his wife chose to immolate herself with his corpse. As she was dying, she was asked whether the Indians would deliver Qandahar and she answered that the Persians would be victorious.[11] Even if most of the rest of the paintings in the Chihil Sutun were finished in time for its completion in 1056–7/1647, this scene would have been added no earlier than 1059/1649 after Qandahar had fallen to the Safavids. As for the paintings of Europeans in the verandas, they may have been intended to convey to visitors the internationalism of the Safavid court. In addition, if these paintings were conceived as portraits, they could collectively represent a gallery of familiar characters of mid-seventeenth-century Isfahan.

The same ingenuity and awareness of the person within the monument as well as the view of the structure from the outside apply to the Khwaju bridge, erected in 1060/1650 on Turkman foundations and spanning the Zayandeh-Rud in Isfahan [fig. 121]. Unlike the Allahvardi Khan bridge, the Khwaju bridge is shorter and punctuated in the centre by an octagonal pavilion and a half octagon at either end. On the upper level a road runs down the middle of the structure while to either side walkways extend the length of the bridge from which one can enter the arched niches to enjoy the view. The pavilion has inner and outer rooms on the upper level and balconies facing the river for royal viewing. The lower level is built on a stone platform with elements that jut out to break the river's flow upstream and steps down to the water and sluices on the downstream side. Within the stone platform are wooden gates that can be closed to raise the level of the river. The bridge was placed on an axis with the *maidan*, a now disappeared bazaar on the north side of the river and the Zoroastrian quarter to the south, and it was also a favourite meeting place, with its discreet niches on the upper level and cool arches on the lower level, some of which are now converted into coffee houses. Although it was probably commissioned by Hasan Beg, a general, it is an inspired piece of royal architecture.

Like his predecessors Shah 'Abbas II did not neglect the Shiite shrines. He restored or added to each of the three major shrines: Ardabil, Qum and Mashhad. In addition to repairs on the Friday mosques of Kashan, Qazvin, Qum and Isfahan made during his reign, the Hakim Mosque [fig. 122] in Isfahan was constructed with money provided by the shah's erstwhile physician, Muhammad Da'ud Hakim, known as Takarrub Khan, who had emigrated to

122 Hakim Mosque, Isfahan, 1067–73/1656–63, south *ivan*. Unlike the royally commissioned mosques of the earlier 17th century, tile decoration has been employed judiciously on this building, while unglazed bricks define its vertical and horizontal framework.

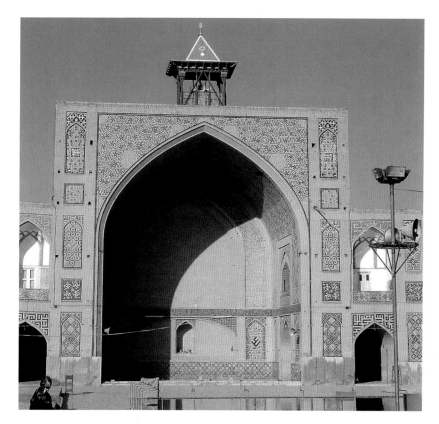

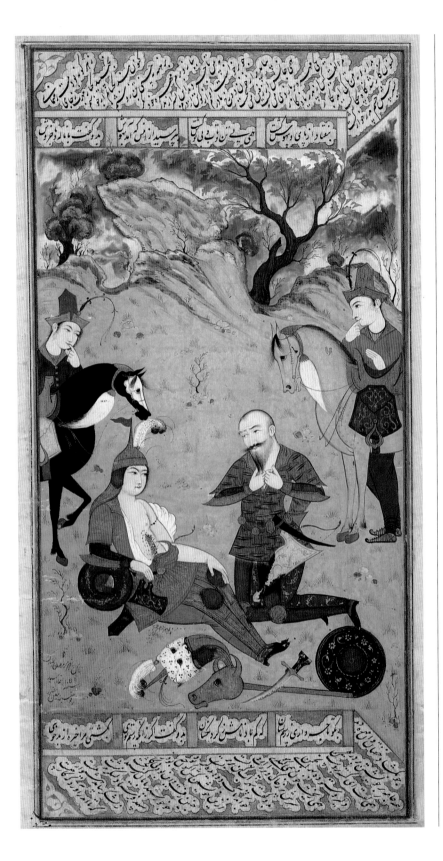

India under a cloud. Built on the site of a tenth-century Buyid structure, the building contains several inscriptions ranging in date from 1067/1656–7 to 1073/1662–3. Not only are the tiles signed by Mirza Muhammad the Kashi-paz ('potter'), but also the inscription tiles in the *qibla ivan* are signed by Muhammad Riza al-Imami al-Isfahani al-Adhami and dated 1069/1658–9. Muhammad Riza al-Imami was a leading calligrapher in the period of Shah 'Abbas II. Two other inscriptions in the mosque also contain his name and dates; one with verses from Sura 17 of the Qur'an runs around the *mihrab* and is dated 1071/1660–61 and the other, also from 1071, is in the interior of the *mihrab*. A second *mihrab* is dated 1069/1658–9 and contains the names of the twelve imams, while a third *mihrab* was added in the late eighteenth century. The most striking contrast between this mosque and those constructed by Shah 'Abbas I on the *maidan* or even the Chihil Sutun Palace is the retreat from surfaces entirely covered with tile revetment or painted decoration. Instead, inscription bands, glazed bricks and tile panels add colour to the expanses of warm buff-hued brick. The mosque is built on the standard four-*ivan* plan with a two-storey arcade running between the *ivan*s. Along with the decorative programme, structural elements have also been simplified, so that *muqarnas* squinches in the *qibla ivan* have been replaced by plain surfaces in the zone of transition. Although this mosque does not signal the end of elaborately decorated monuments, it does represent a departure from the style established by Shah 'Abbas I at Isfahan.

Painting during the reign of Shah 'Abbas II is characterized by its eclecticism. At the conservative end of the spectrum, Mu'in Musavvir evolved a distinctive style out of the late mode of Riza-yi 'Abbasi, who had been his teacher. Although Mu'in illustrated five *Shahnameh*s [fig. 123] and as many as three copies of *The Anonymous History of Shah Isma'il* between 1058/1648 and the 1670s, he apparently worked independently of the court atelier. His oeuvre, consisting of manuscript illustrations, painted single-page portraits and drawings of a variety of subjects, exhibits a remarkable stylistic consistency over the course of more than sixty years from about 1044/1635 to 1109/1697. Whereas Mu'in's drawings are characterized by rapid, lightly drawn strokes of the pen, his paintings feature round-faced figures, slimmer than those in other artists' work in the 1640s and 1650s, and often with their heads held at an angle to

123 (opposite) 'Rustam beside the Dying Suhrab', from a *Shahnameh* of Firdausi, signed by Muʿin Musavvir, Isfahan, dated 1059/1649, opaque watercolour, gold and ink on paper, 28.8 × 14.3 cm, British Museum, OA 1922.7-11.02. The hero Rustam had never seen his son, Suhrab, until he mortally wounded him in battle and, upon removing Suhrab's armour, discovered the amulet he had given the boy's mother.

124 (right) 'The Fate of the Fickle Old Man', from a *Haft Aurang* of Jami, signed by Muʿin Musavvir, false signature of Riza-yi ʿAbbasi, Isfahan, dated 1057/1647–8, opaque watercolour, gold and ink on paper, 25 × 16.6 cm, British Museum, OA 1920.9-17.0301. An old hunchback declared his love for a beautiful youth as they stood on a rooftop. The youth pointed to a more handsome young man behind him. When the old man turned to look, the youth pushed him off the roof, to show that it is impossible to have more than one true love.

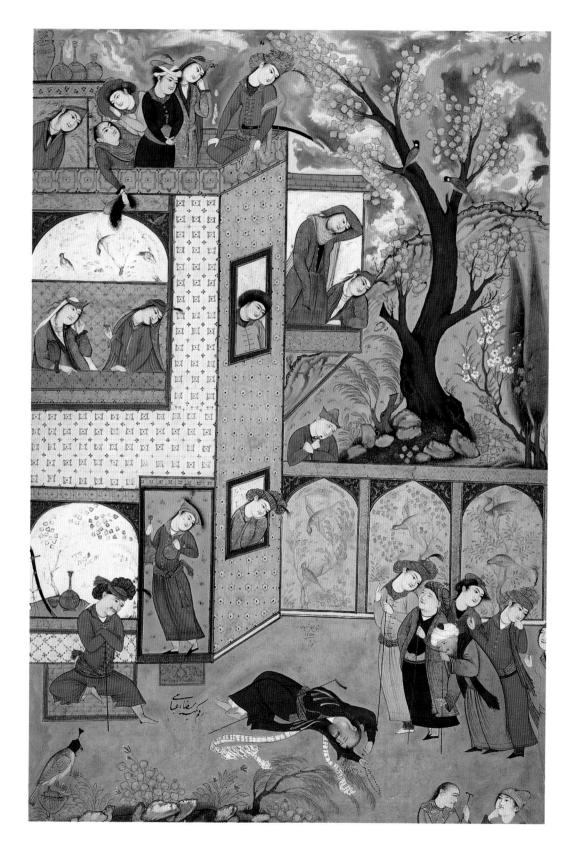

their body [fig. 124]. He shows a fondness for bright pink or mauve grounds, sky painted in a dramatic wash and, in album pages, streaky gold clouds and clumps of vegetation. Some works adhere to compositional norms established in sixteenth-century manuscript illustration, but these may reflect the taste of patrons rather than Mu'in's inclination to reduce the number of figures and place them close to the picture plane.

At the other end of the spectrum from Mu'in Musavvir is the artist Bahram Sofrehkesh, whose two signed works are dated 1050/1640–41, slightly before the beginning of Shah 'Abbas II's reign. Both works depict an Indian woman, either alone [fig. 125] or with a man, and they highlight the Safavid adaptation of Indian as well as European artistic ideas. Nothing is known of the artist except that his name suggests he might have held a position in the royal kitchen.[12] The subject matter, the rows of birds in the sky and the European-style townscape in the background, including buildings with pitched roofs and odd structures resembling haystacks, suggest that the artist had looked at Mughal painting of the late sixteenth or early seventeenth century. The use of heavy shading on the girl's face and on the sides of her chest and skirt could be an attempt to copy European modelling techniques or Mughal paintings that were influenced by the European use of chiaroscuro. The result of this manner of experimentation is a hybrid, where the Persian artist has not sought to attain the level of naturalism found in Mughal or European painting, but has borrowed the forms and some of the techniques of those schools. Although Bahram Sofrehkesh himself may not have worked for the court, he appears to have taught Shaykh 'Abbasi, whose title "Abbasi" shows that he was attached to the court atelier of Shah 'Abbas II. This artist's earliest known dated work, from 1057/1647, is a drawing of an Indian girl dressed almost identically to the girl in Bahram's painting[13] but placed in an Indian setting. Later works by the artist incorporate townscapes which combine European and Iranian buildings and retain similar shading to that found in the works of Bahram Sofrehkesh. Despite the fact that his figures are very stiffly posed, Shaykh 'Abbasi was chosen to depict an Indian embassy to Iran which took place in 1074/1663, presumably because the shah admired his interpretation of Mughal painting.

Another artist, Shafi' 'Abbasi, also appears to have worked in

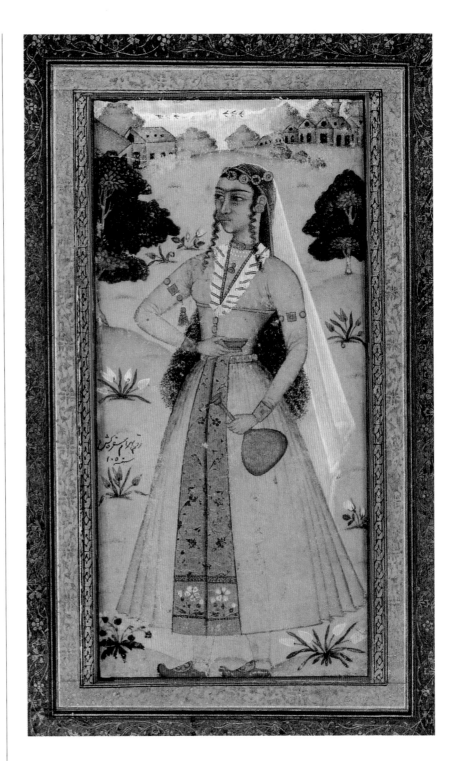

125 'Woman in a Landscape', signed by Bahram Sofrehkesh, Isfahan, dated 1050/1640–41, opaque watercolour and gold on paper, image 12.2 × 5.8 cm, Collection of Prince and Princess Sadruddin Aga Khan.

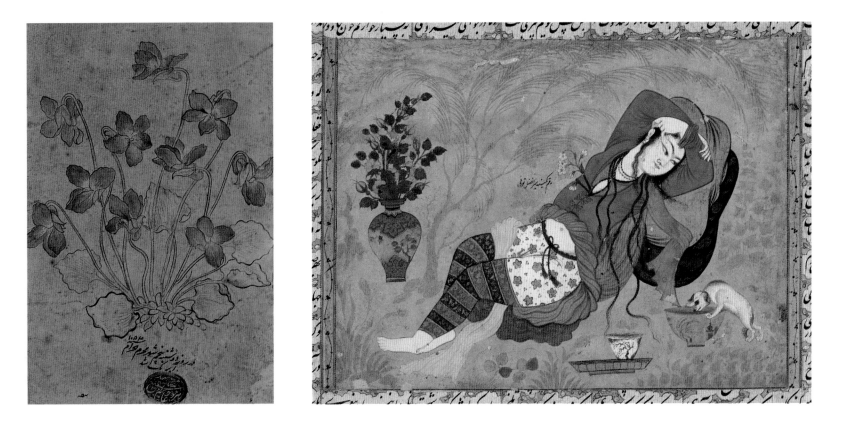

126 (above, left) 'Violets', attributed to Shafi' 'Abbasi, with the stamp seal of Muhammad Shafi', Isfahan, dated 5 Muharram 1052/5 April 1642, ink and watercolour on paper, 16.9 × 9.6 cm, British Museum, OA 1988.4-23.044. This is a rare instance in Safavid painting in which the artist has stamped the work with his seal rather than signing it.

127 (above, right) 'A Lady Watching her Dog Drink Wine from a Bowl', signed by Mir Afzal Tuni [Afzal al-Husayni], Isfahan, c. 1050/1640, opaque watercolour and gold on paper, 11.7 × 15.9 cm, British Museum, OA 1930.4-12.02. All the elements of this picture, from the woman's pose and rolled-up skirts to the dog, suggest sexuality and desire.

the court atelier from the time of Shah 'Abbas II's accession. The album with his flower drawings from the reign of Shah Safi also contains drawings of the 1640s and 1670s [fig. 126]. While his delicate drawings of the 1640s may have been designs for textiles, his elegant paintings of birds resting on flowering branches were destined for albums, some of which belonged to the shah.[14] These pictures combine European, Persian and possibly Mughal influences. The careful depiction of flowers with blossoms and buds and leaves viewed from both sides derives from European botanical prints, complete with bees and butterflies. Paintings of individual birds, on the other hand, figure in the work of Riza, Shafi''s father, and according to an inscription on one of Riza's bird paintings Bihzad had also painted a single bird. Furthermore, the artist Mansur, who worked for the Mughal emperor Jahangir (1014–37/1605–27), specialized in paintings of natural history subjects – birds, animals and plants – and copies of these works may have found their way to Iran. Certainly the treatment of the ground out of which Shafi' 'Abbasi's plants grow closely resembles the ridges of grass to be found in Mughal botanical paintings from the 1630s,[15] which in turn derive from European treatment of landscape. Although Shafi' 'Abbasi's repertoire was limited primarily to completing the unfinished works of his father and to bird and flower paintings and drawings, the patronage of the shah demonstrates that Shafi''s ability to filter new foreign influences and produce Persian painting with an exotic inflection was another expression of the new style in evidence in the history paintings of the Chihil Sutun.

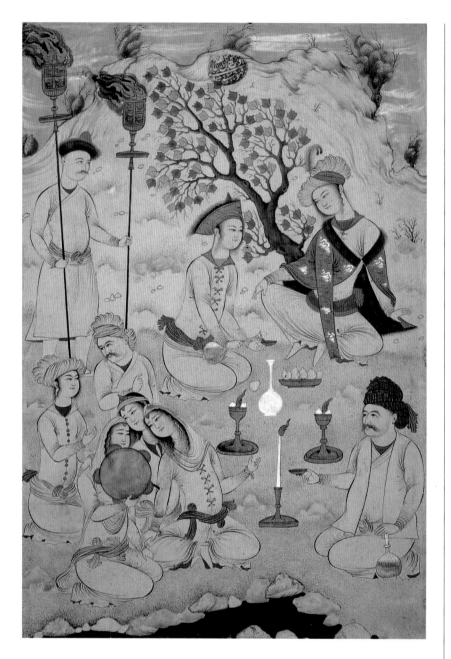

128 'Prince Being Entertained in the Countryside', attributable to Muhammad Qasim, Isfahan, c. 1060/1650, opaque watercolour, wash and gold on paper, 25.2 × 17.4 cm, British Museum, OA 1920.9-17.0275. This picnic takes place at night, as the torches and candles indicate, but the artist has adhered to Persian pictorial convention by depicting the group fully illuminated.

Other artists working during the reign of Shah 'Abbas II used different aspects of Riza's work as a point of departure. Thus Afzal al-Husayni borrowed the themes of the reclining woman and a dog drinking wine from a bowl from Riza and combined them in a painting of a 'pin-up girl' of the 1640s [fig. 127]. The rolled-up dress, flashy knickers, exposed belly and flowers tucked in her undergarment are all signs of this woman's seductiveness, as most likely are the dog and wine. For all his kingly virtues, Shah 'Abbas II was a lascivious man and paintings such as that of Afzal al-Husayni capture the new emphasis on sex that existed in some segments of Safavid society. Stylistically, the work of Afzal al-Husayni adheres closely to that of Riza. Not only are trees and plants painted in gold but also a high level of specificity is maintained in the depiction of costume and blue and white ceramics. Other followers of Riza such as Muhammad Qasim painted erotic pictures,[16] but like Afzal al-Husayni he also illustrated manuscripts and produced single-page paintings for inclusion in albums. Thus in the period 1052–61/1642–51 when Afzal al-Husayni was working on a *Shahnameh* for presentation to the shah,[17] Muhammad Qasim was working with Malik Husayn Isfahani, his son Muhammad 'Ali and Muhammad Yusuf on a *Shahnameh* for the superintendent of the sanctuary of the Mashhad shrine. This manuscript, now in the Royal Library at Windsor Castle, was completed in 1058/1648. The paintings attributed to Muhammad Qasim in the *Shahnameh*[18] as well as his single-page works feature liquid rocks and stippled grass [fig. 128]. His young figures, both male and female, have very round cheeks, slightly smiling mouths and expressive eyebrows. Although some figures in his *Shahnameh* illustrations verge on the grotesque, the personages in his album paintings rarely display any individuality.

Similarly, in Muhammad 'Ali's oeuvre numerous drawings of young men portray the figures as types seated outdoors with fruit and bottles of wine, a formula used repeatedly by the followers of Riza. Muhammad Yusuf's portraits of young dandies, like the work of Afzal al-Husayni, reveal a greater debt to the work of Riza than do the drawings of Muhammad Qasim and Muhammad 'Ali. Of the artists working during the reign of Shah 'Abbas, Muhammad Yusuf took the greatest care to render faithfully the opulent textiles woven with thread of gold and ceramic cups and bottles which in

some cases are of types that have not survived [fig. 129]. Unlike Bahram Sofrehkesh, Shaykh ʿAbbasi and Shafiʿ ʿAbbasi, the artists commissioned to work on important *Shahnameh*s – Afzal al-Husayni, Muhammad ʿAli, Muhammad Qasim and Muhammad Yusuf – were sparing in their use of European and Indian techniques. As at the Chihil Sutun where the traditional and Europeanizing styles coexisted, the two sets of artists represented the two parallel but separate strains that dominated painting in the period of Shah ʿAbbas II.

The third of the four dated Safavid carpets falls within the reign of Shah ʿAbbas II. It is a vase carpet dated 1067/1656 and signed ʿUstad Muʿmin ibn Qutb al-Din Mahani'. Assuming that the weaver/designer had stayed in the region of Mahan, which is very close to Kirman, this inscription would support evidence for Kirman as one of the main sources for carpets in the vase-carpet technique. While the designs of carpets in this group vary, the technique is quite consistent. The warps are cotton and the first and third wefts are wool, while the second is usually silk or cotton or a silk–cotton ply. The pile is wool and the knotting and overall structure of the carpets is tight and sturdy, which may account for their good survival rate. Vase carpets in a range of quality were produced over the course of the seventeenth century. As Beattie has remarked, 'Good drawing itself is not necessarily indicative of an early period as the graceful design of the Sarajevo carpet of 1656 shows, but good draughtsmanship points to Court patronage.'[19] Although the multiple medallions in the Sarajevo carpet do not include animals or figures as some sixteenth- and early seventeenth-century examples do, the design underscores the continuing high quality of vase carpets in the middle of the seventeenth century. Unfortunately, the design of the 1656 carpet is not shared with enough others to help date a large group of Persian carpets. Moreover, from the variety of examples, including garden carpets, produced in the vase-carpet technique, one must conclude that Kirman carpet makers served a broad market both within Iran and in India, if not other foreign lands.[20] As for other carpet types, production of Polonaise carpets in silk with silver and gold brocade would have continued in the period of Shah ʿAbbas II with Isfahan and Kashan as the centres of production. Unfortunately, the conventionalized depiction of carpets in illustrated manuscripts from this period offers no help in identifying what styles were prevalent.

129 'Young Dandy', signed by Mir Yusuf [Muhammad Yusuf], Isfahan, c. 1640–45, opaque watercolour and gold on paper, 17 × 10.5 cm, British Museum, OA 1948.12-11.015, Bequest of Sir Bernard Eckstein, Bt. It is possible that the faces that appear on the bottles and cushion covers of some 17th-century paintings are allusions to the absent lover of the main sitter in the portrait.

According to one scholar, 'Persian silk-weaving reached a peak under Shah ʿAbbas II.'[21] Magnificent figured velvets continued to be produced in the early years of Shah ʿAbbas II's reign, as attested by a coat decorated with swaying drinkers and flowers presented to the Russian czar by Queen Christina of Sweden in 1054/1644.[22] Unlike carpets, textiles that appear in the paintings of Afzal al-Husayni and Muhammad Yusuf give some indication of what was current in the 1640s and 1650s. Interestingly, the drinkers in the textile wear robes decorated with lancet leaves similar to those seen on the jacket of the kneeling youth in the painting by Muhammad Yusuf [see fig. 129]. The pattern of black and white flowers on the gold ground of the kneeling youth's trousers also is closely related to an extant fragment of brocaded taffeta [fig. 130].

While a group of figured velvets of pairs of women by a pool bear the inscription 'the work of Shafi'', the absence of the name ʿAbbasi may indicate a date in the period of Shah Safi whereas a

130 (left) Brocaded taffeta fragment, mid-17th century, silk, 40.3 × 23.7 cm, Textile Museum, Washington, DC, 3.138, acquired by George Hewitt Myers in 1930. Although the background has faded from bright pink to beige, the pleasing colour harmonies and elegant design of the brocaded flowers remain intact.

131 (opposite) Ewer, mid-17th century, beaten brass, engraved, h. 27 cm, diam. of base 7.6 cm, British Museum, OA 78.12-30.736, Henderson Bequest. The decoration of this ewer includes inscriptions, flowers and peacocks, whereas one ceramic counterpart is covered with an opaque monochrome glaze and is otherwise without ornament.

signed brocaded silk on metal ground in the shrine of Imam 'Ali at Najaf includes "Abbasi' after Shafi', implying its manufacture after 1052/1642.[23] The design of the cover consists of a lattice of ogives formed of wide bands of gold brocade punctuated by rosettes where the bands touch and on the diagonal. The motif within the ogive is comprised of a spear-shaped floral element on a stalk that springs from a cloud form and is set in the middle of a flowering ogival vine. The design is complex and elegant without being at all fussy. None the less, it is stiffer than Shafi' 'Abbasi's flower drawings and one wonders to what degree the textile specialist, the *naqshband*, needed to adapt Shafi' 'Abbasi's design. It is possible that Shafi' 'Abbasi also supplied designs to court silversmiths because, as Allan has pointed out, the lattice ornament on the silver door facings at the Ardabil shrine is closely related to textile designs of the 1630s and 1640s.[24] Although silk kilims provide some of the closest analogues to the silver door facings, Allan notes that curtains would have covered the doorways and may have been designed to correspond to the actual doors they covered. In this context, tomb covers such as the one from Najaf would have formed another element of a complete design ensemble, made possible through the periodic refurbishment of the Shiite shrines commissioned by the shahs.[25]

The striped, patterned leggings of Afzal al-Husayni's 'Lady Watching her Dog Drink Wine' are typical of the fashion for embroidered silk or cotton lady's trousers that began in the Safavid period and survived into the nineteenth century. Her flowered knickers with a drawstring, on the other hand, are not seen so often in paintings and are not the sort of textile of which extant examples have been widely published. The material was presumably printed cotton or possibly silk. Large quantities of cotton were imported from India from the 1620s on, but simple patterns such as that in the painting are difficult to assign to either Iran or India with any confidence.

If a footed tinned copper bowl dated 1053/1643–4 in the Victoria and Albert Museum[26] can be considered representative of the period, established shapes of objects evolved slightly while decoration became more fragmented in this period. The standard inscription band below the rim is now separated from the ornament on the lower sides of the bowl by a plain rib plus a scroll. The decoration of the lower sides consists of pairs of figures with animals in compartments. While resembling the red and white silk of the 1620s or 1630s with its compartments, on a round metal bowl the sections interrupt the circularity of the bowl. An undated ewer [fig. 131] displays a breaking up of the decoration to a far greater degree than the bowl of 1053/1643–4. Although its dating to the period of Shah 'Abbas II is by no means assured, a ewer of the same shape is carried by a servant girl in an illustration to a *Khamseh* of Nizami dated 1060/1650.[27]

The ewer with its high, wide neck, bulbous body, tall curving spout, conical lid and outward curving handle is decorated with bands of low relief ornament and inscriptions separated by plain, narrow borders. *Thuluth* inscriptions appear in interlocking cartouches along the rim, in two bands on the neck, at the shoulder and at the widest point of the body as well as in one band on the lid. On the lid quatrefoils containing blossoms appear between

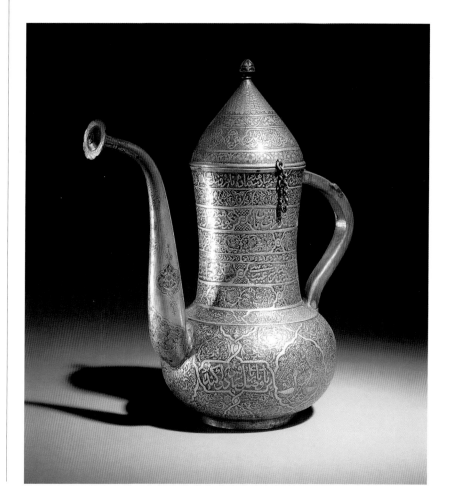

inscription cartouches on a ground of crosshatching, while above and below are bands containing simple floral scrolls. Lappets run to the point of the lid topped by a floral knob. On the side and base of the spout are lobed medallions containing floral ornament similar to that on the lid. The decoration of the neck and body displays a variety of motifs in addition to inscription bands. These include a band of overlapping split-palmette arabesques, two bands of interlocking cartouches with arabesques and cloud bands, and narrow bands of scrolls in oblong segments. On the bulbous body inscription cartouches interlock with lobed ogives containing confronted peacocks. This motif appears as early as the 918/1512 façade of the Harun-i Vilayat in Isfahan and figures again, among other instances, in the pendants of the so-called Behague Sanguszko carpet, attributed to the period of Shah 'Abbas I.[28] The switchback split-palmette leaf arabesque that fills the area between the cartouches, ogives and half-ogives at the shoulder and foot also recall carpet designs, as does the association of cartouches and lobed ogives. It is possible that, as with earlier Safavid metalwork and carpets, the basic motifs and the notion of what combinations were suitable originated with bookbinders or illuminators. Although the *thuluth* script may indicate a North Indian provenance, the use of the Y-fret motif above and below the lobed medallions resembles that found on a metal bowl inscribed in Armenian and assigned to western Iran in the seventeenth century.[29]

A handful of dated examples contributes to our understanding of ceramics in the reign of Shah 'Abbas II. As before, wares decorated in underglaze blue and black on a white stonepaste body abound. Two dated tomb tiles are decorated in these glazes; one made for Fatima bint Nur Allah of Darband is dated 1055/1645,[30] and the other, inscribed with the name of Malik ibn Husayn and dated Dhu'l

Hijja 1052/February 1643, is decorated with images of a Qur'an stand, a turban, spectacles, a penbox, penknife and other implements of a 'man of the pen'.[31] Although interesting in their own right, these tomb tiles shed little light on the stylistic development of blue and white ceramics in the 1640s. By contrast, a large dish with a floral spray incised in the centre under a clear greenish glaze and an inscription in white on a black ground in cartouches in the cavetto with the date 1057/1647 indicates a new taste for inscriptions or ornamental bands scratched through a black ground.[32] While this revives a technique found in late fifteenth-century wares from north-west Iran, it is also a characteristic of a group of wares attributed to Kirman. On dishes and bowls the black band appears in the cavetto, whereas on objects of other shapes the band is placed near the top or near the bottom or both. The motif has a life of at least fifty years, as later examples will demonstrate. In addition, a vogue for combining passages of unpainted incised decoration with ornament rendered in underglaze blue or black like that found on the 1057/1647 dish can be assigned to the mid-seventeenth century.

The technique of incising through the underglaze was not limited to inscription and decorative bands on blue and white ceramics from Kirman. Based on a *qalyan* dated 1068/1658–9,[33] a group of monochrome wares with decoration either carved through the underglaze or applied in slips contrasting in colour with the ground can be assigned to the mid- to late seventeenth century. While the dated *qalyan* is decorated in white and yellow ochre with a spray of dianthus and storks and clouds, most of the ornament on pieces of this type is vegetal. The decoration ranges from simple sprays of spiky flowers and loose split-palmette elements, identical to those on the rim of the 1057/1647 dish and found on a

large dish [fig. 132], to acacia trees combined with medallions containing arabesques as on a vase with a celadon-coloured glaze [fig. 133]. The acacia trees recall the gold-painted vegetation found so often in the paintings of Riza and Afzal al-Husayni, whereas the arabesque medallions derive from manuscript illumination, moulded monochrome pottery of the period of Shah 'Abbas I and metalwork. By the late 1650s these motifs were clearly well established in the general decorative repertoire of the Safavids. Ceramics in this group vary greatly in shape. Long-necked *qalyan*s are common, but round ones can be found as well. Dishes, bowls and vases glazed blue or green vary in hue according to the firing.

The decorative style of the slip-painted or carved monochrome wares relates closely to that of one of the largest Kirman groups, the polychrome wares. Along with similar arabesque and spiky floral designs, this group includes a broad range of figural vignettes [fig. 134], and pieces that combine Chinese-style blue and white landscape elements with arabesque medallions. In addition to blue, the underglaze palette includes coral red and green. Like the Kirman wares with white inscriptions on black grounds, this style of ceramics maintained its popularity into the last quarter of the seventeenth century. The great number of such pieces that survives suggests that this class of Kirman wares was produced in large quantities to satisfy markets that suffered as a result of the so-called Transitional Period when Chinese exports all but ceased from the end of the Ming dynasty (1644) until the end of the seventeenth century. Although blue and white ceramics were certainly the dominant substitute for Chinese blue and white, other groups such as the Kirman polychrome wares must have been deemed acceptable as well by the Dutch and English trading from Bandar 'Abbas. In addition, the size of objects such as the *qalyan*s is very uniform no matter what the glaze type, suggesting that kilns turned out large quantities of blanks to be glazed and decorated by various potters.

Although Chardin's line, 'When this gentleman [Shah 'Abbas I] ceased to breathe, Iran ceased to live' has been used repeatedly to demarcate the point at which Iran began to decline, the state of Iran was probably more prosperous and stable at the end of the reign of Shah 'Abbas II than in 1038/1629. New artistic ideas were welcomed at the highest level as the Europeanizing paintings in the Chihil Sutun demonstrate. While the presence of European artists in Iran and the wealth and internationalism of the Armenian population contributed to awareness of European art, trade with Europe and India galvanized the textile and ceramic industries. The demand for imitations of Chinese ceramics translated into the continuation of production of blue and white wares, which were probably made in the largest numbers in Kirman, with Mashhad another major centre. Shah 'Abbas II's tolerance for dervishes may have resulted in an upsurge of popularity for *kashkul*s, or begging bowls, made in metal or ceramic, their boat shape following a long tradition rooted in ancient wine bowls. At the time of Shah 'Abbas II's death Iran was a strong link in the world economy, and was maintaining its own vibrant and distinctive culture in the visual arts. As always, the seeds of decline were already sown, but the man on the street in Isfahan in 1077/1666 would have probably had fewer complaints than his grandfather.

132 (opposite, above) Dish, Kirman, mid-17th century, stonepaste, moulded, opaque blue glaze, diam. 47 cm, British Museum, OA 1970.2-7.1, Bequest of Lily Nora Ziegler. The use of white slip to produce a design on a blue ground appears in at least one Chinese dish in the Ardabil shrine, suggesting a Chinese inspiration for the technique of this Persian dish, if not its floral decoration.

133 (opposite, below) Vase, Kirman, mid-17th century, stonepaste, white slip decoration, green underglaze, transparent glaze, cut-down neck, h. 23.8 cm, British Museum, OA 96.6-26.3, Franks Collection. This vase has an acacia design on one side and a medallion containing an arabesque on the other.

134 (above) *Qalyan* (hookah base), Kirman, mid-17th century, stonepaste, polychrome underglaze decoration, h. 29.8 cm, British Museum, OA 90.5-17.13, presented by Sir. A.W. Franks. The traditional imagery of Khusrau spying Shirin bathing is enhanced on this piece by the depiction of Khusrau as a falconer complete with a groom running before him and his horse.

The Patrimony Squandered

Shah Sulayman (Safi II)

1666–1694

When the Emperor marches out with his Women, and all the Seraglio, it is forbidden the Day before by a
Publick Cryer, for any Man on pain of Death to invade his Walks . . . The King like a Dunghil Cock,
struts at the Head of the Amamian Army.[1]

The oldest son of Shah 'Abbas II, named Safi Mirza, was born to a Circassian mother in late 1057/December 1647–January 1648. Like his father and grandfather, he was reared in the harem without the benefit of any training in statecraft. Although he had received some form of education from his eunuch tutor, he was entirely unprepared to become the next Safavid shah. Nevertheless, the advisers to Shah 'Abbas II preferred Safi Mirza to his seven-year-old brother and he was crowned Shah Safi II on 30 Rabi' I 1077/30 September 1666. Like his namesake, Safi I, the nineteen-year-old shah's first inclination was to indulge in a prolonged celebration involving extravagant gifts, granting of fiefs and filling all vacant administrative posts at great cost to the royal treasury. The damage thus inflicted on the economy was aggravated by earthquakes in Shirvan and Tabriz, followed by disease, drought and famine. Furthermore, ever mindful of the potential loss of central control at the time of a change of shah, the Uzbeks and a newer threat, the Cossacks, wasted no time in raiding Khurasan and Mazandaran. Clearly something had to be done to arrest the slide into chaos. The court astrologers obliged by blaming all the recent misfortunes on a miscalculation of the most auspicious time for Shah Safi II's enthronement ceremony. As a result, a new horoscope was drawn up, indicating 24 Ramazan 1077/ 20 March 1667 as the day for a new coronation.

To give himself every opportunity for a clean slate, the shah even changed his name, becoming Shah Sulayman. He also seems to have undergone a complete change of heart, if not personality. As John Fryer, who arrived in Iran in 1677, described him:

In the beginning of his Reign, like another Nero, he gave good Specimens of his Inclinations, not unworthy of the Heroes that were his Ancestors; but when he began to Hearken to Flatterers, and give himself over to Idleness, he left off to Govern, and lifted himself in the service of Cruelty, Drunkenness, Gluttony, Lasciviousness, and abominable Extortion, where he perpetrated things not only uncomely to be seen, but even offensive to the Ears.[2]

Where he had erred on the side of extravagant generosity, he now veered into miserliness and cruelty. The number of troops in the royal army declined drastically, as did appointments to government

135 Detail of fig. 140.

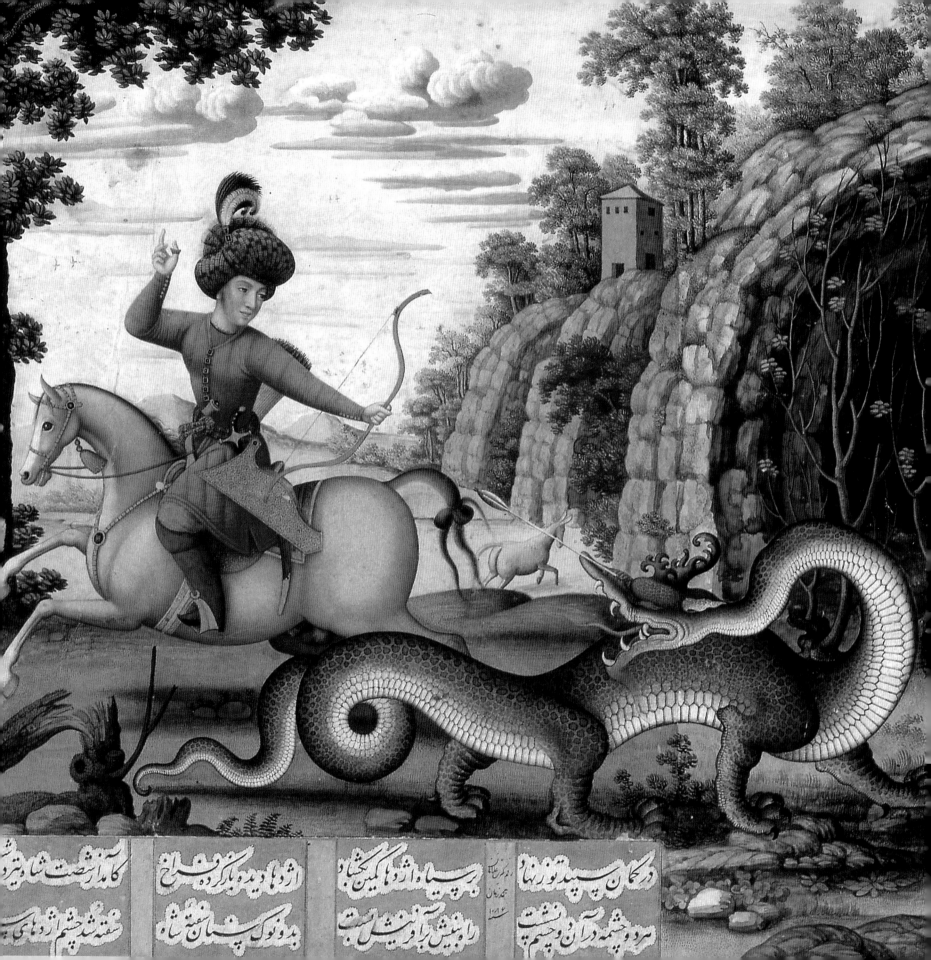

posts, while new and higher taxes were imposed. The combination of higher taxation and business failures led in the 1670s to social unrest and poverty. In spite of the general decline in the standard of living in Iran, pomp and opulence abounded at Shah Sulayman's court.

For all of his apathy and lack of sustained interest in governing, Shah Sulayman, most likely with the good advice of a succession of grand viziers, managed to keep Iran out of wars with its neighbours. In the 1680s opportunities arose for him to assume control of Mesopotamia, which had been formally ceded to the Ottomans in 1049/1639. Yet he adhered to the established treaty. Likewise, the Cossack raids on the northern provinces of Iran did not spark an all-out war with Russia, as they might have done with a different shah on the throne. Mathee's recent assessment of Shah Sulayman's policy towards the various rapacious bands on his borders suggests that his inaction was the result of the need to husband his resources and to concentrate on keeping the Uzbeks and Baluch tribesmen in the east at bay.[5] Although the raids did not stop, the Safavids and the khans of Bukhara enjoyed good relations in this period and territorial boundaries remained intact.

Shah Sulayman spent increasing amounts of time in the harem, disregarding his ministers and the structures that existed to ensure the smooth running of the government. Instead of the appointed government ministers, a *de facto* council of eunuchs, astrologers and the queen mother effectively controlled the government. The weakening of the country that ensued led to new incursions on Iran's eastern borders and rebellion in Georgia and Kurdistan. Although Shah Sulayman had enjoyed the service of an honest grand vizier for the last two-thirds of his twenty-eight-year rule, the sensible reforms put forward by the vizier were not as effective as they might have been because of the shah's lack of sustained support. One area of decline noticed by all was the debasement of the currency, in part due to the scarcity of silver which was being exported illegally along with gold to India. Yet ironically the shah and his court continued to feast on gold platters and drink from gold jewel-studded goblets. Although the religious hierarchy, the *'ulama*, did not exert much control over the shah, they did not approve of his degenerate activities. Shah Sulayman appears to have been as apathetic towards questions of religion as he was towards government, which also displeased the *'ulama* but spared

religious minorities from persecution. Nevertheless, Sufism was increasingly frowned upon by the *'ulama* and the court as potentially heretical and politically threatening, a development that played a more decisive role in the reign of Shah Sulayman's successor, Shah Sultan Husayn.

On 6 Dhu'l Hijja 1105/29 July 1694 Shah Sulayman died at the age of forty-seven. Although he was considerably older than his own father at the time of his death, he had accomplished far less. As addicted to alcohol, drugs and sex as his father, Shah Sulayman did not have the redeeming qualities that were needed to keep Safavid society in balance and prosperity and well protected against external enemies. His love of splendour benefited the arts and architecture, at least at the royal level, and foreign visitors during his reign still marvelled at the beauties of Isfahan. Yet the same visitors – Chardin, Kaempfer, Tavernier, to name a few – all realized how little attention the shah paid to matters of state, and they more than anyone have left a valuable record of the mood of the era.

136 Hasht Bihisht, Isfahan, 1077–80/1666–9, north façade, from Pascal Coste, *Monuments modernes de la Perse* (Paris, 1867), pl. xxxvi. This 19th-century view of the Hasht Bihisht palace not only illustrates how the outdoors is brought indoors through the high, open porch but also how the arches on two levels served as screened windows before they were blocked with concrete.

The major expression of Shah Sulayman's architectural patronage is the Hasht Bihisht, a palace set near the north-east end of the Chahar Bagh beside the Garden of the Nightingale [fig. 136]. The name, meaning 'Eight Paradises', may have been borrowed from the famous palace of the Aqqoyunlu Turkmans at Tabriz, but the plan, an irregular octagon, essentially a square with truncated corners, is found in a late fifteenth-century *khangah* (dervish lodge) in Isfahan and another *khangah* of about the same date in Bundarabad.[4] While no connection can be established with the Timurid buildings, such a ground plan, at least, was not a novelty in late seventeenth-century Isfahan. Moreover, one of Shah Tahmasp's pavilions at Qazvin was also an irregular octagon. Otherwise, the elevation and division of the spaces of the building exemplify the continuing originality of Safavid architects. In the centre of the north, east and south sides of the building are *talar*s with pitched roofs extending from the top of the upper storey of the building, while the south side has an arched *ivan* which is now closed to the outside but was originally open. Of these openings the north *talar* is the widest, the east and west are of the same dimensions and the south *ivan* is half the width of the northern *talar*. On the ground floor the central octagonal hall with a pool and fountain in the middle of it rises the full height of the two-storey building to a dome faced with *muqarnas* decoration and topped by a domed lantern. In the four corners of the central hall are rooms on two storeys, thus totalling 'eight paradises', along with galleries and other rooms that look out on the exterior of the palace. Here again the architect sought variety by constructing four octagonal chambers around the dome on the ground floor, but the rooms directly above them are square.

The decoration of the palace was totally refurbished in the nineteenth century, but Jean Chardin's description provides a vivid impression of the palace interior:

> Everywhere is something different and new: in one are
> fire places, in others basins with fountains which can be
> turned on by pipes let in to the columns ... The base up to
> 10 feet high was covered all round in jasper.
>
> The bannisters are made of gilded wood, the frames of
> silver and the panes are of crystal or fine glass of all
> colours. The decoration is magnificent, unsurpassed. It is

coloured only in gold or blue. As for the paintings many of them are full of scenes of enjoyment and nudity, which have an abundance of astounding beauty and animation, with crystal mirrors here and there. Little chambers have mirrors on the walls and in the domes ... There were many plaques on which voluptuous verses or moral sayings were written.[5]

137 Hasht Bihisht, Isfahan, spandrel with tile revetment, 1077–80/1666–9. The decorative programme of the *cuerda seca* tile spandrels consists of a range of animal combats, mythical beasts, and hunts which are intended to reflect the superior might of the patron of the building, Shah Sulayman.

Even at this date, the mirrors were still imported to Iran and they must have been valued for the way in which they and the pools in and around the building reflected from both above and below. In a more general sense, the mirrors were just one of the means by which the outside was brought into the inside of the Hasht Bihisht, the most obvious being the *talar*s, central pool and windows which originally were not bricked up but had woodwork grilles.

On the exterior, arcades of niches with pointed arches on two storeys run between the *talar*s. Above each of these are tile revetments featuring animal combats, hunting scenes, vignettes from literature and mythical and other beasts [fig. 137]. Taken together, these subjects symbolize power and must have been intended to communicate the potency of Shah Sulayman, while the paintings in the interior rooms were designed to set a more intimate mood. The *cuerda seca* tiles [fig. 138] exemplify the taste for bright yellow glaze combined with bright apple green, turquoise and cobalt blue that became popular in the 1660s and is found in the areas of the Masjid-i Shah decorated under Shah Sulayman as well as in the Armenian Church of the Holy Mother of God in Isfahan.[6] Many of the spandrels contain flowers and insects which closely resemble those found in the album containing drawings by Shafi' 'Abbasi, and the style of the figures follows the traditional mode practised by Mu'in Musavvir, although it seems far-fetched to attribute their drawing to him.[7]

Another palace, the Talar Ashraf, was built near the site of the Talar-i Tavileh, the *talar* of the royal stables to the south-west of the 'Ali Qapu. Despite its name this building had served as one of the private palaces of the shahs and was the setting of extravagant receptions. Probably built about 1101/1690, Talar Ashraf consists of a vaulted central pavilion with a smaller room on each side and three *ivan*s on the façade. This building was saved from ruin in the twentieth century, and some of its fine stucco decoration remains.

Like his predecessors, Shah Sulayman repaired various existing buildings, including three *madrasa*s at the Mashhad shrine (Du Dar, Parizad and Balasar, 1088–91/1677–80), but except for the Talar Ashraf his architectural patronage appears to have abated well before the end of his reign.

Painting under Shah Sulayman followed a course determined by the Europeanizing artists at the court of Shah 'Abbas II. While Shafi' 'Abbasi continued to be active during the reign of Shah Sulayman, several new names are associated with court painting. All these artists employed European techniques to a greater or lesser degree and in some cases they may have viewed their European sources through the lens of Mughal paintings which in turn copied or adapted European prototypes. One such artist was 'Ali Quli Jabbadar, whose signature suggests he was the son of a converted Christian slave. In his lifetime royal artists were under the administrative care of the armoury, hence the title Jabbadar ('armourer'). His earliest work, a painting of Majnun outside an encampment, dated 1068/1657–8, is a copy of a work attributed to the Mughal artist Govardhan, working about 1040/1630.[8] Many of 'Ali Quli's paintings throughout his career until 1128/1716 are outright copies and the majority of them are based on European prints. However, he also painted portraits of Iranians, such as that of a prince and a lady [fig. 139].[9] Where his copies of European prints exhibit a faithful rendering of drapery and adherence to the composition of the original print, his paintings of Persian subjects, mostly portraits of courtly figures, are characterized by a stiffness and relative two-dimensionality, as if the figures were supported by a carapace rather than the bones within the skin. The selective shading on the face of the prince recalls the work of Shaykh 'Abbasi and raises the question whether 'Ali Quli might not have been trained by the older master. In any event, the discrepancy between 'Ali Quli's copies of European prints

and his paintings of Persian subjects suggests that he was a skilled imitator but either unwilling or unable to employ the full array of European techniques in the portrayal of Persians. Nevertheless, 'Ali Quli Jabbadar's group scenes of the Safavid court mark a significant break with the idealized portraiture of previous eras by individualizing the facial features of the shah and various important grandees so that they are differentiated from one another first by physiognomy and then by posture and attire. By contrast, beardless youths continued to be depicted as types rather than individuals.

The other leading proponent of the Europeanizing style at the court of Shah Sulayman was Muhammad Zaman, son of Hajji Yusuf Qumi. The early years of this artist's career are not yet clearly understood because his first dated paintings from 1087/1675–6 are those of a mature artist.[10] These include illustrations added to the 1539–43 British Library *Khamseh* of Nizami and the Chester Beatty Library *Shahnameh* made for Shah 'Abbas I, the painting 'Majnun Visited in the Wilderness',[11] and the painting 'Venus and Cupid' based on an engraving by the Flemish artist Raphael Sadeler. The inscriptions on Muhammad Zaman's additions to the *Khamseh* state that he completed them in Ashraf, the Safavid royal complex near the Caspian Sea, indicating that he was in the employ of Shah Sulayman by this time. The range of subjects from 1086–7/1674–6 indicates the breadth of taste at court level in this period. Muhammad Zaman, unlike 'Ali Quli Jabbadar, rendered these in a consistent

138 (opposite) 'Archer', Isfahan, second half of the 17th century, *cuerda seca* stonepaste tile, h. 16.5 cm, British Museum, OA 1949.11-15.8, Gift of Mrs Percy Newberry. As at the Hasht Bihisht, tile panels depicting a range of activities, from hunting to feasting, were produced in the *cuerda seca* technique in which the colours were separated by a waxy line to keep them from running together during firing.

139 (right) 'A Prince and a Lady', signed 'ghulamzadeh Qadimi 'Ali' ['Ali Quli Jabbadar], Isfahan, c. 1080/1670, opaque watercolour and gold on paper, 23.1 × 13 cm, British Museum, OA 1920.9-17.0295. Aside from the extravagant array of feathers and jewels in the prince's turban and the décolletage of his lady, this picture presents a somewhat odd combination of European landscape elements and modelling, on the one hand, and the very flat treatment of the prince's robe on the other.

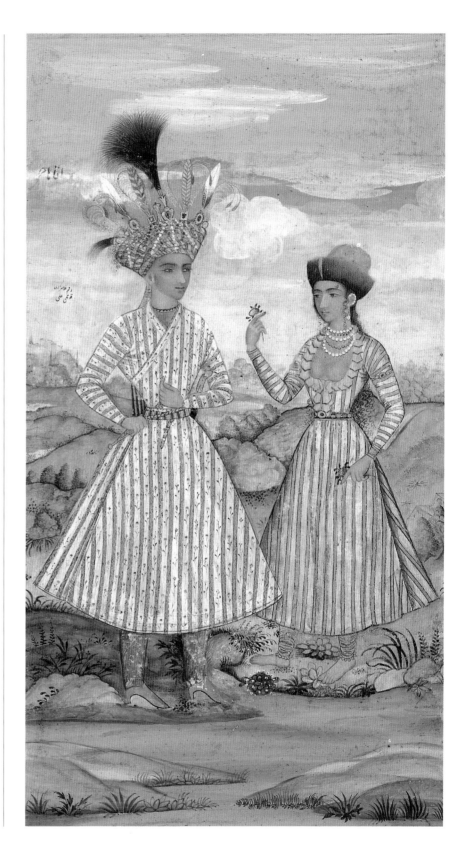

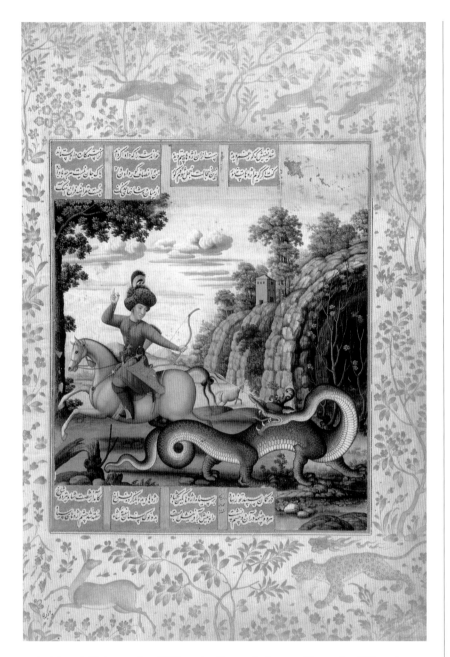

140 (above) 'Bahram Gur Killing the Dragon', from a *Khamseh* of Nizami, signed by Muhammad Zaman, Ashraf, Mazandaran, dated 1086/1675, opaque watercolour, gold and ink on paper, page 36 × 25 cm, British Library, Or. 2265, fol. 203*v*. This is one of the paintings added to Shah Tahmasp's *Khamseh* of 946–50/1539–43 by Muhammad Zaman.

141 (opposite) 'Wrestlers and a Trainer', from the Engelbert Kaempfer Album, Isfahan, 1096/1684–5, opaque watercolour and ink on paper, page 20.9 × 29.2 cm, British Museum, OA 1974.6-17.01(19). Wrestling contests in Iran include lifting heavy bats like those seen lying on the ground.

style. He was also mindful of a single source of light and the use of cast shadows and modelling as pictorial devices [fig. 140]. Puffy clouds, rows of birds in the sky and leafy trees typify many of his works, and drapery is often rendered with brightly lit folds separated from one another by dark crevasses. Despite Muhammad Zaman's adoption of various aspects of European painting, his figures are nonetheless stiff and often have unnaturally swollen eyes. Some paintings of Christian subjects from the 1680s may have been commissioned by Armenians, as at least one inscription identifies the patron as 'Isa, an Arabization of the word 'Jesus' and a common name given to Christians living in Iran.[12] Also, from the 1680s comes a group of flower paintings by Muhammad Zaman.[13] These exquisite works are rendered in rich polychrome, sometimes on a coloured ground; they neither grow out of the earth nor reveal the flowers in bud and blossom like Shafi' 'Abbasi's flower drawings, which appear to have been based on botanical prints.

Even at the more commercial end of the market, some painters followed the Europeanizing trend. One such practitioner signed his works 'Jani farangi saz son of Bahram farangi saz', meaning 'Jani who works in the European style, son of Bahram who works in the European style'. This artist signed two of the forty paintings in an album compiled for the Dutch physician Engelbert Kaempfer, who spent the years 1684–5 in Isfahan with a Swedish diplomatic mission, followed by two and a half years in Bandar 'Abbas. The paintings in Kaempfer's album consist of pictures of pairs of people such as one would find in Isfahan [fig. 141], animals in pairs or in combat or singly, scenes of amusements and one scene from literature. While this album provides a valuable adjunct as a social document to Kaempfer's account of his stay in Iran, it also shows which aspects of European painting were generally deemed essential for artists working in the European style. Despite the lack of landscape in most of the pictures, the artist has included cast shadows and modelling to indicate folds of drapery. As an array of types the figures in the album exhibit almost no facial differentiation; their individual characteristics are defined through various forms of dress and identifying labels in Persian and German. Although one might argue that the artist tailored his style to suit his European customer, such an album does demonstrate how thoroughly European ideas had infiltrated Persian painting at all levels by the 1680s.

Meanwhile, more traditional artists continued to be employed on illustrating manuscripts. These included two histories of the Safavid dynasty from its origins to 1077/1666, commissioned by Shah Sulayman, and several versions of the anonymous *History of Shah Isma'il I*. Although the illustrations in these manuscripts include some shading and modelling of faces, the landscapes reveal little or no attempt at one-point perspective or naturalistic atmospheric effects. By the end of Shah Sulayman's reign the European style had made inroads into manuscript illustration as exemplified by a *Shahnameh*, copied between 1074/1663 and 1079/1669 and illustrated between 1104/1693 and 1109/1698, now in the Metropolitan Museum of Art, with traditional paintings signed by Mu'in Musavvir, his student Fadl 'Ali and Ghulam Pir Beg, and Europeanizing ones by 'Ali Naqi ibn Shaykh 'Abbasi and an artist whom Robinson has identified as Muhammad Zaman.[14] While the royal encouragement of artists working in the European style during the reign of Shah 'Abbas II helped establish the style, the continuing favour during the reign of Shah Sulayman led to its broad adoption by commercial as well as court artists.

A significant development in the area of painting during the second half of the seventeenth century was the expanded repertoire of lacquer objects decorated by leading artists. Whereas sixteenth-century court artists were known to paint scenes that often were analogous to double-page frontispieces on lacquer book covers, seventeenth-century Europeanizing painters such as Shafi' 'Abbasi, 'Ali Quli Jabbadar and Muhammad Zaman produced lacquer penboxes and possibly mirror-covers and caskets. In fact, it appears that Muhammad Zaman came to the attention of Shah Sulayman as a lacquer-painter, since a rectangular lacquer penbox that he made for the shah is dated 1084/1673–4,[15] a few years before most of his first dated paintings. Both the penbox of Muhammad Zaman and an example by Shafi' 'Abbasi in the Khalili Collection dated 1061/1650–51[16] are decorated with a unified theme, a landscape with figures on Muhammad Zaman's penbox and individual flowers, birds and insects on Shafi' 'Abbasi's. Later individual subjects, such as portrait busts, were combined with arabesque or floral decoration on one surface and unrelated motifs on the sides and interior covers of penboxes.

The one datable carpet from the reign of Shah Sulayman was produced in 1082/1671 for the tomb of Shah 'Abbas II at Qum.[17] This single silk example with metal thread brocade is consistent with the Polonaise group but does not shed much light on the stylistic development of that type of carpet. Its design consists of a central medallion, a border of two overlapping scrolls, half-cartouches intruding on the field from the sides and palmettes, vases and lancet leaves, like a compendium of seventeenth-century carpet motifs, decorating the field. A painting of Shah Sulayman with courtiers and musicians from about 1080/1670 [fig. 144] depicts the gathering taking place on a veranda covered by a red-ground carpet with palmettes, lancet leaves and thin tendrils forming arabesques which closely resembles the woollen carpets of the so-called Herat type.[18] Although it is not known whether 'Herat' carpets were made in Herat or Isfahan, this type was exported both to Europe and India. While courtiers stand and kneel on the Herat carpet, the shah is seated on a white cotton cloth with a small floral arabesque pattern placed on a gold rug of which the borders are visible. The gold rug is probably from the family of Polonaise carpets, and the cotton cover is of a type described by European travellers used for protecting carpets at feasts and other occasions. Most likely this cloth was imported from India.

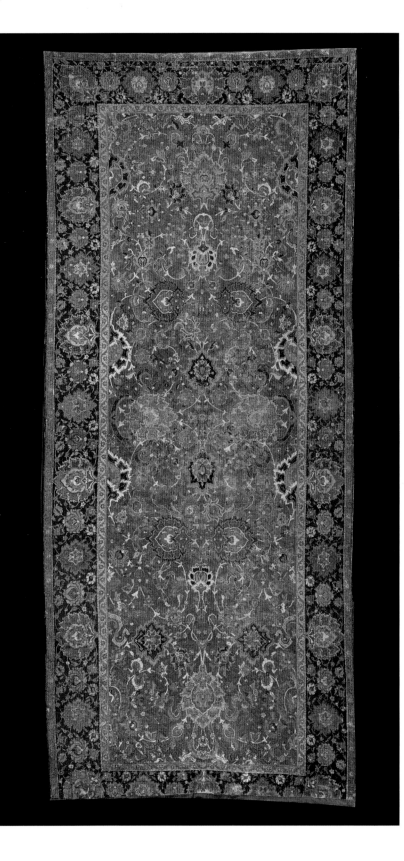

142 (left) Herat carpet, Isfahan or Herat, mid–late 17th century, wool, Courtesy of the Textile Gallery, London. In this example lotus blossoms and spiral tendrils, rather than lancet leaves, predominate.

143 (right) Metal-ground textile, second half of the 17th century, silk and foil-wrapped wefts, plain weave with supplementary wefts, 54.6 × 41.9 cm, Collection of Farhad Hakimzadeh. The rose and butterfly motif of this textile may be based on a design from a European pattern book.

Another painting of Shah Sulayman with a courtier and a servant from the same album as that mentioned above includes a variant of the Herat-style carpet.[19] Here green lancet leaves and pink and white four-petalled flowers are combined with cloud scrolls and lotus flowers on a ground that appears black but may have been dark blue. Blue-ground variants of the Herat type are extant, though the choice of palette as a function of artistic licence cannot be ruled out entirely. As in the group scene, the shah is seated on a white-patterned cloth that covers a small gold carpet. While the gold carpet represents a variation on the one in the group scene, the white coverlet is designed like a carpet with a border of irises alternating with pink flowers with pointed petals and a ground of rows of roundels, each containing a four-petalled flower. As only three of what must have been many types of carpets available in the last quarter of the seventeenth century, these floor coverings indicate the continuing manufacture of luxury metal ground and silk carpets as well as the development in Herat carpets away from the inclusion of animals to strictly floral and vegetal designs in the seventeenth century [fig. 142]. The cotton covers,

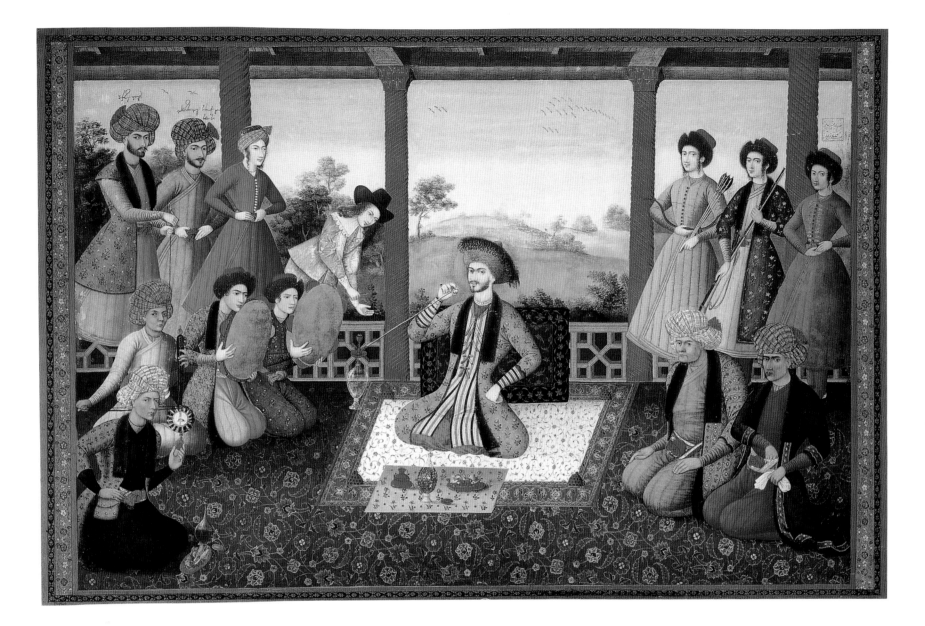

assuming they were Indian, demonstrate how thoroughly the taste for Indian cottons had spread in Iran by the 1670s. In addition, the cotton covers in both paintings are held down by small gold domes studded with jewels, called 'slaves of the carpet'.[20] These weights were produced in India and do not appear in other Persian paintings, even ones from the reign of Shah Sulayman. Assuming the two paintings are accurate depictions of Shah Sulayman's court, the slaves of the carpet may be further proof of this shah's taste for Indian products and style.

144 'Shah Sulayman and his Courtiers', signed by 'Ali Quli Jabbadar, Isfahan, c. 1080/1670, opaque watercolour, gold and ink on paper, 28.2 × 42.1 cm, Institute of Oriental Studies, St Petersburg, album E-14, fol. 98r. Although two of the standing figures at the left are identified in unread Georgian inscriptions, all the figures in this group scene are highly individualized and must have been familiar faces at the Safavid court.

145 (above) Lidded bowl, dated 1089/ 1678–9, tinned copper, engraved, with black composition, h. 28.6 cm, diam. 35 cm, Victoria and Albert Museum, 983-1886.

146 (left) Openwork plaque, dated 1105/ 1693–4, steel, h. 34.3 cm, w. 25.4 cm, British Museum, OA +368.

147 (opposite) Dish, Kirman, dated 1088/1677–8, stonepaste, underglaze blue, black, green and red decoration, diam. 40.5 cm, British Museum, OA 1983.308, Godman Collection.

Indian textiles also found wide use outside court circles. Silks with tulip designs are extant and may be the type of fabric used for the lining of coats or for complete robes,[21] as seen in paintings by Muʿin Musavvir from the 1660s and 1670s. In Iran opulent gold-ground textiles decorated with flowers of alternating colours on the diagonal, in stripes or as part of a lattice pattern continued to be produced and made into elegant fur-lined coats, robes and waistcoats [fig. 143]. In some examples the size of the repeat pattern decreased, but extant fragments show that the single flower repeats on gold ground were still large in scale in this period. However, the standing figures and smaller patterned figural vignettes of the first half of the century ceased to be prevalent in the reign of Shah Sulayman.

The metalwork of the period of Shah Sulayman does not mark a radical departure from that of the mid-century, but some small developments can be noted. A lidded tinned copper bowl dated 1089/1678–9 [fig. 145] and inscribed with the names of the Shiite imams follows the shape of a late sixteenth-century piece with its lack of foot, convex body and concave neck rising to a narrow, everted lip. The neck is proportionately higher than in earlier examples and the use of an escutcheon to separate sections of the inscription band is an innovation.[22] Otherwise, the animals, hunters and animal combats that decorate the body and lid of this piece fall squarely within the repertoire of seventeenth-century Persian metalwork, bookbinding and illuminated manuscript borders.

A significant development in Safavid metalwork, namely the production of openwork panels for fixing to doors and possibly cenotaphs, had begun in the sixteenth century but continued apace in the seventeenth. A remarkable set of gold openwork inscription plaques was presented to the Mashhad shrine by Shah Tahmasp in 947/1540–41, and similarly designed openwork inscription cartouches of ivory were produced about 930/1524 for the cenotaph of Shah Ismaʿil at Ardabil. Steel openwork panels appear at least as early as the sixteenth century set into ʿalams, or standards, and in decorative and inscription plaques shaped variously as quatrefoils, cartouches and lobed medallions. An example of the latter bears the date 1105/1693–4 and is inscribed in Arabic, 'It is from Sulayman and it is this: In the name of God the Merciful, the Compassionate' [fig. 146]. Although it is not certain whether the Sulayman of the inscription is the shah himself, the medallion would have formed

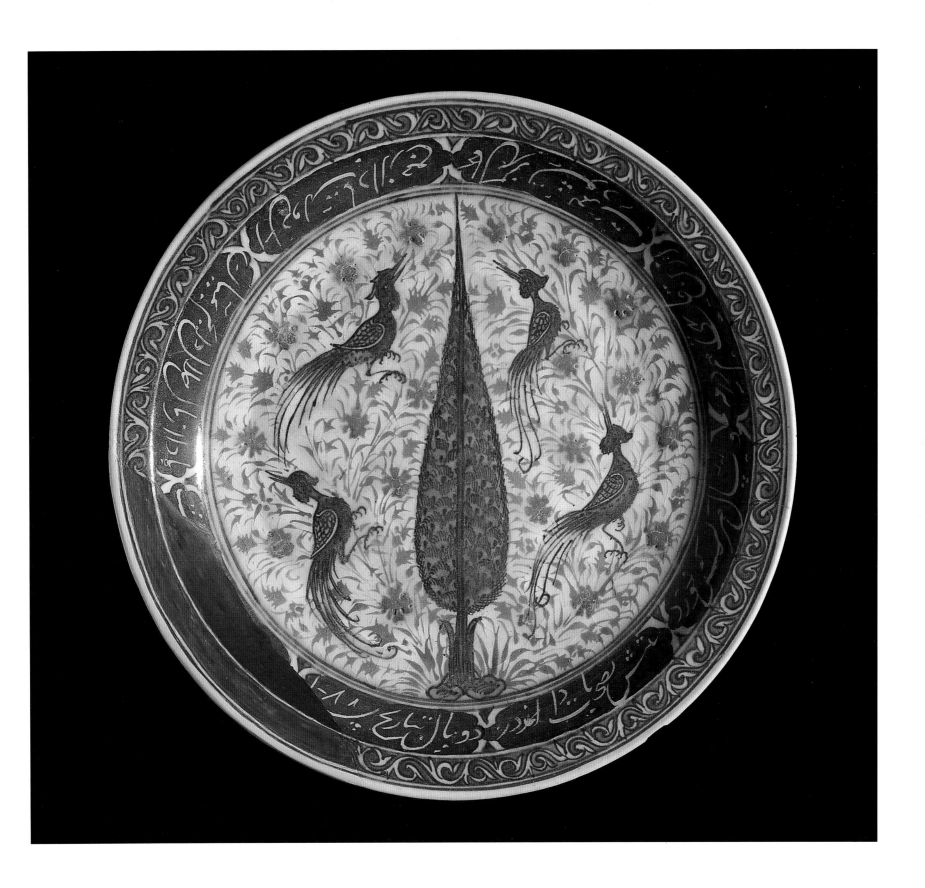

part of an ensemble of similarly worked panels containing more extensive inscriptions that probably would have elucidated the meaning of the lobed medallion. The bold *thuluth* inscription appears to float above the wiry tendrils of an S-shaped spiral arabesque, following the general principles of carpet design in which one ornamental scheme overlaps another. If this medallion was used on a door or other vertical, rectangular panel, it was most likely placed in the centre of a larger lobed medallion of sheet metal with a plain surface beneath the plaque and ornamented with a chased design around the edges. Such an arrangement is found on the silver doors of the Masjid-i Shah (Masjid-i Imam) in Isfahan of 1046/1636–7 and again on the doors of the Madrasa-yi Chahar Bagh of 1126/1714,[25] suggesting that its appeal remained strong at the royal level throughout the seventeenth century.

During the reign of Shah Sulayman the potters of Kirman sustained their output without radically altering their style. A large dish dated 1088/1677 [fig. 147] reveals the same polychrome effects as the *qalyan* [see fig. 134] and combines the spiky flowers and grasses typical of earlier Kirman wares with pheasants and a cypress tree in underglaze blue analogous in form to those found in the borders of illuminated manuscripts, bookbindings and carpets. The black band with the inscription scratched through it had been in use for at least thirty years and the division into cartouches remained popular until the end of the century. As would be expected, shards of this type of ware were collected in the region of Kirman and Makran by Sir Aurel Stein, but it also must be assumed that such wares were used widely throughout Iran, as the large numbers of extant pieces suggest.

Blue and white wares thought to be made in both Kirman and Mashhad in the period of Shah Sulayman continued to supply both local and foreign markets unable to buy enough Chinese porcelain during the Transitional Period between the Ming and Qing dynasties. Some Persian blue and white pieces used Chinese examples as their point of departure but distorted the original composition to such a degree that it became unintelligible [fig. 148]. While the leafy scroll in the border of the flattened flask has been straightforwardly rendered, the floating monks at sunset reflect a misunderstanding of the prototype on the part of the potter and

lead to confusion on the part of the viewer. Other blue and white ceramics adhere to typical Persian subjects, such as a youth being offered wine by a young woman [fig. 149]. The flask appears to have been carved so that the compositional elements stand out in low relief and are left uncoloured except for details picked out in black, while the background is painted in underglaze blue. The branch in the youth's hand and the jointed tree trunk behind the woman are close in style to branches and tree trunks found in pieces attributed to Mashhad, which is probably where this flask was produced. In addition, the use of carving may be a development from the mid-seventeenth-century practice at Mashhad of carving floral designs in low relief in the cavettos of bowls and dishes and leaving them uncoloured. Such pieces may also represent the popularization of the use of motifs from manuscript illustration first encountered on the monochrome wares of the early seventeenth century thought to have been produced at Isfahan.

A particularly elegant ewer [fig. 150] demonstrates the enduring fascination that Indian metalwork shapes held for Persian potters as well as their perennial ingenuity in creating new forms from a known vocabulary. The moulded ewer consists of a ribbed pear-shaped body resting on a six-sided foot and rising up beyond a lobed collar to the neck, with its slight ring, and the crescent-shaped top. The spout, which is joined above the widest point of the body, ascends vertically and turns outwards to end in a dragon's head, while the handle in the form of a split-palmette may hint at the dragon's tail. The ewer is covered with a pale bluish-green glaze that in places reveals a buff colour beneath it, as if the ewer had an undercoat of buff slip. While the six-sided foot is most closely paralleled in Chinese ceramics, the ribbing and pear shape, crescent-shaped top and dragon-headed spout all relate to Mughal and Deccani metal ewers of the sixteenth and seventeenth centuries.[24] For this reason Zebrowski and Rogers have both suggested that this ewer was intended for the Indian market.[25] However, given the tradition of copying Indian metalwork shapes among Persian potters of the seventeenth century and the taste for Indian goods in the period of shahs 'Abbas II and Sulayman, this ewer could just as well have been made for Persian clients in Isfahan. Furthermore, the use of a celadon-coloured glaze and the technique of moulding support an attribution to Isfahan, the likeliest source

150 Ewer, Isfahan?, second half of the 17th century, stonepaste, blue-green glaze, possibly buff-coloured slip, moulded, h. 29 cm, British Museum, OA +739. This is a fine example of how Safavid potters combined the influences of China and India, relying on the former for glaze types and the latter for object shapes.

of the copies of Chinese celadons and moulded wares of the first half of the seventeenth century.

One other group of ceramics that can plausibly be assigned to the period of Shah Sulayman is lustreware. Although production of lustreware may not have stopped entirely in the fifteenth century, only a few lustreware objects can be considered to date from the sixteenth. Nonetheless, the technique did not die completely, because a distinctive group of wares with coppery lustre glazes can be assigned to the second half of the seventeenth century. Only one dated bottle of this type has been published and the date has been read as 1006/1597, 1062/1651 and 1084/1675.[26] Arthur Lane accepted the latest date as correct, which is borne out by the novel shapes of some objects in this group. Along with so-called 'tulip vases' which have several wide-lipped spouts rising from the shoulder so that bulbs could be wedged in them, small spittoons, delicate coffee or egg cups and squat teapots join the more common bowls and long-necked bottles in the range of shapes [fig. 151]. The lustre is applied over a cobalt blue, yellow, turquoise or colourless transparent glaze. The decoration consists of landscape vignettes with or without animals and relates much more closely to the gold illuminated borders of manuscripts than to other pottery decoration. Although this might indicate that the lustrewares were produced in Isfahan, Kashan, the traditional centre of lustreware production in medieval times, may be a more likely source of these wares.

More vexing than where these small and glittering wares were made is the question of why and for whom they were produced. It has long been thought that medieval lustreware ceramics were acquired as an affordable alternative to gold and silver plate by well-to-do, non-royal members of society. Furthermore, lustrewares have the visual appeal of precious metals without breaching the Muslim law against the use of gold and silver. Could these same factors have applied to late seventeenth-century Iranian users of lustreware? It seems unlikely that potters and their patrons would

151 A group of lustrewares, Isfahan?, late 17th century, stonepaste, cobalt blue and lustre glazes. All British Museum. Spittoon, h. 11.3 cm, OA 1983.391, Godman Collection; bowl, h. 4.4 cm, diam. 8.1 cm, OA 78.12-30.603, Henderson Bequest; long-necked bottle, h. 24.1 cm, OA 1938.370, Godman Collection; bowl, h. 4.4 cm, diam. 7.9 cm, OA 1983.370, Godman Collection; bowl, h. 4.3 cm, diam. 13.5 cm, OA 1983.363, Godman Collection.

have been concerned about the Islamic prohibition on gold and silver in a multicultural society with many wealthy non-Muslims. However, the shortages of precious metals that led to the debasement of Safavid coinage and excessive export of gold and silver may also have had an impact on the availability of vessels of gold and silver to wealthy patrons. This is not to say that gold ceased to be available in the quantities necessary for producing metal thread for carpets and textiles, nor that its use at court wavered. Rather, the lustrewares produced during the reigns of the last two Safavid shahs in shapes that are analogous to those of gold objects depicted in paintings of the court must have supplied a clientele who were aware of gold and silver vessels employed at court but unable or unwilling to buy them.

From the mirrors on the walls and ceilings of the Hasht Bihisht to the delicate ewers from which red wine was dispensed, fine glass in the time of Shah Sulayman was imported, primarily from Venice. Shiraz wine was packed in large glass bottles and some flasks were made locally, but these were utilitarian objects of indifferent to bad quality, cloudy and full of air bubbles. By contrast, the curvaceous Venetian glass ewers depicted in the paintings of 'Ali Quli Jabbadar appear limpid, sparkling and lightweight.

For all the ineffectiveness of Shah Sulayman as a ruler, his love of luxury sustained the arts of the court and in particular encouraged painters working in the European style. Although Eurasian trade became increasingly competitive in the second half of the seventeenth century, fine textiles and ceramics were sold in Europe and India through the increasingly rich and powerful Armenians of Isfahan, among others. The fissures in the social fabric of Iran which began to appear under Shah Sulayman were not yet sufficiently deep to disrupt artisanal output. However, the shah's weak and decadent personality restricted his influence on the arts to the extent that, except for the Europeanizing court painters, little innovation in design occurred during his reign. Rather, carpet makers, weavers, potters and metalworkers relied on the decorative vocabulary established in the first half of the seventeenth century and earlier and recombined familiar motifs in new ways. The result was an attractive, sometimes opulent array of objects that rarely exhibit the spark of originality and technical precision found in the sixteenth and early seventeenth centuries.

Disintegration of the Dynasty

Shah Sultan Husayn

1694–1722

Most of the time the Shah spent in the company of divines, sayyids, the Hakīm-bāshī,
the Mullā-bāshī, discussing literary problems and poetry, the preparation of dishes and medicines,
while the ordaining of the state affairs was left to the amirs, who hated each other. [1]

Like all the Safavid shahs after Shah ʿAbbas I, Sultan Husayn was reared in the harem without the benefit of any formal education or preparation for his role as ruler of Iran. Had his great-aunt and champion, Princess Maryam Begum, not been the first to discover the dead Shah Sulayman, Sultan Husayn's more dynamic younger brother, ʿAbbas Mirza, might have been designated shah and the Safavid dynasty might have lasted longer. As it was, the passive, pious Sultan Husayn was crowned shah on 14 Dhu'l Hijja 1105/6 August 1694. For a while Muhammad Baqir Majlisi, the leading theologian and shaykh al-Islam, then *mulla-bashi* (both terms signifying chief cleric), exerted a strong influence on the twenty-six-year-old shah. Edicts were issued outlawing the consumption of alcohol and expelling Sufis, the descendants of the original Qizilbash followers of the Safavid shaykhs, from the capital. The triumph of the orthodox Shiite hierarchy, the *ulama*, not only was the death knell for the Sufis but also marked a shift in the power structure of the Safavid élite. Although the eunuchs and royal princesses of the harem enticed Shah Sultan Husayn into drinking alcohol, the *ulama* with Muhammad Baqir Majlisi at their head instituted religious intolerance to a degree not previously endured in Safavid society. Christians, Jews, Zoroastrians, Sunnis and Sufis all suffered from discrimination, if not persecution and forcible conversion, which in turn immeasurably weakened the loyalty of the diverse population which had steadfastly supported the Safavid shahs in times of crisis.

Given the indifference of the shah to governing, the attempts of the *ulama* to convert the whole country to Shiism amounted to the main political policy. This was especially dangerous in the borderlands where Sunni populations had remained loyal to the Safavids despite the presence of their co-religionist neighbours, the Ottomans in the west and the Mughals in the east. One such group, the Ghalzai Afghans, who held sway in the region of Qandahar,

152 Velvet fragment, Isfahan?, late 17th century, silk, 103 × 99 cm, David Collection, Copenhagen, 10/1989.

were attacked and suppressed by Gurgin Khan, a Georgian who had been appointed governor of Qandahar in Muharram 1116/May 1704. Gurgin Khan captured the Ghalzai leader, Mir Vais, and exiled him to Isfahan. Because of his power and wealth, Mir Vais insinuated himself into court circles and developed a thorough understanding of the weaknesses of Shah Sultan Husayn and his government. By 1121/1709 Mir Vais was back at Qandahar and had overthrown the Safavid governor. Even though the Safavids sent an army against Mir Vais, the troops took nearly two years to reach Qandahar and were too disorganized to maintain their siege once they did arrive. In Sha'ban 1123/October 1711 the Safavids retreated, pursued by the Ghalzai, who murdered the Safavid commander. After one other unsuccessful attempt to retake Qandahar, the Safavids abandoned the city to Mir Vais, who then ruled the region independently until his death in 1127/1715.

A similar Safavid attempt to impose Shiism in Herat led the local tribal power, the Abdalis, to revolt. Again, despite expeditions to Herat the Safavid army was unable to regain the city, and eventually the rebellion spread to Mashhad. Meanwhile, in the Persian Gulf Bahrain fell to the imam of Oman, and in the north Sunni Lezgians and Shirvanis were rebelling. Shah Sultan Husayn responded by moving his capital to Qazvin in 1129–30/1717–18 with the hope of raising a more effective army. The court remained at Qazvin for three years but was singularly unsuccessful at countering the insurgencies in the east and north. In addition, when government forces did become involved, as in the war between the Lezgians and the Georgians, who were Safavid feudatories, their position was so devoid of strategy or long-range objectives that they lost their valuable allies while saving people of lesser importance to the survival of the Safavid state. The traditionally restive populations took advantage of the situation, the Kurds raiding Hamadan in the north-west and the Baluchis raiding Bam and Kirman in the east.

Despite the judgement of the grand vizier, Fath 'Ali Khan Daghistani, that the Omani threat to the Persian Gulf was the most serious of those confronting the Safavids, the death of the Mughal emperor Aurangzeb in 1118/1707 and subsequent disarray in India enabled Mahmud, the young Ghalzai leader of Qandahar who had succeeded his father, Mir Vais, to build up his strength undetected

or at least unopposed. In 1132/late 1719 Mahmud took Kirman, forcing the governor to flee, but within a year he returned to Qandahar to defend it against a Safavid army that had set out with the shah at its head. By the time the army reached Tehran, the enemies of the grand vizier had accused him of plotting to overthrow the shah. Sultan Husayn reacted not by inquiring into the allegations but by removing the grand vizier from office and blinding him and by imprisoning his nephew, the governor of Fars, who commanded a sizeable army. At this point, Dhu'l Hijja 1132/October 1720, the court returned to Isfahan, the resolve to fight for Qandahar having collapsed. In the wake of the grand vizier's fall from power, the Lezgians and Shirvanis in the north again rose up against the Safavids, this time seizing Shamakha and transferring their allegiance to the Ottomans.

Once the Safavid court had arrived in Isfahan in Jumada I 1133/April 1721 after its retreat from Tehran, Mahmud decided to renew his attempt to capture Kirman. Following an unsuccessful siege of the city in Dhu'l Hijja 1133/October 1721, he advanced to Yazd, where he accepted payment in exchange for lifting his siege. By Jumada I 1134/March 1722 Mahmud and his army had advanced to within twenty-five miles east of Isfahan. A Safavid force of over 40,000 men, more than double that of Mahmud, met him on the battlefield on 19 Jumada I/8 March and at first dominated the fighting. The numerical advantage of the Safavids was soon cancelled out by the fact that the grand vizier and the leader of troops from 'Arabistan were joint commanders whose personal enmity made communication impossible. The Afghans, by contrast, were united and well enough organized to carry the day. Having suffered many casualties, the Persian army retreated to Isfahan in a state of disarray. Rather than pursue them, Mahmud waited three days and then continued the march on the capital.

Entering Isfahan from the south, Mahmud seized Shah Sultan Husayn's palace of Farahabad and set up his headquarters there, then proceeded to sack the Armenian community of New Julfa. At this point Mahmud began his siege of the main part of the city, north of the Zayandeh-Rud. The shah, surrounded by utterly ineffectual advisers, spurned two offers to negotiate with Mahmud, in Jumada II and Dhu'l Qa'da 1134/April and August 1722, and failed to muster troops or start military engagements with the Ghalzai in

other regions that might have diverted them from their siege of Isfahan. Meanwhile, the Afghans began tightening their hold on Isfahan to the east and north and famine deepened in the city. The traditional allies of the Safavids from the border regions provided no relief, either because they felt no loyalty to the regime that had tried to convert them to Shiism by force or because they were defeated by the Afghans. As the situation in Isfahan degenerated, disease and starvation led to cannibalism, but it was not until Muharram 1135/October 1722 that Shah Sultan Husayn finally capitulated to Mahmud. On 13 Muharram/25 October the shah and Mahmud rode into Isfahan and before the grandees of Iran Shah Sultan Husayn acknowledged Mahmud as his successor. Although the Afghans and their followers maintained members of the Safavid royal family as puppets until Nadir Khan proclaimed himself shah, the last vestige of political power disappeared with the abdication of Shah Sultan Husayn.

Despite the shah's fatal indifference to his governmental duties, he seems to have appreciated the visual arts, for at least one major architectural complex was built in his name and the work of artists in the court atelier system continued unabated. A number of repairs to older buildings are dated to his reign, and mosques, *madrasa*s and tombs were constructed by other individuals in provincial centres as well as in Isfahan. Yet the most significant commission at the end of the Safavid dynasty is the Chahar Bagh *madrasa*, bazaar and *caravansarai*, which was paid for by the shah's mother.[2] Monumental in scale and regular in plan, these buildings were erected between 1118/1706 and 1125/1714 on the eastern side of the Chahar Bagh next to the Hasht Bihisht. Unlike the mosques on the *maidan* with the contrasting alignments of their entrances and interiors to accommodate the need of the *qibla* wall to face Mecca, the Chahar Bagh *madrasa* is built strictly on a north–south/east–west axis so that its prayer hall and *mihrab* face due south and not southwest towards Mecca. A dome on a high drum decorated with *hazar baf* tile arabesques in predominantly yellow and turquoise covers the sanctuary and is preceded by a façade flanked by two minarets [fig. 153]. The surface of the courtyard is divided into four rectangular gardens and a pool fed by a canal running east–west [fig. 155]. Two levels of arched niches open onto the courtyard and are punctuated by an *ivan* in the centre of each wall and low domed

153 (top) Façade and dome of the Chahar Bagh *madrasa*, Isfahan, viewed from the west, 1118–25/1706–14, from Pascal Coste, *Monuments modernes de la Perse* (Paris, 1867), pl. xviii. Known as the Madar-i Shah *madrasa*, that is, the College of the Shah's Mother, this is the last great religious building of the Safavid dynasty.

154 Chahar Bagh *caravansarai*, Isfahan, 1118–25/1706–14, from Pascal Coste, *Monuments modernes de la Perse* (Paris, 1867), pl. xxxii. Unlike the *madrasa* to which it is attached, this *caravansarai* is relatively unadorned, as is typical of most Safavid *caravansarais*.

155 Courtyard of the Chahar Bagh *madrasa*, Isfahan. The water that fills the elegant pool in the courtyard of the *madrasa* forms part of the canalization system that provides water to the gardens of the Chahar Bagh and the *caravansarai* next to the *madrasa*.

chambers placed at an angle in each of the four corners. Although the architect of this building retreated from the all-over tile decoration of the Masjid-i Shah, he modelled the main dome closely on that of the earlier building.

The *caravansarai* to the east of the *madrasa* is also built on a four-*ivan* plan and has interior façades of arched niches on two levels around a large courtyard, now planted as a garden [fig. 154]. Running along the northern edge of the *madrasa* and *caravansarai* is the bazaar, which is still in operation. In order to maintain a straight passageway through the bazaar, the shops adjacent to the *madrasa* were designed to be somewhat deeper than those next to the *caravansarai* where the wall between the bazaar and the *caravansarai* is slightly further to the north than that of the *madrasa*. The income from the bazaar and the spacious *caravansarai* with its extensive stables was used to support the *madrasa*. While this arrangement may no longer apply, all three parts of the complex remain in use today and provide an insight into how trade, travel

and religion were intertwined in Safavid Isfahan. In Islamic architecture a long tradition exists of funerary buildings and shrines commissioned by women, but in the fifteenth century both Timurid and Turkman royal women paid for the construction of major mosques. Even if the Chahar Bagh *madrasa* does not represent a significant departure in female patronage, its size and expense underscore the wealth and power enjoyed by the key women of the Safavid harem for most of the last century of the dynasty's rule.

Painting at court level during the period of Shah Sultan Husayn presents a continuum of the Europeanizing style of the period of Shah Sulayman. Muhammad Zaman worked during the 1690s until his death in about 1111/1700, but by the second decade of the eighteenth century a new generation of painters worked alongside the older artists who were still active, 'Ali Quli Jabbadar and Muhammad Zaman's brother, Hajji Muhammad. A portrait of the grand vizier Shah Quli Khan bestowing a ring on a young man, attributable to Muhammad Zaman, dates from the first year of Sultan Husayn's reign, 1106/1694–5 [fig. 156].[3] The horizontal format and setting with the figures arrayed on a veranda before a landscape that recedes into the distance corresponds to the type found in 'Ali Quli Jabbadar's portrait of Shah Sulayman and courtiers from the 1670s [see fig. 144]. However, the treatment of drapery, the atmospheric, somewhat misty rendering of the landscape and the three-dimensionality of the figures conform to Muhammad Zaman's style. A later portrait of the grand vizier by Hajji Muhammad[4] reveals a less thorough integration of European techniques; while the sitter's face is naturalistically depicted, his body and garments are hardly modelled at all.

The textiles, carpets and metal objects depicted in Muhammad Zaman's portrait of the grand vizier will be discussed below; it is worth noting here, however, the lacquer penbox placed before the knees of the young courtier. Both Muhammad Zaman and Hajji Muhammad excelled in painting lacquer objects, and the example in this painting demonstrates that boxes with rounded ends, with the interior nested inside the exterior rather than with a hinged top, and decorated on the upper surface with a single figure, were in use by the mid-1690s. Several such penboxes were signed by 'Ali Quli Jabbadar in the early eighteenth century,[5] but it is possible

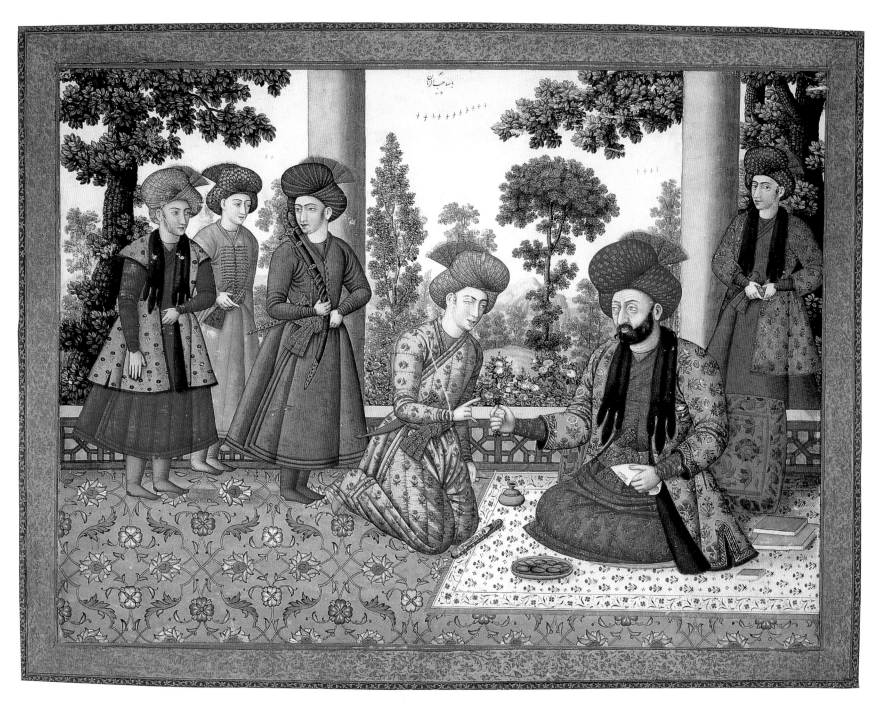

156 'Shah Quli Khan Bestowing a Ring', attributable to Muhammad Zaman, Isfahan, dated 1106/1694–5, opaque watercolour, silver and gold on paper, 22.2 × 30.3 cm, Institute of Oriental Studies, St Petersburg, album E-14, fol. 97*r*. This painting is inscribed with the epithet most often associated with Muhammad Zaman, 'Ya sahib al-zaman' ('Oh lord of the age!'), and is consistent with his style.

157 Penbox, top and side view, Hajji Muhammad, Isfahan, dated 1116/1704–5, lacquer, watercolour and metal strips on pasteboard, 21.5 × 3.8 × 3.8 cm, Nasser D. Khalili Collection of Islamic Art, LAQ 297. From the second half of the 17th century onwards many court artists painted lacquerwares as well as album paintings and even large-scale wall paintings.

that Muhammad Zaman was the originator of the use of a single figure on the lid of a penbox. Likewise, Hajji Muhammad introduced multiple cartouches enclosing figure busts, birds and flowers, as well as inscriptions to penbox lids, as early as 1116/1704–5 [fig. 157]. The side of the box contains floral sprays in cartouches separated by smaller medallions of gold floral ornament on a black ground. Flattened strips of metal have been applied like stripes to the surface of the penbox to provide extra glitter, an experiment that was not repeated.[6]

In addition to lacquerware, Safavid painters in the second half of the seventeenth century adopted the European practice of painting large-scale portraits in oil on canvas. Like the smaller-scale works on paper and in lacquer produced in the reigns of the last three shahs, Safavid oil paintings, of which at least eleven are extant,[7] are executed in the Europeanizing style. To a greater or

lesser extent the artists borrowed from European sources, duplicating architectural details, curtains and objects found in European prints and paintings and in the works of the European artists active in Iran. The figures in the paintings, however, are dressed in Persian garb, even if some of them are now thought to represent Georgians or Circassians who served at the Safavid court.[8] Like the wall paintings in the Armenian houses and royal palaces of Isfahan, these large oil paintings were conceived as pairs or in groups as part of an overall decorative programme. Whether they were portraits of specific people or of generic types, the technique gained currency from the late Safavid period to the eighteenth century until it became one of the dominant art forms of the nineteenth-century Qajar dynasty.

From about 1111/1700 Muhammad 'Ali, the son of Muhammad Zaman, carried on the work of his recently deceased father, producing lacquer objects and paintings on paper. Two lacquer penboxes dating from 1132/1719–20 and 1133/1720–21 by Muhammad 'Ali reveal a debt to Muhammad Zaman in the depiction of European-style background but a distinctive figural style in which faces are not puffy-eyed and ponderous like those of his father, but are more delicately modelled. In the painting 'The Distribution of New Year Presents by Shah Sultan Husayn', dated 1133/1721 [fig. 158], Muhammad 'Ali concentrated on portraying the shah and his court rather than elaborating on the setting in which this ceremony took place. Shah Sultan Husayn is depicted in an opulent gold brocade coat with three fur tails forming the collar and a purple and gold turban rising higher and more perfectly fanned out than those on the figures around him. The shah and his courtiers kneel and stand on a veranda before a stormy sky. With the exception of the carved bases of the columns and leaf forms and diagonal lines on the columns themselves the building is devoid of ornament; even the carpet is plain except for its grey and white lozenge-pattern border. Unlike Muhammad Zaman's paintings in which all figures are equally illuminated, here the artist has indicated two light sources, one from the right and one from the left, which oddly leave the central figure of the shah in relative darkness. Although Muhammad 'Ali was certainly aware of the use of light and shadow in European painting to define forms and to suggest three-dimensionality and spatial relationships, his understanding seems not to have

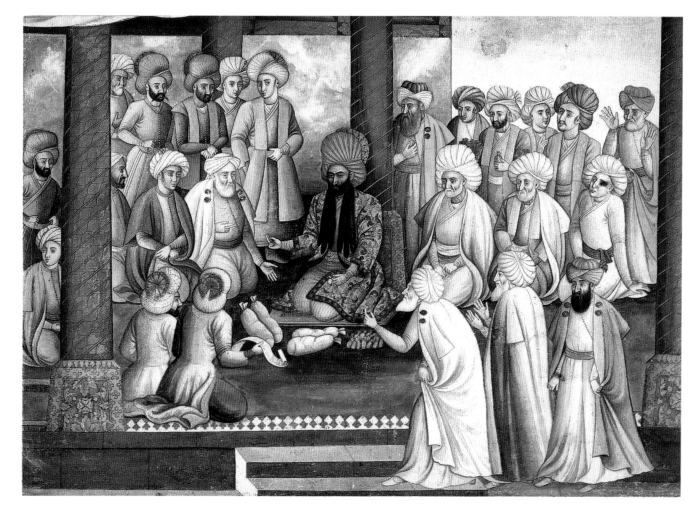

158 'The Distribution of New Year Presents by Shah Sultan Husayn', signed by Muhammad 'Ali, son of Muhammad Zaman, Isfahan, dated 1133/1721, opaque watercolour and gold on paper, 24.5 × 33.1 cm, British Museum, OA 1920.9-17.0299. With the exception of the portrait of the shah himself, the use of watercolour has become softer than in paintings of the 17th century.

extended to showing the light source itself or depicting cast shadows in a logical fashion.

As the figure in the left foreground, viewed from behind, reads the list of recipients of royal largesse, a figure in the right foreground and another in the right background raise their hands as if to applaud. Two figures in the right background hold small red bags of money, while before the shah large white sacks and rows of small bags await distribution. The contrast between the dark-skinned, black-bearded shah and the pale-faced youths and greybeards that surround him is marked as the shah appears to recede into his splendid raiment. In Jumada I 1133/March 1721, when this event would have taken place, the shah and his court were returning to Isfahan after failing to go to battle with the Ghalzai Afghans. Possibly the plainness of the surroundings reflects the fact that the court celebrated Nauruz, the Persian new year, outside the capital. The shah had recently dismissed his grand vizier and was relying for advice on his court physician and his shaykh al-Islam, who are presumably included in this scene but cannot be identified. The darkness of the shah, the cloudy sky and gestures and facial expressions of the courtiers all contribute to an impression of impending doom. While the artist would have been justified in implying that all was not well with the shah and his court, we should be wary of imposing such an interpretation in hindsight on a scene that may in fact be no more than a piece of honest reportage. Even so, the contrast with the audience scene with Shah Sulayman, where music, food, drink and tobacco enlivened the gathering, underscores the depths to which the Safavids had sunk by the spring of 1133/1721.

159 Chasuble, late 17th century, silk and silk wrapped in metal foil, brocade, 110 × 74.5 cm, David Collection, Copenhagen, 7/1975. While it is possible that this textile was exported to Europe and made into a church vestment, it is equally likely that it was used in one of the many Christian churches that existed in Safavid Isfahan.

While Muhammad 'Ali's painting of Shah Sultan Husayn and his court provides insights into the state of the Safavid dynasty in 1133/1721, Muhammad Zaman's portrait of the grand vizier Shah Quli Khan [see fig. 156] includes textiles and objects that are closely paralleled by extant examples. The striking ochre-ground carpet with a lattice pattern of four leaves, two peony blossoms and two pink or red four-petalled flowers, all joined by tendrils, corresponds closely to a group of related fragments that have been variously assigned to Iran and India.[9] A velvet fragment in Copenhagen shares the palette and general layout of the carpet in the painting, although the velvet contains more details, such as the small multi-petalled blossoms at the points of the four leaves [fig. 152]. On the other hand, the leaves in the painting are bent in an S-curve which enlivens the design. Although using velvet for a floor covering seems extravagant, the men in the painting wear soft-soled boots, and such a 'carpet' would have been used as much for sitting as for standing. As to whether the extant velvet fragment was produced in Iran or India, Muhammad Zaman's painting lends credence to Iran as its source. Nonetheless, von Folsach has assigned the velvet to India on the basis of the similarity of its pattern to that found on

some seventeenth-century Indian carpets. Since trade between India and Iran continued unabated in the 1690s, it is possible that Indian carpet weavers adapted the designs of imported Persian velvets.

The textiles from which the coats and quilted robes in Muhammad Zaman's painting are made also have close counterparts in existing pieces. The robe worn by the grand vizier consists of a gold ground with brocaded irises, roses and petunias, diagonally striped borders to the sleeves and hem and a fur lining and collar similar to that on Shah Sultan Husayn's coat in figure 158. One related example, made into a chasuble [fig. 159], includes a greater variety of flowers, but like those in the painting they are placed in rows of alternating species and are not touching one another. The silver-ground coat on the youth behind the grand vizier and the gold floral repeats on the robes of the grand vizier himself and the youth who kneels before him reveal the continuing production of these luxury textiles right up to the end of the Safavid dynasty. Unfortunately, the technique declined and disappeared in the wake of the fall of the Safavids.

As the jewelled hilts and dagger sheaths tucked into the sashes of the grand vizier and his attendants indicate, objects of precious metal were also still produced in the reign of Shah Sultan Husayn. Enamelling of metal objects was a rare technique in Safavid Iran and may well have been introduced from India, where enamel was applied to precious metals as well as copper from at least as early as the seventeenth century.[10] Although very little is known about Safavid enamel, and Chardin even stated that it did not exist in Iran,[11] enamelled ewers and other objects were in use from the late sixteenth century onwards. Possibly Iranian metalworkers adopted the technique to achieve a similar effect to that of inlaying precious metal with jewels and created objects that were more affordable than the jewel-studded precious metals used at court. The introduction of the enamelling technique in the late sixteenth century eventually led to a major vogue under the Qajars (1779–1924) when a whole range of objects and jewellery were decorated in a broad palette of enamels.

Among the rituals central to Shiism is the commemoration of the martyrdom of Husayn, grandson of Muhammad and son of 'Ali, who died at Karbala on the tenth of Muharram (*ashura*). Throughout

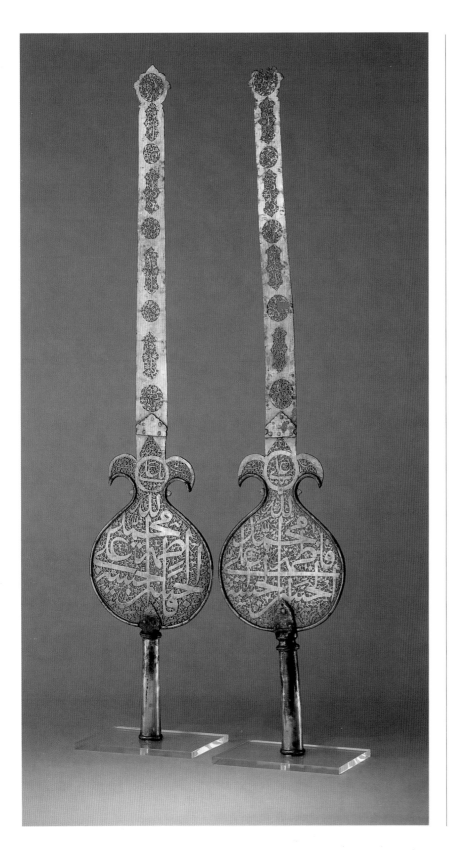

160 (left) Pair of ʿalams, late 17th century, gilded brass with openwork inscriptions and designs, h. 127 and 128 cm, British Museum, OA 88.9-1.16–17, Franks Collection. Standards such as these would have been carried in religious processions and symbolize the sword of Imam ʿAli.

161 (below) Astrolabe of Shah Sultan Husayn, made by ʿAbd al-ʿAli ibn Muhammad Rafiʿ al-Juzi and decorated by his brother Muhammad Baqir, dated Shaʿban 1124/Sept.–Oct. 1712, h. 53 cm, British Museum, OA +369.

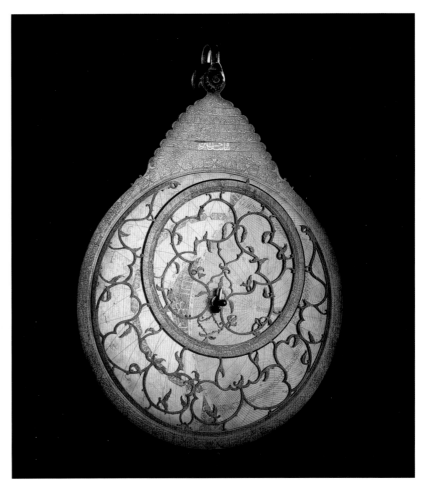

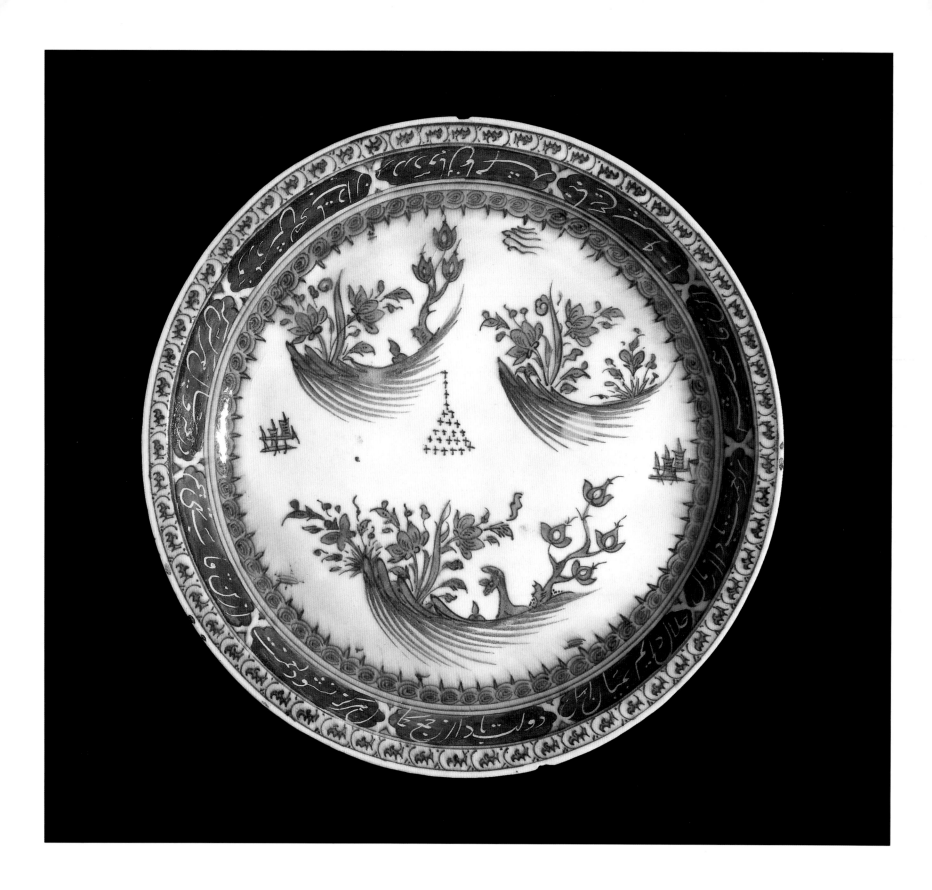

Iran, but especially in the great shrine cities of Qum and Mashhad, the faithful march in processions to the shrines chanting words of mourning and symbolically re-enacting the martyrdom by flagellating themselves. Such processions are led by men carrying 'alams, metal standards that signify the battle standards carried by Husayn and his band of supporters. The most common shapes of 'alams are the stylized hand of which the five fingers represent Muhammad, 'Ali, Fatima, Husayn and Hasan, called the Ahl-i Bayt ('[Five] People of the Household'), and the drop-shaped form with one or more vertical projections, the embodiment of 'Ali's sword, Zu'l-Fiqar.[12] One pair of gilt brass 'alams [fig. 160] is inscribed with the names of the Ahl-i Bayt in the drop-shaped base and with the name of 'Ali in the roundel from which the shaft springs. The openwork cartouches and roundels along the length of the shaft also contain the names of the Ahl-i Bayt. Although the 'alams are not dated, they were most likely produced at the end of the seventeenth century, a period in which the Shiite religious orthodoxy was particularly strong in Iran, partly in reaction to the dissolute activites of Shah Sulayman and his harem and then as a reflection of the religious concerns of Shah Sultan Husayn.

The magnificent brass astrolabe inscribed in silver with the name of Shah Sultan Husayn, signed by 'Abd al-'Ali ibn Muhammad Rafi' al-Juzi and his brother Muhammad Baqir and dated Sha'ban 1124/September–October 1712, may also reflect the shah's piety [fig. 161]. In a Muslim context astrolabes were used to determine the direction of Mecca and were usually portable, as it was especially important to know the correct direction of prayer while travelling. This exceptionally large astrolabe, however, must have been produced for use in one place, and one is tempted to suggest that one of the mosques or madrasas renovated by Shah Sultan Husayn would have been a worthy home for it. In addition to the place names and diagrams inscribed on the plates of the astrolabe, its rete – the openwork disk which indicates the ecliptic, the signs of the zodiac and the fixed stars – consists of an elegant vine with leaves extending at the necessary intervals corresponding to the position of specific stars. At the top of the astrolabe a polylobed panel in the shape of a half-oval, called the throne, contains a seven-line inscription with the name and titles of the shah on one side and a lively split-palmette leaf arabesque on the other. The use of this type of ornament is a throwback to the early sixteenth century when similar split-palmette leaf patterns were employed on the spandrels of the Harun-i Vilayat of 918/1512 in Isfahan [see fig. 13] as well as in paintings and decorative arts of that period. It remains a mystery why the makers of this astrolabe should have looked back so far when Muhammad Salih, the producer of the silver door decoration at the Chahar Bagh madrasa of 1125/1714, was incorporating the lush floral motifs of early eighteenth-century border illuminators in his work.[13] Possibly the ornament matched

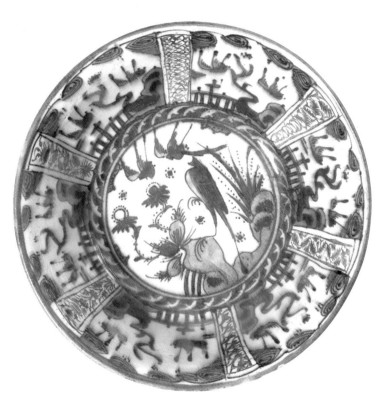

162 (left) Dish, Kirman, dated 1109/1697–8, stonepaste, blue and black underglaze decoration, diam. 43.8 cm, British Museum, OA 96.6-26.5, Gift of Sir A.W. Franks. The design in the centre of this dish is loosely based on the landscape scenes found in late 16th-century Chinese blue and white dishes, of which several examples are in the Ardabil shrine collection.

163 (above) Lustreware bowl, Isfahan?, late 17th–early 18th century, stonepaste, blue and brown glaze, diam. 21 cm, British Museum, OA 1970.2-7.3, Bequest of Lily Nora Ziegler. Although the bird and landscape in the centre of the bowl are 'legible', the vegetation in panels on the walls of the bowl is abstracted beyond recognition.

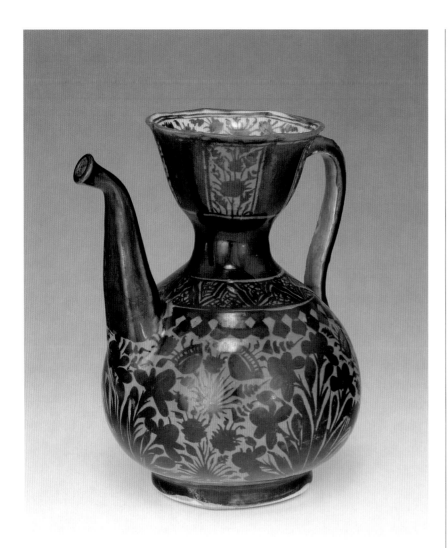

164 Lustreware ewer with a wide mouth, Isfahan?, early 18th century, stonepaste, transparent cobalt glaze, h. 20.5 cm, British Museum, OA 1983.392, Godman Collection. Another ewer of this shape and nearly identical dimensions but without a handle suggests that potters made large numbers of 'blanks' to which they could add handles and lids and, in the second firing, decorate with lustre glazes in a variety of ways.

that of the setting for which the astrolabe was intended, or the astrolabist came from an artisanal group whose ties with the court atelier were weaker than those with, for example, the ʿulama, who would have been frequent users of astrolabes.

Ceramics that can be attributed to the reign of Shah Sultan Husayn with confidence exhibit few innovations. Rather, many motifs and techniques that became current in the reigns of shahs ʿAbbas II and Sulayman continued in use. Meanwhile, the compositional disintegration evident in pieces such as the flattened flask [see fig. 148] occurs in the blue, black and white dish dated 1109/1697–8 [fig. 162]. In the centre of the dish three groupings of vegetation rise like strange islands out of something resembling a palm frond or a feather. A vestigial cloud floats in the sky above, while in the middle of the dish a group of Xs in the shape of a triangle with a projection from one point may be the potter's mark. Near the right and left cavetto clusters of vertical and horizontal lines resemble exotic buildings and may be the remnants of architectural elements from the Chinese blue and white porcelain prototype of this piece. While the inscription band reserved in white on black in the cavetto is consistent with earlier examples, the border design also shows signs of over-stylization. What was once a simple vine scroll with leaves has now metamorphosed into a series of roundels enclosing forms that resemble bats more than leaves.

The distortions away from the Chinese source in a dish such as this may reflect a decline in the market for Persian ceramics which occurred as a result of the end of the Transitional Period and the re-establishment of trade in Chinese blue and white porcelain. Alternatively, the taste for blue and white wares with black and white inscription bands may have run its course by the 1690s to be replaced by pieces with blue and white designs on the interior and brown glaze either on the rim or over the whole exterior, a style that remained in favour in the eighteenth century. A bowl with brown glaze on the rim and lustre-glazed arabesque bands separating the panels on its sides shows its reliance on Chinese Kraak porcelain [fig. 163]. The central image of a bird on a rock in landscape is surrounded by a band of wave pattern and stylized repeating landscape elements in the panels on its walls. The exterior of the bowl is decorated in lustre over cobalt blue. The combination of lustre decoration on the exterior, brown glaze on the rim

and blue and white on the interior of this bowl indicates that the production of Safavid lustrewares continued into the eighteenth century.

Further proof of lustrewares made at the end of the Safavid period can be found on those decorated with floral motifs that are closely related to the lush floral sprays found in lacquerware and the silver doors of the Chahar Bagh *madrasa* from the second decade of the eighteenth century. A ewer with a wide, lobed mouth is decorated with panels containing tulips of the type found in album borders and other media [fig. 164]. The use of these motifs by lustreware potters lends support to the idea that they were producing their wares in Isfahan or at least had access to designs generated from the court workshops at Isfahan. As with the earlier examples, the lustreware shapes tended to follow those of metal objects, such as the spittoon or sand-shaker in the painting of the grand vizier [see fig. 156].

While glass bottles were certainly being produced in the late seventeenth and early eighteenth centuries, it is by no means certain which of the extant bottles assigned to Shiraz in that period might actually be Safavid and which might be later. A pair of examples are included here [fig. 165], chosen for their simplicity and similarity to the types of bottles illustrated by Kaempfer. However, it is possible that more elaborate bottles were being produced before the fall of the Safavids and eventually some new type of data, either archaeological or written, will shed further light on the evolution of late Persian glass.

While the apathy and misrule of Shah Sultan Husayn adversely affected most aspects of life in Iran, artists and craftsmen maintained their workshops and continued to produce their wares for Persian patrons and foreign trade. Given the power of the eunuchs and women of the harem, court painters may have worked for them as much as for the king. Likewise, wealthy merchants, whether Armenian or Persian, may have driven the market for new types of objects, such as enamels or lustrewares, and thus Safavid art did not entirely stagnate under its last shah. While the spark of an inspiring and inspired royal patron is absent in late seventeenth- and early eighteenth-century Iran, the artists themselves had enough ingenuity to develop ideas introduced in the second half of the seventeenth century. Thus paintings in oil on canvas, lacquerwares, enamelled objects and some classes of fine ceramics continued to be made through the turmoil of the post-Safavid eighteenth century until they became in the nineteenth century the primary media of Qajar artistic expression.

165 Two glass flasks, Iran or Turkey, late 17th–early 18th century, blue and green glass, h. 20 and 22.5 cm, British Museum, OA 74.6-13.6–7, Gift of Rev. Greville Chester. Although these two bottles were collected in Turkey, their shapes are the same as those published by Engelbert Kaempfer as being in use in Shiraz in the late 17th century.

Epilogue
The Safavid Legacy

Many scholars have described how the sixteenth-century Safavid artists who emigrated to Mughal India and Ottoman Turkey helped found new schools of painting or develop new decorative modes. Artists such as Mir Sayyid 'Ali and 'Abd al-Samad left Iran at the invitation of the Mughal emperor Humayun in the late 1540s at a time when Shah Tahmasp was releasing his artists from royal service. At first, their paintings conformed to Safavid pictorial norms [fig. 166], but with the death of Humayun and accession of Akbar in 963/1556 the cool, balanced compositions of Safavid painting gave way to the vibrant intensity of early Akbar period illustrations. At the Ottoman court two sixteenth-century Persian artists, Shah Quli and Vali Jan, introduced a vogue for album drawings that existed alongside the prevailing Ottoman taste for illustrated historical manuscripts [fig. 167]. Likewise, in Uzbek Bukhara Shaykh Zadeh, who had contributed illustrations to the 931/1524–5 royal Safavid *Khamseh* of Nizami, helped found a distinctive school of painting whose artists adhered to the figural proportions of the late fifteenth-century Herat school rather than those of Shah Tahmasp's Tabriz painters [fig. 168]. The vogue for album paintings and decorative borders at Bukhara may have been influenced by Safavid examples, but the choice of manuscripts to be illustrated reflected the Uzbek preference for eastern Iranian literature.

Yet sixteenth-century painters were not the only means by which the Safavid style reached foreign shores. The textile trade grew in importance over the course of the sixteenth century when raw and woven silk from Gilan and Mazandaran was sold in Turkey or in Europe by way of Aleppo. However, the heyday of Safavid textile exports began with the reign of Shah 'Abbas I and continued through the seventeenth century, with silk and wool being exported to Europe and Asia and silk and metal thread carpets being presented as royal gifts to foreign embassies. By the end of the seventeenth century certain types of textiles were produced in Iran, copied in India or vice versa, making attribution to one centre or another very difficult. Similarly, the schools of North Indian and Iranian metalwork are closely related in the Safavid period and are often differentiated by inscriptional details or stylistic minutiae that do not answer questions of which way the influence flowed, from east to west or west to east. While Safavid

166 'The Princes of the House of Timur', detail, Mughal India, 1550–55, opaque watercolour and gold on cotton, 108.5 × 108 cm, British Museum, OA 1913.2-8.01. Although this painting was refurbished in the 17th century, it retains the composition, palette and in some instances the figural style of mid-16th-century Safavid painting and has been attributed variously to Mir Sayyid 'Ali and 'Abd al-Samad working for the Mughal emperor Humayun.

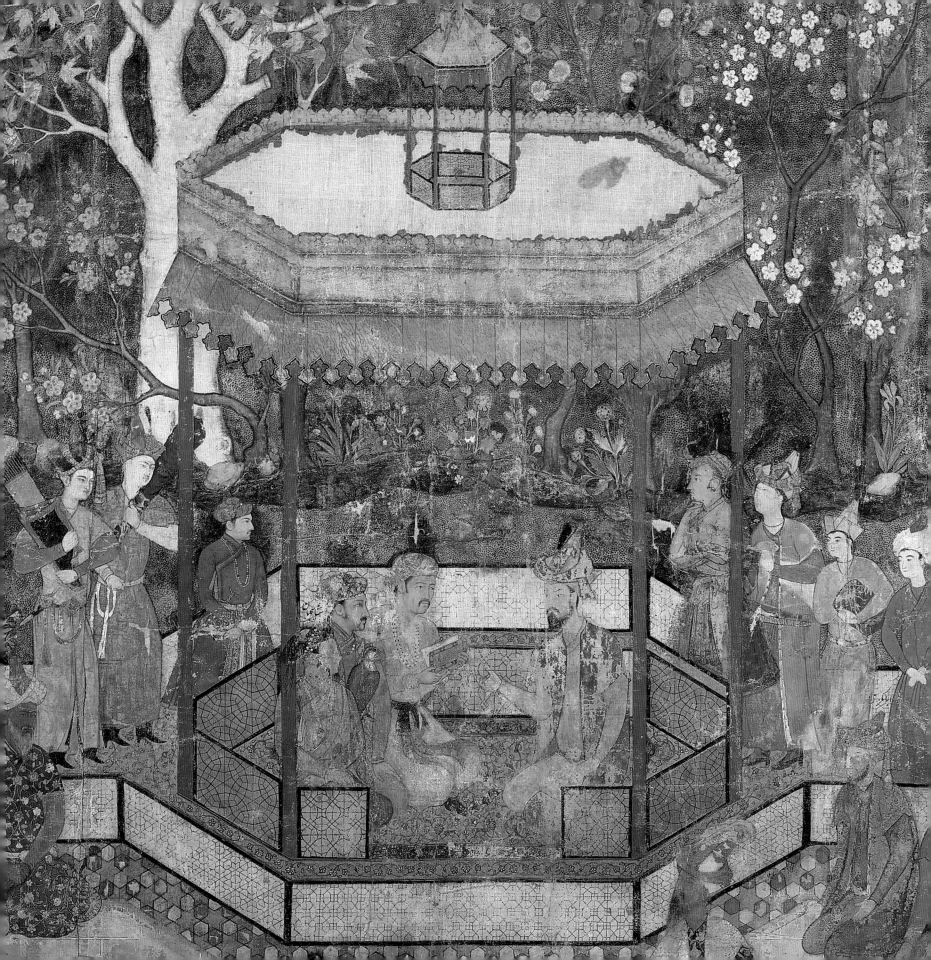

'A Youth with a Rose', Ottoman Turkish, early 17th century, ink on paper, 17.7 × 8.4 cm, British Museum, OA 1994.5-19.01. This is one of several versions of this Turkish youth standing in a landscape. The swing of the figure's skirt recalls Qazvin painting of the last third of the 16th century.

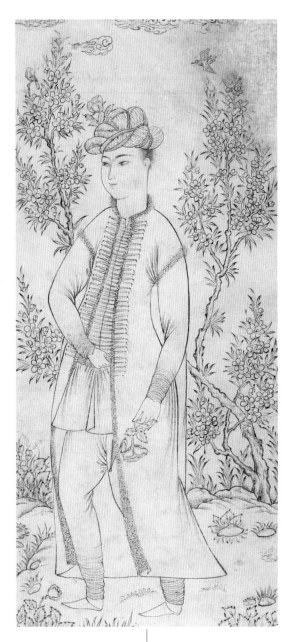

blue and white ceramics exerted an influence on Delft wares during the seventeenth century, they were in turn the medium most dependent on external prototypes, both Chinese blue and white porcelains and Indian metalwork shapes. As with textiles, Safavid ceramics in the seventeenth century figured in the expansion of international trade which was propelled by the Dutch and English East India Companies and the later entry of the French and Russians.

Because of the number of European travellers who wrote accounts of their sojourns in Iran and the number of European historians who have consulted these sources,[1] the Safavid influence on other parts of the world, such as Southeast Asia, has received less attention. However, metal ground silks were produced in Iran in the early eighteenth century for export to Thailand; these are woven in the Persian technique but reflect Thai taste.[2] It is equally likely that Indonesian illuminated documents of the seventeenth century relied on Persian prototypes for the gilded arabesque forms used for headings and margins. Some Persian ideas reached other parts of the world not through direct trade but second-hand. Thus Moroccan bookbindings of the seventeenth century that appear to be based on Safavid examples were more likely derived from Ottoman

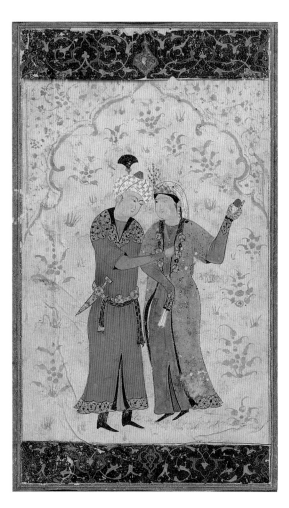

168 'Lovers', Uzbek Bukhara, c. 1560–70, opaque watercolour on paper, 19.4 × 12.1 cm, British Museum, OA 1948.10-9.057, Bequest of P.C. Manuk and Miss G.M. Coles through the National Art Collections Fund. The gold niche and the flattened faces of the figures are typical of Bukhara painting of the second half of the 16th century.

bookbindings which in turn were influenced by Safavid prototypes.

Iranian art of the eighteenth and nineteenth centuries, of course, developed on the foundations that were laid in the Safavid period. Oil painting on canvas, lacquerwares, glass and the Europeanizing style of painting had all been introduced by the late Safavid period. Vase, Herat and garden carpets, first produced under the Safavids, continued their long lives into the twentieth century. The perennial fascination with Persian carpets throughout

169 (right) 'Persian Dream', by Carolinda Tolstoy, London, 1990s, ceramic with polychrome and lustre glazes, h. 38 cm, diam. 16 cm. The lovers on this vase by a contemporary British potter are derived from a painting of 1630 by Riza-yi ʿAbbasi.

170 (far right) Vanity case, made by the Renault and Cartier workshops for Cartier, Paris, 1930, enamelled gold, diamonds and emeralds set in platinum, 8.5 × 5.5 cm, Cartier Collection. The arabesque design on this cigarette box was inspired by a Safavid source, probably an illuminated page or a metal object. Louis Cartier was an important collector of illustrated Persian manuscripts in the early 20th century.

the Western world has certainly contributed to the longevity and revival of the various Safavid styles, although none of the modern versions can match the colour harmonies and technical perfection of the great classical carpets of the sixteenth and early seventeenth centuries. Perhaps more important than the continuation of Safavid carpet designs themselves has been the abiding belief that Persian carpet makers are among the best in the world. This reputation and the self-belief on which it is based are directly connected with the exceptional products of the Safavid era and the universal respect in which they were held by all who remarked upon them.

While industrialization and cheap imports from South and East Asia have taken their toll on many of the traditional crafts of Iran, the making of glazed tiles for the repair of major Safavid monuments has continued unabated. In the Masjid-i Imam (Masjid-i Shah) in Isfahan, work on the tiled exterior of the dome proceeds on the ground, where an enormous curved form in the dimensions of a section of the dome receives the tiles that will eventually be placed on the dome. Although the use of such a form may not date back to the Safavid period, the local production of glazed tiles for the refurbishment or building of monuments has remained a standard practice since the Safavid period and well before, probably going back to the thirteenth century.

For historians Safavid art and architecture mirror the times in which they were made and are the visual testimony of the taste and status of their patrons. Yet nearly five hundred years since the founding of the Safavid dynasty the power of its art is manifest in more than the continuing repetition of its designs on carpets or other objects and in its ability to stimulate continuing scholarly debate. The fact that Safavid art has inspired twentieth-century artists as diverse as the potter Carolinda Tolstoy [fig. 169] and the jewellers Cartier [fig. 170], not to mention Iranian artists working within their own cultural milieu, illustrates its lasting allure. Forged in the sixteenth century in the same process that united the eastern and western halves of Iran, Safavid art and design achieved an exceptional level of refinement under its first real Maecenas, Shah Tahmasp, but the impetus for its dissemination originated in the reign of Shah ʿAbbas I and, once begun, the process never ceased.

Notes

1 PRELUDE TO THE CONQUEST

1. Zeno 1873, p. 43.
2. Membré 1993, p. 26, states that Shah Isma'il changed the distinctive headdress introduced by Haydar. This assertion is supported by the absence of the turban in Turkman painting of the late fifteenth century and its appearance in the earliest Safavid paintings of the sixteenth century.
3. A variant of this story says that they were kept in Shiraz by Mansur Beg Purnak. See Morton 1996, p. 43.
4. By the 1450s when Junayd, Isma'il's grandfather, became shaykh of Ardabil, the word 'Sufi' in the Safavid context meant more than 'Islamic mystic'. According to Roemer (1986, p. 203), the words *sufi* and *ghazi* ('soldier of the faith') were equated: 'Members of a sūfi order, whose mystical rule was probably preserved only as a more or less faded memory, were converted to the ideals of a Holy War which are inherent in Islam, trained as fanatical warriors and, as we shall see, actually led into battle.'
5. Ross 1896, p. 295.
6. Morton 1974, pp. 48–9.
7. Ibid., p. 57.
8. Golombek and Wilber 1988, vol. 1, p. 363.
9. Ibid., p. 367.
10. Hillenbrand 1994, pp. 426–8.
11. Ross 1896, p. 287.
12. For example, the Gur-i Amir in Samarkand, 807/1404; see Golombek and Wilber 1988, vol. 1, p. 262.
13. Wilber 1955, p. 148.
14. Ibid.
15. Robinson 1976a, p. 160 notes that the *Shahnameh* 'is divided into two volumes'. Volume I is in the Museum of Turkish and Islamic Art, Istanbul (MS 1978) and contains 202 miniatures; Volume II is in the Library of Istanbul University (Yildiz 7954/310) and contains 109 miniatures. Between 1912, when F.R. Martin published it as in the Monastery of the Dancing Dervishes, Galata, and 1929 when Armenag Bey Sakisian described it, the manuscript had been stolen, sold to a foreign diplomat and recovered with close to forty miniatures removed from it.'
16. Ibid., p. 179. Stchoukine 1966, pp. 3–4 notes that the manuscript, in the collection of the Topkapi Saray Library, H.762, consists of 317 folios and contains 19 miniatures. At least three paintings were removed and are in the Keir Collection. The calligrapher was 'Abd al-Rahim ibn 'Abd al-Rahman al-Khwarizmi al-Sultani al-Ya'qubi, working at '*dar sultaniyeh* Tabriz'.
17. Golombek *et al.* 1996.
18. Ibid., p. 130.
19. Barbaro and Contarini 1873, p. 56.
20. Ibid., p. 132.
21. Allan 1991, pp. 153–9.
22. Woods 1976, p. 147.
23. Barbaro and Contarini 1873, p. 60.
24. Erdmann, 1977, pp. 62–4, pl. v, fig. 64.

2 LIKE A BURNING SUN

1. Savory 1964, p. 59, quoting British Library, Or. 3248, fol. 28b.
2. Eskandar Beg Monshi 1978, p. 43.
3. The very fine, small *Anthology*, British Library, Or. 1656, produced at Shamakha in Shirvan in 1468, may have been part of Isma'il's booty.
4. Eskandar Beg Monshi 1978, pp. 44–5. Although this and other texts mention Isma'il's enthronement, there is no description of a ceremony of enthronement or coronation, either because of a lack of eyewitness accounts or a lack of a specific secular event connected with his accession.
5. Ibid., p. 46.
6. Anonymous 1873, p. 198. Hillenbrand 1986, p. 768 notes 'a minaret decorated with the horns and skulls of game' on the outskirts of Khuy, but does not say whether this is connected with Shah Isma'il's palace there.
7. Eskandar Beg Monshi 1978, p. 61.
8. Stchoukine 1959, pp. 6–7.
9. Savory 1965, p. 93, citing Nasr Allah Falsafi.
10. The repairs at the shrine of Imam Riza at Mashhad were completed in 920/1514. Hillenbrand 1986, p. 967.
11. Two articles on the subject of Isma'il's tomb by Robert Hillenbrand are forthcoming.
12. Hillenbrand 1986, p. 766.
13. Savory 1960, p. 98.
14. Rogers and Köseoğlu 1987, p. 196, no. 48.
15. Allan 1987, p. 105, cat. 190. The cast brass jug dated 918/1512 (David Collection, Copenhagen, 34/1986) is signed by 'Ali ibn Muhammad 'Ali Shahab al-Ghuri who also signed a jug made in 1497 for Sultan Husayn Bayqara (British Museum, 1962.7-18.1).

16. Rogers and Köseoğlu 1987, p. 206, no. 115.

17. Ibid., p. 200, no. 76.

18. S.C. Welch 1979, p. 21. Zettersteen and Lamm 1948, p.27 believe the scribe to have been Sultan 'Ali Mashhadi.

19. S.C. Welch 1979, p. 34.

20. Thackston 1988, p. 43.

21. Ibid., p. 44.

22. This connection may not be as far-fetched as it seems. The Qaraqoyunlu Turkmans were first the allies and then the conquerors of the Jalayirids, one of whose capitals was at Tabriz. The Aqqoyunlu Turkmans, who took over the Qaraqoyunlu lands and capital at Tabriz, were respectful of their cultured Jalayirid antecedents, a view that may have been shared by Shah Isma'il.

23. Petrosyan *et al.* 1995, pp. 220–21.

24. Dickson and Welch 1981, p. 7.

25. Because the majority of illustrations in the manuscript were completed during the reign of Shah Tahmasp, the manuscript will be discussed as a whole in the next chapter.

26. Richard 1997, p. 133, no. 79. The *Mihr o Mushtari* of Assar Tabrizi was copied in Shiraz in 909/1504 by Shaykh Murshid and contains an incipient version of the Haydari *taj*.

27. Robinson 1980, p. 155.

28. Golombek and Mason 1995, p. 36, n. 2.

29. Ettinghausen 1935, p. 53.

30. Golombek and Mason 1995, p. 36.

31. Melikian-Chirvani 1982, p. 260.

32. Ibid., pp. 279–80.

33. Ibid., pp. 283–5.

34. Hillenbrand 1986, p. 768 mentions carved woodwork in the shrine of 'Abd al-Azim at Rayy, 918/1512; the Imamzadeh Ibrahim at Amul, 924/1519; the tomb of Baba Afzal at Maraq, 912/1515; and the Imamzadeh Zaid, Tehran, Rajab 920/August–September 1514. Bivar and Yarshater 1978, p. 9 mention the southern door of the shrine of Bibi Sukaineh at Babulsar, a wooden door carved by Shams al-din b. Ahmad-e Sari and dated 911/1505–6.

3 THE YEARS OF WAR

1. Eskandar Beg Monshi 1978, p. 112.

2. Ibid., p. 73.

3 Savory 1961, p. 68.

4. Ibid., p. 69. It seems that Shah Tahmasp was not wearing the crown when it was struck.

5. Ibid.

6. Roemer 1986, p. 240.

7. Eskandar Beg Monshi 1978, p. 79 describes the two Ustajlu amirs abandoning the fight immediately when they 'caught sight of the gilded ball on top of the royal standard'. See also his p. 114.

8. Ibid., p. 203.

9. Morton in Membré 1993, p. xvi.

10. Eskandar Beg Monshi 1978, p. 144.

11. Allen 1983, p. 52.

12. Anonymous 1873, p. 167.

13. Godard 1938, pp. 256–9.

14. Qadi Ahmad 1959, p. 152.

15. Savory 1961, pp. 79–80.

16. Membré 1993, p. 29.

17. Ibid., p. 31.

18. Ibid., p. 30.

19. Morton 1975, p. 41.

20. Ibid., p. 43.

21. King 1996, pp. 88–92. Blair forthcoming.

22. King 1996, p. 91.

23. Ibid.

24. Membré 1993, p. 20.

25. Ibid., p. 21.

26. Dickson and Welch 1981, vol. 1, pp. 33–4.

27. Dost-Muhammad, 'Preface to the Bahram Mirza Album', in Thackston 1989, p. 348.

28. S.C. Welch 1979, pp. 25 and 50.

29. Dost-Muhammad, 'Preface to the Bahram Mirza Album', in Thackston 1989, pp. 348–9; Malik Daylami, 'Preface to the Amir Husayn Beg Album', in Thackston 1989, pp. 351–2; Mir Sayyid Ahmad, 'Preface to the Amir Ghayb Beg Album', in Thackston 1989, pp. 353–6; Qadi Ahmad 1959, pp. 180–90.

30. S.C. Welch 1979, pp. 96–7.

31. Membré 1993, p. 39.

32. Qadi Ahmad 1959, p. 186.

33. Dost-Muhammad, 'Preface to the Bahram Mirza Album', in Thackston 1989, p. 348. Although Dust Muhammad refers to the artist as Mir Musavvir, the word *musavvir* means 'painter'. Since he refers to the artist as a *sayyid* and says that his works are in the *Khamseh* along with those of Aqa Mirak, it seems likely that he is not discussing Mir Musavvir, who did not contribute to the *Khamseh*.

34. Ibid., p. 349.

35. Qadi Ahmad 1959, pp. 135–6.

36. Ibid., p. 139.

37. 'The Canons of Painting by Sādiqī Bek', in Dickson and Welch 1981, vol. 1, pp. 262, 264–5.

38. Melikian-Chirvani 1982, p. 289, inscription from a bowl dated Rajab 945/November–December 1538. Zebrowski 1997 publishes this piece, fig. 130, p. 115, and calls it a 'pi-suz' (p. 113), which implies that it held a dish for burning oil rather than a well in which candles were placed.

39. Melikian-Chirvani and Zebrowski have pointed out that many metal lampstands were presented by pious donors to shrines of Sufi saints, which may explain their absence in paintings of nocturnal scenes. See Melikian-Chirvani 1987, pp. 117–47; Zebrowski 1997, p. 111.

40. Zebrowski 1997, p. 263.

41. Sonday 1989, p. 83.

42. Robert Hillenbrand will publish this cenotaph in a forthcoming article in the proceedings of the Third Safavid Roundtable.

43. Although this theory is very close to that proposed as pertaining to the Timurids, Shah Tahmasp seems to have been far less concerned with proving the legitimacy of his dynasty to rule Iran than with having his artists produce a visual environment that expressed his personal taste. See Lentz and Lowry 1989.

4 A NEW CAPITAL AND NEW PATRONS

1. D'Alessandri 1873, p. 216.
2. Eskandar Beg Monshi 1978, p. 203.
3. Morton in Membré 1993, p. 68.
4. Savory 1978, p. 188.
5. D'Alessandri 1873, p. 215. Either d'Alessandri underestimated the boy's age or, less likely, some of the shah's younger children escaped the notice of the Persian sources.
6. Eskandar Beg Monshi 1978, p. 205.
7. Echragi 1982, pp. 120–23.
8. Ibid., pp. 123–4.
9. Qadi Ahmad 1959, p. 182.
10. Eskandar Beg Monshi 1978, p. 271.
11. Ibid.
12. Luschey-Schmeisser 1969, p. 183.
13. Hillenbrand 1986, p. 773 notes that this technique is very unusual in the Safavid period but not so rare in later times. Possibly for this reason Dr Sussan Babaie, in conversation with the author, has suggested that the decoration of the palace may be later in date than 1565–5.
14. Smirnova et al. 1969, fig. 135.
15. Eskandar Beg Monshi 1978, p. 274.
16. Ibid., p. 275.
17. Simpson 1997.
18. Ibid., pp. 44–5.
19. Eskandar Beg Monshi 1978, p. 273.
20. S.C. Welch 1976, p. 24.
21. Robinson 1992, pl. VIIa–c.
22. Bier 1987, p. 184.
23. Eskandar Beg Monshi 1978, p. 169.
24. Haldane 1983, pl. 91. The composition on the exterior of this book cover consists of a princely picnic with figures wearing the Safavid taj, which could indicate a date in the 1550s. Unfortunately, the faces on this surface have been retouched so the book cover may date as late as the 1570s.
25. Eskandar Beg Monshi 1978, p. 210.
26. Melikian-Chirvani 1982, p. 263.
27. Ibid., p. 265, fig. 65.
28. Ibid., p. 297, no. 129.
29. Atasoy and Raby 1989, figs 370–71.
30. Melikian-Chirvani 1982, p. 302, no. 132a.
31. Lane 1957, pls 66–7.
32. Ibid., pl. 20.
33. D'Alessandri 1873, p. 218.

5 THE LOWEST EBB

1. Eskandar Beg Monshi 1978, p. 292.
2. D'Alessandri 1873, p. 215.
3. Ibid.
4. Eskandar Beg Monshi, 1978, p. 205.
5. Ibid., p. 291. In July or August 1576 Isma'il had Tahmasp's coffin taken to the Imamzadeh Husayn shrine, where Isma'il's three murdered brothers were buried, to await transport to Mashhad in the autumn.
6. Ibid., p. 297.
7. Ibid., p. 311.
8. Robinson 1976b, pp. 1-8.
9. Robinson et al. 1988, p. 19.
10. Eskandar Beg Monshi 1978, p. 582 states that shortly after Nauruz 998/spring 1590, 'On arrival at Rayy, Shah 'Abbas released his father and the royal princes, who had been imprisoned there in the fortress by Morsedqoli Khan.' This would imply that both Muhammad Khudabandeh and his sons had been moved from Alamut to Rayy at some point between October 1588 and spring 1590. They were then imprisoned in the fortress of Tabarak at Isfahan and freed in the spring of 1591, only for Shah 'Abbas's brothers to be sent to Alamut and blinded. Muhammad Khudabandeh remained in Qazvin.
11. Eskandar Beg Monshi 1978, p. 272, cites Maulana 'Abd al-Jabbar Astarabadi, a calligrapher who began by working for Khan Ahmad in Gilan, then came to Qazvin where he ran an artists' workshop and was a member of the royal library, and then returned to Gilan when Khan Ahmad was reinstated by Shah Muhammad Khudabandeh.
12. Simpson 1997, p. 300.
13. Çağman and Tanindi 1996, p. 136.
14. Robinson 1988, pp. 125–8.
15. Jackson and Lockhart 1986, pl. 12.
16. Sarre and Trenkwald 1979, p. 22.
17. Hetjens Museum 1973, pp. 138–9, no. 186.
18. Dimand 1930, p. 118, fig. 55.

6 FROM QAZVIN TO ISFAHAN

1. Herbert 1677, p. 215.
2. Eskandar Beg Monshi 1978, p. 590.
3. Roemer 1986, p. 264.
4. Eskandar Beg Monshi 1978, p. 800. Three years later Shah 'Abbas performed the pilgrimage to Mashhad on foot from Isfahan.
5. Eskandar Beg Monshi 1978, p. 724.
6. Gregorian 1974, p. 671.
7. Eskandar Beg Monshi 1978, p. 724.
8. Hillenbrand 1986, p. 785 says that Shaykh Lutfallah was the father-in-law of Shah 'Abbas. Eskandar Beg Monshi 1978, p. 249 describes his progress during the reign of Shah Tahmasp. An Arab from Jebel 'Amel, he studied at the shrine of Imam Riza at Mashhad under Maulana 'Abdullah Shushtari and lectured on theology at the shrine. He remained there until the time of the Uzbek occupation when 'he sought refuge at court and lectured for a while at Qazvin. From there, at royal command, he went to

Isfahan and took up residence in the neighborhood of the mosque in Naqš-i Jahān Square, opposite the royal palace, one of the great architectural monuments of Shah 'Abbas I. There he discharged the duties of an imam (prayer leader), gave lectures on jurisprudence and *hadis* and occupied himself with worship and obedience to God.' Shaykh Lutfallah, according to Eskandar Beg Monshi (1978, p. 1230), had lived within the precincts of the mosque. He died in 1032/1623.

9. The mosque is now called Masjid-i Imam.

10. Eskandar Beg Monshi 1978, p. 1038.

11. The discovery forestalled Shah 'Abbas's plans to demolish the Masjid-i Jami' of Isfahan in order to reuse its marble for his mosque, according to Chardin as quoted in Godard 1937, p. 112. Despite this find, the actual placement of the marble dado panels in the mosque did not occur until 1047/1637, eight years after the death of Shah 'Abbas.

12. Hillenbrand 1986, p. 788 gives the overall dimensions of the mosque as 140 by 130 metres. Presumably Shah 'Abbas was impatient for the mosque to be completed; he may have been promised that it would be finished by a date that the builders could not achieve. In 1029/1619–20, after the shah commissioned Muhibb 'Ali Kika Lala, the supervisor of the mosque project, to begin work on a vast tunnel to divert the course of the Kurang River, he withdrew his support of Muhibb 'Ali because 'he had no confidence in Lala Beg's [Muhibb 'Ali's] ability to complete the work in the contracted time.' Eskandar Beg Monshi 1978, p. 1171.

13. Hillenbrand 1994, p. 367.

14. Eskandar Beg Monshi 1978, p. 1059.

15. Ibid., pp.1065–6.

16. Wilber 1962, p. 135.

17. Eskandar Beg Monshi 1978, p. 536.

18. Ibid., p. 955.

19. Tavernier, quoted in Spuhler *et al.* 1987, p. 34.

20. Because of the misidentification of a coat of arms on a carpet of this type made for export to Europe, the group has been named 'Polonaise'.

21. Erdmann 1960, p. 44.

22. The *Anvar-i Suhayli* of 1002/1593 in the collection of Prince and Princess Sadruddin Aga Khan. See A. Welch 1976, pp. 125–42, and Canby 1998, pp. 70–72.

23. Canby 1996b, pp. 39ff.

24. Eskandar Beg Monshi 1978, p. 273.

25. Bailey 1994–5, pp. 29–34.

26. Canby 1996b, pp. 28, 32–4.

27. Ibid., p. 31.

28. Spuhler 1986, p. 723.

29. Ackerman 1939, pp. 2094–101.

30. Canby 1996b, cat. 57, p. 104.

31. Qadi Ahmad 1959, p. 193.

32. Bier 1987, p. 155.

33. Canby 1996b, cat. 124, p. 166, cat. 128, p. 175.

34. Melikian-Chirvani 1973, pp. 110–11.

35. Melikian-Chirvani 1974, p. 552, figs 6–8.

36. Melikian-Chirvani 1982, pp. 317–18.

37. Ibid., pp. 305–7; Melikian-Chirvani 1973, pp.106–8.

38. Melikian-Chirvani 1973, p. 114 publishes an example dated 997/1590–91.

39. Melikian-Chirvani 1982, p. 328 catalogues an example of the former, dated 1017/1608–9, and (p. 329) an example of the latter, dated 1030/1620–21.

40. Ibid., pp. 307–9.

41. Melikian-Chirvani 1973, pp. 118–19; Melikian-Chirvani 1982, pp. 322–6; Zebrowski 1997, p. 152.

42. Lane 1957, pl. 96.

43. Simpson 1980, pp. 90–91.

44. Lane 1957, pl. 97A.

45. Robinson *et al.* 1976, cat. 169.

46. Information supplied by Dr St John Simpson, personal communication.

47. Canby 1996b, p. 177.

48. Lane 1957, p. 120, quoting Chardin.

49. Ibid., p. 99, n. 2.

50. Pope 1956, pls 100–104.

51. Krahl 1986, vol. 2, p. 699, no. 1179.

52. Eskandar Beg Monshi 1978, p. 1199.

53. Erdmann 1960, p. 37.

54. On a British Museum label.

55. Lane 1957, p. 108.

7 A VOLUPTUOUS INTERLUDE

1. Minorsky 1943, p. 16.

2. Eskandar Beg Monshi 1978, p. 1099.

3. Ferrier 1986, pp. 457–8.

4. Saru Taqi's role as a patron of architecture is discussed in Babaie forthcoming, in the collection of papers from the 1998 British Museum symposium 'Safavid Art and Architecture'.

5. Hillenbrand 1986, p. 796.

6. Canby 1996b, pp. 177 and 175.

7. Ibid., p. 167.

8. Ibid., pp. 193 and 195.

9. Titley 1983, p. 121.

10. Ibid., p. 121 notes a similarity in style to that of Muhammad Yusuf which I do not find compelling.

11. Schmitz 1992, pp. 122–8. Dr Schmitz provides the most up-to-date information about this manuscript, its patron, its scribe and its artist.

12. Farhad 1990, pp. 124–5.

13. Ibid., figs 2–3.

14. Gray 1957, p. 225. Canby 1996b, pp. 54–5.

15. Spuhler *et al.* 1987, p. 14.

16. The textiles are discussed at length in Bier 1995, pp. 61–73.

17. Spuhler *et al.* 1987, p. 10.

18. Hayward Gallery 1976, p. 103, no. 67.

19. Ferber *et al.* 1987, p. 236.

20. Melikian-Chirvani 1982, p. 331.

21. Lane 1957, pl. 95c.

22. Zebrowski 1997, pl. 169.

23. Ibid., pls 346 and 350.

24. Lane 1957, pl. 79. A funerary tile attributed to Mashhad, dated 1050/1640–41, reveals a much more eclectic style than the hookah base. See Musée du Louvre 1989, p. 305, cat. 231.

25. Charleston 1974, p. 13.

26. Ibid., p. 18.

8 A NEW FOCUS

1. Minorsky 1943, p. 35, paraphrasing Chardin, v, 315, 323.

2. Roemer 1986, p. 304.

3. Floor 1997, p. 247.

4. Roemer 1986, p. 301.

5. Floor 1997, p. 254.

6. The *talar* is described as 'newly constructed' in 1055/1645, see Floor 1997, p. 259.

7. Babaie 1994, pp. 137–8.

8. This idea is investigated in depth in Babaie forthcoming.

9. Although the name 'Chihil Sutun', literally meaning 'forty columns' but more likely referring to 'many columns', had been used by Shah Tahmasp for his palace at Qazvin, there is no indication that Shah 'Abbas II borrowed the design of that palace.

10. Babaie 1994, pp. 126, 128–9.

11. Ibid., pp. 136–7.

12. Soudavar 1992, p. 367.

13. Ibid.

14. Richard 1997, p. 223.

15. Canby 1998, p. 145.

16. Welch 1973, p. 88 for an illustration of a nude woman with a mostly nude man.

17. Stchoukine 1964, p. 150. The manuscript is in the Saltykov-Shchedrin Public Library, St Petersburg.

18. Ibid., pp. 148–9, pls LV, LX–LXIV.

19. Beattie 1976, p. 17.

20. Ibid., p. 21. The earliest garden carpet, of which later examples in the vase technique are known, was found in the Jaipur Palace at Amber. It has a label on the back stating that it arrived in the palace on 29 August 1632.

21. McDowell 1989, p. 168.

22. Hayward Gallery 1976, p. 59, pl. 84.

23. Aga-Oglu, 1941, pls XII–XIII.

24. Allan 1995, pp. 134–5.

25. The Najaf tomb cover, however, would not have accompanied a renovation of the building since Najaf had fallen into Ottoman hands under Shah Safi.

26. Melikian-Chirvani 1982, pp. 333–4.

27. Richard 1997, p. 221. Bibliothèque Nationale, Mss. or., Suppl. persan 1111, fol. 197.

28. Beattie 1976, pp. 36–7, pl. 2.

29. Melikian-Chirvani 1982, pp. 346–7.

30. Ettinghausen 1939, vol. 2, p. 1693, no. 187.

31. Ibid., no. 186. This tile is in the Victoria and Albert Museum, 1882-76.

32. Ettinghausen 1935, p. 57, fig. 16. This dish is in the Victoria and Albert Museum, L.93-1886.

33. Lane 1957, pl. 88b.

9 THE PATRIMONY SQUANDERED

1. Fryer 1698, p. 355.

2. Fryer 1698, p. 345.

3. Mathee 1997, p. 820.

4. Golombek and Wilber, 1988, pp. 388 and 373.

5. Jean Chardin, as quoted in Ferrier 1996, p. 152.

6. Carswell 1968, p. 27.

7. Luschey-Schmeisser 1978, pp. 39–44. This major study of the exterior of the Hasht Bihisht assumes that Mu'in Musavvir worked within the court milieu, whereas his oeuvre shows no evidence that he did. As with the earlier 'Kubachi' tiles, the tilemakers adapted the dominant figural style to their medium, but there are no extant drawings that could be considered cartoons for these spandrels. Shafi' 'Abbasi, on the other hand, was providing designs for textiles and probably for craftsmen of other media, and his drawings may have been the source of some of the flower and insect tiles at the Hasht Bihisht.

8. Nouveau Drouot 1982, lots 11–12.

9. This painting is signed 'Ghulamzadeh Qadimi 'Ali' and was first attributed to 'Ali Quli Jabbadar by Robinson (1967, cat. no. 87). The attribution is supported by another signature incorporating the word 'ghulamzadeh' with the name ''Ali Quli Jabbadar' on his copy of an engraving by Lucas Worsterman after the painting by Rubens of *Suzanna and the Elders*, see Nouveau Drouot 1982, lot 7, and apparently the identical signature appears on a painting of the 'Shah with a Dignitary and a Servant Holding a Flask': see Akimushkin 1994, pl. 191, fol. 99r. The inclusion of the word 'ghulamzadeh', meaning son of an Islamicized Christian slave, and the presence of Georgian inscriptions on at least two of the artist's paintings in the St Petersburg album raise the question of whether 'Ali Quli was himself a Georgian, not a European, by birth.

10. Diba 1998, p. 117 gives the date of Muhammad Zaman's earliest work as 1671 but does not say what the work is.

11. A. Welch 1973, p. 102. Although the dimensions of this painting are larger than those of the artist's additions to the British Library *Khamseh*, this work may have been intended for the addition to the manuscript but not used.

12. Ibid., p.148.

13. Akimushkin 1994, pp. 71, 73. Buck *et al.* 1988, pp. 110–11.

14. Robinson 1972, pp. 73-86.

15. Diba 1998, p. 117.

16. Khalili, Robinson and Stanley 1996, pp. 50-51.

17. A.U. Pope 1939, vol. VI, pl. 1257. This is one of a group of floral carpets from the tomb of Shah 'Abbas II, signed by Jaushaqan Qali. See pls 1258-60.

18. Akimushkin 1994, p. 89. In a lecture at the British Museum in July 1999 Adel Adamova suggested that the ruler in this picture is Shah 'Abbas II, not Shah Sulayman.

19. Akimushkin 1994, p. 90.

20. Zebrowski 1997, pp. 130–33.
21. Canby 1998, pp. 84–7.
22. Melikian-Chirvani 1982, p. 336.
23. Allan 1995, pls XVIIc and XXa.
24. Zebrowski 1997, pp. 156–8.
25. Ibid., p. 158, and Rogers 1983, p. 135.
26. Lane 1957, p. 104.

10 DISINTEGRATION OF THE DYNASTY

1. Minorsky 1943, p. 24, quoting Muhammad Mushin, *Zubdat al-tavārīkh* (Cambridge University Library, Ms G15 (13)).
2. The three main buildings of the complex are still in use. Only the stables to the east of the *caravansarai* are now gone. The *madrasa* in the past was called the Madar-i Shah Madrasa; the *caravansarai* is now the 'Abbasi Hotel; and an annex of the hotel now stands on what were once the stables.
3. Akimushkin 1994, p. 113 attributes this painting to Muhammad Sultani. However, the use of 'Sultani' may have been a newly adopted epithet in 1694 that referred to Muhammad Zaman's role in the atelier of Shah Sultan Husayn. Adel Adamova in a lecture at the British Museum in July 1999 suggested that the bearded figure is not Shah Quli Khan but Shah Sultan Husayn.

4. Soudavar 1992, p. 378.
5. Khalili, Robinson and Stanley 1996, p. 61, nos 28 and 29.
6. Ibid., p. 69.
7. Diba 1998, p. 130. Two Safavid oil paintings are illustrated by Diba and five more appear in Eleanor G. Sims, 'Five Seventeenth-Century Persian Oil Paintings', *Persian and Mughal Art* (London, 1976), cat. nos 137–41.
8. Diba 1998, p. 130.
9. Folsach and Keblow Bernsted 1993, p. 50.
10. Zebrowski 1997, pp. 50–65 and 80–93.
11. Ferrier 1996, p. 171 paraphrases Chardin and describes tablewares as 'enamelled and ceramic', but this apparently refers to glazed and unglazed ceramic objects, not to enamel on metal.
12. Zebrowski 1997, pp. 321–33.
13. Allan 1995, pl. XXIb.

EPILOGUE

1. Stevens 1974, pp. 421–49; Jackson and Lockhart 1986, pp. 373–409, for a summary of some, but not all of the European travellers who wrote about their experiences in Iran. Almost every historian who has written about the Safavids has consulted European sources.
2. Bier 1987, p. 228.

Select Bibliography

Ackerman, P., 'Textiles of the Islamic Periods: History', in A.U. Pope, ed., *A Survey of Persian Art* (London and New York, 1939), vol. 3, pp. 1995–2162

Aga-Oglu, Mehmet, *Safawid Rugs and Textiles* (New York, 1941)

Akimushkin, Oleg F. *The St. Petersburg Muraqqa* (Lugano, 1994)

Allan, J.W., 'Art from the World of Islam', *Louisiana Revy*, vol. 27, no. 3 (March 1987)

Allan, J.W., 'Metalwork of the Turcoman Dynasties of Eastern Anatolia and Iran', *Iran*, vol. 29 (1991), pp. 153–60

Allan, J.W., 'Silver Door Facings of the Safavid Period', *Iran*, vol. 33 (1995), pp. 123–38

Allen, T., *Timurid Herat* (Wiesbaden, 1983)

Anonymous, 'The Travels of a Merchant in Persia', in C. Grey, ed., *A Narrative of Italian Travels in Persia*, trans. W. Thomas and S.A. Roy, Hakluyt Society, no. 49 (New York, 1873 reprint)

Atasoy, N. and Raby, J., *Iznik: The Pottery of Ottoman Turkey* (London, 1989)

Babaie, S., 'Shah ʿAbbas II, the Conquest of Qandahar, the Chihil Sutun, and its Wall Paintings', *Muqarnas*, vol. 11 (1994) pp. 125–42

Babaie, S., 'Building for the Shah: The Role of Mirza Muhammad Taqi (Saru Taqi) in Safavid Royal Patronage of Architecture', forthcoming

Bailey, Gauvin, 'In the Manner of the Frankish Masters', *Oriental Art*, vol. 40, no. 4 (Winter 1994–5), pp. 29–34

Barbaro, J. and Contarini, A., 'Travels to Tana and Persia', in C. Grey, ed., *A Narrative of Italian Travels in Persia*, trans. W. Thomas and S.A. Roy, Hakluyt Society, no. 49 (New York, 1873 reprint)

Beattie, M.H., *Carpets of Central Persia* (Sheffield, 1976)

Bier, C., ed., *Woven from the Soul, Spun from the Heart* (Washington, 1987)

Bier, C., *The Persian Velvets at Rosenborg* (Copenhagen, 1995)

Bivar, A.D.H and Yarshater, E., eds, *Corpus Inscriptionum Iranicarum*, pt 4: *Persian Inscriptions down to the Early Safavid Period*, vol. 6: *Mazandaran Province* (London, 1978)

Blair, S., paper on the Ardabil carpets delivered at the Third Safavid Roundtable, summer 1998, forthcoming

Buck, Robert, *et al.*, *Masterpieces in The Brooklyn Museum* (Brooklyn, NY, 1988)

Çağman, F. and Tanindi, Z., 'Remarks on Some Manuscripts from the Topkapi Palace Treasury in the Context of Ottoman–Safavid Relations', *Muqarnas*, vol. 13 (1996), pp. 132–48

Canby, S., 'Farangi Saz: The Impact of Europe on Safavid Painting', *Silk and Stone: The Art of Asia, Third Hali Annual* (London, 1996), pp. 46–59 = 1996a

Canby, S.R., *The Rebellious Reformer: The Drawings and Paintings of Riza-yi ʿAbbasi of Isfahan* (London, 1996) = 1996b

Canby, S.R., *Princes, Poets and Paladins: Islamic and Indian Paintings from the Collection of Prince and Princess Sadruddin Aga Khan* (London, 1998)

Carswell, J., *New Julfa: The Armenian Churches and Other Buildings* (Oxford, 1968)

Charleston, R., 'Glass in Persia in the Safavid Period and Later', *Art and Archaeology Research Papers*, vol. 5 (1974), pp. 12–27

Crowe, Y., 'Thèmes et variations du style Transition dans la céramique persane du XVIIe siècle', *La Porcelaine chinoise de Transition et ses influences sur la céramique japonaise, proche-orientale et européenne* (Geneva, 1997), no numbered pages

D'Alessandri, V., 'Narrative of the Most Noble Vincentio d'Alessandri', in C. Grey, ed., *A Narrative of Italian Travels in Persia*, trans. W. Thomas and S.A. Roy, Hakluyt Society, no. 49 (New York, 1873 reprint)

Diba, L., *Royal Persian Paintings: The Qajar Epoch 1725–1925* (Brooklyn, 1998)

Dickson, M.B. and Welch, S.C., *The Houghton Shahnameh*, 2 vols (Cambridge, MA, 1981)

Dimand, M., *Handbook of Muhammedan Decorative Arts* (New York, 1930)

Echragi, E., 'Description contemporaine des peintures murales disparues des palais de Šah Tahmasp à Qazvin', *Art et société dans le monde iranien* (Paris, 1982)

Erdmann, K., *Oriental Carpets* (London, 1960)

Erdmann, K., *The History of the Early Turkish Carpet* (London, 1977)

Eskandar Beg Monshi, *History of Shah ʿAbbas the Great*, trans. R.M. Savory (Boulder, CO, 1978)

Ettinghausen, R., 'Important Pieces of Persian Pottery in London Collections', *Ars Islamica*, vol. 2, pt 1 (1935)

Ettinghausen, R., 'Dated Faience', in A.U. Pope 1939, vol. 2

Farhad, M., 'The Art of Muʿin Musavvir: A Mirror of his Times', in S.R. Canby, ed., *Persian Masters: Five Centuries of Painting* (Bombay, 1990)

Ferber, L. *et al.*, *The Collector's Eye* (Brooklyn, NY, 1987)

Ferrier, R., 'Trade from the mid-14th Century to the End of the Safavid Period', *Cambridge History of Iran*, vol. 6 (Cambridge, 1986), pp. 412–90

Ferrier, R.W., *A Journey to Persia: Jean Chardin's Portrait of a Seventeenth-century Empire* (London, 1996)

Floor W., 'Dutch Painters in Iran during the first half of the 17th century', *Persia*, vol. 8 (1979), pp. 145–61

Floor, W., 'The Rise and Fall of Mirza Taqi, the Eunuch Grand Vizier (1043–55/1633–45), Makhdum al-Omara va Khadem al-Fuqara', *Studia Iranica*, vol. 26 (1997)

Folsach, K. von and Keblow-Bernsted, A.-M., *Woven Treasures: Textiles from the World of Islam* (Copenhagen, 1993)

Fryer, J., *A New Account of East India and Persia in Eight Letters being Nine Years Travels Begun 1672 and Finished 1681* (London, 1698)

Gallop, A.T., *Golden Letters: Writing Traditions of Indonesia* (London, 1991)

Godard, A., 'Isfahan', *Athar-e Iran*, vol. 2 (1937)

Godard, A., 'Historique du Masdjid-e Djumaʿa d'Isfahan', *Athar-e Iran*, vol. 3 (1938)

Golombek, L. and Mason, R.B., 'New Evidence for Safavid Ceramic Production at Nishapur', *Apollo* (July 1995), pp. 33–6

Golombek, L., Mason, R.B. and Bailey, G., *Tamerlane's Tableware* (Toronto, 1996)

Golombek, L. and Wilber, D., *The Timurid Architecture of Iran and Turan* (Princeton, 1988), vols 1–2

Gray, B., 'An Album of Designs for Persian Textiles', *Aus der Welt der islamischen Kunst* (Berlin, 1957), pp. 219–25

Gregorian, V., 'Minorities of Isfahan: The Armenian Community of Isfahan 1587–1722', *Studies on Isfahan*, pt 2: *Iranian Studies*, vol. 7, nos 3–4 (Summer–Autumn 1974), pp. 652–80

Haldane, D., *Islamic Bookbindings* (London, 1983)

Hayward Gallery, *The Arts of Islam* (London, 1976)

Herbert, Sir Thomas, *Some Years Travels into Africa and Asia* (London, 1677, third edition)

Hetjens Museum, *Islamische Keramik* (Dusseldorf, 1973)

Hillenbrand, R., 'Safavid Architecture', *Cambridge History of Iran*, vol. 6 (Cambridge, 1986), pp. 759–842

Hillenbrand, R., *Islamic Architecture: Form, Function and Meaning* (Edinburgh, 1994)

Jackson, P. and Lockhart, L., eds, *Cambridge History of Iran*, vol. 6 (1986)

Keyvani, M., *Artisans and Guild Life in the Later Safavid Period: Contributions to the Social-economic History of Persia* (Berlin, 1982)

Khalili, N.D., Robinson, B.W. and Stanley, T., *Lacquer of the Islamic Lands* (London, 1996)

King, D., 'The Ardabil Puzzle Unraveled', *Hali*, no. 88 (September 1996)

Kleiss, W., 'Der safavidische Pavillon in Qazvin', *Archaeologische Mitteilungen aus Iran*, N.F. vol. 9 (1976), pp. 253–61

Krahl, R., *Chinese Ceramics in the Topkapi Saray Museum Istanbul*, 2 vols (London, 1986)

Lane, A., *Later Islamic Pottery* (London, 1957)

Lentz, T. and Lowry, G.D., *Timur and the Princely Vision* (Los Angeles, 1989)

Lockhart, L., 'European Contacts with Persia, 1350-1736', *Cambridge History of Iran*, vol. 6 (Cambridge, 1986), pp. 373–409

Luschey-Schmeisser, I., 'Der Wand- und Deckenschmuck eines safavidischen Palastes in Nayin', *Archaeologische Mitteilungen aus Iran*, N.F. vol. 2 (1969)

Luschey-Schmeisser, I., 'Engel aus Qazvin: frühsafavidische Kachelbilder', *Archaeologische Mitteilungen aus Iran*, N.F. vol. 9 (1976), pp. 299–311

Luschey-Schmeisser, I., *The Pictorial Tile Cycle of Hašt Behešt in Isfahān and its Iconographic Tradition* (Rome, 1978)

McDowell, J.A., 'Textiles', in R.W. Ferrier, ed., *The Arts of Persia* (New Haven and London, 1989)

Mathee, R., 'Sulayman, Shah', *Encyclopaedia of Islam*, 2nd edn, vol. 9 (Leiden, 1997), pp. 820–21

Melikian-Chirvani, A.S., *Le Bronze iranien* (Paris, 1973)

Melikian-Chirvani, A.S., 'Safavid Metalwork: A Study in Continuity', *Studies on Isfahan*, pt 2, *Iranian Studies*, vol. 7, nos 3–4 (Summer–Autumn 1974), pp. 543–85

Melikian-Chirvani, A.S., *Islamic Metalwork from the Iranian World* (London, 1982)

Melikian-Chirvani, A.S., 'The Lights of Sufi Shrines', *Islamic Art*, vol. 2 (1987), pp. 117–47

Membré, M., *Mission to the Lord Sophy of Persia (1539–1542)*, intro., trans. and notes by A.H. Morton (London, 1993)

Minorsky, V., trans., *Tadhkirat al-Muluk* (London, 1943, repr. 1980)

Morton, A.H., 'The Ardabil Shrine in the Reign of Shāh Tahmāsp', *Iran*, vol. 12 (1974), pp. 31–64

Morton, A.H., 'The Ardabil Shrine in the Reign of Shāh Tahmāsp (Concluded)', *Iran*, vol. 13 (1975), pp. 39–58

Morton, A.H., 'The Early Years of Shah Ismaʿil in the *Afzal al-tavārīkh* and Elsewhere', in C. Melville, ed., *Safavid Persia*, Pembroke Papers, 4 (1996), pp. 27–51

Musée du Louvre, *Arabesques et jardins de paradis* (Paris, 1989)

Nouveau Drouot, *Art islamique*, auction catalogue (23 June 1982)

Petrosyan, Y.A., Akimushkin, O.F., Khalidov, A.B. and Rezvan, E.A., *Pages of Perfection: Islamic Paintings and Calligraphy from the Russian Academy of Sciences, St. Petersburg* (Milan, 1995)

Pope, A.U., ed., *A Survey of Persian Art* (London and New York, 1939)

Pope, J.A., *Chinese Porcelains from the Ardebil Shrine* (Washington, 1956)

Qadi Ahmad, *Calligraphers and Painters*, trans. V. Minorsky, Freer Gallery of Art Occasional Papers, vol. 3, no. 2 (Washington, 1959)

Richard, F., *Splendeurs persanes* (Paris, 1997)

Robinson, B.W., *Persian Miniature Painting* (London, 1967)

Robinson, B.W., 'The Shāhnāmeh Manuscript Cochran 4 in the Metropolitan Museum of Art', *Islamic Art in the Metropolitan Museum of Art*, ed. R. Ettinghausen (New York, 1972)

Robinson, B.W., ed., *Islamic Painting and the Arts of the Book* (London, 1976) = 1976a

Robinson, B.W., 'Ismaʿil II's Copy of the *Shahnama*', *Iran*, vol. 14 (1976), pp. 1–8 = 1976b

Robinson, B.W., *Persian Paintings in the John Rylands Library* (London, 1980)

Robinson, B.W., 'ʿAli Asghar, Court Painter', *Iran*, vol. 26 (1988)

Robinson, B.W., 'Muhammadi and the Khurasan Style', *Iran*, vol. 30 (1992)

Robinson, B.W. *et al.*, *Persian and Mughal Art* (London, 1976)

Robinson, B.W. *et al.*, *Islamic Art in the Keir Collection* (London, 1988)

Roemer, H.R., 'The Safavid Period', *Cambridge History of Iran*, vol. 6 (Cambridge, 1986)

Rogers, J.M., *Islamic Art and Design 1500-1700* (London, 1983)

Rogers, J.M. and Köseoğlu, C., *The Topkapi Saray Museum: The Treasury* (Boston, 1987)

Ross, D.E., 'The Early Years of Shah Ismaʿil, Founder of the Safavī Dynasty', *Journal of the Royal Asiatic Society* (1896), pp. 249–340

Sarre, F. and Trenkwald, H., *Oriental Carpet Designs* (New York, 1979)

Savory, R.M., 'The Principal Offices of the Safawid State during the Reign of Ismāʿil I (907–30/1501–24)', *Bulletin of the School of Oriental and African Studies*, vol. 23 (1960), pp. 91–105

Savory, R.M., 'The Principal Offices of the Safawid State during the Reign of Tahmāsp I (930–84/1524–76)', *Bulletin of the School of Oriental and African Studies*, vol. 24 (1961), pp. 91–105

Savory, R.M., 'The Struggle for Supremacy in Persia after the Death of Timur', *Der Islam*, vol. 40 (1964), pp. 35–65

Savory, R.M., 'The Consolidation of Safavid Power in Persia', *Der Islam*, vol. 41 (1965), pp. 71–94

Savory, R.M., 'Ismaʿil II', *Encyclopaedia of Islam*, vol. 4 (Leiden, 1978), p. 188

Schmitz, B., *Islamic Manuscripts in the New York Public Library* (New York, 1992)

Simpson, M.S., *Arab and Persian Painting in the Fogg Art Museum* (Cambridge, MA, 1980)

Simpson, M.S., *Sultan Ibrahim Mirza's 'Haft Awrang': A Princely Manuscript from Sixteenth-century Iran* (New Haven and London, 1997)

Smirnova, E.I., *et al*, *State Armoury in the Moscow Kremlin* (Moscow, 1969)

Sonday, M., 'Patterns and Weaves: Safavid lampas and Velvet', in Bier 1987

Soudavar, A., *Art of the Persian Courts* (New York, 1992)

Spuhler, F., 'Carpets and Textiles', *Cambridge History of Iran*, vol. 6 (Cambridge, 1986), pp. 698–727

Spuhler, F., Mellbye-Hansen, P. and Thorvildsen, M., *Denmark's Coronation Carpets* (Copenhagen, 1987)

Stchoukine, I., *Les Peintures des manuscrits safavis* (Paris, 1959)

Stchoukine, I., *Les Peintures des manuscrits de Shah ʿAbbas Ier à la fin des Safavis* (Paris, 1964)

Stchoukine, I., 'Les Peintures turcomanes et safavies d'une Khamseh de Nizami, achevée à Tabriz en 886/1481', *Arts Asiatiques*, vol. 14 (1966), pp. 3–16

Stevens, Sir Roger, 'European Visitors to the Safavid Court,' *Studies on Isfahan*, pt 2, *Iranian Studies*, vol. 7, nos 3-4 (Summer–Autumn 1974), pp. 421–57

Thackston, W.M., 'The *Diwan* of Khataʾi: Pictures for the Poetry of Shah Ismaʿil I', *Asian Art*, vol. 1, no. 4 (Fall 1988)

Thackston, W.M., *A Century of Princes: Sources on Timurid History and Art* (Cambridge, MA, 1989)

Titley, N., *Persian Miniature Painting* (London, 1983)

Welch, A., *Shah ʿAbbas and the Arts of Isfahan* (New York, 1973)

Welch, A., *Artists for the Shah* (New Haven, 1976)

Welch, S.C, *Persian Painting* (New York, 1976)

Welch, S.C, *Wonders of the Age* (Cambridge, MA, 1979)

Wilber, D., *The Architecture of Islamic Iran: The Il Khanid Period* (Princeton, 1955)

Wilber, D.N., *Persian Gardens and Garden Pavilions* (Rutland, VT, 1962)

Woods, J.E., T*he Aqqoyunlu: Clan, Confederation, Empire* (Minneapolis and Chicago, 1976)

Zebrowski, M., *Gold, Silver and Bronze from Mughal India* (London, 1997)

Zeno, C., 'Travels in Persia', in C. Grey, ed., *A Narrative of Italian Travels in Persia*, trans. W. Thomas and S.A. Roy, Hakluyt Society, no. 49 (New York, 1873 reprint)

Zettersteen, K.V. and Lamm, C.J., *Mohammed Asafi: The Story of Jamal and Jalal, An Illuminated Manuscript in the Library of Uppsala University* (Uppsala, 1948)

Glossary

abr	cloud-like foliage
'aks	either gold-painted illumination or stencilled decoration
'alam	metal standard carried in Shiite processions
ashura	the 10th of Muharram, anniversary of the battle of Karbala and martyrdom of Husayn, the son of 'Ali and grandson of Muhammad
badiyeh	wine bowl
Bustan	*The Garden*, a *masnavi* poem by the poet Sa'di
caravansarai	inn for travellers (often merchants) and their animals, with storage for their goods
chi'lin	fabulous deer-like animal with flaming haunches, of Chinese inspiration
cuerda seca	(lit. 'dry cord') ceramic glazing technique in which the colours are separated by a waxy substance before firing, which melts and turns black during firing but keeps the colours from running
daftar	a register or bundle of papers tied together
Divan	collected works of poetry or other writings by a single author
divan	a collection of a poet's works; the office of the principal administrators of the government
dïvankhaneh	court of justice
Falnameh	*Book of Divination*, thought to have been written by Ja'far al-Sadiq
farangi	(lit. 'Frank') foreigner, usually referring to Europeans; also Frankish pattern
garak-yaraq	purveyor, person in charge of supplies
Garshaspnameh	*The Story of Garshasp* by Abu Nasr 'Ali ibn Ahmad Asadi of Tus
ghazal	verse form of five to twelve lines, often used for love poems
ghulam	(lit. 'slave') non-Muslim, usually of Armenian, Georgian or Circassian origin, who entered Safavid military or administrative service
Gulistan	*The Rose Garden*, a book of collected anecdotes by Sa'di
hadith	*Traditions of the Prophet Muhammad*, sayings attributed to Muhammad, second to the Qur'an in importance as Muslim holy writings
haft-band	poem of seven-verse strophes
hammam	public or communal bath
hazar baf	(lit. 'thousand weave') glazed and unglazed brick decoration
imam	prayer leader; in a Shiite context, the infallible, divinely guided leader
islimi	ivy and spiral pattern
ivan	open-fronted vault used as an entry portal or facing onto a courtyard
janvar-sazi	animal design
jihad	holy war
kashkul	begging bowl, derived from the shape of a wine bowl
Khamseh	*Five Tales*, a collection of five poems by the poet Nizami and later by Amir Khusrau Dihlavi
khangah	dervish lodge or other building for Sufi devotion
khata'i	Chinese floral pattern
khutba	declaration of the name of the reigning monarch at Friday prayers in the congregational mosque
kitabkhaneh	library *cum* artist's workshop
Kufic	Arabic script with squared letters
madrasa	Muslim religious college
maidan	large open square
mash'al	pillar-shaped candle stand
masnavi	verse form consisting of rhyming couplets (distichs), often of extended length, suitable for epics
mihrab	arched niche indicating the direction of prayer, i.e. the direction of Mecca
mi'mar	architect
muhrdar	keeper of the seal
mulla-bashi	chief cleric
muqarnas	honeycomb or stalactite decoration used in transitional zones from square or polygonal walls to domes and arches
muraqqa'	album of calligraphy or pictures or both
murshid-i kamil	spiritual leader
naqqashi	'decoral art' (trans. Martin B. Dickson)
naqshband	specialist who 'translates' cartoons or drawings into patterns for textile and carpet weavers
nasta'liq	'hanging script', cursive script favoured in Safavid Iran
nilufar	lotus

nisba	the descriptive part of a Muslim name that refers to geographical origin, family or profession
padishah	emperor
qadi	Islamic judge
qaisariyya	royal or luxury bazaar
qalyan	base of a hookah or water pipe
qanat	underground water channel originating in mountains and serving plains and lowlands
qibla	direction of Mecca, to which Muslims face when praying
qit'a	calligraphic sample
qurchi	arms bearer, royal bodyguard
sadr	supervisor of religious endowments, chief of religious affairs
sarvlah	illuminated double-page frontispiece
Shahnameh	*Book of Kings*, by Firdausi, the Persian national epic
sham'dan	candlestick in the shape of a truncated cone with a cylindrical socket
shamsa	sunburst-shaped illuminated medallion
Shiite	follower of the Shi'a, Muslims who believe the caliphate is hereditary and are partisans of 'Ali and his descendants
simurgh	mythical bird similar in form to the phoenix
sufrachi	table-steward
Sunni	follower of one of the four Muslim legal schools, the Hanafi, Hanbali, Maliki and Shafi'i
surahi	long-necked flask
suratgari	figural painting
taj	crown or cap worn under a turban
taj-i Haydari	felt turban cap with tall baton and twelve gores worn by Qizilbash followers of the early Safavids
talar	porch consisting of a flat roof on tall, wooden columns
thuluth	one of the six classic cursive Arabic scripts
'ulama	Muslim clerics or those learned in Islam
unvan	illuminated chapter heading
vazir	vizier, government minister
vazir-i kull	chief minister
waqf	religious endowment
waqwaq	human- and animal-headed arabesque scroll
zaviyeh	meeting room for the faithful

Photographic Sources

Bildarchiv Preussischer Kulturbesitz: 66

British Library: 21, 36, 43, 69, 111, 135, 140

© The British Museum: 7, 10, 15, 20, 22, 26, 33–5, 37, 38–40, 46, 48, 59, 60, 65, 70, 73, 75, 76, 78, 92–5, 97–109, 112, 113, 116–18, 123–9, 131–4, 136, 138, 139, 141, 143, 146–51, 153, 155, 158, 160–68, 170

S.R. Canby: 2, 3, 5, 12, 13, 29, 30, 55–8, 79–89, 119–22, 137, 154

Chester Beatty Library, Dublin: 91

David Collection, Copenhagen: 53, 152, 159

Alistair Duncan, Middle East Archive: frontispiece

Fundação Calouste Gulbenkian, Lisbon: 27, 54, 62, 90, 110, 114

Institute of Oriental Studies, St Petersburg: 144, 156

John Rylands Library, University of Manchester: 23

Keir Collection: 18, 42, 44, 51, 52, 68, 74, 77, 96

Nasser D. Khalili Collection (© Nour Foundation): 157

A.S. Melikian-Chirvani: 45, 64, 71, 115

Metropolitan Museum of Art, New York: 72

Middle East Culture Centre in Japan, Tokyo: 24

Museum of Fine Arts, Boston: 32

Arthur M. Sackler Gallery, Smithsonian Institution, Washington, DC: 1, 4, 6, 9, 11, 41

Textile Gallery, London: 142

Textile Museum, Washington, DC: 28, 49, 50, 61, 130

Carolinda Tolstoy: 169

Topkapi Saray Library, Istanbul: 8, 14, 16, 17

Uppsala University Library: 19

Victoria and Albert Museum, London: 25, 31, 45, 47, 63, 64, 67, 71, 115 145

Map on p. 7 by Ann Searight

Index